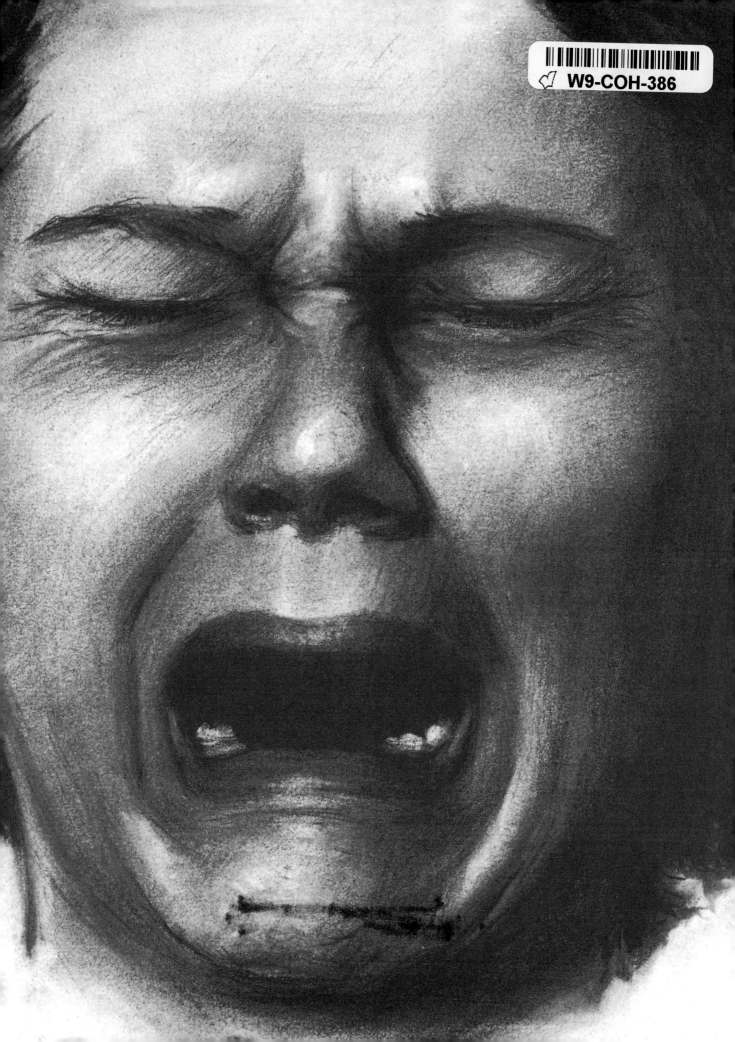

The Artist's Complete Guide to

FACIAL

EXPRESSION

Gary Faigin

WATSON-GUPTILL PUBLICATIONS/NEW YORK

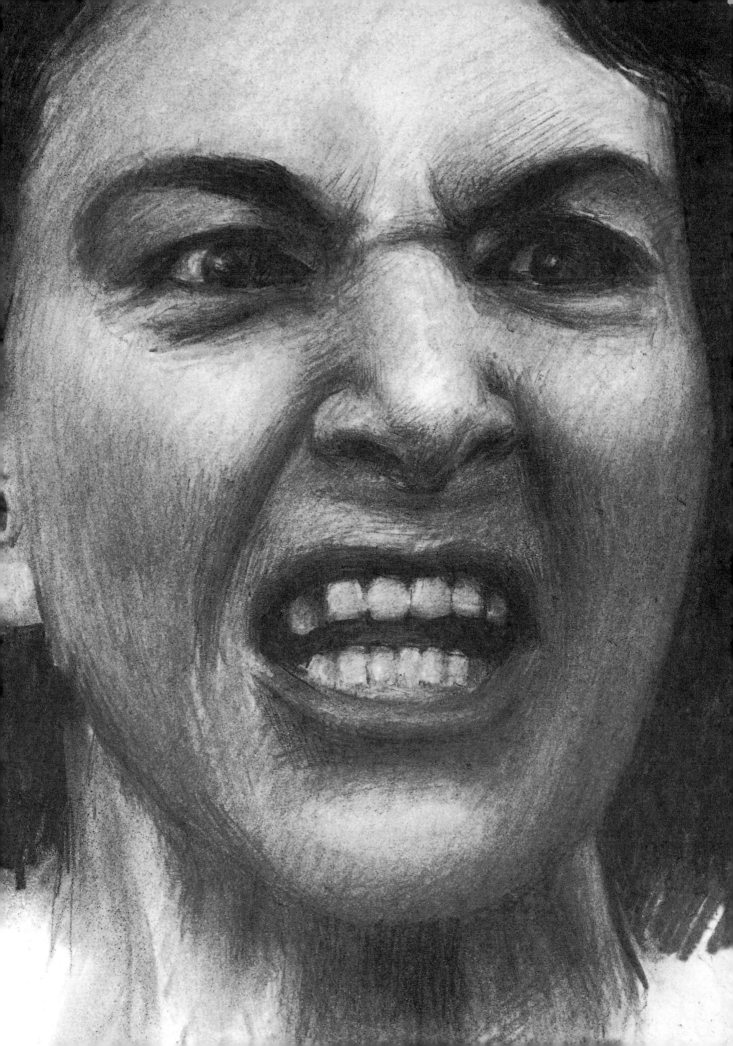

To Henry, Frieda, and Pamela

Senior Editor: Candace Raney
Associate Editor: Carl Rosen
Designer: Robert Fillie
Production Manager: Ellen Greene
Production Coordinator: Marybeth Tregarthen
Typographer: Trufont Typographers, Inc.
Set in Century Oldstyle

First published in 1992 in New York by Watson-Guptill Publications,
a division of VNU Business Media, Inc.
770 Broadway, New York, NY 10003
www.wgpub.com

Library of Congress Cataloging-in-Publication Data
Faigin, Gary, 1950–
 The artist's complete guide to facial expression / Gary Faigin.
 p. cm.
 Includes bibliographical references.
 Includes index.
 ISBN 0-8230-1628-5
 1. Facial expression in art. 2. Art—Technique. I. Title.
N7573.3.F35 1990
704.9′42—dc20 90-48379
 CIP

Distributed in the United Kingdom by Phaidon Press Ltd.,
Musterlin House, Jordan Hill Road, Oxford OX2 8DP

Manufactured in the United States of America

First Printing, 1990

17 18 19 20 21 / 12 11 10 09 08

Illustration credit: Page 10 (bottom)—
Vasily Baksheyev, *The Prose of Life;*
1872; Tretyakov Gallery, Moscow.

Acknowledgments

This book might have remained nothing more than a passing idea had it not been for the initial encouragement of my erstwhile instructor and friend Robert Beverley Hale. In more recent times, Carl Rosen and Candace Raney of Watson-Guptill did more than perform their editing tasks with style and dispatch; they communicated to the author an enthusiasm for the book no publishing contract can guarantee. Johanna Bartelt shouldered the marathon task of obtaining reproduction rights from museums and agencies around the globe; I will never again take the illustrations in a picture book for granted. And rather than single out any one thing to credit to Sallie Gouverneur and Pamela Belyea, I'll just say that without their various services over several years, this book would never have appeared.

The work of Dr. Paul Ekman was of crucial importance both in terms of describing the expressions and analyzing the muscular actions that create them. Other individuals whose help was much appreciated: Nick Ullet, Terry Brogan, and the 13th St. Repertory Company, who provided acting services; the persons at the United States Information Agency who helped contact museums and foreign companies for picture rights; Richard Rudich, who was always available with a "cold eye" and an encouraging word; Judy Wyer, who did valuable research; Claudia Carlson, who reviewed parts of the manuscript; and Don Poynter, who, together with my Art Students League Saturday class, helped in many ways. Others who should be singled out include: Bill Ziegler; Rhoda Knight Kalt; Ray Harryhausen; Elliot Goldfinger; Milton Newman; Patricia Belyea; Howard Buten; Rosina Florio; Dr. Robert Bell; Kyle Wilton; Lee Lorenz; John Kohn of Pro Lab; Jill Herbers; Phil Murphy; Scott Wilson; Arlene Smeal; Robin Weil; Elizabeth Valkenier; Max and Ruth Soriano; Commander Jim Belyea; Claire Gutman; Charles Haseloff; Howard Buten; Joel Kostman; Eli Levin; Marie-Genevieve Vandesande; Shoshanna Weinberger; Janet Hulstrand; Stashu Smaka; Sybil Faigin; Edward Maisel; Ken Aptekar; Joel Miskin; Laurel Rech; Alexandra Baltarzuk; ABC News; Borden Company; Guinness Company; Stephen Rogers Peck; Kay Hazelip; and finally, all the friends, family members, and students who modeled for the illustrations.

Gary Faigin offers workshops and classes around the country. For further information, please contact: The Academy of Realist Art, 5004 Sixth Avenue NW, Seattle, WA 98107.

CONTENTS

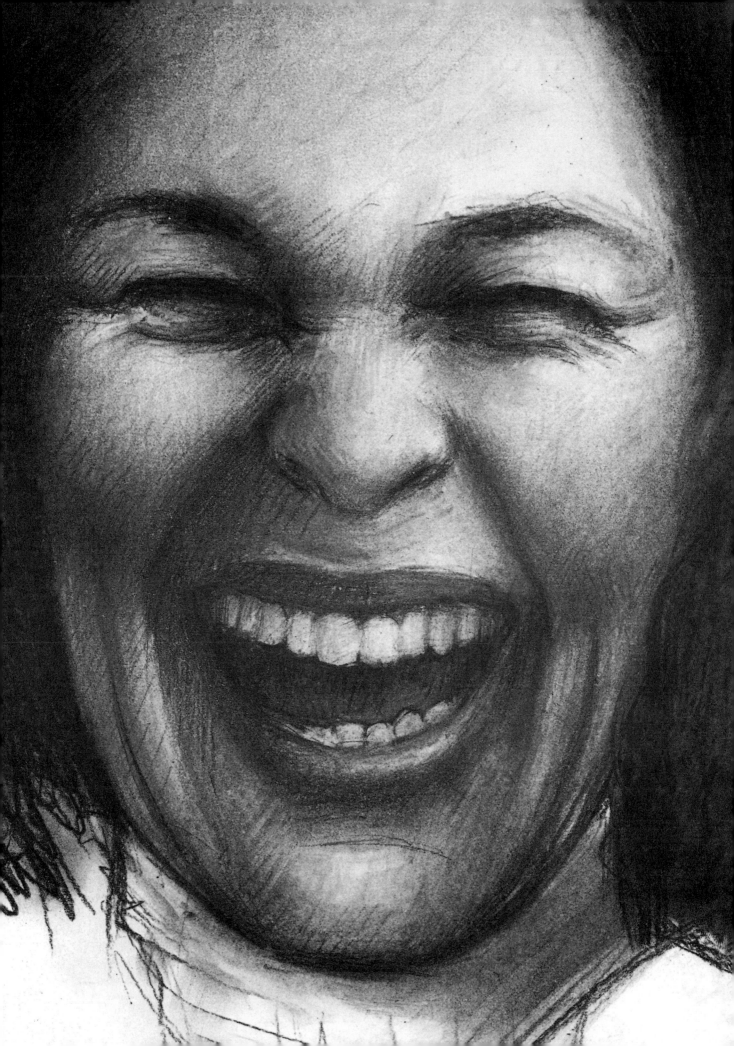

INTRODUCTION

"Charles, I've had it with you and your goddam moods."

There is no landscape that we know as well as the human face. The twenty-five-odd square inches containing the features is the most intimately scrutinized piece of territory in existence, examined constantly, and carefully, with far more than an intellectual interest. Every detail of the nose, eyes, and mouth, every regularity in proportion, every variation from one individual to the next, are matters about which we are all authorities.

We've come to know the face so well because it's so important to us; in fact, it's the center of our entire emotional life. From birth to death, the face links us to friends, to family, to everyone meaningful to us. Few things are capable of moving us as deeply as the face of a loved one; nothing interests us as much as looking at that same face, in all its moods, in its evolution over time.

THE FACIAL EXPRESSIONS

No wonder, then, that the little movements that alter the look of the features—facial expressions—can

have such great significance. The slightest suggestion of a smile can start a conversation between strangers; the slightest suggestion of a frown can start an argument between friends.

When we look closely at expressions like smiles and frowns, we realize how little on the face has to change for us to recognize an altered mood. When we try to *draw* an expression, we then realize that there is a gap between the *recognition* of an expression and the *re-creation* of one.

The actual physical threshold that must be crossed for an expression to be perceived can be very slight. For example, an audience would know instantly if a speaker became sad, drowsy, or annoyed; audience members too distant to distinguish a two-inch P from a two-inch F would have no problem noting a quarter-inch shift in the speaker's eyebrows and interpreting its expressive meaning correctly.

An Innate Skill

Our ability to read facial expressions isn't something we had to learn. It's

part of our instinctive equipment, like our aversion to pain or our feeling of warmth toward creatures with lots of fur and big eyes. Our mastery of expression is so deep-rooted that it's possible to lose the ability to tell one face from another yet *still* be able to recognize a smile from a frown. Researchers studying stroke victims discovered a group of individuals who could recognize various expressions even when they couldn't identify their own faces in a mirror. There's clearly something fundamental about a skill that can persist despite such severe brain damage.

Just as innate as our capability to distinguish the facial expressions of others is the reflex by which expressions appear in the first place. We don't learn to smile or cry by watching adults do it. Facial expressions arise powerfully and involuntarily like sneezes, or shivers. A baby born without sight will laugh and cry like any other baby. In fact, it's probable that babies have laughed and cried in a similar manner as far back as there have been human babies. Most experts believe that the fundamental facial expressions—fear,

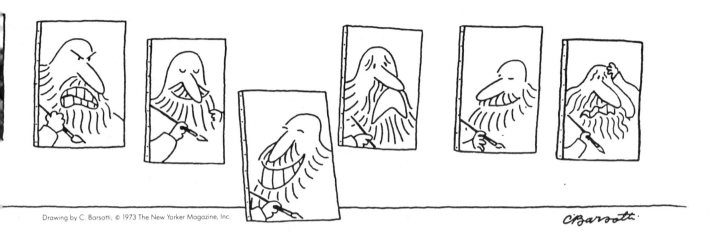

joy, sadness, surprise, disgust, and anger—are common to all human societies and have remained unchanged for thousands of years.

FACIAL EXPRESSION AND THE ARTIST

Facial expression has long attracted the attention of artists. Leon Battista Alberti wrote in his famous handbook for artists, *On Painting* (1435), that a painting "will move the soul of the beholder when each man painted there clearly shows the movements of his own soul . . . we weep with the weeping, laugh with the laughing, and grieve with grieving." He advised artists to carefully study the facial expressions, remarking, "who would ever believe who has not tried it how difficult it is to attempt to paint a laughing face, only to have it elude you so you make it more weeping than happy?"

Alberti's comment nicely summarizes the two most important facts about the relationship of art and expression: (1) facial expression *can* have a decisive impact on the effect of a picture; (2) depicting precisely the effect desired can be maddeningly difficult. These facts are related in two ways. First, it is a short step from recognizing the face's powerful grip on our consciousnesses and the primal nature of expressions to recognizing that the same power applies to *depictions* of the face. By moving us to identify with the emotions of people in paintings, art can gain in power and impact. Second, since depictions of expressions can be so powerful and subtle, they can, by themselves, make or break a picture.

There are many stories about artists struggling to perfect a particular laugh or grimace. Leonardo Da Vinci is said to have worked for years on the smile of his *Mona Lisa*, employing the services of jugglers, musicians, and clowns in an attempt to evoke from his subject that certain smile. While working on his sculpture *Martyrdom of Saint Lawrence*, Bernini is reported to have burned his own leg with a candle in order to study the expression of pain. Ilya Repin agonized over the countenance of the returning exile of his painting *They Did Not Expect Him*, changing it many times—partly in response to published criticisms—because he felt that the whole meaning of the picture depended on it.

Memorable Images

The effort can be worth it: certain masterpieces revolve around a particular vivid expression. It's no coincidence that nearly every acknowledged master of Western art was a master of facial expression. Included in this book are major paintings by Velazquez, Rembrandt, Leonardo, Reubens, and Caravaggio; in each, a vivid expression takes center stage. Alberti's advice, that an artist should show the soul to arouse the viewer, is borne out in each case; our reaction *is* the exercise in empathy that he suggested.

The manner in which artists have depicted facial expression has also depended, to some extent, on the period in which they were working. Artists of the late eighteenth century, for example, were more likely to portray emotions in their paintings by the use of obvious, theatrical gestures—what

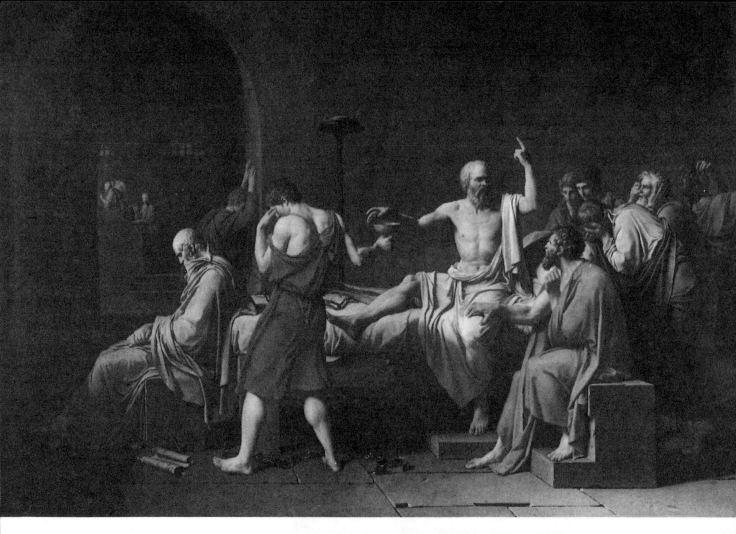

Like actors in a B movie, the characters in the neoclassicist David's *Death of Socrates* overtly demonstrate their anguish over the philosopher's impending suicide. Melodramatic gestures and conspicuous poses (Socrates points heavenward to indicate the immortality of his soul, sorrowful disciples slump against walls or cover their heads with their hands) dispense with all subtlety. The face plays a minor role.

The treatment of emotion in this late-nineteenth-century realist painting is opposite to that of the neoclassicists. Rather than broad, unmistakable gestures, everything is held in; mood depends on nuance and detail. The daughter's stare, the father's scowl, and the mother's expression reinforce the sense of isolation and distress.

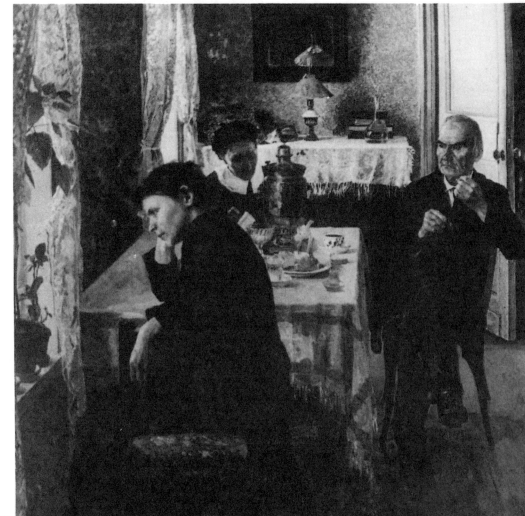

actors call *indicating*—than by focusing on subtle movements of the face. In paintings by the neoclassical artist David, for example, despairing people fling their arms up in the air or slump against walls in a manner that seems terribly exaggerated and artificial to the modern eye. One would have seen much the same thing in the theater of David's time.

Painters working in the late nineteenth century, particularly between 1860 and 1890, placed a higher priority on careful observation from life. Their artistic climate was shaped by the realist movement. Gone were paintings of nymphs and the lives of classical heroes—in their place were scenes of farmers, laborers, and the unhappy bourgeoisie. In the plays of Chekhov and Ibsen, in the novels of Tolstoy and Zola, and in the paintings of Repin and Eakins, there was a similar effort to hold up a faithful mirror to the contemporary world. As actors of the time brought to the stage a new level of craftsmanship and emotional conviction, painters succeeded in portraying the most compelling nuances of facial expressions and gesture. No artists before or since have painted pictures that were so psychologically true in their depictions of the face.

The Twentieth Century

In our century, there's been a very different attitude towards the value of visual truth. Many felt that painters had exhausted the worth of pursuing the "merely visible." Artists like Picasso, Cezanne, and Kandinsky strove to create an art that was independent of nature, in which color, form, and expression were valued simply for their own sake. Painting was conceived of as a universal language, like music, capable of moving our emotions without any reference to recognizable elements. Given this ideal, it's no wonder that painting in the twentieth century has seen little in the way of continuation of the nineteenth-century realists' work.

The work of photojournalists, however, does represent a link with the realist painters of the past (whose drawings often appeared in nineteenth-century newspapers).

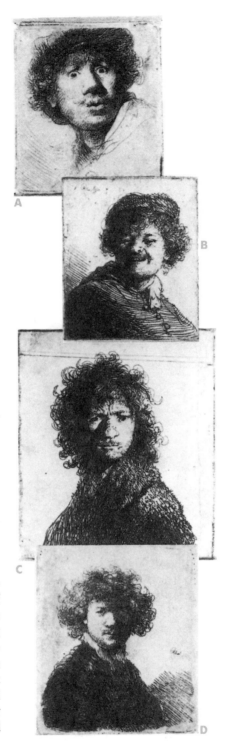

Just practicing. Rembrandt's fondness for self-portraiture arose early in his career. These etchings of the youthful Rembrandt mugging before the mirror were undoubtedly meant as exercises in rendering various expressions. Anyone who has ever etched a plate can appreciate the task he set himself; expressions are not usually held on the face more than an instant, and the effort to maintain the poses of fear (**A**), laughter (**B**), anger (**C**), and the slight smile (**D**) is in itself impressive.

News photos have had an enormous impact on the modern consciousness. We can immediately bring to mind the photojournalist's images such as Lee Harvey Oswald's scream of pain (or his guard's scowl) or crying children fleeing their burning village in Vietnam. Unquestionably, these too are images where people "clearly show the movement of their own souls." These photos are direct successors to the "journalistic" paintings of the nineteenth-century realists. (Ironically, the advent of newspaper photography was part of the reason realist painting fell into decline.)

Painters will always be passionately interested in the face and its moods in a way that transcends periodic fluctuations in style. The power of the face will always inspire artists to explore its expressive possibilities, and pictures that capture emotions in a striking way will always be notable. Moments of strong emotion are rare in the humdrum of daily life, and we're instinctively drawn to images of the face where the "movements of the soul" are clear.

Non-Western Traditions

Artists from nearly every period and culture have recorded the effects of emotion on the face. This book includes the jade head of a crying baby from pre-Columbian Mexico; a wooden, snarling-faced war helmet from the Pacific Northwest; scowling emperors carved in stone from ancient Rome; and theater masks from Japan and North Africa displaying a range of emotions from fear to laughter. Human expressions also appear on the faces of animals, demons, and gods; looking at the art of some civilizations, it is harder to find a face in repose than one contorted by some expression.

HOW ARTISTS HAVE STUDIED EXPRESSION

For artists wishing to inform themselves on the subject of facial expression, there have always been three options: (1) looking in a mirror; (2) looking at other pictures; (3) direct observation.

Direct observation is clearly the

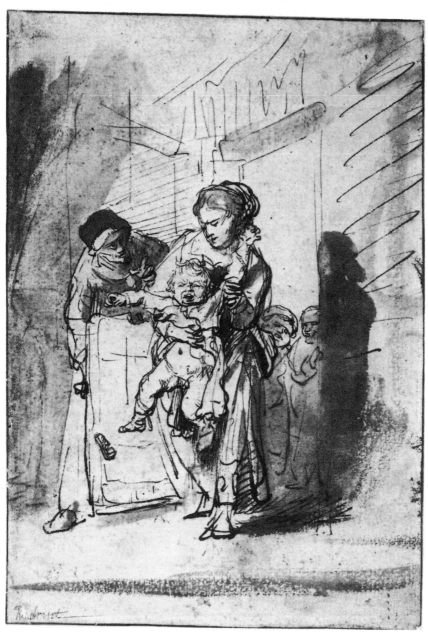

Rembrandt may have relied on quick notations from life for his etchings and paintings, but these drawings represent an unusually clear record of his procedures. The sketch of a screaming, struggling little boy hauled off by his mother is a masterpiece of quick observation. Note the flying shoe, the admonishing gesture of the mother, her scowl.

most difficult option. We don't often see people in the grip of a primal emotion, and even when we do, there are obstacles: expressions don't last very long; they are frequently of the utmost subtlety even when they do last; and we usually feel too inhibited or involved to look on objectively when someone else is suffering anguish or pain.

Some artists have nonetheless persisted in working from direct observation. Rembrandt Van Rijn's sketch of a screaming child, clearly made from life, became the basis for the expression in (and may have inspired) his painting *Ganymede*. Perhaps Rembrandt was aware of Leonardo's advice: "Try to be a calm spectator of how people laugh and weep, hate and love, blanch from horror and cry out in pain."

Rembrandt also (like most artists) studied his facial expressions at the mirror. Many of his early etched self-portraits have a distinctive, dramatic expression. These lively pictures were probably meant as a sort of exercise, unrelated to any specific work. Like a musician studying scales, Rembrandt seems to have been preparing himself for the demands of his future art. In a similar spirit, the French Academy used to require all students to portray a specified emotion in an "expression competition," feeling that it was an important skill that students needed to master.

Traditionally, artists have referred to the work of other artists to learn to portray emotion. For example, students once dutifully copied the anguished grief-stricken face of the classical sculpture *Laocoön*. In the Middle Ages, painters were expected to base their renderings on studio books of standardized drawings. Yet the expressions captured in the *sculptures* of the Middle Ages seem taken directly from life. One wonders if medieval sculptors took more liberties with their research than painters of the same time.

About This Book

Curiously, there have been very few books on the subject of facial expression for the artist. To my knowledge, the last one was Sir Charles Bell's *Essays on the Anatomy of Expression in Painting*, published in 1806, and it wasn't a terribly good book in the first place. Many more recent drawing books have included short sections on expression without shedding much useful light on the matter. In fact, artists familiar with such sources have generally had the good sense to prefer their own judgment and observations.

A great amount of useful information about facial expressions has recently been published by psychologists. Their research, especially that of Paul Ekman, the leading authority on the subject, has been a major source of this book. This book also borrows heavily from the work of modern photojournalists, whose ability to be at the right place at this right time and to point cameras in the faces of people no matter what the circumstances, have done artists a great service.

The Head in Action

This is not primarily a book on how to draw the head—there are plenty of books that do that. It's a book about depicting the actions of the head. It focuses on the facial expression of emotion, but other actions are illustrated, such as the sideways gaze, the open mouth, the raised brow, which add to the liveliness of a face.

The gist of this book is in the illustrations and their accompanying captions. Anyone who reads through the picture pages will have covered most of the material. The text itself offers slightly more detail and discussions of certain theoretical issues.

Part of this book is devoted to the anatomical basis of the expressions. The study of anatomy, it has been said, increases the sensitivity of the artist's eyes, making forms clearer because they are more clearly understood. The expressions offer the eye a potentially confusing landscape of wrinkles, bumps, and altered features. Under-

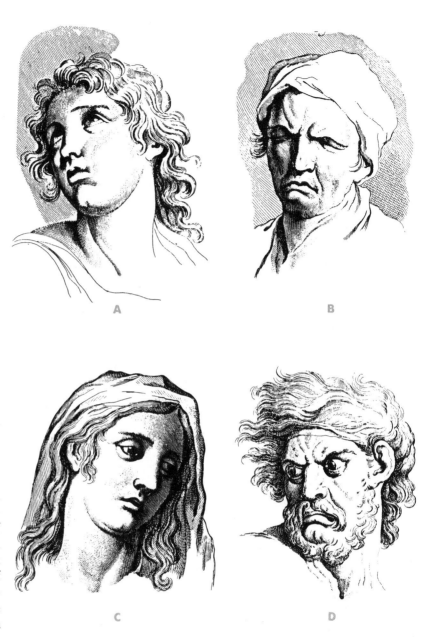

Facial expression for artists. Few reference books have included credible images of facial expression. These excerpts from the Diderot *Encyclopedia*, illustrating (clockwise) reverence (**A**), discomfort (**B**), sadness (**C**), and anger (**D**), strike the modern eye as excessive and unnatural.

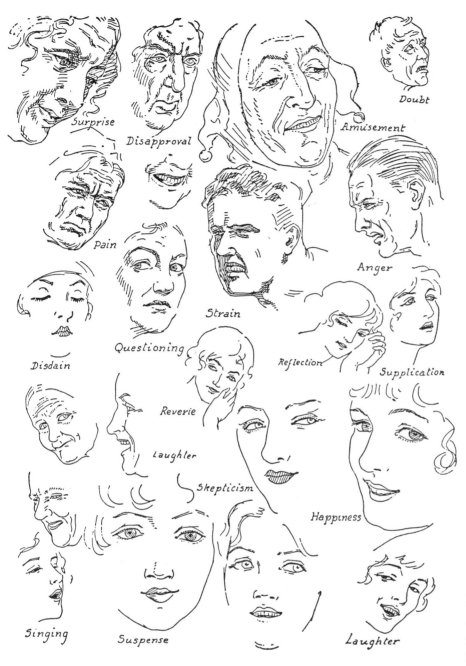

Surprise

Disapproval

Amusement

Doubt

Pain

Anger

Strain

Questioning

Disdain

Reflection

Supplication

Reverie

Laughter

Skepticism

Happiness

Singing

Suspense

Laughter

Anatomy and Drawing by Victor Perard includes this page on facial expression. If you cover the captions, very few of the expressions are easily recognizable. Expressions like surprise, laughter, and anger—when genuine—should *need* no label. Expressions of doubt, supplication, reverie, and disapproval, however, are vague emotional states that have no distinct identity on the face.

standing what creates these forms makes it easier to see the expressions, and it also makes it easier to see the simple underlying pattern that is the true basis of our recognition of a particular expression. Nearly every facial muscle, for example, has a characteristic "signature wrinkle." Once recognized, this characteristic will be seen on nearly every face when the same expression is in progress.

We discuss first the deep bony forms, then the muscles that lie atop them. In the final section, the facial expressions are described in detail, referring back to the individual muscles involved in each expression. The reader is encouraged to regularly examine what's discussed on his or her own face. This book is really meant to become a sort of guided tour to the face.

HOW THE DRAWINGS WERE MADE

My drawings were primarily done from my own photographs. In section 3, however, a number of the drawings of the expressions are based on photographs from newspapers and magazines. My decision to use newspaper photographs was based on an important point: some expressions do not seem to be convincing unless they are completely spontaneous.

At first, I had taken photographs of actors portraying various expressions, but many of these were found to be unconvincing. When I showed people newspaper photographs of angry, frightened, or surprised people who had been in situations where these feelings naturally arose, I got a much stronger response. This was true even though I made sure to remove any clues as to what else was going on in the picture. Since my methods were hardly scientific, it is difficult to draw conclusions from the results. But it seems clear that we can usually tell the difference between a spontaneous expression and a posed one. The artist is well advised to get a second, or even a third, opinion if working with a face where the expression is at all doubtful.

In the end, about half of the expression drawings were based on photographs from spontaneous situations. I

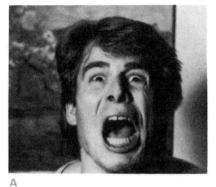

A

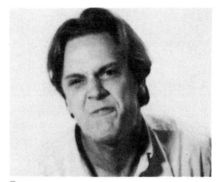

B

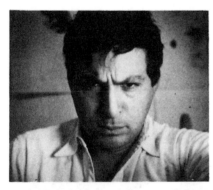

C

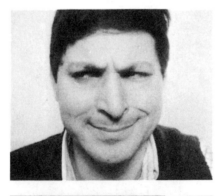

D

The inquiring camera. Hundreds of photos were taken in preparation for this book. The best were used as the basis for many of my expression drawings. Sessions with actors proved useful, but many expressions were judged unusable because they appeared too extreme (**A**) or too ambiguous (**B**). Besides working with actors individually, unscripted scenarios were staged in an attempt to elicit a particular expression. Several actors ganged up on the figure in the dark shirt (**C**), but the expression of fear did not materialize. At (**D**), however, it did.

There were many times when I needed extra detail on a part of a face I was drawing, and taking a closeup of my own face proved another helpful way to do research.

only used photographs that I had shown to a large number of people and for which I had gotten similar responses. Many of those photos had serious technical shortcomings in terms of clarity or lighting. I often studied my own features in similar positions to resolve particular details. I made a careful sketch from my own face, and then I transposed it to the face of someone else.

WHY THE FOCUS ON THE FACE

Posture and gesture (*body language*) can have a decisive effect on the expression of emotion. The back view of an individual slumped over with head in hands vividly shows that person's feelings. In fact, some emotions are inseparable from particular gestures: anger with a lunging forward of the body, sorrow with slumping, horror with an instinctive raising of hands to the face.

The face alone, however, can communicate the full range of human emotion. By just focusing on the face, we can learn many valuable and important things that are no less true because they are also part of a larger context. Think of the face as being like the key solo instrument in a symphony orchestra. In a concerto, the soloist can carry the melody, as can the full orchestra along *with* the soloist. Likewise, the face can act alone to communicate sadness, fear, or pleasure, but more often it's message is reinforced by the action of the rest of the body.

THE INFLUENCE OF CONTEXT

Context, or setting, will also influence the emotional message we get from someone in a picture. If what's going on in picture leads us to expect to see a particular expression, we will seize on the least clue to convince ourselves that that expression exists. For example, imagine a portrait of a man with his eyes slightly widened. We might draw any number of conclusions about his emotional state (including the conclusion that he's not feeling anything in particular). If this same man, however, is painted throwing open the bedroom door on his wife and her lover, we're certain to see a great deal more in exactly the same expression. We're

likely to see shock, anger or both, but we will certainly see something pronounced based on what we *expect* to see.

The faces most susceptible to being influenced by context are those with ambiguous or very slight expressions. The less we see going on in a face, the easier it is to read our own message onto it. Our perception of an up-roarious laugh or a furious shout, however, is little influenced by the surroundings.

A NOTE ABOUT THE MUSCLES

If you want to know which facial muscles do what, you won't find a clear answer in the standard reference books, like Gray's *Anatomy*. Five hun-dred years after Leonardo's pioneering studies, the subject of facial expression still hasn't been entirely sorted out by the experts. Though psychologists have been busy updating our knowledge of the face, anatomists have not. There are major disagreements in the anatomy books on a number of key issues. For example, no two books seem to agree on exactly which muscles make us smile. While some books insist that the *risorius* (Latin for "to laugh") is crucial to the action, others assert that nothing could be further from the truth. Some even dispute the very existence of the muscle, saying that it's a no-show on many faces, and of little importance on others, and it's really another muscle—the *platysma*—that does the work.

Several other facial muscles are in a similar position of having their very existence in doubt. One doesn't encounter this problem studying the anatomy of the arm or the calf. The fact is that the muscles of the face are so minute, so confusingly deployed under the surface, and of so little interest to researchers (not being crucial in disease, sports, or disabling injuries) that some fundamental questions are still unresolved.

This book represents an attempt to compromise between being too vague and being too certain and specific. The drawings show the surface appearances as they are; but exactly what's going on under the surface is still something of a mystery. Few artists will find this a serious handicap; still, it *would* be nice to know what really makes us smile.

HOW TO USE THIS BOOK

This book is meant to be read with a mirror close at hand. Many, if not all of the expressions can be fairly easily posed, though some individuals are more gifted at this than others. The position of the eyebrows in sadness, for example, is very easy for some people to duplicate; others can only do it if they really are sad. But everyone is able to produce the frown or the sneer. It's even more useful to get someone else to sneer or frown and to study that face carefully. It's also helpful to use your sense of touch to trace the three-

Our perception of facial expression is enormously influenced by what we ex-pect to see. A caption can produce an opposing con-text: a sob can become a smile. The faces most sus-ceptible to being influenced by context are those with ambiguous or very slight expressions.

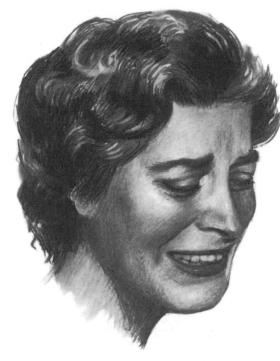

This is a drawing of a wo-man who has just learned of the death of a close relative.

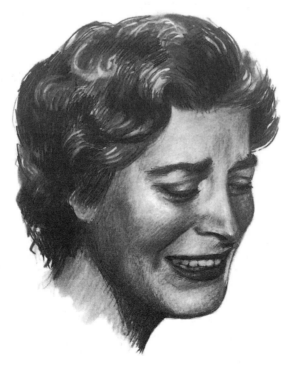

This is a drawing of a wo-man at a reunion with a rel ative she'd thought dead fo many years. With this cap-tion, we see her face very differently than with the more tragic caption (in fact this last caption is true).

dimensional forms on your face when posing the expressions.

Every opportunity should be taken to observe these expressions from life. Front-row seats at the theater are perfect spots for expression research, and playgrounds can also be great places—children don't tend to hold back when they're angry or distressed or mind being looked at. I also recommend lingering at bus stations during rush hours to watch for commuters late for their buses and spying on tables full of tipsy people in cafés. If you discreetly observe travelers saying their good-byes at airports, you may well spot the charming expression in which sadness mingles with a smile. And unexpected opportunities arise: I can still vividly bring to mind the distressed look on the brow of the poor woman I saw once being arrested for shoplifting. Just remember—it's not polite to stare! (though dark glasses can help).

Movies are useful, and videotapes particularly so, as an interesting face can be watched more than once or even frozen as a still frame. The daily papers and news magazines are also scanned a bit differently when you're indulging your curiosity about the face—a clip file can be an important tool.

Finally, have fun with a pencil. The easiest way to begin trying out these expressions is by drawing simple, cartoon-like faces like those in the appendix. Even such rudimentary faces can be quite expressive. Next, you might want to take an existing surplus drawing or painting of a face and experiment with the effects of various alterations in the look of the eyebrows or the mouth. Copying pictures of expressions—either photographs or works of art—is also useful.

Ultimately, the value of this book may be in hinting just how a slight movement here or there can add life to a portrait and help bring a personality to life. It may also help someone trying to *remove* an unwanted expression. My fondest hope, however, is that this book will prove helpful to those artists who have ambitions, beyond those of most of their contemporaries, to create works of art in which the human drama—and the "world of visual appearances"—plays a central role.

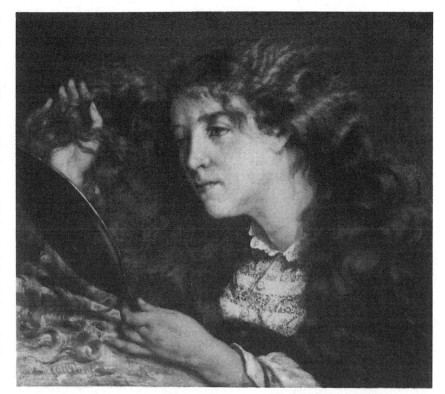

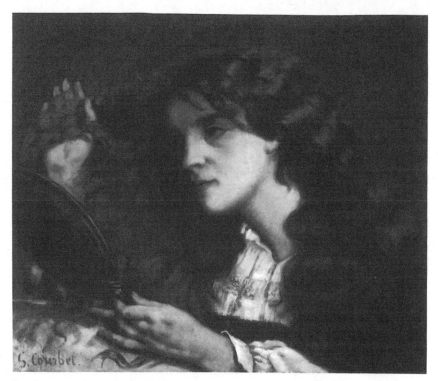

If at first you don't succeed, try a slightly different version. Merely by slightly changing the position of the eyebrows, Courbet gave the top portrait of Jo, Whistler's mistress, an undertone the one above completely lacks. The slightly bent eyebrow (and to a lesser extent, the look of the eye and brow) suggests sadness or worry. Instead of a pretty young woman admiring herself in a mirror, we see the painting as a meditation on the fleeting nature of beauty, or simply a study of melancholy. Many artists might be curious about the effect such a change might have on their painting, but few would be curious enough to paint a complete alternate version.

THE

STRUCTURE

OF THE

HEAD

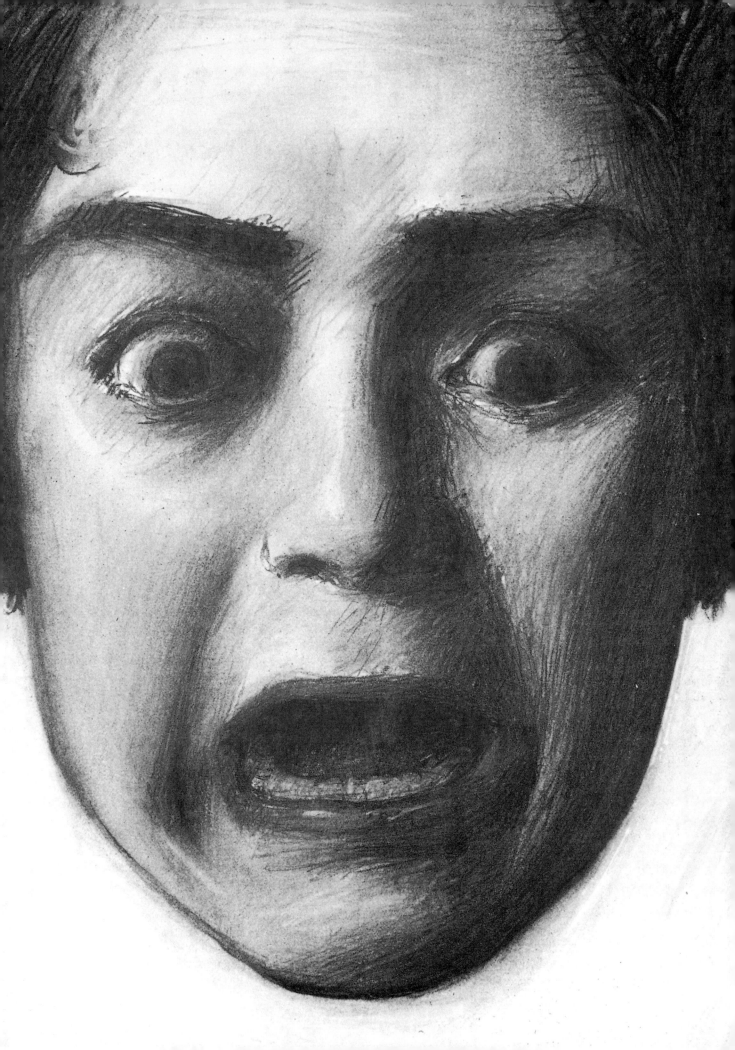

GOING BENEATH THE SURFACE

Facial expressions come and go. They pass over the surface of the face like light ripples on the surface of a pond. The deep structures beneath, like the deep waters on the bottom of a pond, remain unperturbed. But the bony forms of the head make the presence of the facial expressions felt on the surface indirectly; the teeth give form to the smile; the frontal bone gives form to the frown.

A major theme of this book is that knowledge enhances seeing. Once you know what the hidden parts of the face look like, you can see—and draw—their effects on the surface more clearly. So we study the deep forms, and the forms of the head as a whole, before we look at the localized, superficial expressions.

AVOIDING THE BEGINNER'S ERROR

There is another, equally important reason to start out with the head as a whole—it will prevent *the* classic beginner's error: starting with the features first and then adding on the head.

Because of this drawing order, beginners almost always draw the features as far too big, the head holding them as far too small.

There is a universal tendency to misjudge the face in this way, probably because we learn early on that faces and facial expressions are pretty good indicators of whether we can expect to be stroked or scolded. Reward and punishment being such important things in life, we fall into the habit of focusing on the features of those around us. So when we draw or paint a head, we naturally tend to zero in on the part that interests us the most: the face.

Beginners are also under the impression that a likeness depends very much on getting the features exactly right and very little on the rest of the head. So the features are drawn as gigantic, because they loom gigantically in the beginner's mind. The way we recognize someone is actually based on *overall* appearance—the clues that make us recognizable from a distance or as a vague figure in a group photo. It's a pattern that includes hair and head shape and general proportions. No matter how perfectly the eye is drawn, for example, if the surroundings aren't right, the head won't look right.

The cure for these problems is simple—start with the bigger forms, *then* work down to the smaller. We must work very hard at pinning down that big pattern first. When the time comes to work on the details, we look at them in relation to their surroundings; they will shrink in size accordingly. One of my drawing teachers used to say that "in relation to" is the most important phrase in drawing. Nowhere is it more important than when drawing the head.

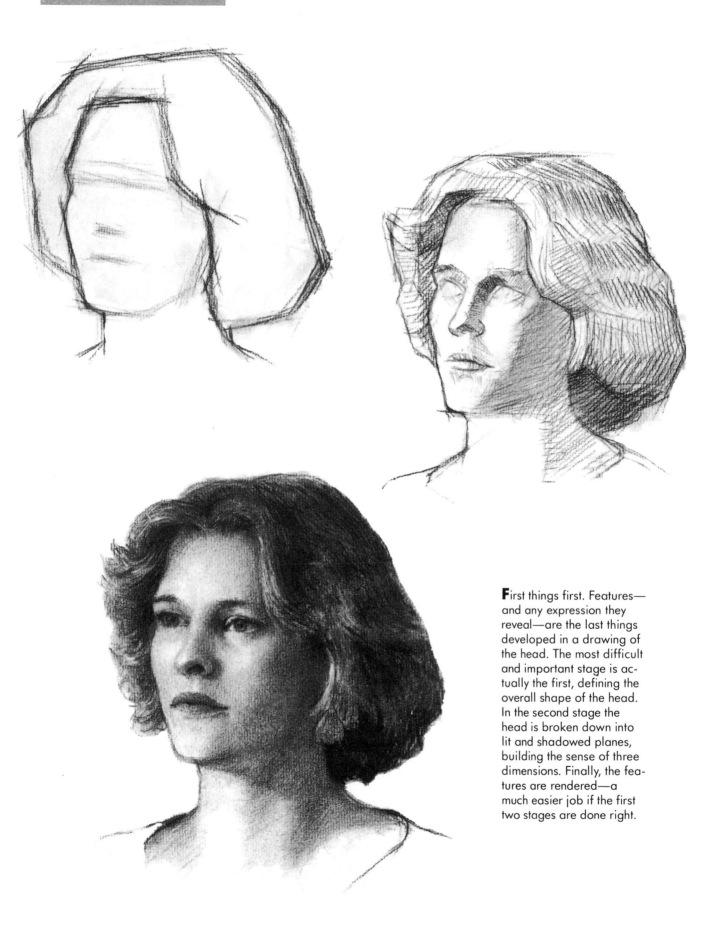

First things first. Features—and any expression they reveal—are the last things developed in a drawing of the head. The most difficult and important stage is actually the first, defining the overall shape of the head. In the second stage the head is broken down into lit and shadowed planes, building the sense of three dimensions. Finally, the features are rendered—a much easier job if the first two stages are done right.

LOOKING AT THE SKULL

The skull is the most important of the deep forms that give shape to the face. Differences between one person and another are largely a result of differences in the skull. The skull determines the shape of our head and the location of our features. Hallowe'en and horror films aside, it is a beautiful and fascinating structure.

Part of an artist's training is to carefully observe and draw the skull from a variety of angles (a plastic skull can be used). Eventually, the skull's basic framework is memorized and then used as sort of a mental armature whenever the head is drawn. Norman Rockwell, whose drawings of heads were always his strong point, recalled, "I had an art teacher years ago (George Bridgeman) who made us draw hundreds of skulls in all positions. I felt he was overdoing it at the time, but now I realized what a wonderful lesson he taught us. Whenever I draw a head, I instinctively feel the skull structure beneath."

We'll look at the skull in a simplified, streamlined version. Then we'll examine it's proportions, finally describing the different parts of the skull and how they relate to what we see on the face.

A Simple Version

The best way to memorize a complex form is to find a simpler form that's a close equivalent. From an artist's viewpoint, cars are boxlike; Christmas trees conelike; smokestacks and pencils simply larger and smaller versions of cylinders. Relating objects to simple forms is very helpful both in drawing them from life and from the imagination. Although attempts have been made to equate the head with a box, an egg, or another fundamental form, most artists prefer a slightly more complex shape to use as their imaginary model. One example is illustrated.

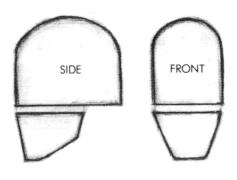

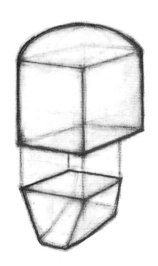

A simple model for the head, the combination of a slightly rounded box and a smaller wedge, can be easily visualized from a variety of positions. The box form is like a cube with a bit added on; the wedge is a streamlined version of the skeletal jaw.

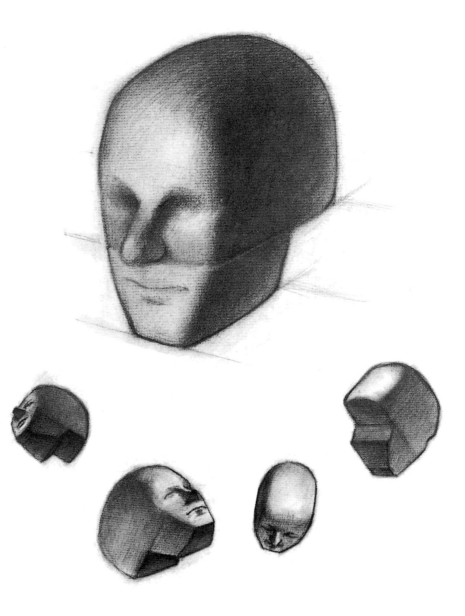

Skull and Head Proportions

Although the skull is what makes our heads different, all skulls are basically the same. We *think* that because everyone looks so different, the differences between one person and the next must be quite pronounced. But we're experts; we've been looking at faces every day of our lives. If you've ever watched an expert in another field at work— say, a geologist examining a rock, or a palm reader looking at a hand—you know how much more they see in what they're examining than we do. Their long experience lets them distinguish tiny variations between items we might think identical. The distinctions we are capable of making with the face are just as refined, but skulls are another matter—we simply don't have enough practice looking at skulls, and so the variations aren't obvious. People, and skulls, *are* different, but not all that different. We're just used to people.

The consistent shape of the skull makes proportional rules for the head possible. The exceptions to the rule aren't off by much. It's not true, for example, that all people have eyes halfway up their heads. The exception might be someone with eyes slightly higher or slightly lower. And for the vast majority of us, this pattern will hold true.

SOME PROPORTIONAL FACTS

There have been a lot of rules invented concerning the proportions of the skull going back at least as far as the Greeks. I discuss below the ones I think the most important.

Overall Shape
The height of the skull and the depth of the skull are nearly the same. Keeping this fact in mind helps avoid the common drawing error, "cutting off the back of the head"—making it too short. In a side view, before marking off the end, compare the height to the depth, making sure they're approximately the same.

The width of the skull is the smallest dimension. The average skull is only about two-thirds as wide as it is tall. It gets that wide at the level of the cheekbones; it's narrower above and below. Skulls with wider cheekbones have a more oval shape. With slender cheekbones, the skull appears more rectangular, because there's less difference in size between the cheekbones and the rest of the skull.

SOME PROPORTIONAL FACTS

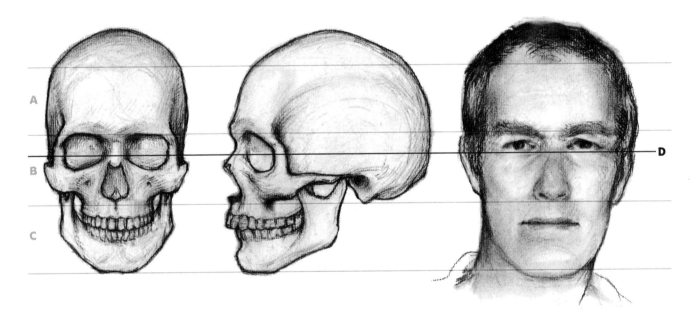

The similarities among human heads are more striking than the differences. Artists have a name for the major type of similarity: proportion. Proportional patterns in the head have been the subject of artists' attention since classical times. We use the skull as our guide because its landmarks are the most stable. The most consistent, and useful, proportional rule regarding the skull is the location of the halfway point. It almost always falls in the middle of the orbit, which on the face is the middle of the eye: The eyes are halfway up the head. Exceptions to this rule are rare. Another important pattern is the rule of thirds. From the top of the forehead, the skull divides into three equal sections: forehead–brow; brow–base of nose socket; base of nose socket–chin.

A. UPPER THIRD
B. MIDDLE THIRD
C. LOWER THIRD
D. HALFWAY POINT

Location of the Eyes

The smaller forms of the skull help determine the locations of the features. The eye socket, for instance, determines the position of the eyes. Since the eye socket invariably falls about halfway up the skull, the eyes are always found on or near the midline of the head. To be more precise, the inner eye corner usually sits on an imaginary line drawn through the middle of the head. This rule alone would save many students a lot of grief. Because people tend to make the features too big, the eyes tend to go a lot higher up the head than just halfway.

The Rule of Thirds

The skull can be divided in another way. A point is located just below the top of the skull called the "widow's peak." This is the spot where the *frontal bone* (corresponding to the forehead) makes a sharp break with the upper plane—it's just slightly below the actual top. From here the skull is divided into thirds, and each dividing line falls on a major landmark as follows:

☐ One-third of the way down from the widow's peak, the bony prominence called the eyebrow (or *superorbital*) ridge bulges out above the eye socket. On the face, this is where the eyebrows grow.

☐ Two-thirds of the way down from the widow's peak, the bottom of the oval-shaped nose socket is found. On the face, this is where the nose ends— where the tip turns under to meet the upper lip.

☐ The lower border of the skull is the edge of the bony jaw. On the face, this is the border of the chin, where the face ends and the neck begins.

This proportional pattern—the dividing of the skull (and face) into three equal regions—is not quite as universally true as the one concerning the eyes. But skulls—and people—don't vary from this arrangement by much.

When there are exceptions to this rule, it's usually the central third that varies from the arrangement. According to the rule of thirds, the distance from the base of the nose to an imaginary point between the eyebrows is the same as the distance from nose base to the bottom of the chin. I'd say this is right on the mark about 70 percent of the time. The rest of the time it's usually the length of the nose that's short. About 30 percent of us have noses that are a bit shorter than the space from nose to chin. It is exceedingly rare to find someone with the distance from nose base to eyebrow *longer* than the distance from nose base to chin.

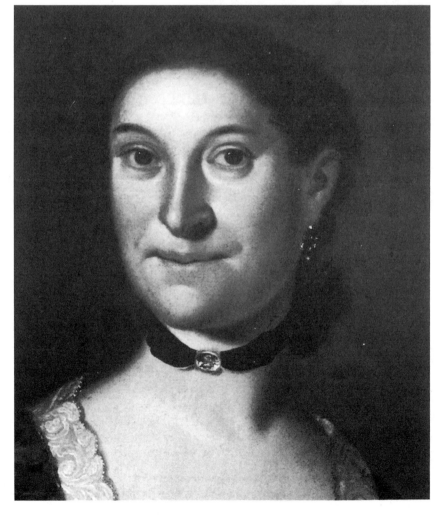

Nobody's perfect. Was it she, or was it her portrait painter? A most peculiar-looking effect occurs when the eyes fall higher than halfway up the head. The woman might have looked this way, but a far more likely explanation is that the artist (an early American painter) inadvertently left out part of her forehead. Taking a bit off the top is the most common of all errors in portraiture.

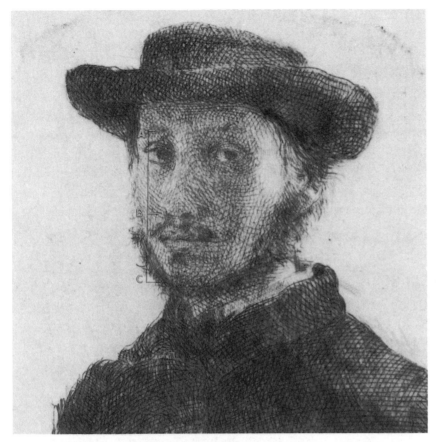

Long-nosed or average? The aristocratic Eduard Degas painted many self-portraits. A striking feature of most of them is his long, slim nose. Long indeed; as seen in the etching, Degas's nose is longer than the distance from the base of his nose to his chin. On the average face, the distance from the top of the nose (**A**) to the nose base (**B**) is the same as the distance from the nose base to the chin (**C**). On one out of four people, A to B is shorter. The Degas nose occurs less than 5 percent of the time.

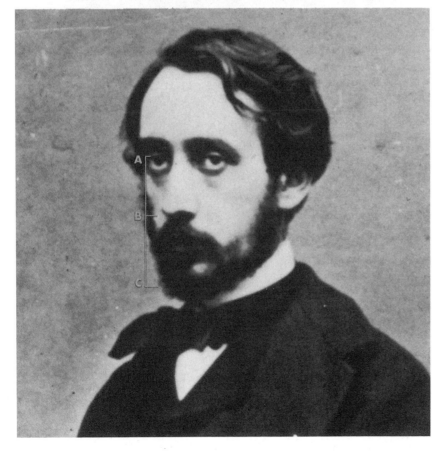

Is this the "Degas nose"? Examining the photograph of the artist, it appears that he had proportions more average than those he painted, that is, his nose and chin lengths seem equal. Rather than being as literal as they seem, Degas's self-portraits may represent a calculated exaggeration, a sort of self-caricature.

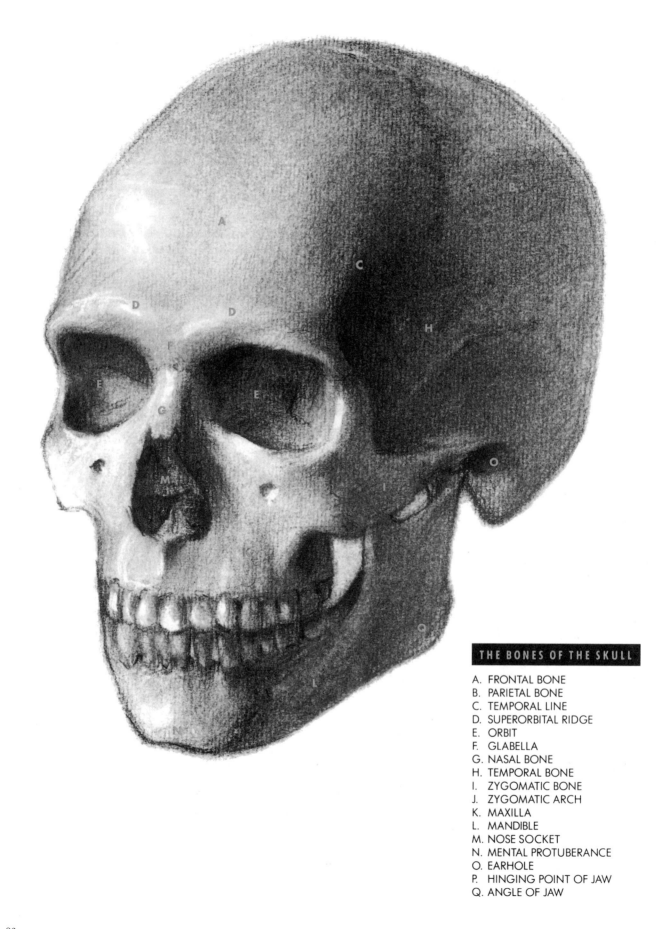

THE BONES OF THE SKULL

A. FRONTAL BONE
B. PARIETAL BONE
C. TEMPORAL LINE
D. SUPERORBITAL RIDGE
E. ORBIT
F. GLABELLA
G. NASAL BONE
H. TEMPORAL BONE
I. ZYGOMATIC BONE
J. ZYGOMATIC ARCH
K. MAXILLA
L. MANDIBLE
M. NOSE SOCKET
N. MENTAL PROTUBERANCE
O. EARHOLE
P. HINGING POINT OF JAW
Q. ANGLE OF JAW

No other skeletal form inspires such strong associations as the human skull. It's so close in shape to the head that it almost seems to have its own personality. Here, each of the key forms of the skull is added to the simplified head block, area by area. Each makes its presence strongly felt on the surface of the living head. Artists can benefit greatly by retaining these forms in their minds as a sort of armature upon which renderings of the head can be based.

The skull can be summarized as a wedge hanging below a rounded, rectangular block. By adding on and carving away, these simple shapes can be altered to produce a version much closer to the skull's actual appearance. This will be done in stages based on the three sections: widow's peak to brow; brow to base of nose; and base of nose to chin.

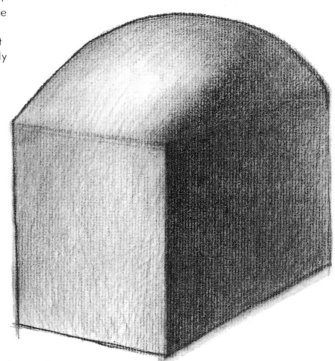

The basic block: a perfect square in front, rectangular on the side, and rounded on the top.

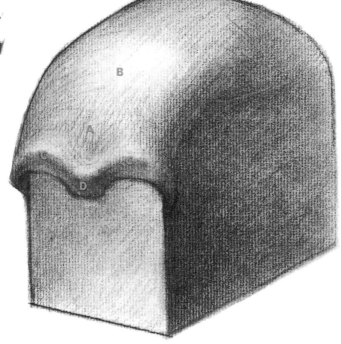

The forehead plane (**A**)—the vertical portion of the frontal bone—makes an abrupt break with the curved dome of the skull at the widow's peak (**B**). Its surface is gently rounded, like the roof of a car. So slow is the curve that the light values change on the forehead more gradually than anywhere else on the face. The lower edge of the forehead plane protrudes out as the two arched mounds of the eyebrow or superorbital ridges (**C**). Linking them in the middle is the keystone-shaped glabella (**D**), the attachment point for the frowning muscles.

27

CONSTRUCTING THE EYE SOCKET

The eye sockets are roughly rectangular. The best way to understand their shape is by clearly visualizing their bony rims, curving from front to side and bending from above to below. Here, a rim's shown as a wire frame, twisted by the steps below into required shape.

A. The primary form is a rectangular frame with rounded corners, like the frame of a pair of eyeglasses.

B. The lower, inside corner is cut off, replaced by an arc. (This curved line will shows on most faces.)

C. The entire frame folded a bit along its waist, bending left and right verticals.

D. The outermost quarter of the frame is twisted to the outside, so that part of the frame faces frontward, part sideways. The in-and-out curve of that outer edge shows up in all three-quarter views.

Brow ridge to base of nose socket. The middle third of the skull is the most interesting part. It's got the shadowy, sad-looking eye sockets and the projecting cheekbones. It's also the part where the forms are the most complex. Curiously, the upper and lower half of this area are practically reverse images of each other. The upper half, around the eyes, consists of two voids connected by a bony plane; the lower half, around the nose socket, is made up of two bony planes separated by a void. With the exception of the nose socket, which is completely invisible on the living face, all these forms are felt strongly on the surface.

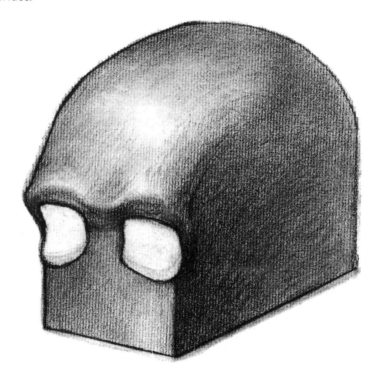

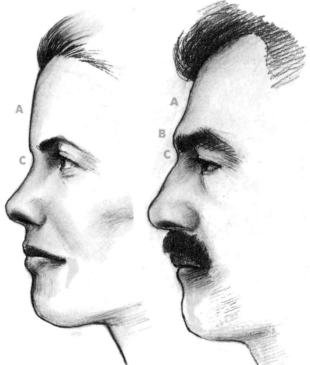

MALE VERSUS FEMALE

As seen in profile, the forehead slope (**A**) varies from nearly vertical to quite angled. As a rule (with plenty of exceptions), men's foreheads are more sloped than women's. A strong eyebrow ridge (**B**) is a more constant indicator—if a skull has it, it's *definitely* male. Without the brow ridge, the female profile always shows a smoother transition from forehead to nose. Note the slant of the glabella (**C**)—it always looks downward.

CONSTRUCTING THE NOSE SOCKET

The nose socket has a keyhole-shaped, raised edge. The upper portion, between eye sockets, is formed by the bridge of the nose. The bridge, a strong, sharp-cornered form (**A**), projects outward at about the same angle that the glabella (**B**) projects inward. The angularity of this (never softened by fat) produces the sharpest edges on the head. When light comes from the side, nowhere else is the boundary between light and dark as clearly visible. The bridge can be felt clearly under the skin; below the bridge the rim of the nose socket is not so clearly marked on the surface.

A. Three flat planes arranged in an upside-down U make the bridge of the nose, also called the *nasal bone*. This shape is similar to that of a row of staples.

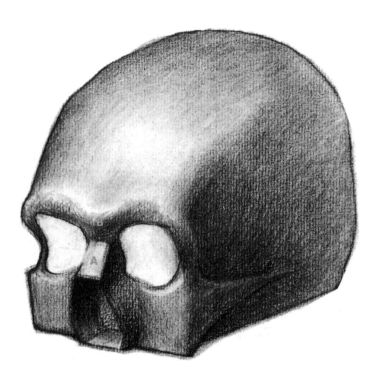

B. To complete the nose socket, the side planes of the bridge are extended down the skull, flaring outward slightly and curving in a sort of oval. The bottom of this construction, found on the living face beneath the tip of the nose, is simply a little flat shelf.

CONSTRUCTING THE CHEEKBONES

The angular cheekbones, like the forehead and bridge of the nose, can be felt just below the skin. Once you find the beginning of the cheekbone beneath the eye socket, you can follow the raised bony surface back to the ear. But just below the cheekbones no bone is felt at all. This is the location of the thickest fatty pad on the face.

Here, the cheekbones are visualized as resembling a pair of cardboard spectacles. The flat, squarish front planes are similar in size to the eye sockets; where they sit is always the widest point on the face. The eyeglass "stems" are known as the *zygomatic arches*, prominent not just on our skulls, but also on those of many of the mammals, like cats and mice. The arches end just in front of the earhole, halfway back on the skull. Where the stem and the front plate join, a thin, upright stem arises, following the eye socket along its outer rim. This form can be clearly seen on thin people.

Base of nose to chin. The lower portion of the skull is more or less wedge-shaped, the product of the combined forms of the upper and lower jaws. The fixed upper jaw (the *maxilla*) is much simpler in overall form; the horseshoe-shaped lower jaw (the *mandible*) is the one that moves. The forms of both jaws are somewhat hidden on the living face; the clearest penetration to the surface is the outer edge of the lower jaw, which forms the chin and the jaw line extending back to the ear.

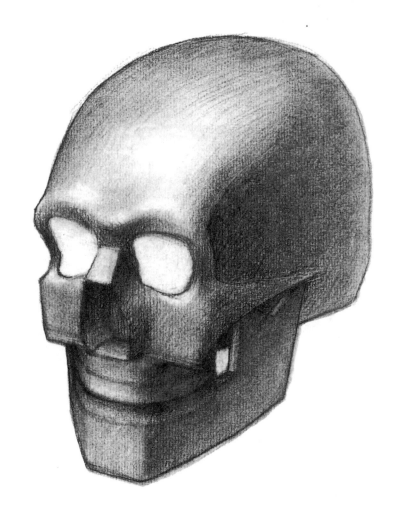

THE UPPER JAW

The upper jaw drops from the cheekbones and nose socket like a small half-cylinder. It's a bit flattened, as cylinders go, particularly the front part. The teeth aren't distinct from the jaw above in terms of shape and direction. They're curved just as their supporting cylinder is curved: a bit flat in the front, turning suddenly to the side. (Line **A** separates identical curves of upper teeth and upper jaw.)

The cylinder of the upper jaw and teeth—like the matching cylinder on the lower jaw—is more sharply rounded than the rest of the face. The mouth, which follows this surface closely, is also more curved than the face surrounding it. The shape of the upper jaw and teeth has a major impact on the shape of the smile, when the stretched upper lip is pulled into close contact.

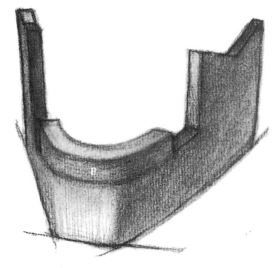

THE LOWER JAW

The lower jaw is basically a horseshoe with arms, supporting the half-cylinder of the teeth (**B**). It's squared off in front (like the teeth), angling backward like the two legs of a V. Two flat, vertical arms rise from the rear end of the jaw to a hinging point just ahead of the ear. The movable mandible can add an inch or two to the length of the face when it drops open.

It takes very little to turn a skull into a face. In many places the outline of the face is the outline of the skull. If you practice drawing the skull for a while, after a time you get the impression of "seeing" the bone through the surface.

Visible planes. This figure shows the shadow edges that follow the planes of the skull underneath. The sharpest edge is usually along the side of the nasal bones, at the bridge of the nose. Notice how the edge softens as it moves onto the fleshy part of the nose. The skull also shows around the inner edge of the orbit and the entire lower edge of the jaw.

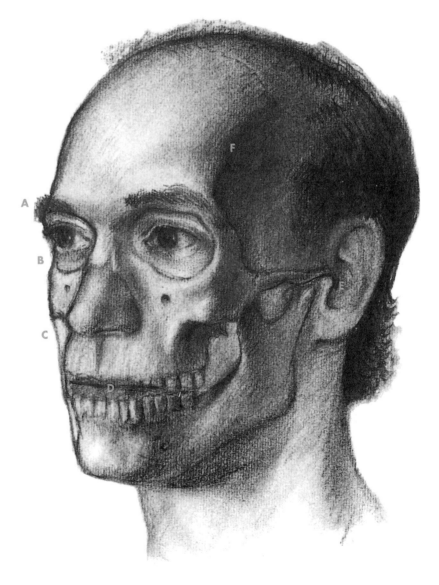

Here are the features, superimposed on a drawing of the skull. The outline on the left side of the face follows the bone exactly, except for the soft area between the cheekbones and the chin. On the right, the skull defines the plane turnings: forehead, cheekbone, edge of the orbit, bridge of the nose, chin.

A. The eyebrows grow out of the superorbital ridge.

B. The cheekbones and orbit are always on the far outline in three-quarter views.

C. There is a change in direction where the cheekbone ends and the fleshy cheek begins. This line is usually fairly straight.

D. The mouth is centered on the upper teeth, not the edge where the teeth meet. The curve of the lips follows the curve of the teeth.

E. The ear is located just in back of the end of the zygomatic arch. This is the location of the earhole.

F. The temporal line sometimes shows on people.

The lower border of the face is defined by the jaw. A sensitive drawing will show its sharp changes in direction. Straight lines will work more effectively than curves.

No matter what angle the lower jaw is drawn from, it can be marked by three defining lines. The first, corresponding to the chin (**A**), is flat from both the front and the sides. It connects on either side with the angled lines of the body of the jaw (**B**); short when seen from the front, long from the side or three-quarter view. The upright ramus (**C**) makes an almost vertical edge, pointing at the ear lobe.

From the front the upright sides of the jaw appear to slant inward slightly from the ears. The break between ramus and body—the angle of the jaw—occurs just below the level of the mouth (**D**). The chin mound is ball-like; on some people there is a groove in the middle, reflecting a similar groove on the front of the jaw.

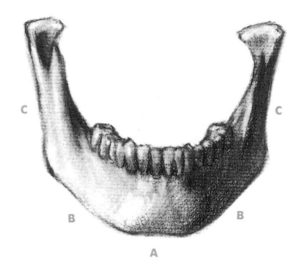

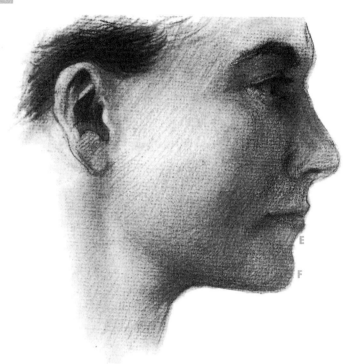

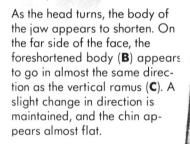

As the head turns, the body of the jaw appears to shorten. On the far side of the face, the foreshortened body (**B**) appears to go in almost the same direction as the vertical ramus (**C**). A slight change in direction is maintained, and the chin appears almost flat.

In profile, the jaw appears as a bent L-shape, consisting of the almost vertical ramus (**D**) and the almost horizontal body. The back edge of the ramus points at the front of the ear. The chin has an in-and-out shape because of the canine fossa (**E**) and the mental protuberance (**F**).

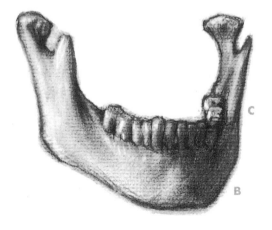

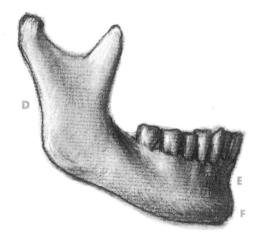

33

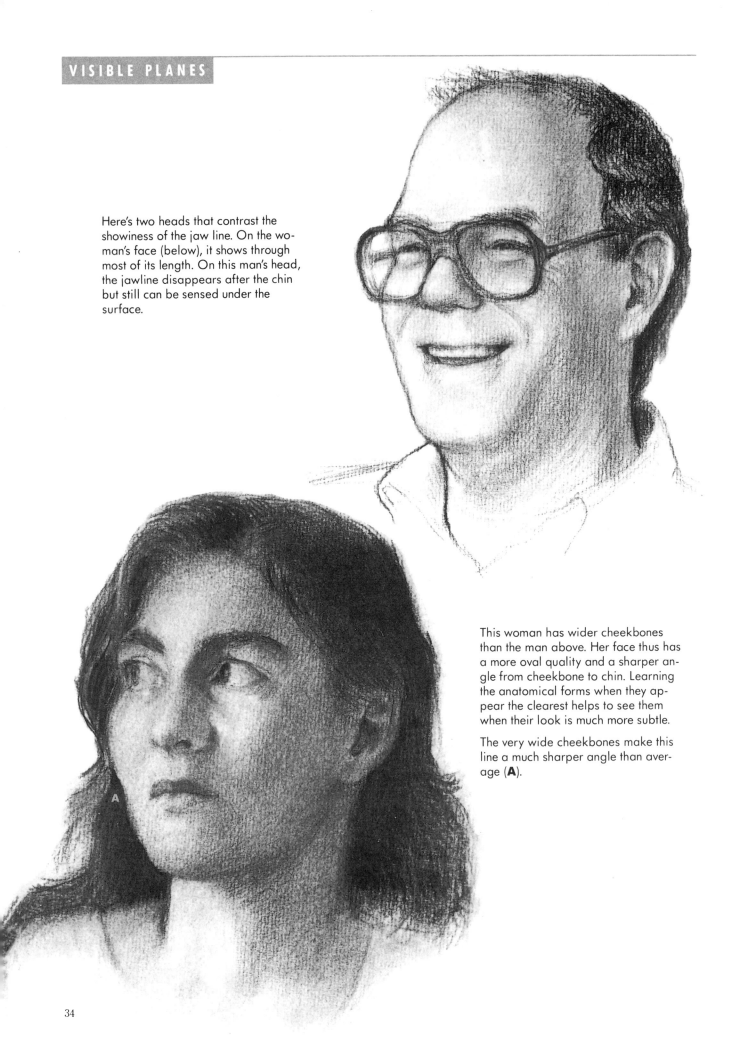

Here's two heads that contrast the showiness of the jaw line. On the woman's face (below), it shows through most of its length. On this man's head, the jawline disappears after the chin but still can be sensed under the surface.

This woman has wider cheekbones than the man above. Her face thus has a more oval quality and a sharper angle from cheekbone to chin. Learning the anatomical forms when they appear the clearest helps to see them when their look is much more subtle.

The very wide cheekbones make this line a much sharper angle than average (**A**).

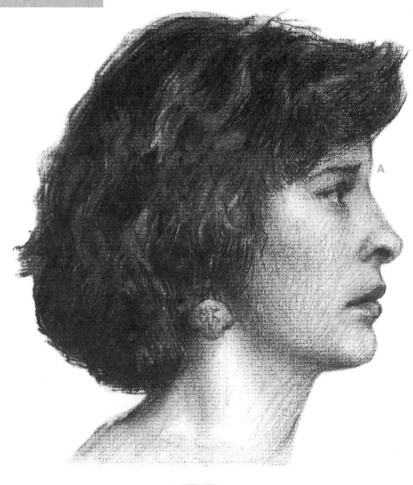

In profile, the relationship between skull and face is particularly clear. The hair follows the shape of the skull—straighter hair would hug the form even tighter. The eyebrow ridge is only a vague bump (**A**). Whether or not the cheekbones show up depends on the thickness of the fatty pad of the cheek as well as the shape of the cheekbone itself.

B. The jaw often becomes less sharply marked as it rises from the angle of the jaw.

C. This shadow is caused by a lack of cheek fat underneath the prominent mound of zygomatic arch; we call this "high cheekbones."

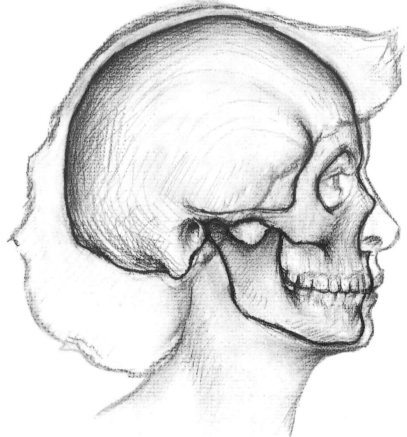

CONSTRUCTING THE FEATURES

The skull determines the big picture; the features control the nuances. I've started with the skull to emphasize the importance of having the right framework before you start to work up the details. Get the *relationships* of one part of the head to another right, and you have a solid foundation for your rendering.

The rest of this book looks at the features and the muscles that act on them. In this section, I start by discussing the fundamentals: the underlying construction and primary forms of the eye, nose, and mouth. By primary forms, I mean "three-dimensional"; it's crucial to visualize the features as solid, rounded objects—not just lines on paper.

Study and draw your own features up close in a mirror. It's also useful to copy the features from master drawings and sculptures, where the forms have already been clarified and interpreted. Also try drawing heads in various positions from your imagination; there's no better way to stretch yourself and find out where the gaps are in your understanding. The better you're able to draw heads *without* a model, the better you can draw them *with* one.

THE SYMBOLIC EYE

The eyes have it. The eyes, the most compelling feature, are often drawn oversized. This is done by both beginners, accidentally, and nonobjective artists, on purpose. In both cases, the eye is seen as a symbol, not a thing. Symbols, unlike things, are not affected by perspective or light and shade; here, exactly the same symbol is used for two radically different views of the eye. To draw the eye realistically, we have to forget the symbolic view of the eye as a symmetrical oval with a circle in the middle; we have to forget its emotional associations and merely draw it as a collection of shapes and forms, as we would a tree trunk or a rock.

The Eye

The eye is both the most important feature and the most difficult one to draw. Students fuss over the rendering of the eye in their drawings, and they're right: a poorly drawn eye will make an otherwise tolerable portrait look amateurish. Why does the eye present such a challenge?

Part of the problem is psychological. We are so engrossed in our preconceptions of the eye that we tend to draw from an idea rather than what we actually see. We conceive of the eye as important, so we draw it too large; we think of the eye as symmetrical and flat, and so it appears in drawings.

Part of the problem is more mundane. Under usual circumstances— say, in a drawing class—we're simply too far from the eye to see very much detail. To make matters worse, the eye is the part of the face most often in shadow, further hiding the forms. But watch two people drawing the same model from the same distance and learn a valuable lesson. The more-experienced artist will draw on a mental image of the eye to make up for the limited amount actually visible, not unlike the way a computer "enhances" a photograph from a distant planetary probe, filling in what's left out, making educated guesses. The less-experienced person can only draw what is visible, with no help from the experienced imagination. The results will show the difference. A good rendering of the eye, then, is based on a *combination* of prior knowledge and direct observation.

STARTING WITH THE SPHERE

Here's one of the main things that prior knowledge will tell you: the eye is round, not flat! Imagine cutting a small slit into a piece of soft leather cloth, then holding the cloth tight over a table tennis ball. The cloth will mold itself over the ball, and the slits will curve around it like lines of latitude on a globe. The eyeball is in fact an exact duplicate of the table tennis ball in size and shape, and the cloth acts like the eyelids, molding around the ball.

From most views, and on most faces, the ball of the eye makes itself felt: in the curving path of the lid rims as they arc from corner to corner; in the fullness of the lids themselves; and in the way light plays over the whole, revealing the roundness of the lids and the exposed eyeball.

Try looking at your own eye in a mirror as you move your head back and forth and up and down; you'll notice that the eyelids always stay pressed tight against the eye and follow its curves no matter how it moves. Raise your eyebrows as high as you can and look at the upper lid—the ball underneath becomes vividly apparent. Gently feel your eye and the surfaces around it for the limits of ball and bone.

If you want to master the drawing of the eye, grab a ball from your closet, set it on a table in good side lighting (one well-defined shadow zone, one well-defined zone of light), and draw it until it looks round. (You'll know when you've succeeded.) You have to be able to shade such a sphere before you can shade an eye.

GOING BEYOND THE MASS CONCEPTIONS

The first part of going beyond the symbolic eye is observing its roundness; the second part is getting beyond symmetry. A well-drawn eye shouldn't look like it could be turned upside down and work just as well. The upper and lower eyelids, and the border they make along the eye, are quite different from each other. The inner half of the eye is shaped differently from the outer.

Fortunately, there are some predict-able ways that the eye is irregular in it's shape. The eye's not horizontal: The inner corner of the eye is situated a little lower down the face than the outer corner. This arrangement has practical value: tears, which are constantly moistening the eye's surface, move downward to their drain, the little red gland in the inner corner. So just like in a bathtub, the drain in the inner eye corner is located at the lowest point of the eye.

Though the lids are both arched, they do not get to the peak of their arcs at the same point. The upper lid rises sharply from the inner corner, curving more slowly down to the outer (it's not as far down); the lower lid is very flat at first, dipping low further to the outside. The high point of the upper lid and the low point of the lower are *diagonally* across from each other.

THE IRIS AND PUPIL

The colored portion of the eye, the iris, is centered around a circular opening, the pupil. Even if the iris is partly hidden, the pupil must be in the middle of the entire, and not just the visible, circle.

When you draw the iris, be sure to judge its real size relative to the eye-whites surrounding it; there is a tendency to draw it much too large. A good rule is that the iris, in the adult eye, is always about one-third the width of the entire eye opening. One problem with making it too big is that you give whomever you've drawn an infantile look; babies have huge-appearing irises because their eye slit isn't wide enough to show much of the rest of the eye. When the face grows, the *apparent* size of the iris shrinks.

This just gets us started with the eye. Later we'll look at the fascinating and subtle ways the eye changes to accompany our various moods.

The eyeball is one of the more nearly spherical forms in nature. Its roundness shapes the surfaces surrounding it, especially the lids. An awareness of this helps give a sense of solidity to renderings of the eye. And the more solid feeling the eye, the more lifelike, the more expressive.

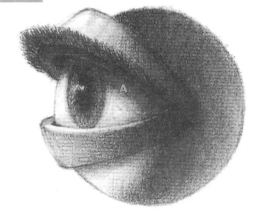

Imagining the eye as a ball with thick, visorlike lids produces a drawing bearing close resemblance to the living eye (as well as a medieval helmet). The light is visualized as falling from upper left, throwing right-hand forms into shadow. Always show movement of tones on white of the eye to avoid the "dead fish" look.

When lit from above the upper lid casts a shadow on the eye itself (**A**). Its thickness, and that of the lower lid, is due to a reinforcing plate of cartilage about the thickness and pliability of belt leather. Whenever the line of the lid is drawn, it should be imagined as traveling across the surface of a sphere.

The lower lid is narrower and less arched. Its upper surface, curved and upright like the rim of a teacup, catches bright light—often brighter than that on the eye. The rest of the lid surface, looking down more than up, is usually much grayer than the bright, top-facing upper lid. Notice how both lids—and the eyeball itself—curve away into shadow, increasing the illusion of roundness.

The three-quarter view is a good angle to see the curving structure of the lids. Beyond the eye is the inner eye corner, seen here as a small notch (**B**). It does not follow the ball but is set into the face, and so takes on its own direction, bending away from the rest of the eye. It often catches a good bit of shadow. The shadowed edge of the upper lid is quite dark—it's one of the darkest, heaviest lines in the face. It appears to overlap the lower lid line, then continues on, becoming a shallow skin fold (**C**).

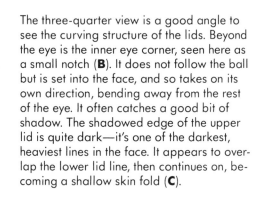

When the eye closes, the upper lid does all the moving. The line of the closed lids is simply the original lower-lid line, its thickness increased by the joining of the eyelashes. More of the upper eyelid is exposed when it closes—part of its upper surface is usually hidden by a skin fold.

The eyeball is set into a ring of bone, the orbit. What makes every eye unique is the particular way three forms—bony rim, eyeball, and underlying fat—assert themselves.

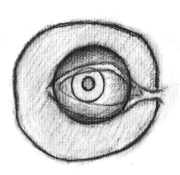

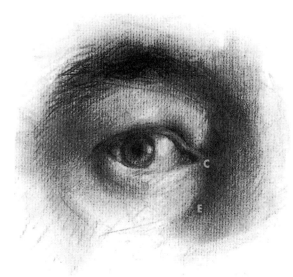

The inner eye corner is a U-shaped pit where the two lids join (**A**). It does not sit on the ball but starts where the ball ends. On Asiatic eyes this corner is hidden by a skin fold. The eyeball rests on a pad of fat; the less full the pad, the deeper set the eye. A pouch often forms above the outer corner of the eye (**B**), softening and partly hiding the upper lid.

The eyeball sits more-or-less centered in the hollow, bony orbit. The eyelids are anchored to the orbit at either corner by small ligaments, the inner of which is often visible (**C**). The size of the eyeball itself varies very little between one face and another. What makes eyes appear big or small is their relationship to their surroundings.

The curve below the eye (**D**) marks the end of the eyeball; the globe shape shows through the lid. The upper portion of the eyeball, on the other hand, is more hidden. The rim of the orbit (**E**) is very distinct along the nose and above and below the inner eye corner; it is usually softened around the outside corner.

In an older face, what's underneath begins to show through the surface. Here you can see the rim of the orbit the entire way around the eye, including the outer corner (**F**) where it is usually hidden. The entire upper eyeball shows through the lid. The skin has lost its elastic qualities, which smooth over these forms in younger faces.

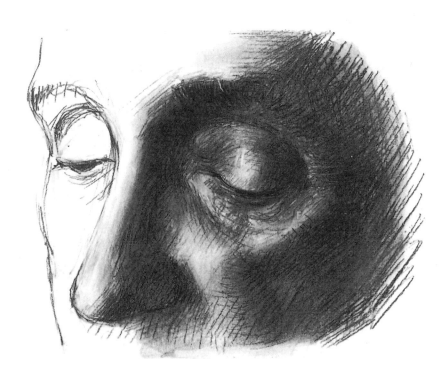

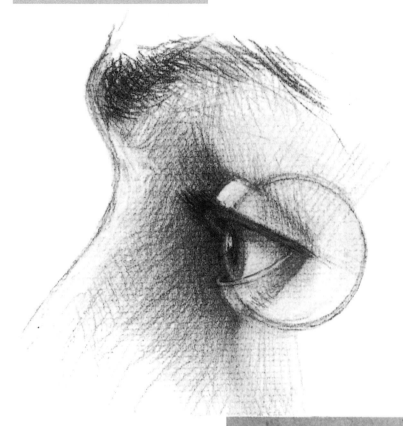

The circle represents the eyeball, most of which is hidden within the eye socket. The exposure of the eye in profile is very narrow; beginners tend to extend the eye corner too deeply toward the ear. Note the relative curvature of the lids: The upper lid is more arched and, because of its thickness, extends farther beyond the eyeball. The lower lid is thinner and flatter—closer to being horizontal.

In this study for an angel's head by Leonardo, the curving forms of the eyelids are rendered with particular clarity. Note arching of lids around the eyeball on the far eye, and the way the light (from above) separates the edges of the lids from the rest. The thick edge of the upper lid faces downward and is dark; that of the lower lid faces upward and is light. The lids themselves are shaded as full, rounded forms. Note how eye, upper lid, and lower lid all move into shadow together, following the tonal movement on the sphere underneath.

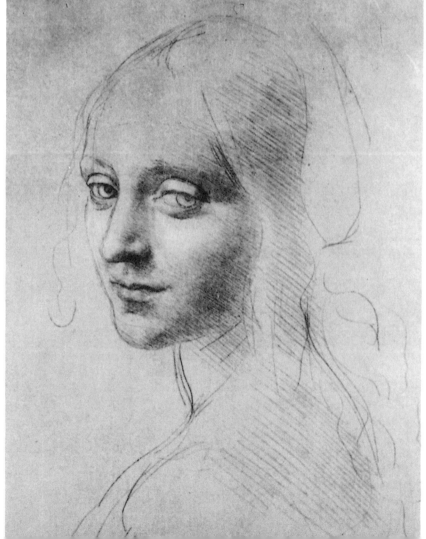

The eye is not symmetrical. The upper and lower lid margins have very distinct shapes. An imaginary diagonal (**A**) connects the high point of the upper lid with the low point of the lower; these points are not vertically aligned, as they would be if the eye was a simple oval. The high point is closer to the inside corner, the low point to the outer. Also, the inner eye corner, with its prominent notch, is always located *below* the outer eye corner, not just on Asiatic eyes, as is commonly supposed.

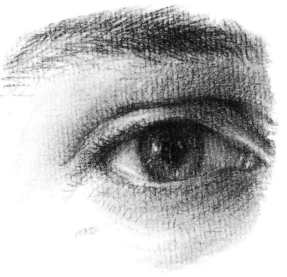

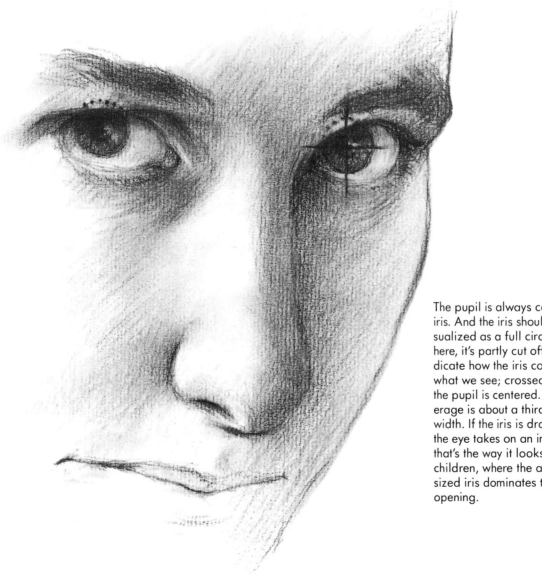

The pupil is always centered in the iris. And the iris should always be visualized as a full circle, even when, as here, it's partly cut off. Dotted lines indicate how the iris continues beyond what we see; crossed lines show how the pupil is centered. Iris width on average is about a third of total eye width. If the iris is drawn much wider, the eye takes on an infantile look, for that's the way it looks with very young children, where the already adult-sized iris dominates the small eye opening.

The Nose

It's hard to say too much about the eye; when it comes to the nose, people lose interest a little more quickly. In fact, this lack of excitement over the nose is carried to an extreme in fashion illustration. It's not unusual for fashion illustrators to omit the nose entirely, leaving the more fashionable mouth and eyes to carry on without it. Even when included, the fashion nose is often little more than a flick of the brush.

I won't argue that the nose is of much account in facial expression. Though lots of expressions drastically affect the nose tip—smiling and sneering immediately come to mind—we do not really react to the nose in those faces but merely note its presence and its contribution to the total effect. (Actually the sneering nose, at times, *does* seem to be an important part of the expression.)

The very fact that the nose has so little to do with our emotional response to a face ultimately makes it easier to draw than an eye. There is less of a tendency to see it conceptually or symbolically, more ease in drawing it as just another form. There are two main problems people seem to have with the rendering of the nose: constructing the wings and the tip and making the nose appear to come out from the face. These problems are particularly severe in the front view, where the wings and tip are most foreshortened and the projection of the nose is subtle.

The nose tip might be even easier to draw if it was a bit more well defined. At least the eyes offer obvious lines that can be copied, like the line of the upper lid and the line around the iris. The nose tip, however, doesn't present us with any clear-cut boundaries (except in the profile), and we can only render it by determining those boundaries ourselves. And since the boundaries are rounded, their expression must be tonal, not linear: shading rather than lines.

Another Geometrical Model

When it comes to shading, nothing helps us see where tonal changes must occur like having a clear sense of planes. The nose has four main planes. Each plane is quite flat, and together they form a long, wedge-shaped block, shaped like a flat-sided brick chimney that narrows as it rises. In the upper portion of the nose, where the bones of the nasal socket dominate, the simplified planes of the tapered block serve quite well as a sort of template for rendering. We've already seen how the sides of the nasal bone make a flat, sharp turning with the front. At those edges, and the other major edges of the block, we look for the value changes that will establish the nose volume. If the light is coming from the side, for example, one of the side walls will always be in shadow, one will always be lit. The block helps us organize our seeing of the actual nose.

About halfway down the nose, the simple bony planes give way to the more complex planes of the nasal cartilage. The cartilage makes the tip of the nose tricky to get right. Cartilage is a stiff but pliable substance—it is also found in the ear—and it varies greatly from person to person. It is the cartilage—not the bone—that makes every nose so distinct.

But before we get into the details of the nose tip, look at it again in terms of the simple block. If you see through the interesting detail, underneath it all is essentially the form we've illustrated: the end of a block. The wings and the rounded tip are just little bumps on the large form; they're not large enough or defined enough to change the overall plane movement. If the flat side plane of the nose block is in shadow, for example, the wing and the side of the tip on that side will be in shadow too. The details follow the mass.

Constructing the Tip

A simplified construction for the nose builds on the block form, with separate pieces for the septum, wings, and ball. The ball is seen as a sort of shallow dome added to the end of the block; the wings as two little wedge-blocks; and the septum as a flat, slightly folded plane underneath the tip. Shapes that are particularly boxy and angular are helpful when trying to render an area that is often a bit vague. In fact, I suggest looking carefully at sculpted and drawn heads to note how artists often make the nose tip an extra bit chiseled and angular to give it a more solid presence.

Note that the nostrils are entirely contained in downward facing planes. Beginners tend to cut them out of the sides of the nose—a major anatomical *faux pas*.

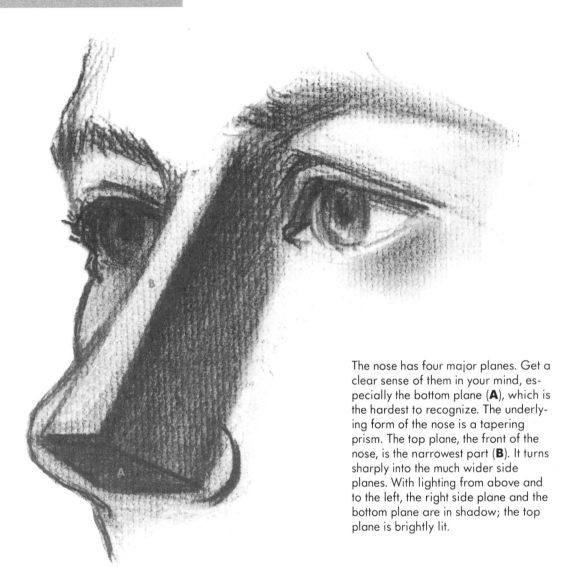

The nose has four major planes. Get a clear sense of them in your mind, especially the bottom plane (**A**), which is the hardest to recognize. The underlying form of the nose is a tapering prism. The top plane, the front of the nose, is the narrowest part (**B**). It turns sharply into the much wider side planes. With lighting from above and to the left, the right side plane and the bottom plane are in shadow; the top plane is brightly lit.

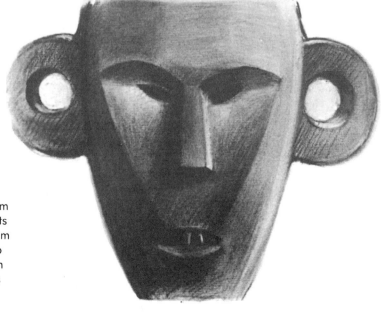

The African mask uses the same block form for the nose. When artists stylize the nose, the prism is frequently used; it's so close to the natural form that it seems an obvious choice.

CONSTRUCTING THE NOSE TIP

The tip of the nose is the most complicated part to draw. It's composed of several separate forms, all built around the underlying tapered block (shown here with the light coming from the upper right).

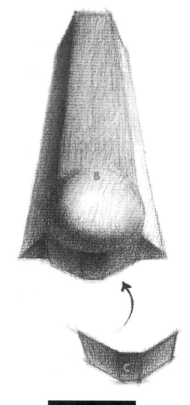

THE TIP

The nose tip is rounded at the very end but is flattish along the sides. It's not exactly a ball; it's more like a curve in shallow relief, as if the large end of an egg had been cut off (**A**). When that shape is added to the box, it merges smoothly with the ridge coming from above (**B**, right) but drops off sharply on either side and below.

THE SEPTUM

Underneath the nose tip is the septum, a ridge of cartilage that connects the nose to the upper lip. A simple way to visualize the septum is as the covers of an opened book, with the flat spine connecting the two tilted sides (**C**). The septum covers the center part of the underside of the nose and contains part of the nostril opening (bottom).

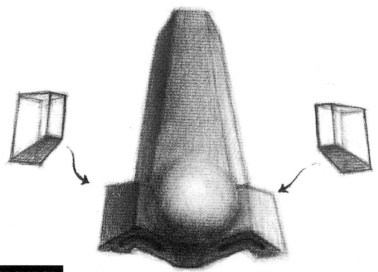

THE WINGS

The wings can be thought of as two wedges, like wood-splitting blocks, added to the prism alongside the tip. Though they are rounded off in life, they retain their wedge shape. The nostrils fall partly on the underplane of the wedge, partly on the underplane of the septum; avoid digging them out of the side of the nose (as in illustration on p. 36).

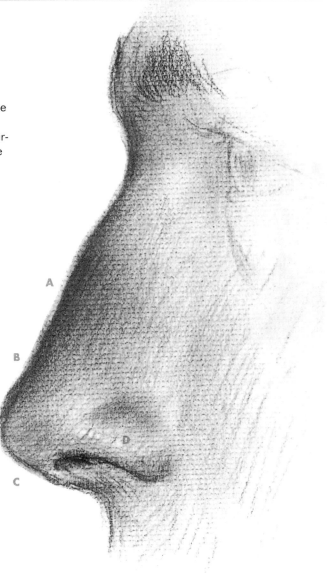

A. At the point where the bone meets the cartilage, look for a change in direction and/or a bump. From here to the tip is all cartilage.

B. This is a break where the cartilage of the tip meets cartilage of the shaft. There is almost always a slight change in direction—the tip curves out more.

C. The septum starts here: curved piece, separating two nostrils and making the transition to the upper lip.

D. The wing is mostly fat, not cartilage, giving it a softer contour, softer edges.

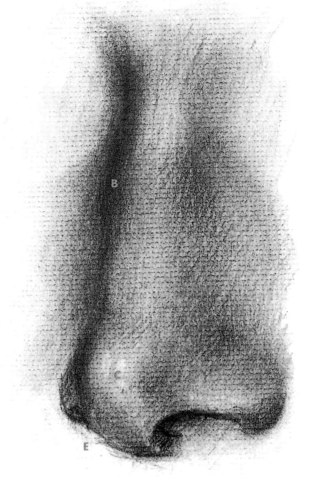

A. Below the level of the orbit, the side plane of the nose begins to swell out. The base of the nose is widest where the bone meets the cartilage. The form is gently rounded, like the section of an egg. The transition from top to side is much sharper than from side to face.

B. Shadow sharply defines the far side of the nose. The near side is not in shadow, but, as light is more to the front than side, the side plane is slightly grayed down. No matter what direction the light is from, if there is only one main source, every major plane will have a different value.

C. The tip is usually the location of a sharp highlight, one of the brightest on the face.

D. The nostril looks down, not sideways. Near edge of the nostril is sharper than the far edge, which is closer to the face.

E. Far nostril just shows beyond the tip; as the head turns, it disappears completely, well before profile position is reached.

The Mouth

There's one major difference between the mouth and the other features we've looked at. The nose and the eyes are built around a solid, fixed element anchored in place to the skull. The mouth, however, has no fixed attachment whatsoever. This, combined with the fact that there are a host of muscles specifically aimed at stretching and moving the mouth around, makes the mouth the most *variable* feature in the face. Learning it in repose is one thing; learning it in action is another. Most people who've just gotten out of art school still can't draw a smile because it changes the mouth's shape too much! One of the functions of this book, of course, is to address this very problem.

The extent to which the mouth is a continuation of its surroundings is easy to overlook because of its different color. As you can confirm by feeling your own face, the mouth doesn't so much interrupt the forms around it but continues them. The three-part curve of the region under the nose flows into the three-part curve of the upper lip; the lower lip is an extension of the shelf above the chin. These rounded forms are created by the rounded forms of the skull beneath—the curves of the teeth, upper jaw, and chin. So we'll look at the mouth in its *region*, not just by itself, continuously referring back to those skeletal shapes below.

UNDERNEATH THE NOSE

A lot of "threes" crop up in dealing with the upper lip. There are three planes above the lip, and these flow into the three parts of the upper lip itself. In regard to proportion, the edge where the upper and lower lip meet—the line between the lips—is one-third of the distance between the base of nose and the chin.

The "threes" of the upper lip structure go back to our earliest beginnings. There is a stage in the development of the fetus where the skin above the mouth is actually divided into three unattached lobes. When these join at around eight weeks they still maintain something of their separate character.

The center lobe becomes the creased part; the outer two become angled planes alongside. We always sense the division between them.

The whole arrangement is something like a curtain with three large folds. The two outer folds start at the outer ends of the nose, and, widening as they descend, sweep down to the upper lip. The center plane faces directly forward and is split by a shallow groove, the *filtrum*. It may be deep and well marked, with soft ridges running along either edge, or it may be barely visible. In any case it disappears when the lip is stretched, as in a smile.

The portion of the skull underneath this area has a rounded form like a section of a parasol—curving from side to side, as well as sloping forward. The folds above the lip follow this general form. They slope forward as they part and curve from side to side; like the skull, they are flatter in the front—where the filtrum is—and more curved along the sides.

A crease often separates the cheeks from the upper lip. This is referred to by anatomists as the *nasolabial fold*. It runs downward, from the nose to the outer corner of the mouth. Although its deepening is a sign of age, it appears even on a young face when the mouth stretches in certain expressions, most particularly the smile. There is a natural tendency for folding at that point for two reasons: many facial muscles attach to the lip right along this line, and their pulling action leads to folding; and there's a fatty layer underneath the cheek that ends along the line.

THE UPPER LIP

Technically, the upper lip includes the area all the way from the base of the nose to the line between the lips. The red lips are really just a well-defined turning under of the skin. The folded-in part has a different sort of skin from its surroundings; it's actually the outer edge of the lining from inside the mouth. It appears dark because there are more blood vessels close to the surface. In some expressions even more of the mouth lining is turned inside out, making the lips appear wider.

If you think about the mouth as just the thickness of the skin showing through the edges of a hole, then the mouth's relationship to its surroundings makes more sense. The peaks of the Cupid's bow shape of the upper lip, on the "hem" on the folds of the lip above, join the ridges of the filtrum. The dip of the bow lies below the filtrum's groove. The bow's sloping legs follow the curving sides of the upper lip above.

The central notch-two wing arrangement is universal, regardless of particular lip shape. In rendering the upper lip, care should be taken to preserve its crisp, angular quality, the sense of form folding sharply under. Note that all the lip surfaces are subtly rounded, both from top to bottom and from side to side.

THE LOWER LIP

The lower lip is usually fuller and softer as a form than the chiseled upper lip. It is composed of two rounded halves, each egglike and with a simple lower and upper outline. We don't usually see the upper margin, actually— it's covered by the upper lip. Its two-hill-and-valley shape is exposed when the mouth opens.

Underneath the lower lip and sitting on the chin is a rounded ledge, which is similar to those half bowl lighting fixtures you see on the walls in up-scale office lobbies. Feel it on your own face. The ledge has a hollow spot right in the middle where the lower lip overhangs the most and shadows almost always appear. But at the outer corners of the ledge the lower lip merges with it smoothly. I often challenge people in my classes to find the edge of the lip at this spot; you can't. There is a color change, but not a plane change. When drawing this area, artists should ask themselves, are we creating a border because we think there should be one, or because we *see* one? The lower lip is better left less-defined in these corners, especially when the corner is in shadow.

The area below the nose is always marked with three strong divisions, like folds in a curtain. The folds are draped over the curving, forward-tilted form of the upper jaw beneath. The "curtain" ends where it joins the cheeks, a border often marked by a crease. The three folds line up exactly with the three parts of the base of the nose and the three sections of the upper lip; this is due to the common origin of all these forms in three tiny subdivisions in the embryo.

A. Almost invisible on a younger face, the curved border between cheek and upper lip deepens as we age. The line—which also marks an important change in plane—is called the nasolabial fold. It always

CONTOUR LINE OF UPPER LIP

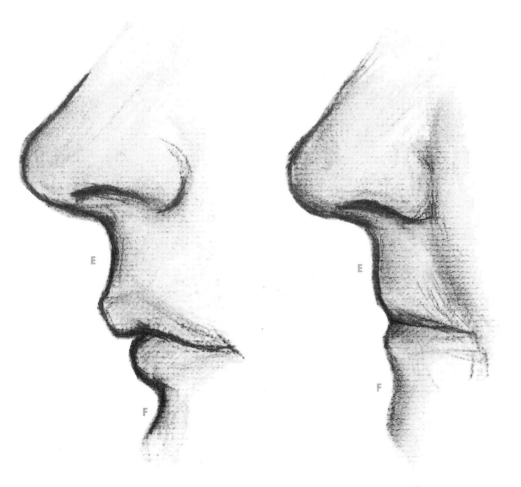

starts alongside the nose wing and ends just opposite the mouth corner.
B. With strong light from the left, this section of upper lip will always be in shadow—look for slight tonal change where it meets the cheek.
C. Groove down middle of lip, called the filtrum, gets wider as it descends. Note that outer edges of groove line up with peaks in upper lip, and center lines up with the dip.

As we age, the lips and their surroundings change. The line of the filtrum (**E**), concave in profile in a younger face, loses its curve and conforms more closely to the form of the skull beneath. It becomes either straight or slightly bowed outward, as here. The indentation below the lips may also be flattened out (**F**). The lips themselves thin and become less shapely.

THE FORMS OF THE LIPS

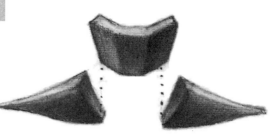

The upper lip is more complex than the lower. Its three sections, linked to the three planes of the skin above, are reflected in both the stretched M-shaped upper outline and the M-line between the lips—the peaks of the M are where the sections join.

Schematic version of planes of upper lip: keystone-shaped central part and two arching wings. Key-stone projects more forward than the rest and drops down farther; there's an indentation in lower lip to receive it (**A**). Its inner planes are usually not well defined. The triangular wings are curved from top to bottom and side to side.

Skin curls upward just above lip line, leaving a "white edge" along the border of the lip. The border of the entire upper lip is usually distinct. The lower lip is only well defined in center, not so along outside. The borders of the upper lip are typically shaped like the legs of a radically stretched M—the Cupid's bow. Upper edge is a more angular version, the lower edge less. Almost every lip, even those that seem straight across, contains elements of the bow. In drawing the lips, artists usually start with the line between the lips and work outward. This is perhaps the heaviest line in the face.

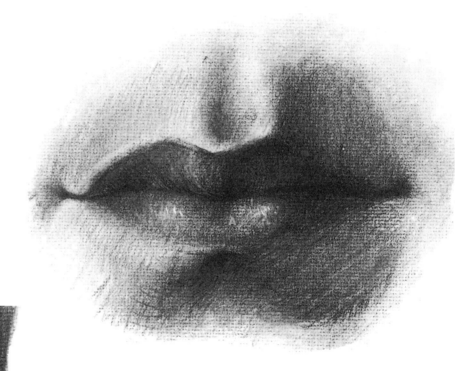

The three parts of the upper lip. The central notch is like a continuation of the groove above; the peaks to either side are in line with the ridges along the edge of the filtrum. The upper lip is usually darker than the lower, as it faces away from the usual above light direction. Here it's clear how the lip faces more downward in the near corner (**B**), then turns more upright, and lightens, toward the middle (**C**). A shadow is cast on the lower lip.

There are two major forms of the lower lip, each shaped like an egg with a bit of a tail. The slight groove between is where the notch of the upper lip sits. Upper portion of the lip is usually light in value; the lower portion moves into shadow with an egg-like edge.

The lower lip is an extension of a shelf that comes out from the chin (**D**). The shelf is hollowed-out in the middle and rounded at the ends; it's shaped like a half a bowl with a dent in the center. At (**E**), the change is only a color difference, not a plane change. For that reason artists often break the outline at this point when drawing lower lip.

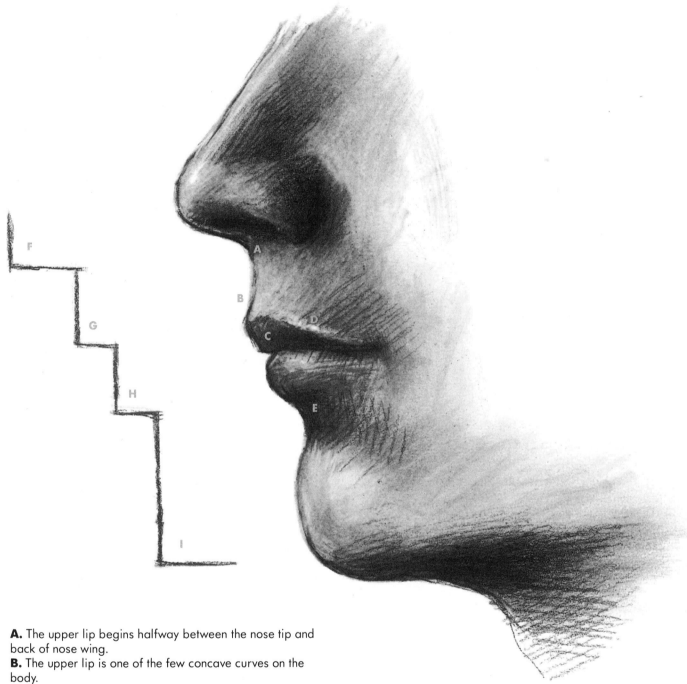

A. The upper lip begins halfway between the nose tip and back of nose wing.

B. The upper lip is one of the few concave curves on the body.

C. The upper lip usually overhangs lower, reflecting the overhanging upper teeth. The upper lip faces downward, usually catching a lot of shadow.

D. The shape of the upper lip in profile is exactly half of the Cupid's bow: one dip, one peak, and one long slope to the corner.

E. Sharp undercut below middle of lower lip with the outer edge only vaguely defined.

Descending from nose each form steps back:

F. Nose

G. Upper lip

H. Lower lip

I. Chin

THE PERSPECTIVE FACTOR

For some reason people are mortally afraid of the subject of perspective in a way they never are of anatomy or proportion, both equally technical. It's all how you approach it. Perspective is basically the science of how point of view affects the way we see the physical world.

Point of view affects the way the mouth looks in two main respects:

1. The curve of the line between the lips is straight when the mouth is on our eye level, an upward arc when the head is tipped up, a downward one when the head is tipped down. This same principle governs the way any curve looks in perspective. Think of it this way: When the head is tipped down, you have to give the mouth a "smile" to make it look like it has no expression at all.

2. The difficulty of drawing three-quarter views of the mouth is also a factor of perspective. It's the principle of foreshortening: objects appear shorter as they turn sideways to our view. In a three-quarter view, the far side of the mouth is going around a much tighter turn than you might expect. The turning of the teeth is very abrupt here, and the mouth follows the turning of the teeth. The near half of the mouth will appear three or four times longer than the far part because the far half is seen practically edge-on; that is, almost completely foreshortened. Beginners tend to make both halves of the mouth equal no matter what the view, leading to grievous results.

The bottom line of this chapter is that facial expressions are only as effective as the head they're on. First, one masters the head, then the features, then the expressions. And how is this mastery achieved? How do you get to Carnegie Hall? The same way—practice.

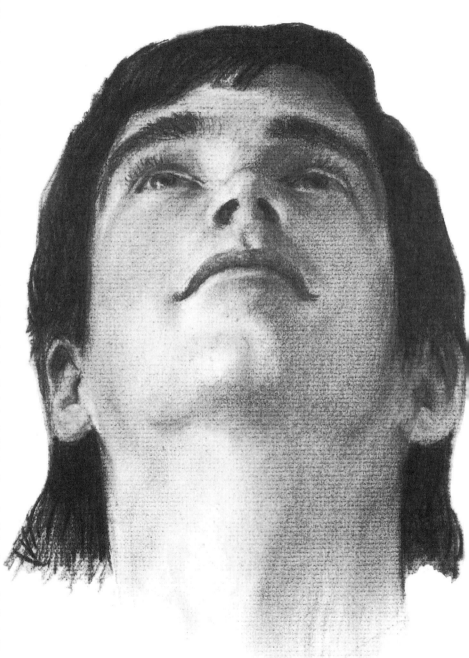

The mouth curve is greater than the curve of the face surrounding it.

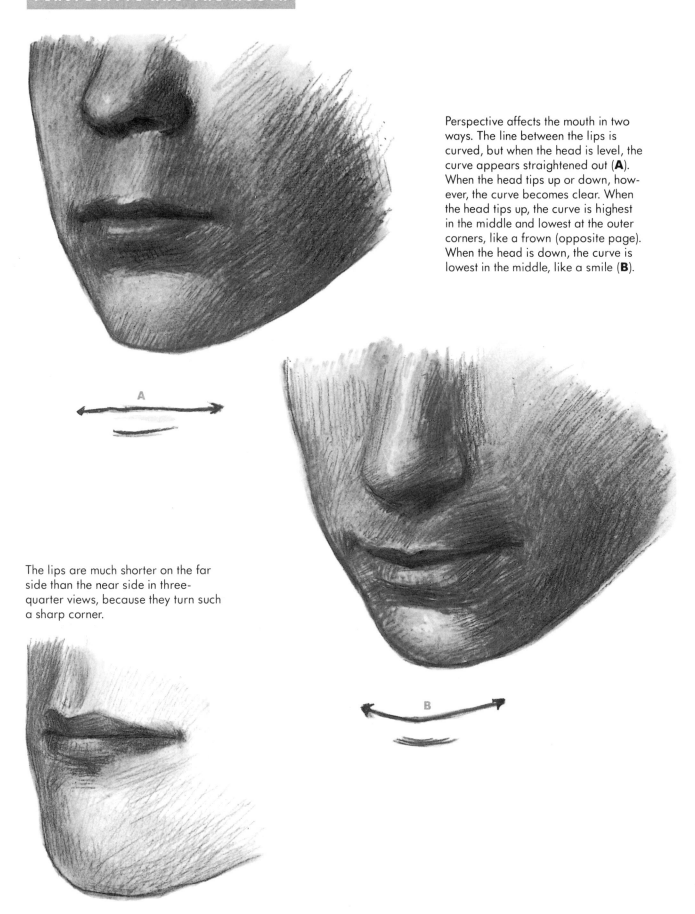

Perspective affects the mouth in two ways. The line between the lips is curved, but when the head is level, the curve appears straightened out (**A**). When the head tips up or down, however, the curve becomes clear. When the head tips up, the curve is highest in the middle and lowest at the outer corners, like a frown (opposite page). When the head is down, the curve is lowest in the middle, like a smile (**B**).

The lips are much shorter on the far side than the near side in three-quarter views, because they turn such a sharp corner.

THE

MUSCLES

OF

EXPRESSION

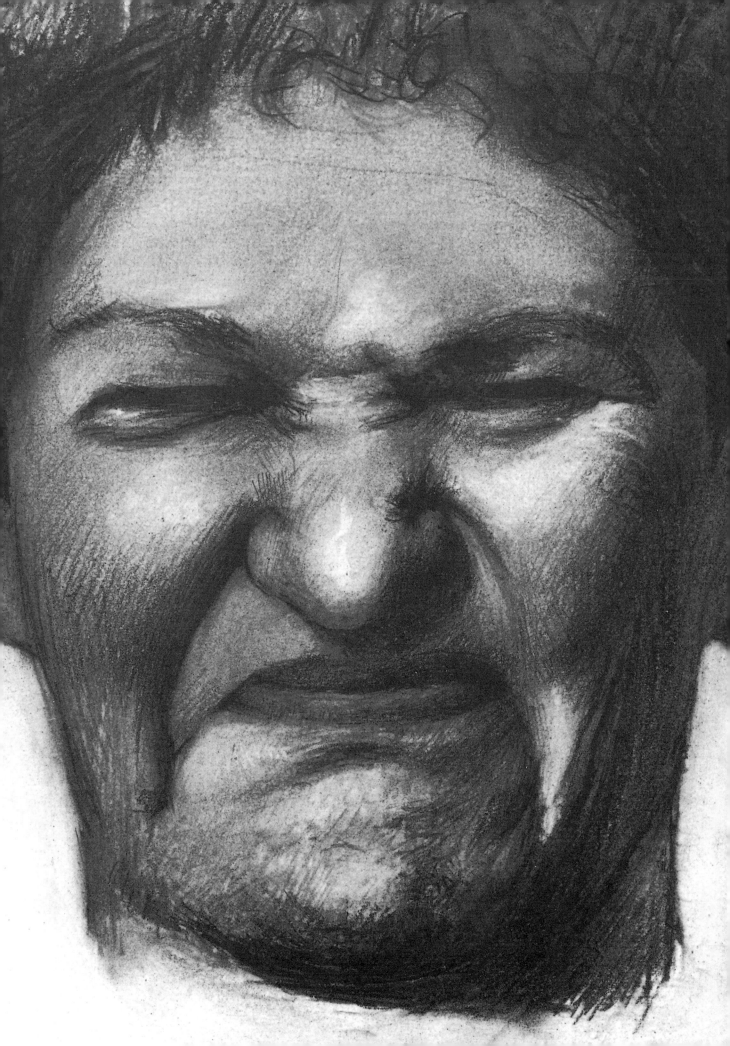

THE NATURE OF THE FACIAL MUSCLES

Everyone's face is continually re-shaped in response to different moods and impulses. Watch people in conversation; their faces are rarely at rest. Their features respond as they listen and accompany their voices as they speak. The fact that we are capable of so much communication with our faces is a great help in our lives as social creatures. Those around us can share in our pleasure when they see us smile or be moved to cheer us up when they see we are sad.

Our faces are as expressive as they are because of a complex group of tiny, thread-like muscles: the muscles of expression. There is a network of these muscles running beneath the surface of the face, as thin and refined as a spider's web. By their movements, these muscles can totally alter the way a face appears. Though these are relatively small and weak muscles, they are attached so close to the surface of the skin that a modest movement of muscle fiber often translates into a big movement of skin. Certain of these muscular movements are recognized as reflections of emotional states. These are the facial expressions.

I was once explaining the nature of the muscles of expression to someone, and he pointed to his cheek in surprise, "You mean its not all muscle in there?" His question made sense. Look at someone's arm or calf, and much of the bulk of what you see is the musculature underneath the skin. Take away the muscles, and there wouldn't be much left. On the other hand, take away the facial muscles, and the face would probably look more or less the same. The facial muscles are virtually the only muscles on the body that have no real form of their own.

SOME PREDECESSORS: LEONARDO AND DARWIN

The way the facial muscles are mixed in with everything else under the skin made life very difficult for early anatomists trying to map out the muscles of the face. The famous anatomy of Vesalius, published in the late 1500s, shows the facial muscles in a vague and misleading way. Other muscular systems of the body, larger and easier to dissect, were more accurately portrayed.

Nearly a century earlier, another pioneer anatomist had patiently explored and diagrammed the facial muscles in beautiful, accurate drawings. But the anatomical drawings of Leonardo da Vinci, like so much of his scientific and artistic work, were by the time of Vesalius scattered in private collections and unknown to the world at large. The anatomical text Leonardo intended to publish had never been realized.

From my own experience, I know how excruciatingly patient one must be to explore the anatomy of the face. It's much like trying to extract the threads of just one color from a complicated tapestry. In Leonardo's case, the result of all his meticulous effort was not just anatomical drawings. The men in his battle scenes, just like the women in his portraits, have faces more real, and more alive, than any that had appeared in painting before. Science in the service of art led to a mastery of expression.

Though Leonardo and others had mapped out the facial muscles, the function of the various muscles were not well understood until the nineteenth century. In the mid-nineteenth century, Duchenne of Boulogne found that slight electrical jolts to various points on the face caused the muscles to contract individually. His photographs of electrically-induced smiles and snarls are both strange and compelling; his descriptions of which muscles do what, an important advance.

The question of *why* we smile and snarl was addressed by a man more famous for his work in another field. Charles Darwin's book on facial expression, *The Expression of Emotion in Man and Animals* (1872), remains to this day probably the single best book on the subject. Making use of the work of Duchenne and others, Darwin speculated about why we make the faces we do and whether they are specific or universal. (In recent times there has been a resurgence of interest in facial expression, led not by artists or anatomists but by psychologists interested in the realm of nonverbal communication.)

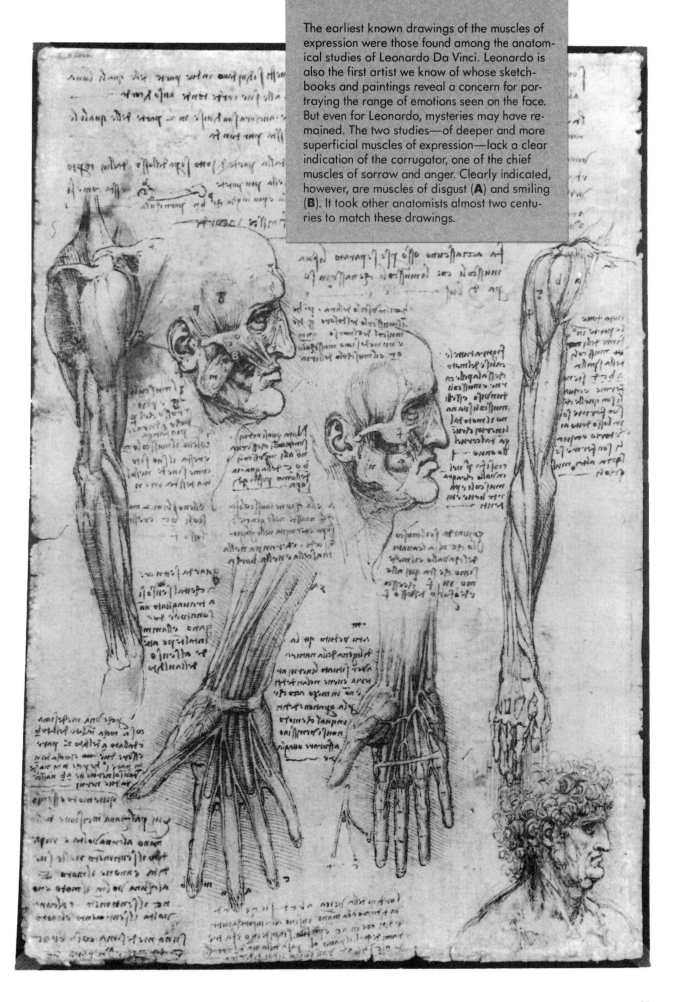

The earliest known drawings of the muscles of expression were those found among the anatomical studies of Leonardo Da Vinci. Leonardo is also the first artist we know of whose sketchbooks and paintings reveal a concern for portraying the range of emotions seen on the face. But even for Leonardo, mysteries may have remained. The two studies—of deeper and more superficial muscles of expression—lack a clear indication of the corrugator, one of the chief muscles of sorrow and anger. Clearly indicated, however, are muscles of disgust (**A**) and smiling (**B**). It took other anatomists almost two centuries to match these drawings.

We have ways of making you laugh. Dr. Duchenne of Bologna, a nineteenth-century French scientist, became famous for his explorations of muscle function using electrical stimulation. In his book *Mecanisme de la physionomie humaine*, he illustrated the actions of many of the facial muscles by photographing subjects whose faces he "stimulated" with electrified needles (it's said to be a very unpleasant feeling). Here Duchenne demonstrates the action of the zygomatic major, touching the ends of the muscle—on the zygomatic arch—with his electrodes. The muscle reacts by contracting, pulling the mouth into a smile.

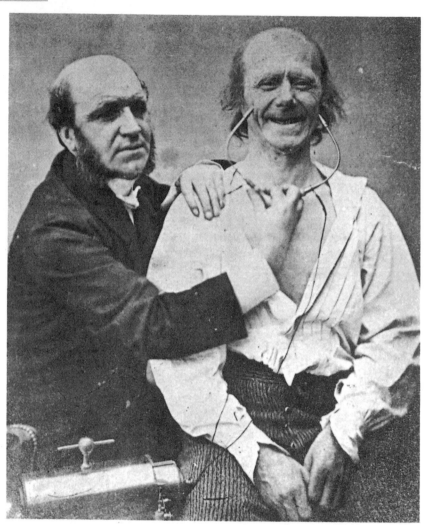

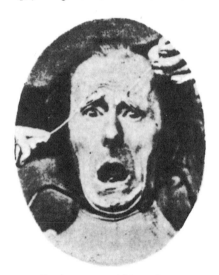

Duchenne used his technique to attempt to demonstrate emotions as well as individual muscle actions. Here multiple electrodes are employed, applied to both the neck and the forehead, to illustrate the expression of fear. The muscles activated include the corrugator, the frontalis (forehead), and the risorius and platysma (neck).

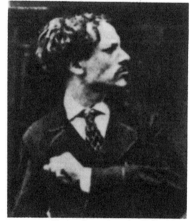

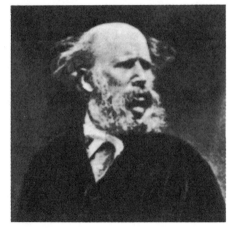

Several actors portraying "anger" from Charles Darwin's *Expression of Emotions in Man and Animals*. Darwin's book remains the best written on the subject. Much of his information came from his own meticulous observations of family and neighbors. But the book's illustrations—though full of period charm—are not its strong point. Even today, good photos of facial expression are not plentiful, and Darwin made what use he could of his limited sources; his best pictures are those from Duchenne.

How Facial Muscles Act

In what they do, and how they do it, the facial muscles are different from other muscles in the body. Most of our muscles, like the biceps in the arm or the hamstrings in the leg, stretch from one bone to another, usually across a joint. When these muscles contract, the bones involved are brought closer together, often bending at a joint. Muscles *always* pull things together; it's the only way they work. They shorten, and their ends approach. They never push. For example, when the biceps contract, the radius in the forearm is pulled closer to the humerus in the upper arm, and the arm bends. When the hamstrings contract, the tibia approaches the femur, and the leg bends.

Facial muscles, however, usually have just one fixed end, attached directly or indirectly to the bone of the skull. The other end of the muscle is stitched into the skin (or into another muscle that attaches to the skin). When a muscle of expression contracts, skin, rather than bone, moves. The portion of skin near the end-strands of the muscles is pulled in the direction of its attachment on the bone.

Take the smiling muscle, the *zygomatic major*. Its bone-end attachment is on the cheekbone, just below the outer corner of the eye. Then the muscle stretches diagonally downward toward the mouth, where it attaches indirectly to its outer corner. When it contracts, the corner of the mouth rises up toward the cheekbone, and we smile. This is typical of the way most of the muscles of expression work.

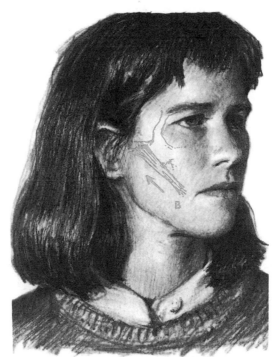

Facial muscles do their work by pulling on the skin, unlike most other muscles, which are designed to move the bones. When a facial muscle contracts, it creates very visible changes; often a whole hill-and-valley landscape of bulges and wrinkles appears, as an area of the face folds on itself.

The zygomatic major is a typical muscle. It has a fixed end (**A**) attached to the zygomatic arch and a free end (**B**) attached to the corner of the mouth. A smile is the result of **B** approaching **A**. The naso-labial fold (**C**) is formed at right angles to the direction of pull; most wrinkles arise in a similar fashion. Note also the bulging cheeks (**D**) and wrinkles under eyes.

The Importance of Wrinkles

When the zygomatic major contracts, and its mouth end rises towards the cheekbone, the skin caught between the two ends of the muscle has nowhere to go. The skin in the cheeks, pressed up from below, bulges out like a tiny balloon being squeezed.

Above and below this bulge, wrinkles appear. The wrinkle that runs from the side of the nose to the side of the mouth is particularly noticeable. This crease, the nasolabial fold, is a perfect example of the sort of wrinkles that most frequently form when expression muscles contract: it lies at right angles to the direction of the pull. Similarly, the horizontal wrinkles that appear when we raise our eyebrows are perpendicular to the vertical pull of the forehead muscle. Look at the vertical folds that appear when you frown; the frowning muscle pulls directly across this fold.

Though overall patterns tend to be recognizably the same, details of wrinkle lines are quite different from person to person. The age of the individual is probably the most important factor in wrinkling. Very young people might not show any wrinkles at all when they lift their brows, while on older people, many permanent wrinkles may make new wrinkling difficult to perceive.

Thin people and obese people have different-looking smiles, as do men and women. A smiling woman would tend to show fewer crease lines than a smiling man of the same age (all other factors being equal) because of an extra layer of fatty tissue always present under a woman's skin.

The strength of the pull is also a factor. If we smile half-heartedly, some of the folds might appear only faintly, or not at all. But if we smile widely, added creases and dimples might form.

Signature Wrinkles

The wrinkles that arise when a particular facial muscle tightens are like its signature: distinctive and recognizable. We have discussed a few of these signature wrinkles, like the nasolabial fold for the smile. Wrinkles are one of the keys to understanding and depicting expression—they are part of

Same expression, different age. Wrinkling when we smile is not a factor of age, but the nature and amount of the wrinkling is. The fundamental pattern of the smile is the same in both faces, but the older face shows a more complex version of the pattern, with more minor wrinkles. Almost all the wrinkles on the older face (bottom) are permanent; they merely deepen when she smiles.

With the passage of time, the more ephemeral wrinkles created by facial expressions become permanent. Although attempts have been made to "decipher" personality from the pattern that emerges, almost all the wrinkles here may be caused by either expressive, conversational, or even functional (i.e., squinting in the sun) use of the same muscles.

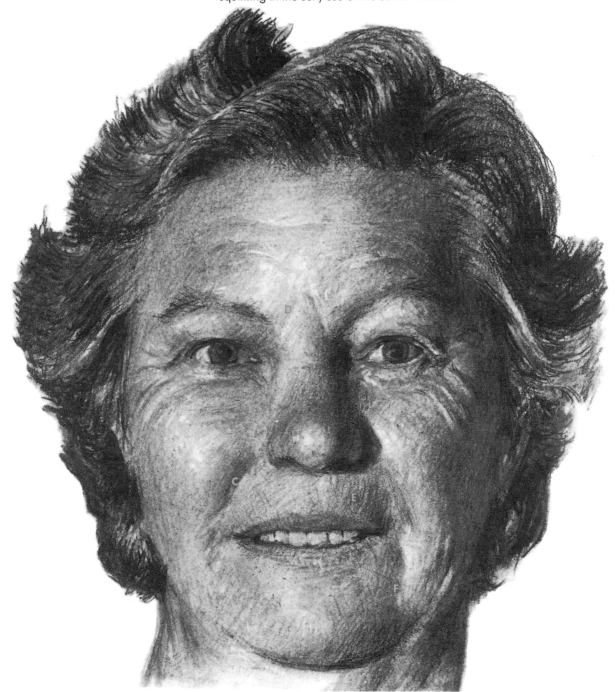

A. Brow wrinkles. Horizontal folds owing to action of frontalis.

B. Crow's feet. Lines radiating from corners of the eyes, owing to action of orbicularis oculi and zygomatic major.

C. Nasolabial fold. Crease from nose to side of mouth corner, created by sneering muscle and zygomatic major.

D. Frowning folds. Vertical folds owing to action of corrugator.

E. Creases of upper lip. Very faint, vertical lines formed by action of mouth-squeezing muscle, orbicularis oris.

F. Commissural fold. Crease from mouth corner to jaw. Results from all the actions that widen the mouth: speaking, smiling, eating.

the code by which the face communicates. Much of their identity is retained even when they combine in complex expressions; we recognize certain elements that we have become aware of. Almost everyone's signature wrinkles are the same.

Cartoonists and primitive sculptors, among others, have developed highly skilled and effective ways to summarize these crucial elements. They've learned the most important things about depicting expression: what you can leave out and what you can't.

Do Wrinkles Reflect Personality?
It is said you can read a lot about personality from the pattern of folds that forms as a person ages. This is not entirely true, although an expression leaves its mark on your face if you repeat it often enough.

If we smile a lot, the smiling wrinkles will be among those that become permanent grooves. If we frown a lot, we should develop vertical creases between the eyebrows. In fact, these wrinkles are awfully common among, say, middle-aged businessmen in Man-

hattan. Yet people with crow's feet are not necessarily accustomed to smiling frequently. A number of years of having to squint in the bright sun will develop exactly the same lines. Many facial muscles are used regularly in ordinary conversation. Don't jump to conclusions about the origin of a wrinkle pattern!

Drawing Wrinkles
Creases are not just lines on the skin. They are complete forms, with top, side, and bottom planes and long rounded edges; think of them as miniature hills and valleys. Rendering drapery is good practice for doing wrinkles.

Now, raise your eyebrows and look in a mirror. You are using the *frontalis* muscles to raise your brows, creating horizontal wrinkles across your forehead. Chances are, the light is falling from above. To shade an individual crease, we would begin by gradually darkening the skin tone as we move down the hill into the valley; the valley will be the darkest value—the deeper the wrinkle, the darker the tone; as we rise up out of the crease, we suddenly

move from darkest dark to a very light tone on the opposite, upward-looking slope (perpendicular to the light)— this is the only hard edge; finally, as we move down this slope, we gradually merge back into the skin tone we started with.

In a line rendering of the face, creases are best expressed as a turning, rather than as a crack in a smooth surface; this is done with a light, broken, or double line (or all three), distinct from the harder line used for the outline of a face.

Here's another important point. Suppose you were drawing a head, with brow raised, and rows of wrinkles emerged. Even if those wrinkles were evenly spaced and unbroken, like the stripes on a flag, it would not be a good practice to draw them that way. Organic forms are irregular by nature. If we let any element in our depiction become too mechanical, or too uniform, it begins to look stiff. The accidents, the unevenness, helps a drawing or painting of the face look right. Invariably, if you think a pattern is regular, look again.

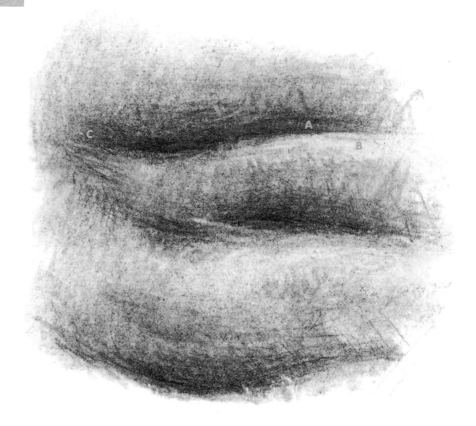

Wrinkles on the face are very much like folds in a piece of fabric. Like drapery, they are rendered tonally, not simply with lines. Here the light is from above. The tone gradually darkens as the surface curves under. In the trough of the fold (**A**), a heavy shadow accent occurs, with a sharp lower edge. The brightest tones (**B**) often occur right up against darkest tones. Shallow folds lack the sharp lower edge and darker tones. Often a deeper wrinkle trails off into a shallow one (**C**).

Looked at closely, no two wrinkles are alike. They differ in shape, in length, in spacing, and in depth. If drawn in even rows, they look "off"; living form is never mechanically repetitive.

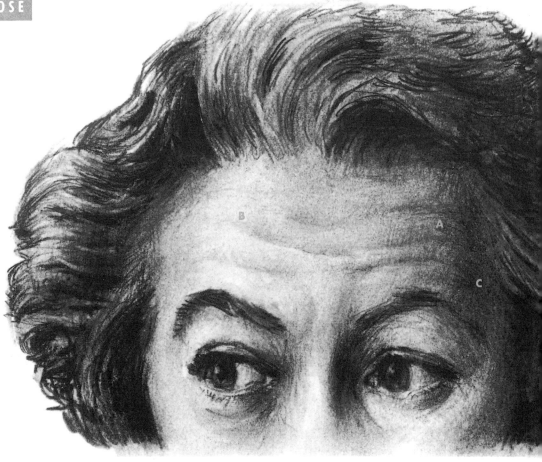

Wrinkles are clearest in areas of transition between light and dark (**A**). In lightest areas, wrinkles, unless they are very deep, will show up only faintly (**B**). In shadows, wrinkles, unless very deep, will fade into the general gloom (**C**).

A pen-and-ink version of the same face. In this medium, achieving soft transitions is more difficult. In a detailed rendering, crosshatching is used to achieve the desired gradations— soft above, sharp below. In a simpler, more linear style, like that used in cartoons, a different approach is used. Wrinkles are indicated with a light or broken line, distinct from the heavier line used for the outline.

TWO THINGS TO BEAR IN MIND

1. Only Part of the Face Is Involved

The whole face does not participate equally in most expressions. The burden of getting the message across usually falls most heavily on the brow in combination with the eyes, and the mouth and its surroundings. These two locations are the areas of the greatest muscular development and so are capable of undergoing the greatest changes. They are also, not coincidentally, the parts of the face we always notice first and to which we respond the most strongly.

If you cover your nose, you will find that you will lose very little in terms of expression; cover your eyes, and you lose everything.

Since there are so many muscles of expression (from twenty to twenty-six, depending on which anatomy book you are using) examining them grouped by active area will simplify our task greatly. A certain number of muscles are excluded because they don't do much expression-wise, are hardly ever used, or both.

This leaves us with a total of twelve key muscles, five of which act on the eye/brow area and seven of which act on the mouth. Even here we can simplify things somewhat. The muscles can be grouped according to what they do: for example, most of the muscles that surround the mouth can be placed into the category of downward puller, upward puller, or outward puller.

2. How We Know What We Know: Neutral Positions

Our knowledge of the features in repose make recognition of change possible. We know how the eyebrows tend to sit, what the corners of the mouth look like, how wide open the eyes usually are. These elements are constant enough from face to face that we can normally recognize a changed face. This is true whether we are familiar with the person's face at rest or not.

Wrinkles are important, but not absolutely essential, in helping our perception out. It's the same principle of unconscious familiarity we use to pick out any change in our environment. We don't think about where the furniture is in our parent's house, for example, but if something is moved while we're away, when we return it's the first thing we notice. We get *habituated* to the features at rest and therefore notice any changes right away.

Being consciously familiar with the at-ease look of the features can also help us avoid unintentionally creating an expression when none is desired. This is often a problem in portraiture, as indicated by John Singer Sargent: "a portrait is a picture of the head with something wrong with the mouth." Given the suggestiveness of the mouth, that "something" is often the existence of an accidental scowl or grimace or sneer or a similarly unwelcome expression. Not the thing to please a touchy client!

WHERE EXPRESSIONS GET EXPRESSED

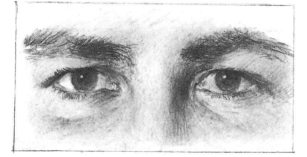

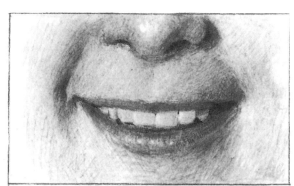

The areas enclosed in the two boxes are where we look when we want to determine someone's mood. They're the attachment place for most of the facial muscles and the location of most of the surface changes. Occasionally we get crucial information from elsewhere—the cheek, for instance, helps read the smile—but most often the rest of the face is a "frame" for the eyes/brow and mouth.

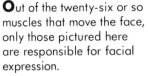

Out of the twenty-six or so muscles that move the face, only those pictured here are responsible for facial expression.

1. Orbicularis oculi. Attaches to inner orbit and skin of cheek; squeezes eye, as in squinting.

2. Levator palpebrae. Originates on orbit, attaches to upper eyelid. Raises eyelid, as in surprise.

3. Levator labii superioris. Three branches—inner branch originates on base of nose; middle branch on bottom edge of orbit; outer branch on zygomatic arch. All insert into skin above upper lip. Known as the sneering muscle.

4. Zygomatic Major. Originates on zygomatic arch; inserts into mouth corner. Pulls mouth into smile; known as the smiling muscle.

5. Risorius/platysma. Risorius originates over rear of jaw, inserts into mouth corner; platysma originates on upper chest, inserts into mouth corner. Both act together, stretching mouth, as in crying. Known as the lip stretcher. (The platysma is not pictured here, as it would cover other muscles.)

6. Frontalis. Originates near top of skull, along hairline; inserts in skin under eyebrows. Raises eyebrows straight up, as in surprise. Known as the brow lifter.

7. Orbicularis oris. Originates from muscles of corner of mouth. Curls, tightens lips. Known as the lip tightener.

8. Corrugator. Originates on nasal bridge; attaches to skin under middle of eyebrow. Lowers inner end of eyebrow. Known as the frowning muscle.

9. Triangularis. Originates along lower margin of jaw; inserts into mouth corner. Pulls down on mouth corner. This is the "have-a-bad-day" muscle.

10. Depressor labii inferioris. Originates along bottom of chin; inserts into lower lip. Pulls bottom lip straight down, as in speaking.

11. Mentalis. Originates just below the teeth, on lower jaw; inserts into skin of ball of chin. Wrinkles chin, creating raised "island"; pushes lower lip up. Known as the pouting muscle.

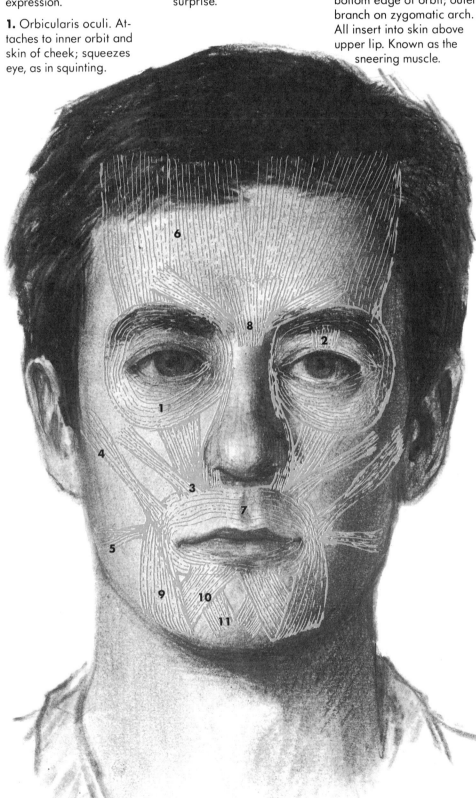

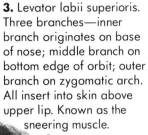

MUSCLES OF THE BROW AND EYE

The eyes and brow together are easily the most magnetic and compelling part of the face. There seems to be something almost magically responsive and alive in the organ of vision. We instinctively feel that the eyes provide our most direct link to the person within. The brows too seem to have a life of their own.

We can be responsive to the subtlest of shifts in the eyes and brow, measurable in mere fractions of an inch. For example, if you're talking to someone and his or her eyes shift *past* you, you will notice it immediately. What is it you've noticed? When your friend's eyes switched away from looking directly at you; the irises moved about 6mm (¼″) further away from each other. That's the difference between the *close focus* and *distant focus* positions of the eye. The closer the object we are looking at, the closer the irises come to each other; the further away the object, the more separated they are. The fact that we recognize such tiny changes instantly and effortlessly suggests how great a capacity we have for subconsciously retaining important facts about the eye.

STARTING PLACE: THE RELAXED POSITION OF THE EYELIDS

The irises are the key to judging the general state of the eye. The amount of iris exposed by the upper and lower lids is crucial to most facial expressions. Although eyes vary, they do so in a range narrow enough to make possible certain generalizations about lid position.

The Range of the Upper Lid

Let's look at the relationship between the upper lid and the iris first.

LOWER LIMIT—*The neutral lower limit of the upper lid is the top of the pupil.*

When we are alert, the upper lid always covers part of the iris, but it stops just short of the upper edge of the pupil. If it falls any lower and begins to actually block the pupil—even slightly—the whole face immediately takes on a different cast. It begins to look sleepy, sad, dopey, or drunk. Anything but alert.

The top of the pupil marks the low point of the *range* of the neutral upper lid. Depending on the individual, their particular neutral position may be anywhere from there to the top of the iris. Each face has its own personal spot. The upper eyelid will always return to this same resting position.

UPPER LIMIT—*The neutral upper limit of the upper lid is the top of the iris.*

When the lid moves above the relaxed upper limit, white begins to show and the eye begins to look excited. A few people always show some white above the iris. Theoretically, we should find it difficult to tell if such people are excited or not; but in fact we know instantly that their lid simply sits higher than usual. We are probably carefully noting telltale details: the fullness of the upper lid (which would be retracted if the eye was open extra wide) or the lack of extra arching in the line of the lid edge.

You can perform a simple exercise to understand a bit more about why the upper lid sits the way it does. Look in a mirror and lower your lid until it begins to cover the pupil. Immediately, you become aware of the lid in your vision. You will not allow this if you are awake

enough to care. But to lift your lid above the iris takes a special effort; this can't be sustained either.

The Range of the Lower Lid

The lower lid's range of resting positions is much narrower.

UPPER LIMIT—*The neutral upper limit of the lid is just above the bottom of the iris.*

The lower lid usually just grazes the iris, covering a bit of its lower edge. In expressions that involve squinting, like laughing and crying, the lower lid can rise much higher, covering part of the pupil from below.

LOWER LIMIT—*The neutral lower limit of the lid is just below the iris.*

Sometimes we can see white below the iris. Wherever it is, this lower border of the lid is fixed; the lower lid almost never moves below its neutral position. It's an island of stability in the eye's complex, movable landscape.

THE RELAXED POSITION OF THE EYEBROWS

UPPER LIMIT—The eyebrows also vary within a predictable range. From the viewpoint of expression, the inner third of the eyebrow (near the nose) is where all the action is. It's the most movable portion, the part over which we have the most subtle muscular control. In a neutral face, it is always either level with, or slightly below, the outer two-thirds of the eyebrow. As soon as it curls upward even slightly, the eye takes on a look of distress. Since the brow never naturally grows this way, we can recognize distress from the brow position alone, even without the usually accompanying wrinkles and bulges.

LOWER LIMIT—The lower limit of the eyebrow is established by a particular facial landmark: the fold that marks the top of the upper lid. No matter how low the eyebrow grows, it seems to never go below an imaginary line drawn level with this fold. When the brow crosses below this line, pulled by the *corrugator* muscle, the face takes on an expression. It may look thoughtful, or angry, or perplexed, depending on what the rest of the face is doing.

The resting position of the eyelids is the position the lids take when the eye (and the person) is relaxed. In the average eye (**A**), the lid line crosses the iris with room to spare above the pupil. On some people, the eyelid sits much lower (**B**). This is as low as the lid can go before it begins to interfere with vision. The upper limit is less well defined; though the eye at (**C**) has an unusually high upper lid, it is also possible to find people with lids even higher, where white always shows above the iris. A great deal of white showing above indicates either an unhealthy condition or an expression.

The lower lid normally hides a bit of the iris (**D**), but it is not uncommon for it to allow white to show (**E**). Unlike white showing above the iris, white showing below has no emotional connotations whatsoever; there are no expressions where the lower lid moves farther down in response. In fact, there are no muscles to move the lower lid down.

65

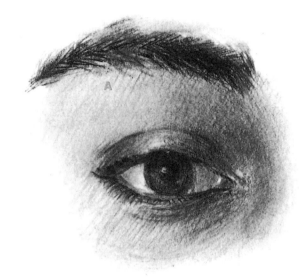

The average male eyebrow (left) is heavier and closer to the eye; women's tend to be thinner and higher (right). In both cases the eyebrow follows the bulge of the eyebrow ridge; for men, the brow tends to sit on the downslope, while on women it's on the upslope. The eyebrow always shows at least a bit of arch, with typically more arch on a woman's than a man's. The break in the arch is about two-thirds of the way from inner end to outer (**A**), right at the point where the forehead (and the brow) turns from front plane to side.

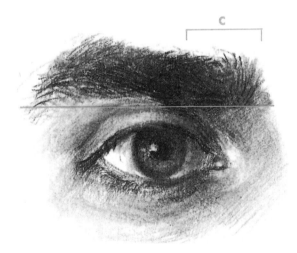

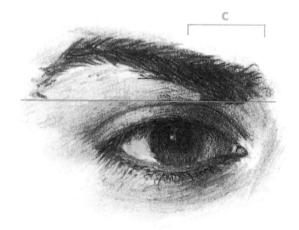

LIMIT OF BROW

There is a lower limit beyond which even the lowest male or female brow will not normally drop. It is the top edge of the upper lid (**B**). Here both brows, male (left) and female (right), fall just above that limit. In expressions that involve frowning, like concentration or anger, the inner brow end (**C**) will move below the line, pulled downward by the corrugator muscle.

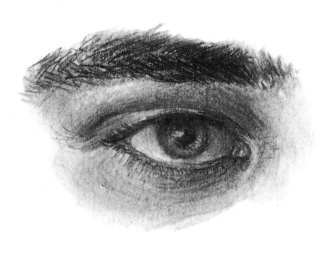

STRAIGHT-ACROSS TYPE

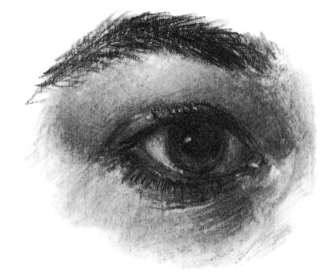

HIGH-ARCHED TYPE

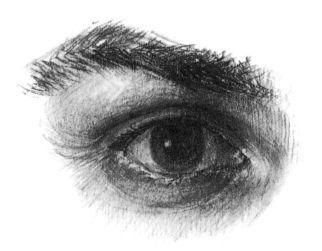

LOW-ARCHED TYPE

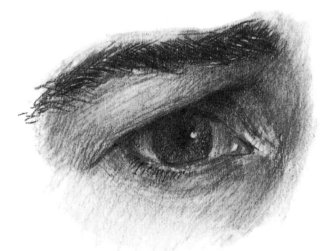

BROW OF DISTRESS

DISTRESS: INNER BROW END SLANTS UPWARD

The inner end of the eyebrow can be very expressive emotionally. If it drops down below a certain point (see p. 66), it indicates one sort of emotional state. If it moves above a certain point, it indicates distress. What separates these is the relationship of the inner third of the brow to the outer two-thirds. Ordinarily, the inner third lies either level with or below the rest of the eyebrow. If it moves even slightly above the rest of the eyebrow, the eye looks distressed.

Henri de Toulouse-Lautrec never saw an eyebrow he could leave alone. Toulouse-Lautrec demonstrates a caricaturist's fascination with the changes a simple twist or slant in the eyebrow can bring, combined with a genius for painting and portraiture—a rare combination.

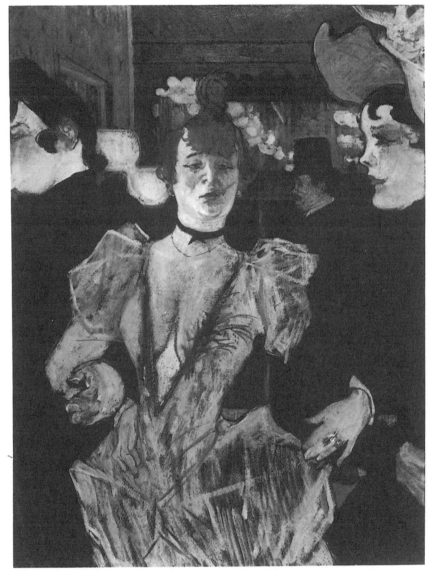

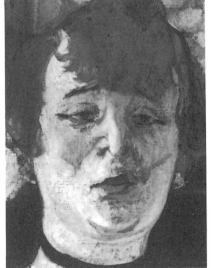

UPSLANTED

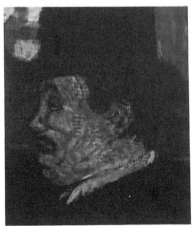

RAISED

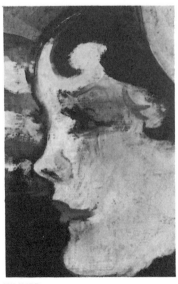

KINKED

No particular expression (anger, sadness, joy, etc.) is suggested by most of these faces—just a vivid sense of liveliness and strong character.

UPSLANTED

UPSLANTED

DOWNSLANTED

Muscles of the Brow

Considering how much can be expressed by the eyes and brow, it is surprising that there are only five muscles responsible for it all: two under the forehead and brow, and three surrounding the eye. Our control over these muscles is so fine-tuned that we can express virtually the whole range of emotions with just a little twist here, a little lift there: our perception is so practiced that we can instantly recognize the differences.

THE EYEBROW RAISER: FRONTALIS

The *frontalis* lifts the eyebrows straight up the forehead, creating the familiar worry lines on the forehead. It's often thought of as the muscle of surprise (as in the expression, "that'll raise some eyebrows"), but it also contributes to fear and sadness.

It is a broad, flat muscle that lies across the entire width of the forehead, like a sweatband. Its fibers run vertically, dropping from the hairline, where they are fixed in place, to its free end, the skin underneath the eyebrows. You can trace its line of attachment by running your hand along the upper rim of your eye socket, starting at the outside and continuing across the glabella, the root of the nose. The frontalis attaches along this entire edge.

When the frontalis contracts, all the skin just above the eyes and nose is pulled straight up toward the hairline, with the eyebrows coming along for the ride. As the forehead rises, the skin caught in the way gathers into horizontal creases: the worry lines mentioned above.

You may have no crease lines, or you may have half a dozen or more, fairly evenly spaced, but the creases will never be exactly straight. Typically, they will have a long dip in the middle, and as they approach the side of the forehead, they will suddenly change direction, curve sharply downward, and die out. They are arched very similarly to the way the eyebrow is arched.

When the lift of the brow is only partial, fewer wrinkles, and fewer complete ones, will appear.

Other Effects

As the eyebrows are pulled upward, the skin below them, rather then being wrinkled, is stretched taut across the underlying bone. Bags and wrinkles are smoothed out, as though ironed flat. The upper edges of the orbit, the glabella, and nasal bones all show clearly through the tight skin. That portion of the skin that usually bags over the upper lid, partially or completely hiding it, is lifted free, and the entire rounded form of the lid shows clearly. The eye itself, however, does not necessarily open any wider. Its opening is a separate function.

The creases, the tightened skin, and the exposed lid, taken together, are important in showing that the frontalis has acted. The eyebrows move upward as well, but sometimes eyebrows simply grow high. The other effects, however, only occur when the frontalis contracts.

Outer half/Inner half

Portions of the frontalis muscle can act on their own. Many people are able to use just the outer half to raise up the outermost portion of one eyebrow. Wrinkles form above this portion, resulting in an odd, rather quizzical expression. When just the inner half contracts, only the innermost ends of the eyebrows are raised, and wrinkles form across just the middle of the forehead. Most people can only move the inner portion in combination with the corrugator group in expressions of grief or anxiety.

ATTACHMENTS OF FRONTALIS

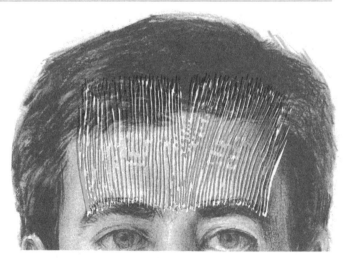

The frontalis is a sheet-like muscle running vertically down the forehead. There are two distinct halves, which join just above the nasal bones. The fixed end of the frontalis is right at the widow's peak, where it attaches to the thick fiber of the scalp. The free end attaches along a horizontal line at the level of the eyebrows. Some people have conscious control over just one half of the muscle, allowing them to raise one eyebrow. When we're distressed, only *innermost* fibers of muscle contract (**A**). This raises inner end of eyebrow and only happens in combination with action of corrugator.

The frontalis is the muscle underneath the forehead. Its basic action is simple: it lifts the eyebrows straight upward, creating rows of wave-shaped wrinkles. The expressions of fear, surprise, and sadness all involve some degree of this brow lifting. But the fact that so many older people have these wrinkles has a more mundane explanation: raising the eyebrows is the most common of all the conversational expressions. We raise our brows frequently and unconsciously to accompany our talk, with the same sort of meaning as a hand gesture.

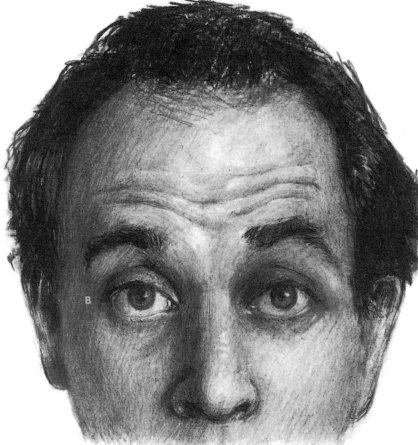

The wrinkles of frontalis are arched like the eyebrows, with a dip in the middle, and a descending leg on the side. The higher the eyebrows are raised, the deeper the wrinkles. Some of the wrinkles may be broken, or only part way across, particularly if the eyebrows are only part-way raised. The topmost wrinkle is the most shallow. The eyebrow does not glide evenly up the forehead. The outer end is "pinned" to the face and does not move with the rest. So as it rises, the eyebrow changes in shape from a shallow arc to a deeper one. As the brow rises, it also stretches the skin around the eye. Most of the upper eyelid is exposed. The skin of the upper orbit and glabella is smoothed, and the bony forms show more clearly underneath (**A**). The eye may be opened more, as at (**B**).

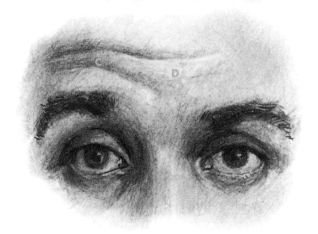

Raising just one eyebrow is a skill some people have. A slightly quizzical look may result. This action's made possible by the fact that the different sections of the frontalis can be controlled separately. In this case (**C**), the right half is being contracted; the left half is relaxed. The arching "signature wrinkles" fade out as soon as they reach the midline (**D**). Note the difference between the two upper lids and the two upper eye sockets.

71

THE FROWNING MUSCLE: CORRUGATOR

The *corrugator* is the most human of the expression muscles. Some might argue in favor of the zygomatic major, the smiling muscle, but it's too easy to smile with nothing behind it. No one tries to cry, to be afraid, or to scowl with concentration—all expressions in which the corrugator is the main protagonist. They're responses to the ups and downs of life. The smile can be a mask; when we use the corrugator, it's often because the world has broken through.

The corrugator has thus acquired a very bad reputation. When novelists talk about someone's "troubled brow," "knit brow," or "darkened brow," the corrugator is responsible. Almost all the actions of the corrugator are negative in effect. In concert with other muscles, the corrugator is what makes us look sad, troubled, or angry. By itself, it simply makes us look perplexed.

Description

The corrugator's basic action is to pull the eyebrows down and bring them closer together. Actually, two muscles, the corrugator and the *procerus* (or *pyramidalis*) do this; since they always contract simultaneously, they can be considered functionally as one muscle (the *corrugator group*).

The corrugator group has fibers that radiate upward from the bridge of the nose and go into the skin of the lower, middle brow. The corrugator itself has its two fixed ends anchored to the skull at the outer corners of the glabella. From this point the two muscle bodies, strips about as wide across as your little finger, run diagonally outward and upward to a point just above the middle of the eyebrow. Here, the free ends are knotted into the skin.

The procerus is fan-shaped. The base of the fan is fixed onto the nasal bone where the bone meets the cartilage. The upper, movable end is attached to the skin in the area between the two eyebrows.

Action

Look in a mirror, frown, and you can trace the various effects of the contraction of the corrugator group on the brow. The overall sense of a frown from the front view is that the two eyebrows are unsuccessfully attempting to join up. The inner ends of the eyebrows have moved together and downward; the skin in between is bunched and wrinkled ("corrugated"). Usually, the entire eyebrow appears tipped downwards; this is the classic effect cartoonists seize on and exaggerate when drawing an angry face.

If you look at the picture of corrugator from the side, you'll note that the movement of the brow is more than just down and together; it's also forward. The bunching of the skin above the eye creates a sort of shelf, projecting outward.

Other Effects

The movement of the eyebrows also affects the area *between* the eyebrows, where two—three, at the most—very deep, vertical wrinkles tend to form. These wrinkles, inside of each inner-brow lump, are quite straight for most of their length, but they often curve under the brow lump before fading out. These wrinkles are permanently etched into the face of most older people, particularly men.

New Skin Fold

The downward pressure and forward pressure of the brow drags the skin below along with it. A new, sharply defined, skin fold appears above the eye, pulled across the upper lid. The lid itself is pressed down further on the eye, partly closing it. Especially in the innermost corner of the eye socket, the eye appears more shadowed.

The minimum elements necessary to recognizably depict a frowning brow are these: inward-slanting eyebrows, vertical in-between creases, and extra-low level of the brow. The other, more subtle changes enhance the effect.

CORRUGATOR: THE FROWNING MUSCLE

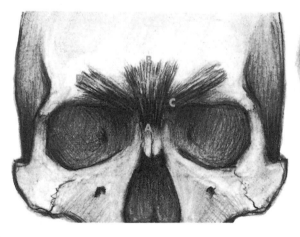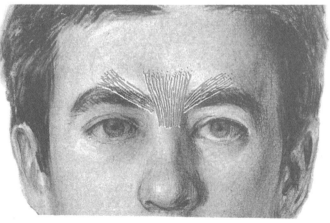

The attachments of the corrugator. The corrugator is actually two separate muscles, the procerus and the corrugator. They always contract together. The fan-shaped procerus attaches to the bone at the base of the nose (**A**), and to the skin at (**B**) between the eyebrows. The paired corrugators rise diagonally from their anchorage in the inner corner of the orbit (**C**) to their insertion in the skin above the middle of the eyebrow (**D**).

RELAXED EYES FOR COMPARISON

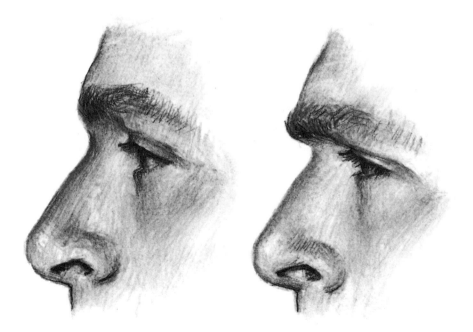

The corrugator pulls the brows down and together. It's active in most moods of distress and central to the expression of fear, sadness, and anger. It's also used unconsciously in talking or concentrating. The consequences of these uses is the eventual development of frown lines on the face. In the action of the corrugator, the eyebrow lowers, especially the inner third. It drops below the top of the upper lid. The eyebrows move closer together. A cashew-shaped lump appears at the inner end of the eyebrow, with a curved, vertical crease along its inside edge (**A**), the "frown line." A small, crescent-shaped dimple appears (**B**) above the middle of the eyebrow. This is where the muscle attaches to the skin and so becomes a low spot when the muscle contracts. A new, nearly horizontal fold appears above the eyelid (**C**). As the skin folds, it hides part of the upper lid, particularly the inner half. The inner end of the skin fold runs right into the descended inner corner of the eyebrow. The hollow created under it, at the inner corner, is in deep shadow (**D**). The downward pressure of the brow shoves the upper lid a bit lower, hiding more of the iris.

The side view shows clearly the pulling downward and forward of the brow. Note also the lengthened and straightened skin fold (**E**) above the eye and the narrowing of the eye itself.

Muscles of the Eye

The frontalis muscle and corrugator muscle act directly on the brow and indirectly on the eye and its surroundings. Now we'll look at the two muscles, *levator palpebrae* and *orbicularis oculi*, that act directly on the eye and upper cheek and, sometimes, *indirectly* on the brow.

THE EYELID LIFTER: LEVATOR PALPEBRAE

The upper lid is the more movable of our two eyelids because it has its own muscle: the levator palpebrae. It attaches to the skin of the upper lid on one end and to the roof of the eye socket on the other. When it contracts, the upper lid is lifted; the more contraction, the more lift—the more lift, the more wide open the eye.

Normally, the levator is slightly contracted, holding the upper lid in its awake position. When the levator begins to relax, the upper lid, pulled by

LEVATOR PALPEBRAE: THE EYELID LIFTER

Opening the eye extra wide with the levator palpebrae acts to intensify many of the expressions. But even in an otherwise relaxed face, the contraction or relaxation of the levator can have a drastic effect.

A. Excited. The eyelids are open as wide as possible. Most eyes will show a bit of white above the iris with the levator fully contracted. The lids arch more sharply, and the eye has a staring quality.

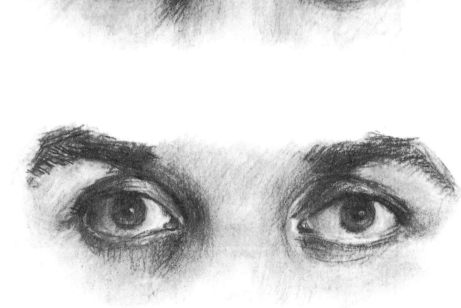

B. Alert. These eyes are open somewhat wider than normal. The iris begins to be covered by the upper lid (above).

C. Neutral. This is the ordinary, awake state for this person. The iris is still cut off quite high; more than half is showing.

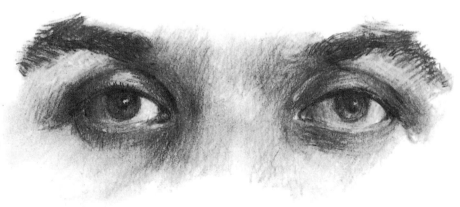

the force of gravity, begins to drop down over the iris. If the levator relaxes completely, the upper lid will fall against the lower lid, closing the eye. The contracting levator will reopen the eye; if it continues to contract, the lid will rise past its normal open position to expose more eye than usual.

Intensity

The levator is a sort of "intensity control" for the face. In the case of anger, fear, or surprise, the more vivid the expression, the more the eye will open. And the opposite is true: the more the eye closes, the more lackluster the face.

The crucial element in gauging the state of the eye is the shape of the iris, and white showing around it. Because the contrast between the dark iris and the bright eyeball is so strong, whatever that state is shows up from a long way off. We are the only animal with such a conspicuous eye display.

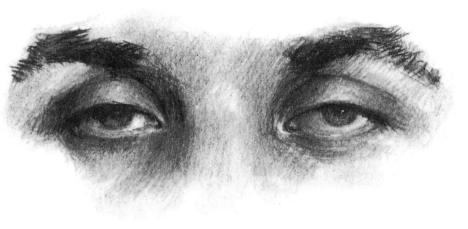

D. Sleepy. This iris is exactly half hidden. The relaxation of the levator allows the lid to fall. The pupil is partly blocked. This is a transitory state; we cannot stay conscious for long once our lid has fallen this low.

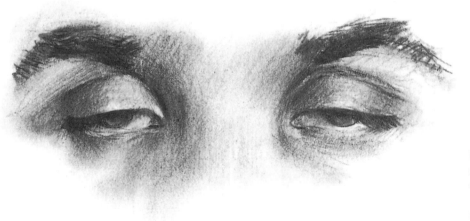

E. Losing consciousness. A momentary state. Either the person has just awakened or is just falling asleep. With this much of the pupil blocked, vision is seriously impaired. The iris is two-thirds covered.

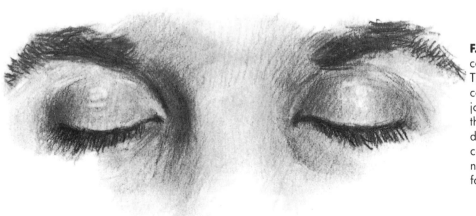

F. Eye closed. When the levator is completely relaxed, the eyes close. The curved line of the lower lid becomes the line for both lids. The joined lashes are more prominent, and though lashes are often left out of drawings of the face (being so delicate), in this case their doubled thickness makes them a substantial enough form to include.

The Eye-squeezing Muscle: Orbicularis Oculi

There are times when we wish to *pull* the eyelids closed. When we squint, or squeeze our eyes shut, we are using the orbicularis oculi. When it contracts, the eye, and often a much larger area of the face, including the cheeks and the mouth is affected. This is very unlike the modest action of the levator.

The orbicularis oculi is a large oval-shaped muscle, encircling the eye and spreading into the cheek beyond. It takes up the area that would be covered by a good-sized eyepatch. Clearly, when this muscle contracts, it's going to take a lot of face with it.

Imagine a large circle. Within it there are more circles, each one smaller than the last. The outer circle represents the boundaries of the orbicularis oculi; the lines within it trace the paths of its muscle fibers. The fibers travel in upward or downward arcs from one end of the eye to the other. All the fibers are fixed to the side of the bony nasal bridge; their free ends are attached to the skin of the cheeks and at the outer corner of the eye.

Action

When the orbicularis contracts, the skin around the eye is pulled in toward the nasal bridge. The eye begins to close, and the familiar crow's feet appear at the outer eye corner. The more the fibers of the muscle shorten, the stronger the contraction, and the smaller the oval around the eye gets. The smaller it gets, the tighter the eye is closed and the more the skin wrinkles. Eventually, the eye is closed so tight it becomes hard to tell the eye line from the wrinkle lines. When the orbicularis is that strongly contracted, it also bulges up the cheeks, deepens the nasolabial folds, pulls on the corners of the mouth, and sometimes lowers the brow.

The orbicularis oculi has distinct functional areas. The center of the muscle, where muscle fibers run through the eyelids themselves, is one independent region, the *palbebral* portion. Surrounding this is the remainder of the muscle, the *orbital* portion, which has two independent halves, upper and lower. The lower half, below the eyelids, is a key component of the smile; the upper half is used only when all portions of the muscle contract at once, as in the expression of pain.

The Eyelid Tightener

The palpebral portion of the orbicularis oculi runs through the thin skin of the eyelids. It is attached to the bony inner wall of the orbit. This portion is so tiny that its full contraction leaves only the slightest of flexion wrinkles (those that form at right angles to muscle pull) in its wake. Its major effect, when tensed, is to tighten and compress the eyelids. When the eyelids are tightened, the only movement they can make is toward each other; that is, they begin to close.

Typically, the mild contraction of the palpebral muscles pulls the lids in just enough to give the eye a narrowed look. The lower lid closes more than the upper, taking on a more rounded, defined look. This narrowing lower lid movement is important in two very different expressions: anger and happiness.

The Orbital's Lower Half

The lower orbital portion of the orbicularis oculi is one of the two muscles that create the expression of joy (the other is the *zygomatic major*). Its surface form is worth studying carefully.

Many people do not have voluntary control over this portion. Those that do have smiles that look sincere, even if they are not.

Try squinting so that just one eye is partly closed. If you can do it, you'll observe that the cheek, particularly the upper part, rises; a smile-shaped crease appears below the eye; crow's feet appear at the outer eye corner; and the eye narrows. This narrowing is usually absent in an insincere smile. Amidst all these changes, the area above the eye is left relatively undisturbed; all the action is below.

If you squeeze hard enough, you can close the eye completely. This is what happens in the laugh. But don't squeeze so hard that your brow starts lowering. If you do, it means you've also triggered the upper half of the muscle.

CONTRACTION OF THE EYELID PORTION ONLY

When only the eyelid portion of orbicularis oculi contracts, the main effect is to narrow the eye opening. The difference in appearance compared to simply closing the eye has to do with the lower lid. It straightens, rises up the eye, and covers the iris almost up to lower edge of pupil. This is how eyes look in first stage of a smile. There's also a little extra bulge below eyes (**A**); this is better defined when more of orbicularis oculi contracts.

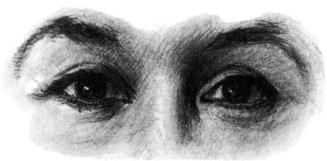

NEUTRAL EYES FOR COMPARISON

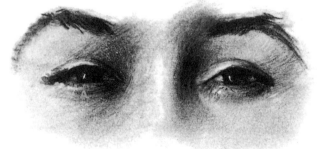

EYELID PORTION CONTRACTED

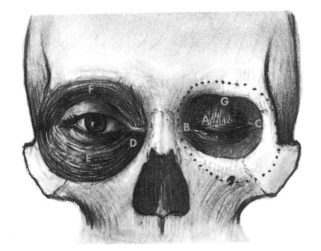

The attachments of orbicularis oculi. The orbicularis oculi, the muscle of the squint, has three parts, with separate functions. The inner, eyelid part, the palpebral portion (**A**), runs crosswise through the lids and attaches at the eye corners, along with the lids (**B** and **C**). The outer, orbital por-
tion has its fixed attachment on the skull (**D**) and its free attachment into the skin of the cheek. It has a lower half (**E**) and an upper half (**F**), which are semi-independent. Also pictured is levator palpebrae, eyelid lifter, with its fixed attachment to orbit (**G**), and its insertion on eyelid.

When the entire lower portion of orbicularis oculi contracts, the narrowing of the eye is combined with the bulging of the cheeks. This is a key action in the smile.

The area above the eye is completely relaxed (**A**). This contraction affects only the eyelids and the area below and beside the eye.

The eyes narrow . Now the lower lid is virtually a straight line and has begun to cover part of the lower pupil; the upper lid, not affected, is still above the pupil's *upper* edge.

Wrinkles (the "crow's feet") radiate out from the outer eye corner like spokes on a wheel. They follow closely the contours of the surface beneath. These, and the crease be-
low the eye, are the signature wrinkles of the orbicularis oris.

The wrinkling starts where upper lid line ends. Each line (**B**) tips progressively more downward, fading out as they pass to the side plane of the face. The last and lowest wrinkle emerges from the outer end of the little smile-shaped fold.

The cheek swells, particularly the upper half. Above the cheek, the little smile-shaped fold (**C**) or folds appear. Above it, the lower lid has a full look.

The crease from the nose to the mouth (the nasolabial fold) is deepened (**D**). If the pull is strong enough, the corner of the mouth may rise.

The Orbital's Upper Half

The upper half of the orbicularis oculi is not as free to move as the lower half because many of its fibers are intermingled with the fibers of such other muscles as the frontalis and the corrugator. But when it does contract, the whole upper part of the eye region is reshaped.

Keeping one eye open, look at yourself squeezing one eye tightly closed. Watch the inside end of the eyebrow. As soon as it starts to be pulled down, you know that you've started adding the action of the upper half of the orbicularis to the action of the eyelid and lower portions. In the upper eye area, the skin above the upper lid is shoved downward, hiding most of the upper lid itself. The lower lid is pressed upward from below, and the two lids meet in the line of the eyelashes.

Wrinkles radiate out from the inner corner of the eye like deeper mirror images of the crow's feet. One or two particularly deep folds may join their counterparts clear across the nose. They're not pretty. (Neither are the circumstances under which we use this muscle.)

The eyebrow is also pulled down, especially at its inner end. You can look at the muscle diagram and see why; the top part is right underneath the brow, so the brow is pulled toward the inner eye corner along with everything else. The corrugator may also be triggered, adding its pull to that of the orbicularis.

The net effect of the contraction is of an explosion of lines radiating out from the inner eye corner. The feeling is of compression and stress. The nose-to-mouth crease is greatly deepened; the nose itself is pulled upward, distorting the tip and creating horizontal creases along its length. And the pull on the corner of the mouth is much greater. The crow's feet and lower eyelid wrinkles also get much deeper.

One way to think about the muscle portions just described is that their actions appear in stages: the first stage, using the palpebral portion, just narrows the eye a little; the second stage, using the orbital's lower half, starts a true squint, a pleasant-looking one; the third stage, using the whole muscle, squeezes the eye for all it's worth, leading to a pained expression.

CONTRACTION OF FULL ORBICULARIS OCULI

This is the expression of pain. When the entire orbicularis oculi muscle contracts, the eye is buried in a sea of wrinkles. Every feature is pulled toward the inner eye corner. An eye communicating sheer stress and distress is the result. Here the upper half of the muscle, rarely used, adds its action to that of the rest of the muscle. It creates the deep, ray-like wrinkles stretching between the eyes and triggers the pulling down of the eyebrows. We would only expect to see this face in response to some extreme circumstance: intense pain or intense effort.

A. The brows are pulled down, probably by a combination of the corrugator and the upper portion of orbicularis oculi. Most action is at the inner end. A dimple over the middle of the eyebrows is prominent; also shallow, diagonal wrinkles rise upward on the forehead.

B. Vertical wrinkles (at right angles to muscle pull) may appear on the surface of the upper lid. Lid line itself becomes much straighter; the stronger the action, the straighter the line. Upper lid fold has disappeared completely.

C. Deep, radiating wrinkles emerge from inner eye corner: upward, across, and diagonally downward like spreading fingers. Often, a horizontal crease extends fully across nose. These are signature wrinkles of this action.

D. Crow's feet and the smile-shaped eyelid fold get much deeper, and extra folds appear.

E. Nasolabial fold deepens. Wings of nose are pulled upward, giving the nose a pointed shape.

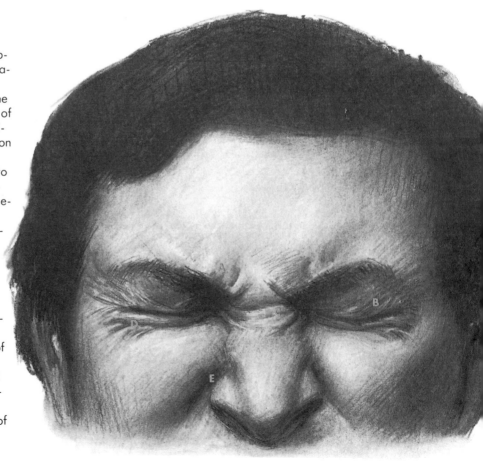

The Eye in Movement

Eyes are the most restless feature. Our eyes are constantly moving about, even when we're not; watch someone sitting on a park bench or standing waiting for a bus. Their eyes will be in motion whether their attention is directed outward or inward; thinking or observing are both accompanied by lively, unconscious movements of the eye. When we sleep, our eyes continue their activity, moving visibly behind closed eyelids when we're dreaming.

THE GAZE

The direction of the gaze can be an evocative element in a portrait. Downcast eyes, upraised eyes, eyes looking sideways, even out-of-focus eyes, are all suggestive of states of mind. Generally, any movement at all will be more expressive than simply depicting someone looking straight ahead. Pictures of rooms full of people with fixed gazes may be suitable for covers of paperback books about supernatural possession, or for statements about alienation, but they fall short of being naturalistic. That's not the way people really look.

As with the opening and closing of the eye, the direction of the gaze is telegraphed for all to see by the shapes of the eye whites and the way they frame the iris. But often, what we perceive is the result of very small shifts between the various elements; we rely on our (unconscious) expertise in deciphering the face to follow the gaze and interpret its meaning.

The Upward Gaze

When paintings customarily had a much stronger religious content than they do today, the skyward gaze was used as a convention to indicate an exalted state of mind, or communion with heaven. Even in our secular era, it's difficult to portray someone with upturned eyes without suggesting some level of metaphorical meaning, unless it's made clear that the person is simply looking at something.

We notice instantly when the gaze shifts from forward to upward, but it isn't immediately apparent what is noticed. This is a good example of how

A rather debatable version of what can be read from the eyes.

There's a strong association between spirituality and the upward gaze. It's not only because heaven is supposed to be up there, but also because we rarely look upward under normal circumstances—it's rather uncomfortable for the eyes. If we do look up, we usually tip the head upward at the same time, so as to keep the gaze level. Looking down, however, is something we do constantly; it's much easier on the eye muscles.

This particular upward gaze is the product of the high arch of the upper lid, the flat line of the lower lid, and the appearance of white below the iris .

much we can perceive without knowing why. In fact, we seem to use several different visual cues in combination. Oddly enough, the most important cue is the shape of the lids and the lids' relationship to the iris. The shape of the iris itself is also a key factor. Only in the extreme upraised position is the white under the eye a major element.

The limit of looking up is reached as the pupil encounters the upper lid edge—this is an uncomfortable position and not one that is held for long. In fact, like most of the positions of the gaze besides dead center, looking upward suggests an active interest, an engagement, on the part of the person, simply because it takes a special effort to do.

The first change we notice as the gaze rises is in the relationship of the iris to the eye corner. On most eyes, when the gaze is straight ahead a small portion of the iris always falls below the level of the inner eye corner. We don't have to be looking up very high before the bottom of the iris rises to this level, then rises higher.

When the gaze travels further upward, the eyelids take on a domelike shape, like a capital *D* lying on its back. The whites of the eye are framed by the sharp upright angles of the upper lid, while the lower lid is almost straight. Perspective makes the iris as a whole appear elliptical; the higher the gaze, the shorter the apparent height of the ellipse.

THE ANGLE OF THE UPPER LID

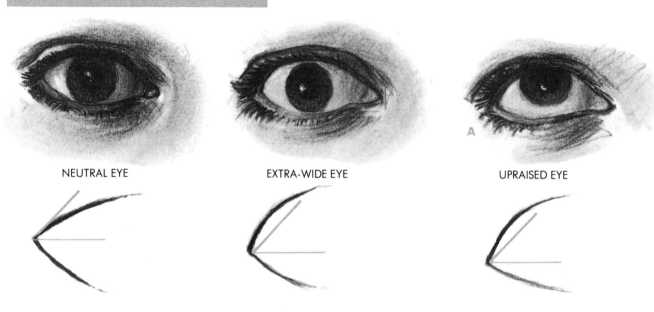

NEUTRAL EYE EXTRA-WIDE EYE UPRAISED EYE

The angle of the upper lid has a great effect on the way we perceive the eye. It's a key element in telling the extra-wide eye from the neutral eye—more important than the white above the iris. Even in a neutral eye with lots of iris showing (left), the steepest angle the lid makes as it rises to the top of the arch will never exceed 45 degrees (line). Once either or both upper legs exceed 45 degrees (center), we recognize that the eye is open wider than usual. This rule holds true for nearly every eye. The upraised eye and the widened eye have certain similarities. In both, the upper lid arches much higher on the eye. Here, the angle of the outer leg is nearly identical. What makes the overall shape of the eye different is the lower lid; when the eye looks upward, the lower lid loses some of its downward bow, and appears slightly straighter, particularly in its outer portion (**A**).

THE CORNER OF THE EYE

One way to find out if the eye is looking slightly up or down is to compare the iris' position to the level of the inner eye corner (line). In a level gaze, the line indicated will cross the lower part of the iris; looking down, the middle of the iris crosses the line; looking up, the iris' lower part rises past the line.

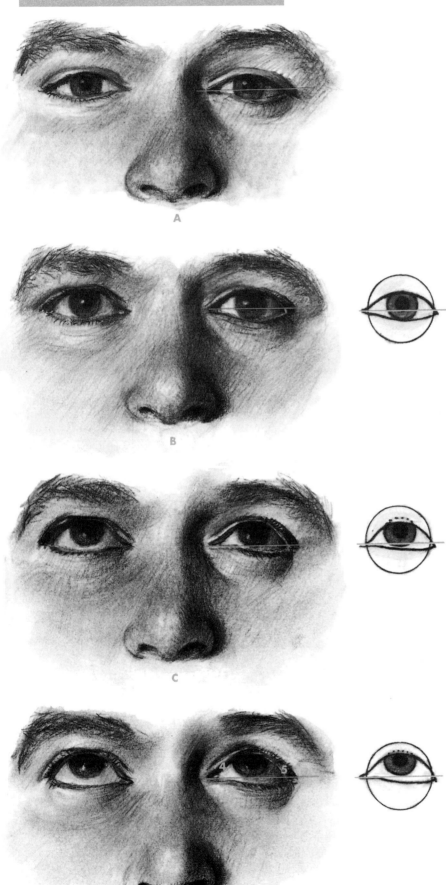

When we look up, the eye reshapes itself in large and small ways to accommodate the movement. Even the obvious lifting of the iris has a subtle aspect: the foreshortening of the iris into an ellipse. The first stage of the upward gaze (**B**) is the most difficult to capture. Great care must be taken to get the angle of the upper lid right, and to raise the iris high in relation to the inner eye corner. Note how in drawings **A–D**, the iris is cut by the upper lid line in the same place no matter how it moves.

A. Looking out. A person with a relatively narrow eye opening. Note relationship between pupil and line across middle of corner; when eye is looking outward, line cuts through lower part of iris.

B. Looking up. Even in this first stage of upward gaze, many changes have occurred (**1**). The upper lid is almost fully retracted. Both inner and outer angles steepened. The upward gaze is more obvious in the eye on the left, where the inner leg is now at a greater than 45 degree angle. As gaze gets higher, arch of upper lid continues to increase by small amounts (**2**). The pupil has moved slightly above the midline of the corner. The bottom of the iris is now visible, and the lower lid is slightly straighter (**3**); the higher the gaze, the straighter it gets.

C. Looking higher. As the gaze rises further, the curve of the lids changes more slowly. The upper lid is now more steeply arched—most angles are greater than 45 degrees. The lower lid is closer to being straight across. White begins to appear below the iris, which appears more elliptical, wider than high. The bottom of the iris has now risen above the middle-of-corner line.

D. Upper limit. Limit of gaze is reached when the upper lid can open no further. Above this point the pupil would begin to be covered. Note the flatness of the lower lid; asymmetry of the two eyes—inner leg of eye on left is still less than 45 degrees (**4**); narrowing of iris ellipse; thickness of upper lid facing us more directly (**5**).

The Downward Gaze

When you depict someone looking downward, any number of things may be suggested—reading, reflection, resignation. Compared to looking up, the downward gaze is more comfortable and takes little effort to maintain. The chief problem for the artist is distinguished between the very similar appearance of the eyes looking down and the eye shutting.

The differing appearance of the two actions revolves almost entirely around the position of the lower lid. When looking down, the lower lid drops just enough to maintain a narrow gap between the lids, allowing room for the pupil to show. There is no muscle responsible for this movement; probably it is the eye itself that pushes the lid. As the lower lid drops, it begins to raise skin furrows below it, like a plow pushing up earth. Except for this instance, there is no other time the lower lid descends.

A good way to see this lower lid action is to look at yourself in a mirror and begin to tilt your head slowly back—your gaze will be forced to drop. Notice the crease that appears under the lower lid. This is the signature wrinkle for the action of looking downward, caused by the lid folding under itself. The further down you look, the deeper the wrinkle gets.

In drawing the lids, take care that they respond to the sense of the ball underneath. The upper lid starts from the inner corner with a straight part, then begins a full curve around the eyeball. The lashes show clearly and are often indicated. The lower lid will dip lowest just below the iris: if we look down and to one side, the low point will follow the iris along. We have a wider range looking down than up, so the variety of possible positions is much greater.

Looking Sideways

Having someone look sideways can also enliven a portrait. Like looking upward, it suggests an active sort of seeing. The further to the side the gaze goes, the more momentary the glance, for two reasons: the more extreme positions are hard to hold, and the head tends to follow the gaze. I've noticed that models have to make a special effort to hold their heads one way if their eyes are turned very far to another.

Compared to looking up or down, however, drawing the eye looking sideways is easier. But don't be misled by the apparent simplicity—nothing about the face is without its subtleties. Here, the *shape* of the eye changes, as the gaze shifts, from an oval with two narrow ends to an oval with one narrow and one blunt end, mostly owing to a rearrangement of the upper eyelid as the iris moves. When the gaze is straight ahead, the top of the upper lid's arch is in the center of the eye. But the high point moves with the iris when the gaze shifts to the side; it stays above the iris no matter where it goes.

Because the *cornea* sits like a permanent contact lens over the iris, making a tiny, transparent mound in the middle of the eye, the lids often get reshaped as they cross over the bulge. In looking to the side, the cornea adds extra lift to the upper lid.

The white space on either side of the iris helps us judge which way the eye is aimed. With straight-ahead eyes, the white space will be approximately equal on both sides. If the gaze is just slightly shifted to the side, drawing the eye to get the gaze exactly where you want it can be an exercise of maddening delicacy. Look carefully at the exact shapes of the white triangles bordering the iris on either side.

The iris also appears less circular the more it rotates away from us. Foreshortening narrows its width, exactly as it does when the head turns to a three-quarter view.

Looking Straight Ahead: Highlights and Focus

Even when we're calm and looking straight ahead, there are nuances to the eyes. When we change our focus from something near to something far, there is a slight rotation of the eyes. The irises move closer together and farther apart depending on how far away the point of focus is. The eyes point inward to focus on a nearby object: as the object moves farther away, they turn to point outward, and the irises separate.

SUMMARY

The shifted gaze is one more way to make faces expressive. Sometimes moving the eyes alone will bring more life into a portrait. Much can be made over the effect of having the eyes looking one way versus another; it's often suggested that Manet's nude *Olympia* would have created far less of a sensation had she been looking any other way than directly out at the viewer.

The shape of the eyes as they move is irregular enough that we need to draw them repeatedly to learn the fine points of the changes in their form. Often a model will look in a particular direction only occasionally; if we want to capture that gaze, we need to fill out what we can gain from observation with what we already know.

The trickiest part of drawing the downward gaze is to not merely end up with a closed-looking eye. When the eyes simply close, the iris and pupil are covered in the process; in the downward gaze, the eye leaves open a space large enough for the pupil to see through. This is accomplished by the bowing downward of the lower lid. A telltale crease, the signature fold for this action, appears below the lid as it moves. As the gaze drops further, the bow gets sharper and the crease deepens. The dip and the crease are the keys to keeping the eye open-looking.

A. Level gaze. Corner midline crosses iris about one-third up from bottom. This is the average for most eyes when gaze is level.

B. Looking down. The shape of the lower lid is bowed downward more than in a level eye (**1**). Note similarity between curve of upper lid in closing eye and downward eye. It's only the position of the iris and the curve of the lower lid that make the two eyes so different.

C. Further down. As the gaze drops further, our view of the eye is more restricted by low angle and by increasing shadow. Note that opening (diagram, left) is just wide enough for pupil. Crease deepens below lower lid (**2**), while upper lid is more fully exposed (**3**). Lashes of upper lid in

lowering are more prominent, note closing eye (right), where same upper lid position has eye almost fully closed.

D. Lower limit. In lowest position, the eye is seen as two curved lines with a dark space in between; iris will be vague or invisible within shadow. Space between lines thickest in center (where the iris is) thins at either end. Note how curve of lid lines starts with straight part at inner corner (**4**), then turns into a full curve around eyeball. Unfolded upper lid with shallow crease or two is at the level where lid normally ends (**5**). Difference at this stage: closed eye has one curved line (with lashes) versus the open eye, which has two curved lines and a dark space (seen through lashes) with crease below.

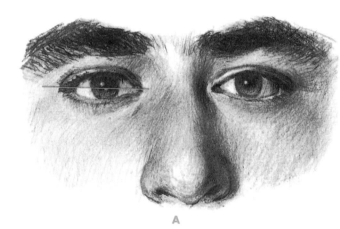

A

EYE LOWERING

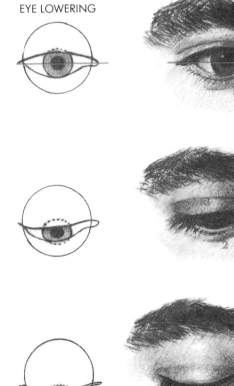

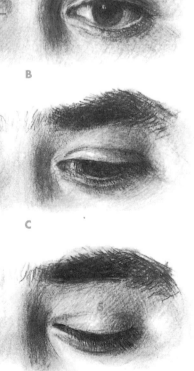

B

C

D

EYE CLOSING

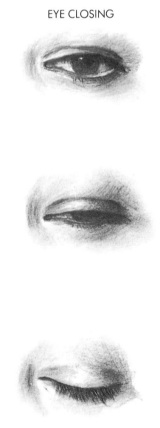

Depicting the sidelong glance presents few technical problems for the artist. These illustrations demonstrate, though, that more changes in the eye than simply the iris moving to the side. The shape of the eye itself alters depending on the iris position. The rule is that the high point of the arch of the upper lid is always above the iris (it's lifted by the cornea). The lower lid, however, changes very little as the iris shifts. The net effect of the modifications is that the eye alters in shape from oval to almond as the iris turns. The iris itself appears less circular as it turns. In the most extreme position (**A**) the iris shape is blunt at one end and much narrower than it is high.

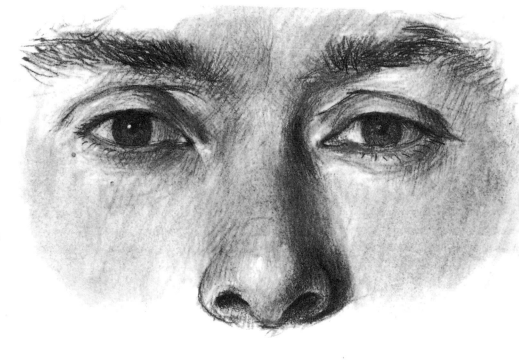

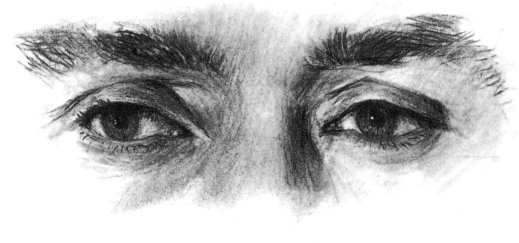

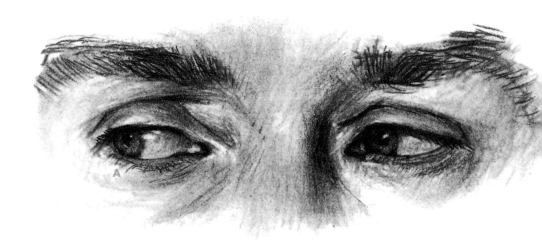

Seen from the side, the iris widens from a narrow black oval, when we are looking straight ahead (**A**), to an ellipse, when we are looking somewhat to the side (**B**). The amount of space between the iris and the eye corner steadily decreases. When the glance is directly to the side (**C**), the iris fills our view of the eye. Its shape appears more circular, and white space has appeared on its far side. It's also widened the eye corner slightly (**D**). The rim of the upper lid bulges above the iris (**A** and **B**) when the lid travels over the tiny mound of the cornea.

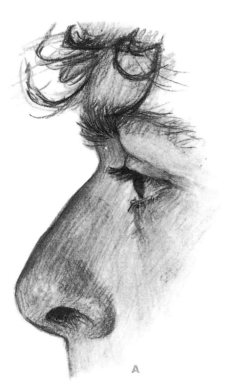

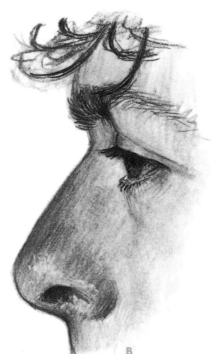

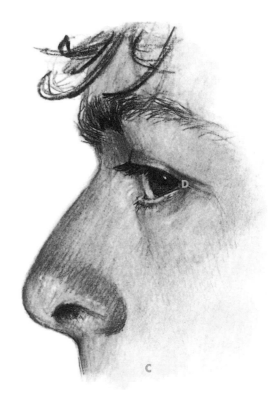

THE CORNEA FACTOR

The cornea is a transparent dome sitting on top of the iris. It has a subtle effect on the drawing of the eye. In the level gaze, the lower lid crosses so low on the dome (**A**), that its curve reflects only the ball underneath. The upper lid, however, crosses a part of the dome where it is higher off the ball (**B**). It is this slight bulge that we see when the gaze shifts from side to side. The cornea also creates the sharp dip in the lower lid when the gaze turns downward.

We can tell from the eyes if someone is looking at something close or far away. When we look at something at very close range, the eyes rotate so that the irises can both aim directly at the subject (**A**). This turning inward brings the irises closer together (see diagram, top). The farther away the subject, the more separation between the eyes (**B**)—up to a point. That point is reached when the eyes go out of convergence, the position the eyes will naturally fall into when we are looking off into space (**C**).

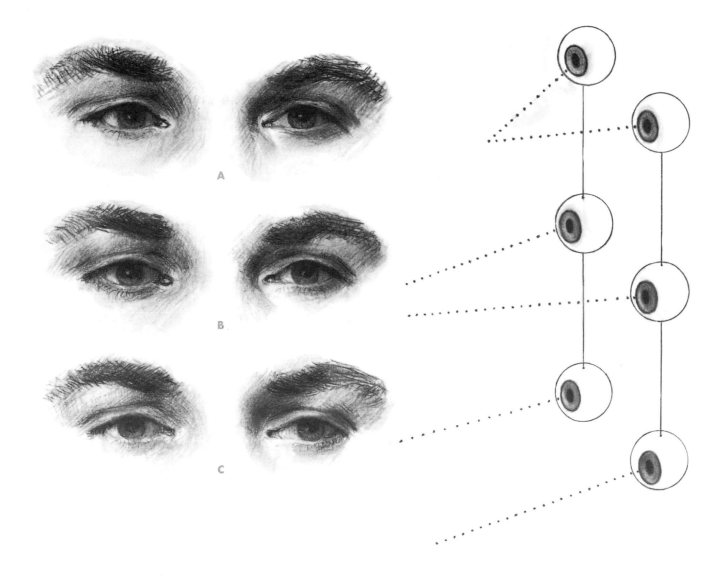

A

B

C

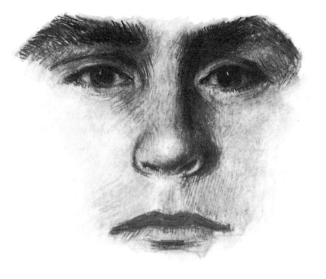

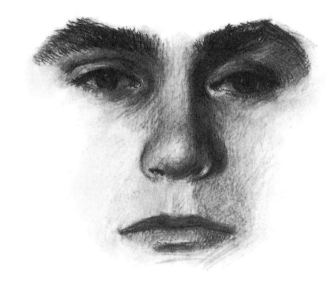

THE "INWARD" GAZE

There are only two differences between these two drawings: the openness of the eyes and the separation of the irises. The face on the left, with more open eyes and irises centered in the eye, seems more outward looking. The face on the right, with eyes *slightly* more closed and irises slightly more separated, seems much more detached. We speak of someone with this look as gazing inward, or, less kindly, of being "spaced out."

EYES OUT OF SYMMETRY

This wall-eyed gentleman may not have been as wall-eyed as he looks. The disturbing effect of the eyes being out of symmetry (left iris closer to the eye corner than the right) dominates this portrait, but it's more likely that it was the *artist* who had eye problems. *The Portrait of Joshua Trevis* by the same artist, Jacob Eichholtz, has eyes with precisely the same problem. A portrait artist might encounter *one* person like this, but two?

THE MUSCLES
OF THE MOUTH

As a minute or two in front of a mirror will demonstrate, the mouth is capable of being stretched, squeezed, or curled into just about any shape. Obviously, it requires quite a muscular network to allow us to do all those funny things with the mouth.

There are twelve muscles in the network, but we can eliminate five right away as having nothing to do with facial expression (several are used, for example, mainly for eating).

Of the seven remaining muscles, one is already familiar—*zygomatic major*, the smiling muscle. There is also *levator labii superioris*, the sneering muscle; *triangularis* and *mentalis*, which work as a team to bend the mouth downward; *risorius/platysma*, which elongates the lips; *depressor labii inferioris*, which pulls the lower lip downward; and *orbicularis oris*, the muscle of the lips, which presses both lips together.

INDIRECT ATTACHMENTS

The mouth is freely suspended. It's only attachment to the skull is indirect—it's surrounded by muscles that attach to the skull at one end and the mouth at the other. Imagine a slit in the middle of a trampoline: like the mouth, it's not attached to anything solid, but it's part of a stretchable fabric attached to a rigid frame. The slit would have enough free play to take on an enormous variety of shapes as the trampoline stretched and sagged.

As a result of its suspension, the mouth can be pulled and pushed as if it were part of a rubber mask. In fact, actors sometimes use the lower part of the face as a mask, holding through muscle tension a facial shape completely different from their own.

Looking at the Open and Closed Mouth Separately

There is another factor that affects our discussion of the mouth that was not an issue with the eye. Though the same muscle may be active when the mouth is both open or closed, the actual appearance of the mouth is quite different, as in a smile with the lips parted and one with the lips together. For this reason the mouth will be discussed in two separate sections.

THE CLOSED MOUTH AT REST

Drawing the mouth is always a delicate matter. It sometimes seems as though the least little change—a little shading here, a break in the angle there—will transform our reading of the mouth from one mood to another. For example, it takes very little to suggest a smile; the slightest angling up of the corners will do. Unfortunately, it can also take very little to suggest a sneer or a pout!

Neutral Positions

It is generally more difficult for the artist to control the expression of the mouth than the eye. One problem is that certain relaxed mouths resemble those engaged in an expression.

For example, we may see people who, on first glance, seem to be permanently sneering or pouting—perhaps some of them are. In most cases, however, a careful look will reveal certain very subtle surface forms indicating that, in fact, no expression is involved. And if no expression is involved, we must avoid emphasizing the wrong wrinkles—those signature wrinkles that suggest that such an expression is in progress.

Lighting can also create problems. Shadows on and below the lower lip are important in defining if the lip is tense or thrusting out.

Finally, there is the perspective factor. When the head is tilted up or down, the curve of the mouth will be altered accordingly. Be careful not to curve the mouth in the direction you're *used* to seeing it in, rather than the one it's actually taking.

The line between the lips (LBL) is the key to depicting the closed mouth. Draw it first and work outward from there: Not only is it a good way to start a drawing, but it's also the major element in defining the expression the closed mouth carries. Here are the three main variations that the LBL takes in the relaxed mouth. The same underlying pattern—dip and two peaks in the middle, two long curving legs on the sides—is common to all three, whether men's mouths (center) or women's mouths (right).

CUPID'S BOW

The most common type. It has a well-developed central dip and a distinct break between peaks and legs. Note that the end of LBL is on same level as middle of LBL; this is true unless the head is tipped.

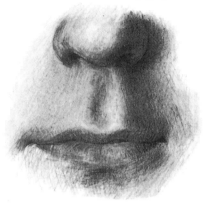
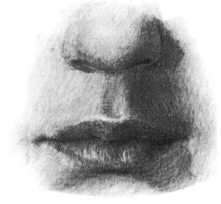

STRAIGHT ACROSS

Not quite as straight as it looks. Really a flattened version of Cupid's bow: dip and two peaks still present—just barely. The three-part pattern of lips goes back to the development of the embryo and is present in every mouth.

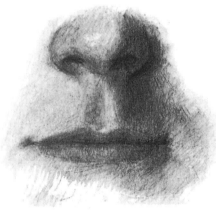
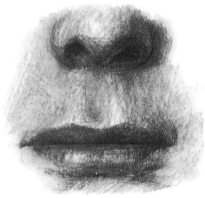

UPWARD ARCH

The arch shape is really another variation of the Cupid's bow, with lower outer corners and a high middle. Usually, the arch is only moderate, like the mouth at center; a high arch (right) is unusual.

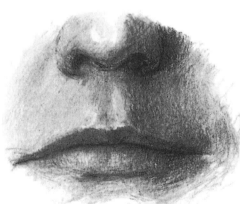
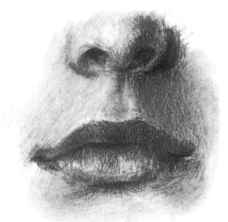

A variation of this type occurs if lips in relaxed mouth don't quite meet. What was the LBL in the closed mouth becomes upper rim bordering teeth.

Key Elements in the Closed Mouth: The Line between the Lips

The way you draw the line between the lips (LBL) will determine 75 percent of the expression you give to the closed mouth. Though lips vary radically, the three main forms of the LBL apply to most mouths:

1. *Cupid's Bow.* The most common pattern. A dip in the middle, two peaks, and a long decline to the corner. The outer portion of the line may curve up slightly, or it may be straight across.

2. *Straight Across.* This should be thought of as "more-or-less" straight across. The "more-or-less" is important. The LBL of a relaxed mouth is never a perfectly straight line. On those people where it seems to be straight, a careful look will show that it's really a flattened form of the cupid's bow, with the same dip-and-two-peaks pattern—sometimes barely evident.

3. *Upward Arch.* The cupid's bow pattern but with the LBL much higher in the middle than at the ends. This type of mouth is one that can most easily suggest a negative expression if it's not well drawn.

When the mouth is relaxed, the LBL in all mouth types will have key elements in common. The direction of the line will change smoothly, not abruptly. The outer end of the LBL will always be either even with or a bit below the center, never above. And if the line of the LBL appears straight, as in 2 above, the upper lip will be full, not compressed.

THE LINE BETWEEN THE LIPS IN ACTION

There are some general rules for what makes the line between the lips (LBL) appear neutral. Ordinarily, a mouth reshaped by muscle contraction will show one or more of the changes listed. If you don't want the mouth you draw or paint to have an expression, these are things to avoid. If you do want an expression in the closed mouth, it may well include one of these elements. Bear in mind that the expression in the mouth can be quite subtle; if the expression in the eyes is strong enough, we tend to perceive the mouth as sympathetic.

If the mouth is neutral, it will not have LBL with abrupt changes in direction or extending well past end of lips. The ups and down of the LBL in the relaxed mouth are gradual. Only when pulled by muscle contraction will the LBL show a sudden break in direction (**A**). The new direction may be up, as here, or down. Usually the same action will pull the LBL well beyond the visible end of the lips. Normally the LBL ends just beyond the end of the lips. An LBL end higher than its center is a definition of the smile. (**B**) A smile begins as soon as either or both of the LBL ends move above the LBL center. (The green line makes this relationship clear.) A relaxed mouth will never have the LBL end higher than the middle. LBL with no kinks and with a thinned upper lip occurs when the mouth is compressed or stretched. But some LBLs have hardly any kink to begin with. The combination of thinned upper lip with straight LBL makes this mouth look tight-lipped (**C**). Another version of this is (**D**); here, not stretch, but the upthrust of the lower lip has eradicated the usual two-peaks-and-a-dip pattern and hidden much of the upper lip.

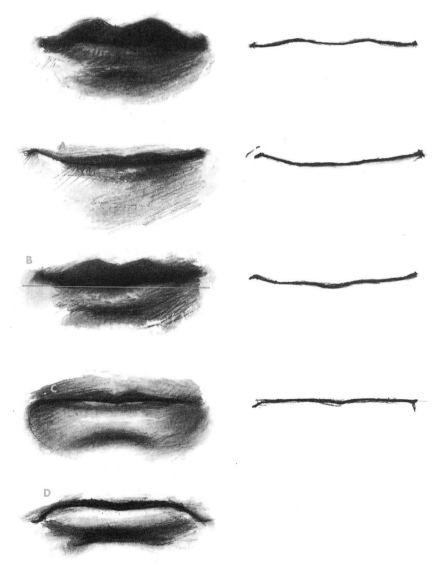

THE CORNER OF THE MOUTH

As anyone who has ever picked up a pencil knows, the expression of the face is based on the corner of the eyes and the corners of the mouth.
—*E. F. Gombrich,* The Story of Art.

The above statement is really more misleading than helpful. The corners of the mouth *do* change in most facial expressions, but so does the line between the lips, the shape of the lips, the cheeks, and the chin. None of these things change by themselves—they're all connected. Taken together, a set of changes occur that we recognize as an expression.

Creases around the Corner

The "corner of the mouth" is an interesting location. The spot where the line between the lips ends is a veritable Times Square for facial muscles—more of them converge on that one point than anywhere else on the face.

As we age, the crease at the mouth corner tends to lengthen and deepen, scoured into the face by the repetitive movements of the mouth. Eventually, it may join with another fold created by mouth movements, the *commissural fold*—a vertical wrinkle that brackets the mouth and chin like parentheses. It's located right at the point where the chin turns from front plane to side. It takes over where the nose-to-mouth fold leaves off; sometimes the two folds connect, and then one long curving fold extends from nose to chin. Together, the mouth-corner crease and the commissural fold can make an upside down L-shape continuing the mouth line.

By themselves, none of these folds will make a mouth smile or frown, and in fact can be confused with the creases that are created by expression. But as long as the lips and LBL and cheeks are in their relaxed form, the mouth as a whole will look relaxed. In your drawings, note where the LBL, which is so important in expression, ends and where the creases around the mouth begin. Usually there is a sharp break in direction between mouth and crease that helps clarify things. Whenever possible, avoid working from photographs. These details are always much clearer when you use a model.

The corner of the mouth receives a dense concentration of facial muscles. As a result, it's one of the more sensitive areas of the face in terms of our ability to precisely control its movement. In any stretching movement of the mouth, it's one of the first things to show a change.

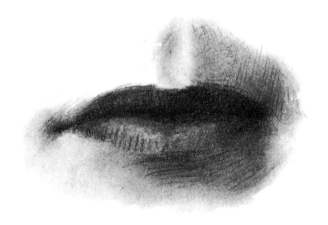

Here is a relaxed mouth (top), contrasted with the same mouth in the first stage of a smile. A little angled crease (**A**) appears as the lip end is pulled deeper into the face. The pull is stronger on the opposite side and the crease is deeper. This is the face of a seventeen-year-old; with time, the crease becomes a permanent one, with slightly softer edges.

The folds that develop around the mouth are some of the deepest on the face. Here's the mark of forty years on a woman's face; the particular pattern shown here seems to be more common with women than men. Though the wrinkle pattern is similar to that of the mouth in certain expressions, we see the mouth as neutral because the LBL, the lip shape, and the shape of the cheeks are all relaxed.

AGE TWENTY

At age twenty (top), the mouth corner is marked by a short, oblique crease. The slight mound outside the crease (**A**) is the "node"—a thickening in the face where a number of the mouth-moving muscles converge. Its form helps to define the mouth corner. There are hints of the way the face will look in forty years in the very soft turnings alongside the mouth and on the cheeks; the crease alongside the chin falls at a natural plane turning between front and side.

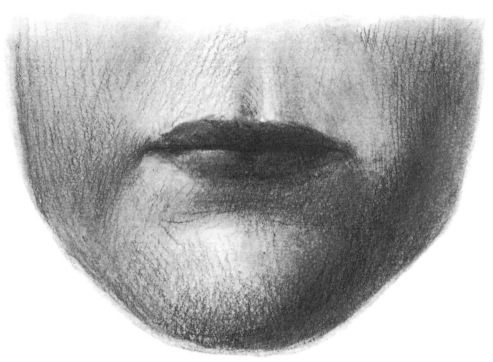

AGE SIXTY

At age sixty (bottom), deep lines around the mouth have appeared. The corner of the mouth crease has deepened and lengthened, making the LBL appear to continue much further than it does; it actually ends at (**B**). From there what we see is a skin fold, not a real gap. The sharp turning is where a separate crease, the commissural fold, begins (**C**). It's often one of the deepest wrinkles on the face. It runs straight down alongside the chin, marking the border between front plane and side. The nose-to-mouth fold has also deepened (**D**); on many faces this joins with the commissural fold, making one long crease from nose to chin. Other changes with the years include a deeper crease under the mouth and a fuller line of the jaw.

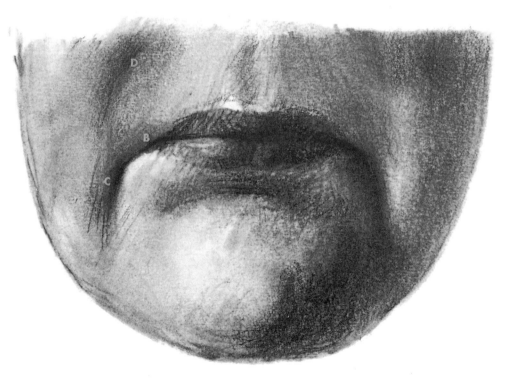

The Closed Mouth: Five Muscles

UPWARD PULLER I: THE SNEERING MUSCLE

If the corrugator makes us human, the *levator labii superioris*, the sneering muscle, is the muscle that makes us obnoxious. If there was a popularity contest for facial muscles, this one would lose, hands down; there's no elegant or flattering or nice way to use this muscle. We tend to use it when we think something stinks, literally. Or when we're furious. Or when we're crying our hearts out.

What the levator labii superioris does in particular is to lift the upper lip in a sneer. The "lip raiser" also curls up the nose and wrinkles the eye area in the process. Its distinctive effect on the countenance, when acting alone,

might be out of place in a portrait, but it does appear in art in various other applications.

Three Branches

The muscle form of the levator labii superioris is like a river with three branches. All three branches come together and attach to the same spot: the circular muscle surrounding the lips, right below the wing of the nose. Some of the muscle fibers also attach much closer to the surface, along the skin line of the nasolabial fold (which their action deepens), and into the nose wing. If you sneer, you can see—and feel—the location next to the nose where all three parts of the muscle attach and the sharp crease that appears when they contract.

After they leave their shared attachment, the three branches separate as they travel upward to their respective bony origins. One branch goes almost straight up alongside the nose, where it has a long attachment that goes as high as the nasal bridge. The middle branch attaches to the bone of the upper jaw, just below eyesocket. The outer branch, usually referred to as *zygomatic minor*, is fixed to the cheekbone at its widest spot, where it turns the corner to the side. We group these muscles together because the effect of their action is so similar: when any one contracts, it squares off the upper lip. Often, one branch contracts while the others relax.

Even though the mouth may look the same, the upper face, nose, and cheeks

LEVATOR LABII SUPERIORIS: THE SNEERING MUSCLE

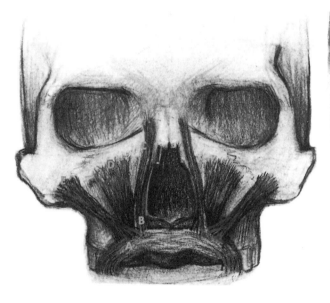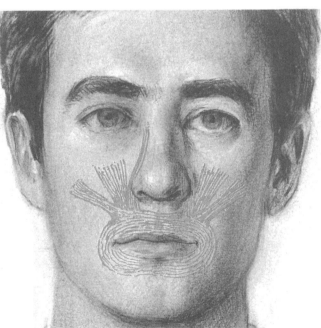

The levator labii superioris pulls the upper lip into a squared-off shape, the mouth of disgust. The sneering muscle pulls on the mouth indirectly: None of its strands attaches to the lips themselves. Instead, it attaches to the circular muscle of the lips (**A**), the nose wing, and the upper nasolabial fold (**B**). The upward pull on the skin and muscle surrounding the lips drags the lips upward as well. There are three independent sections, which can all accomplish the same task: The nasal branch is fixed alongside the upper nose (**C**); the middle branch is fixed underneath the eye socket (**D**). The last section, zygomatic minor, is treated by some anatomists as a separate muscle. It attaches on the corner of the cheekbone (**E**).

look a great deal different depending on which branch is contracting. We'll describe the common element—the mouth—first, then look at the differences between the branches.

Effect on the Mouth

The line between a sneering and a relaxed upper lip can be a fine one. Artists occasionally find themselves struggling to take the sneer out of a mouth without quite knowing how it got there. What should they know that would help them?

First, don't bother redrawing the *lower* lip. The sneer only affects the upper lip, leaving the lower just the same. Second, watch the line of the upper-lip margin. The basic effect of the sneer is the same as pushing your upper lip flat against a piece of glass. The lip is flattened, pushed back, and widened. This changes the upper margin from "stretched *M*" to "square arch." The lip becomes more even in width and drops straight down to its corners, rather than tapering. Don't allow this shape to be approached if you want to avoid a sneer.

As the upper lip curls upward, it lifts slightly off the lower lip. The lift is strongest in the outer ends of the lip, and here the gap between the lips widens.

People often sneer with just one side of the lip. Then the changes are only seen on that side, and the other side remains relaxed.

Changes in the Upper Face: Middle vs. Nasal Branch

You can't sneer without redoing a bit of the upper face as well. Depending on which branch of the muscle you use, you may end up with a little bit of nose and cheek, or the entire face transformed, all from the simple fact of lifting the upper lip.

You can demonstrate on your own face the difference between the two branches. An ordinary sneer uses only the middle branch, which takes less effort. But if you really put your heart in it and concentrate on wrinkling up the nose as well, you'll end up using the inner branch. You can feel the lift in the cheeks right across the face. Isn't it a lovely expression?

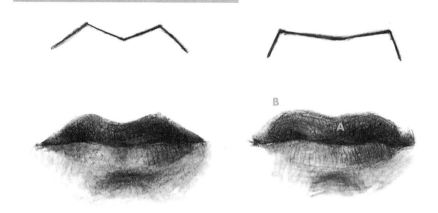

The sneer affects only the upper lip. It's pushed up and back into the face; more inner lip is exposed, so the whole lip looks thicker. A little crescent-shaped crease often appears above the middle. Above the lips, I've drawn the key to the difference. In the sneer, the M shape of the relaxed lip is squared off: (**A**) the middle has been thickened and (**B**) the corners have been squared off. Recall that the relaxed lip always tapers from center to outer corners: here you will note that is not the case—the lip appears equally wide throughout.

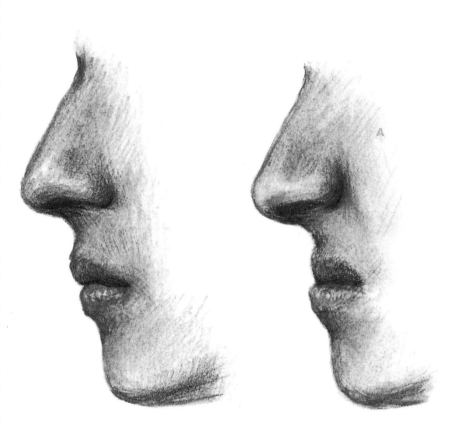

The sneer pushes the upper lip back into the face, as well as pulling it upward. Note the change in the shape of the outer part of the lip; it no longer tapers, but is thick and even-shaped; it drops almost straight down to the outer mouth corner. The nose also has its wing lifted by the action. The muscle attachment is at (**A**). Anyone who teaches a portrait class will see students accidentally draw the mouth on the right. It doesn't take much.

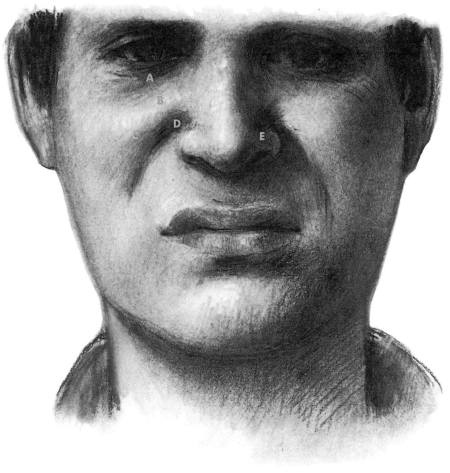

The difference in the upper halves of these faces (the lower halves are almost identical) is the difference in the actions of the two parts of the levator labii superioris. The inner, nasal branch of the sneering muscle (bottom) gives the face a crinkled-up look when it contracts, because its contraction triggers the orbicularis oculi and part of the corrugator. The middle branch of the muscle, if its pull is strong (top), puffs the cheeks and wrinkles the eye a bit. Both create the sharp, hooked crease around the nose, and both pull up on the nose wings.

MIDDLE BRANCH

A. With strong pull, pushing up of cheeks "backs up" all the way to eye, creating crease along edge of eye socket.

B. Middle branch fixed to bone here.

C. Inner cheek bunched up in curved, vertical mound, thickest along nasolabial fold, fades out above and to the outside.

D. Signature wrinkle of the sneer. Hook-like fold, deepest along nose wing, shallower below, with very sharp edges. Little hollow spot with ridge above often forms here.

E. Wings of nose pulled up toward eye, pointing the nose downward. Muscle attaches to skin next to and on nose wing.

INNER BRANCH

F. Mild contraction of eye-circling muscle, orbicularis oculi, triggered by contraction of inner branch. Eye squints, and crow's feet, lower lid folds, and inner, star-shaped wrinkles appear.

G. Eyebrows pulled down slightly by partial contraction of corrugator. Shallow vertical wrinkles appear between the brows, and star-shaped wrinkles below.

H. Creases run alongside nose.

I. Cheeks rise up all across face, but pile up deepest here.

J. Nose pull very similar to above, but more straight up, pointing nose more.

K. Mouth identical to above.

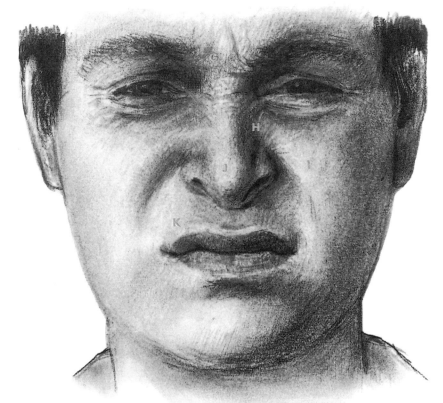

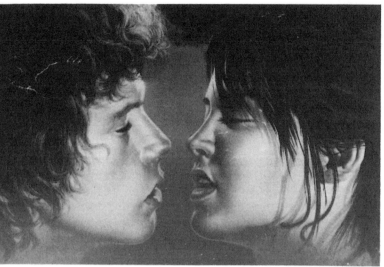

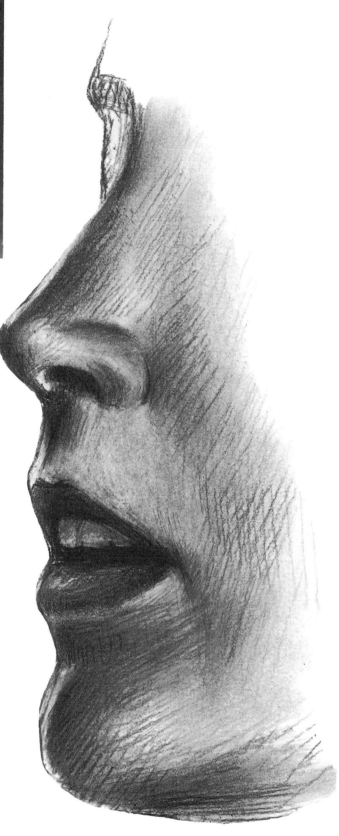

Romance seems to be the furthest thing from the mind of the young woman in this poster for a movie about adolescent love. Though the young man shows the proper readiness for a tender kiss, *her* face seems to be registering disgust. Kissing is normally an action that makes very few demands on the facial muscles. We close our eyes, open our mouths, and make contact. The problem here is that there are no less than three separate cues that her sneering muscles are active. It's safe to assume that sneering was not the effect intended.

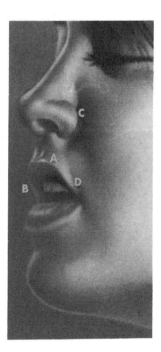

She appears disgusted because her upper lip shape (**A**) is too square—the middle straight section is too long and drops too sharply to the corner; the upper lip (**B**) appears drawn back into the face instead of sticking out *further* than the lower lip, as is normal; she has a "sneer pocket" (**C**) by the nose—a signature wrinkle of the action of the sneering muscle; it never appears on a relaxed face. The crease at (**D**) is another accident—no such crease could exist. By relying too heavily on photographs, illustrators may misinterpret or exaggerate certain details.

"Corrected" drawing of the mouth. To eliminate the sneer, the crease is removed from alongside the nose, and the upper lip is drawn with a much shorter middle portion, along with less steep outer corners. (**D**) is also vanquished, for good measure.

The difference between the two actions relates to the way the two muscles are attached. The fibers of the middle branch, fixed below the eye socket and traveling down to the nose, will affect only the cheek and nose. When they contract, they puff the cheek and lift the wings of the nose. The inner fibers—the nasal branch—attach much higher up the face. When they contract, they also activate a reflexive contraction of some of the muscles around the eye. With the extra muscle action, the contraction lifts the nose wings higher, puffs more cheek, and triggers the lowering of the eyebrows and squinting of the eyes.

Here is something that the two actions share in common: either will create the same signature wrinkle of the sneer, which is a sharp deepening of the upper nasolabial fold. This wrinkle is so distinctive that if it is depicted as being present, it can make the mouth seem to be sneering even if other clues are missing or ambiguous. It, and the shape of the upper lip, are the two key elements that are always present in the sneer.

Artists struggling to take the sneer out of a mouth (or, I suppose, those few who might be struggling to put one in), then, must beware of the hooked fold around the nose.

The Special Case of the Zygomatic Minor

The third branch of the levator labii group, zygomatic minor, is a special case. Its role in the face as a whole is poorly understood. It's one of the few muscles involved in emotional expression over which we seem to have no conscious control. For that reason I couldn't include a drawing of it in action, by itself. Its basic role in the face seems to be to contribute to the face of sadness; as such, it's sort of the flipside of the zygomatic major. It squares the upper lip *without* the sneering look, because the nose lift and cheek crease are missing.

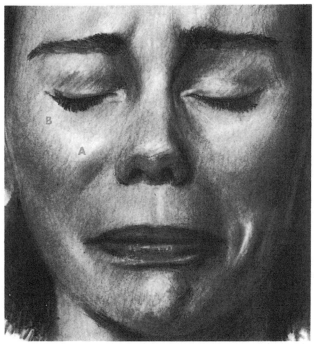

The action of the zygomatic minor is involuntary; it appears only when we're sad, not otherwise (the other two branches of the sneering muscle are under our conscious control). When it contracts, pulling from (**B**), it creates its own signature wrinkle, the little "floating crease" in the middle of the cheek (**A**). This crease marks the insertion of the muscle into the skin. The zygomatic minor also squares off the lip (which is also stretched by the risorius and pushed up by the mentalis here) and bunches up the cheek. But its overall effect is more subtle, and major elements of the sneer—the signature deep fold along the nose, the lifting up of the wings—are missing.

UPWARD PULLER II: THE SMILING MUSCLE

The smile comes after the sneer because both are accomplished by muscle pulls from above: but what a difference a few inches make! If the pull of the main branches of the sneering muscle is seen as coming from the north, the pull of the smile arrives from the northwest. Its muscular attachment is about two inches further to the side of the face. The tiny zygomatic minor is an even closer companion; along the cheekbone, perhaps half an inch separates the face of pain and pleasure.

The smile is accomplished by the contraction of just one muscle, the zygomatic major. In the final part of this book, the appearances of happiness and pleasure are discussed as they affect the entire face (and involve other muscles): in this section we just focus on what happens to the mouth and its immediate surroundings when the zygomatic major contracts. Obviously, the better you understand the nature of the muscle and its effects, the more convincingly you can draw a smile.

The Muscle Described

The zygomatic major is thicker than many of the other muscles of expression. It would be logical to assume that it is thickest on those of us who smile the most (as any muscle grows with repeated use), but I have never heard that particular argument proven. A broad smile moves a lot of face around, and the stout quality of the muscle is what is required even for just the occasional grin, smirk, or giggle.

It is important to fix in your mind the exact point of attachment of the zygomatic major on the cheekbone. It is actually attached on the side of the face, not on the front. From its cheekbone root, the zygomatic major travels diagonally downward to the outer corner of the mouth—its movable end. This diagonal path is the direction the smile follows as it widens.

The outer corner of the mouth is a popular location for muscle attachments. In the same spot, the downward puller (triangularis), the outward puller (risorius), and the upward puller (zygomatic major), all are inserted,

ZYGOMATIC MAJOR: THE SMILING MUSCLE

For such a common expression, the smile is surprisingly difficult to draw. There are two main difficulties: getting a feeling for the turning and stretching of the lips and pinning down the reshaping and creasing of the cheeks. A good starting place is the muscle, where it attaches, and how it pulls. Think sculpturally with the smile; the more volume, the better. Think tension—those lips are *stretched*.

The zygomatic major attaches on the side of the head, not the front. It's fixed to the zygomatic arch, almost halfway back to the ear (**A**). You can feel the spot with your finger when you smile. The thick muscle body (one of the strongest on the face) attaches to the mouth at the corner, right where the little end-of-the-mouth crease is located. It ties directly into the great circular muscle of the lips, the orbicularis oris (**B**).

just underneath the shallow dent that marks the end of the mouth.

For the zygomatic major, its corner attachment marks the last point at which it is near the surface. As it rises upward diagonally toward the cheekbone, it tunnels steadily deeper beneath the surface of the cheek. Halfway up the cheek—the area of the face with the most subsurface fat—the zygomatic major may be an inch or more from the outer skin. This is an extremely important point to grasp. The smile burrows *into* the face as much, if not more, than it goes *up*. The deep push on cheek forces a lot of the overlying skin and fat outward, more than in any other expression.

The upshot is that it's *work* to smile. More than one person has told me that after a particularly happy event—one woman mentioned her wedding—the zygomatic major ached for days! Not surprising when you look at what it has to do to give us that wonderful grin.

The Smile Described

A lot of things happen when we smile. In a broad smile, there isn't a single part of the lower face that isn't shifted around in some manner. The lips, and the surfaces immediately around them are stretched tight around the curves of the skull. The cheeks and the sides of the chin are mounded high, pushed up out of the way. Deep creases appear where surfaces collide, and dents cut through parts of the middle cheek.

Basically, there's a central portion of the smile, including the lips and chin, and there's an outer portion, including the cheeks. The center portion in a broad smile becomes as curved as any feature ever gets, by virtue of being pulled so firmly back toward the ears. The pull presses the lips, the skin right above, and the chin below hard up against sharp curves of teeth, upper jaw, and skeletal chin. The mouth goes from describing a lazy curve to describing a virtual hairpin turn.

The outer portion of the smile becomes a frame for the inner portion. As the inner portion widens and flattens against the skull, the outer portion piles up on itself and lifts further off the skull. It surrounds the inner portion on all sides, in the shape of a diamond, with the top at the nose and the bottom at the chin. Everywhere the inner and outer portions meet, there are either deep creases, or dramatic changes in plane, or both.

You can learn about these things best by feeling them, on your own face. We're so used to looking at smiles that we really don't notice them anymore. But using your fingers, you can get a much better sense of the surface changes as you go from the tight center part to the overhanging mound of the cheeks. Your finger can also sense the tension at the corner of the mouth, where all the force of the pull is concentrated, and the surface is pulled in very deep.

ZYGOMATIC MAJOR: THE SMILING MUSCLE

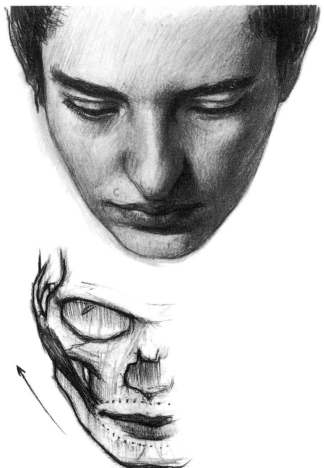

Seen from above, it's clear the smile is doing more than just turning up at the corners. The zygomatic major muscle is buried deep under the cheek (left). When it contracts, it pulls the lips into the face, directly back toward the ears. (**A**) is where mouth corner was. The smiling mouth corner is pulled as far back as the base of the nose, which widens (**B**); the upper lip is pulled tight against the face and follows more closely the curve of the skull beneath. The curve of the relaxed mouth is much softer by comparison (**C**). The cheeks bulge; face widens most at (**D**).

It may take more muscles to frown than to smile, but smiling is more work. When we smile, the zygomatic major attempts to slide the entire orbicularis oris (the muscle that includes and circles the lips) back toward the ear, underneath the cheeks. Where cheeks and orbicularis oris meet, a deep crease, the signature wrinkle of the smile, develops.

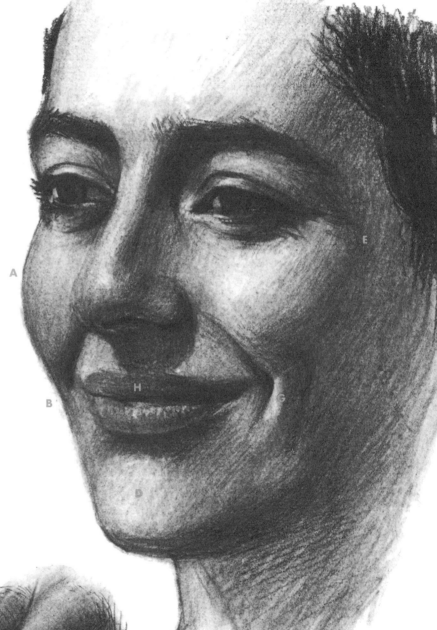

A. Cheeks widest just above level of base of nose.

B. Skin tightly stretched between cheek and chin. Line is concave; almost no concave lines appear in relaxed face.

C. Lips are pulled upward toward nose.

D. Chin appears longer and broader. Smile stretches skin over chin, smoothing it. Lower lip has lifted toward nose, exposing more chin.

E. Attachment of muscle.

F. Cheek piled highest off face here.

G. Dimples are located on side of face; usually, dimples are deeper on one side than the other.

H. LBL almost completely unkinked; compare with LBL of relaxed mouth.

When we smile, the lips are stretched against the teeth, whose shape shows through. This shape is similar to the block form (right)—flattened in the front and turned sharply to the side. Just as a rubber band stretched against that form loses any kinks or sags it may have had, the lips become more uniform in the smile. Compare the LBL in a relaxed face to the smile: the kinks are stretched out.

NEUTRAL MOUTH

SLIGHT SMILE

The first stage of a smile is the most elusive. We notice when the zygomatic major so much as twitches; in the drawing of a weak contraction (top left) it's contracting a bit more than the minimum. The corner of the mouth is the first thing to change, rising above its neutral point (**A**). The corner does not move by much before the cheeks swell and dimples appear; it doesn't change by much before the whole LBL begins to stretch. The broad smile of a strong contraction (below) is not so subtle. Changes start at the bottom of the cheeks (**B**); on some faces the deepening of the nasolabial fold would not be as deep in the early stage of a smile. Even in a slight smile (**C**), shallow wrinkles across the lower lip are smoothed. The cord along the side of a smile stretches down to the chin like a rope caught under the face. It often catches the light (**D**). The pull of the zygomatic is stronger on this side (**E**). Note how far past the rest of the lips the corner of the mouth has moved.

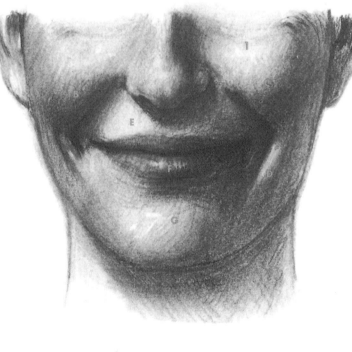

KEY ELEMENTS OF THE BROAD SMILE

A. The line between the lips has a taut look like a V with a very open angle.

B. The nasolabial fold intensifies and is pulled to the side. Just before it ends, it hooks downward, bracketing the mouth corner.

C. The cheek balls up. Steepest edges (watch for sharp shadow breaks) are here. The soft edge is next to the nose. The highlight is crisp on the upside of the cheek, showing the stretching of skin (**1**).

D. Angled cords hang from bottom of cheek mound. Deep inner edge may connect with nasolabial fold; dimple lies on the outside edge.

E. Upper lip becomes a simple, curved plane. Filtrum disappears.

F. Lips are thinned and smooth-looking. Sharp highlight on stretched lower lip. The mouth is now wider; the relaxed mouth is directly below middle of eye; smiling mouth is directly below outer edge of iris.

G. Chin seems larger because of moving up of lips. Under-the-lip crease disappears.

DOWNWARD PULLER I: TRIANGULARIS

The *triangularis*, when contracted, creates a mouth that is an inverted smile. Everyone knows that if you take the curve of the mouth in the "have a nice day" face and turn it upside down, you get a frown, and the triangularis is one of the muscles responsible for creating that change. Charles Darwin called it the "muscle of grief," but that's giving it too much credit; it's really the triangularis plus the *mentalis* that creates the pout, and the mentalis often does it on its own.

The triangularis, unlike the mouth muscles described so far, seems to act *only* on the closed mouth. And when it does contract, it's almost always in the company of the mentalis.

The triangularis (also called the mouth angle depressor) has its fixed end embedded in the bone of the chin, somewhat to the side of the center. From there, it rises diagonally to the corner of the mouth, where it attaches in virtually the same place as the zygomatic major, just beyond the end of the LBL. When it contracts, it draws the mouth corner and the LBL sharply downward, often extending the LBL past the lips.

The triangularis was one of the muscles I had in mind when I mentioned the fact that some people *look* like they're scowling even when they're not. In older faces, the creases that extend the mouth corner can look a lot like the way the mouth looks when triangularis stretches it. The differences are very subtle and turn on distinguishing between a crease (old person) and a gap (stretched LBL). From life, it's relatively easy; from photos, it can take work. Look also for the bulges that show that the muscle is pulling, not present in the relaxed older face.

The triangularis rarely pulls the mouth corner down by itself. It normally appears in the company of the mentalis, as part of the pout or the facial shrug. Because it attaches to the mouth corner at the same point as the zygomatic major, it's also the muscle we use to keep the corner down when we're trying *not* to smile. The triangularis fits around the chin like chinstraps. Its fixed end is sewn into the lower edge of the jaw on either side of the chin. Its free end is attached to the mouth-circling muscle (orbicularis oris) at the same point (**A**) where the smiling muscle, zygomatic major (**B**), attaches.

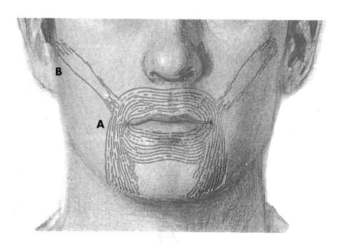

The triangularis is one of the two muscles that makes the mouth frown—the other is mentalis.

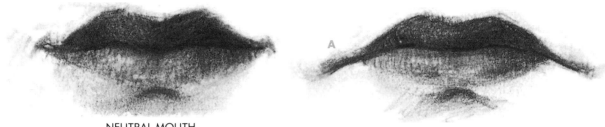

NEUTRAL MOUTH

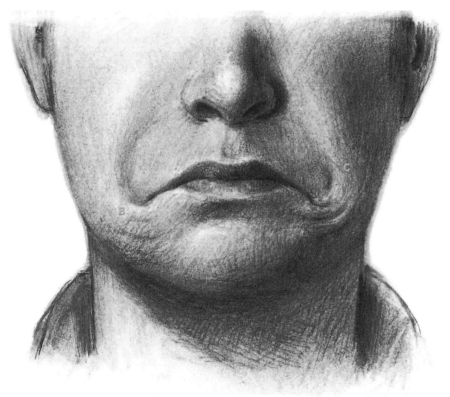

LBL has nearly doubled in length, extending well past the end of the red portion, but the lips are only slightly changed, stretching a bit at the end. LBL has pivoted down from (**A**). Row of curved bulges, like waves approaching a shoreline, appear below mouth corner (**B**). These are the signature wrinkles of the triangularis. The lowermost portion of the nasolabial fold deepens. The skin outside the fold is bulged out and pulled down, looking like a broad, rounded hook on the rim of the face (**C**).

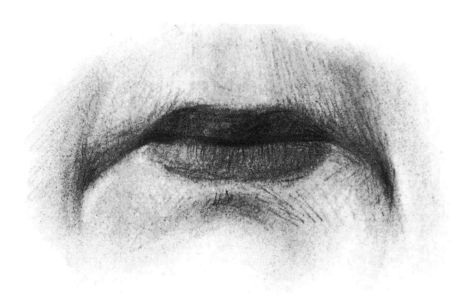

Is this mouth active or relaxed? Creases are very similar to (**B**), but corner ends at (**D**) and is not pulled down. Key is difference between crease and gap (LBL).

DOWNWARD PULLER II: MENTALIS

The mentalis is the other half of the pout. It has a much larger role to play in the face than triangularis. It's another one of those muscles, like corrugator or orbicularis oris, that we use in our everyday expressive gestures. It's part of a great number of expressions, particularly those where there is some effort at restraint involved. This includes partly restrained anger and sadness and the stifled smile.

There's certainly no muscle on the face you can demonstrate to yourself easier: "shrug" the chin, pushing up the *center* of your lips, and you've just performed the basic action of mentalis. There's also no muscle on the face with a more distinctive signature wrinkle—look at what the shrug does to the chin. A little raised island with puckered skin is the unmistakable mark that the mentalis is active—nothing

any other muscle does is at all similar. Incidentally, the facial shrug you've just performed is one of the most frequent ways we use the mentalis, a sort of lower-face version of shrugging the shoulders.

Action
Though I've placed the mentalis in the "downward puller" category, it is a peculiar sort of downward puller. It creates the downcurved mouth *indirectly*, by pushing the center of the lips *up*. The lips are pushed up because the skin over the chin, which is where the mentalis inserts, is on its way toward the base of the teeth, which is where the muscle attaches. When the mentalis contracts, the ball of the chin tries to move up and under the base of the lower lip.

If the push is strong enough, then the lower lip thrusts further out than the upper in a pout. The feeling of the lip being the top of a platform is thus

greatly intensified, with a sharper shadow underneath and more sense of overhang. Along with the changes in the chin, this is a particular detail that helps signal that the mentalis has acted. In fact, it can be more important, as it is possible to inadvertently suggest a pout when you use shadows under the lip that are too sharply defined.

The teamwork of mentalis and triangularis is what we see most often on the face. The action of the two muscles is perfectly complementary. Mentalis is the specialist in pushing the lips up in the middle, and triangularis in pulling the lips down at their ends. The muscles' joint action combines these two motions to push the mouth further up in the middle and further down at the ends, while preserving the signature wrinkles of the individual muscles—namely, the raised ball on the chin and curved wrinkling underneath the mouth corner.

MENTALIS: THE POUTING MUSCLE

The mentalis lifts the skin over the chin. This direct action is not expressive, but the indirect action, the pushing together of the lips, is. We employ the mentalis to squash and pout our lips whenever we're sad and often when we're nervous or angry. It plays a role in the stifled smile and the facial shrug. Here its movement is isolated. In expression, it always acts in concert with other muscles. The signature wrinkle (the puckered chin) is always present, no matter what the expression. The mentalis on the skull does not attach to the mouth. It originates (**A**) in the depression below the teeth. From there the fibers move down and toward the surface, inserting themselves into the skin on the ball of the chin (**B**). In the pout, the pockmarks on the surface are actually the places where the fibers are attaching to, and pulling up, the skin.

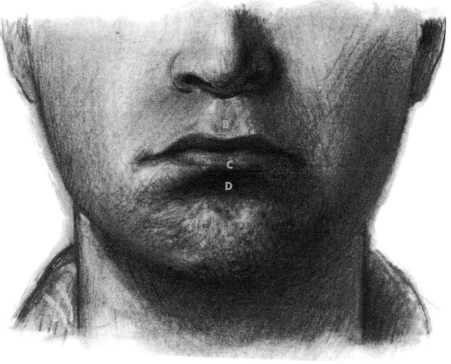

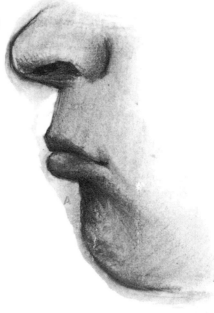

In the basic action of the mentalis, the skin on the chin, pulled toward the base of the teeth, is flattened. The lips lift and project out like a shelf (**A**). The strongest lift is in the center, but the entire lip is thinned (**B**). LBL is straightened; a sharp, bright edge appears on lower lip (**C**). Corners appear pulled down because the center is lifted. A sharp shadow appears under lips—the hollow is more drastic than on a relaxed mouth (**D**). Raised, shield-shaped "island," the signature wrinkle, always appears on the chin, with pockmarked texture (**E**).

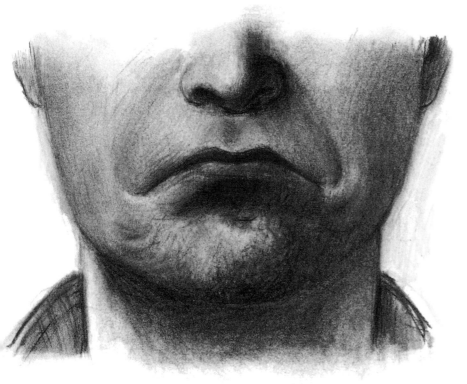

THE FACIAL SHRUG

Triangularis and Mentalis contracting together result in the facial shrug—the facial equivalent to a shoulder shrug. In its more subtle versions it's called the pout. The flattened lips and puckered-up chin of mentalis are added to the down corners and hook-like furrows of triangularis. Lower lip dominates upper and sticks out further and appears larger.

THE LIP COMPRESSOR

No muscle on the face gets more of a workout than the muscle of the lips, orbicularis oris. The other muscles we've talked about pull on the mouth at its edges; orbicularis oris is what's inside the lips themselves. When we talk, it finetunes the lip edges to form the sounds of speech. It's made up of several specialized layers that can shape the mouth just so. It's also one of the principal muscles we use when we eat. But our chief reason for including it here is the way it acts to compress the lips in expressions such as anger and grief.

Most of the actions of the orbicularis oris act to tighten the lips in some fashion. In this, it's similar to the circular muscle of the eye, orbicularis oculi, which creates a squint when contracted. In the case of the mouth, the equivalent of the squint is the tight-lipped look, where the lips themselves are thinned to nearly a single line.

The orbicularis oris runs, just under the skin, in a great oval around the mouth. It's precisely underneath where a juice glass rests when we drink. The muscle stretches from the base of the nose, to the corners of the mouth, to the little crease on the chin under the lower lip. With it's own thickness added to that of the skull beneath, it can at times be sensed through the skin, in form something like the bell of a trumpet, with its small end forward, centered on the mouth.

The attachments of orbicularis oris to the head are unlike those of any other muscle. It's not so much attached as *suspended*. You can find its attachment on your own face if you pinch the skin of your cheek just beyond the mouth corner, with one finger inside and one outside. The thickened spot you feel is a sort of muscular knot, where a half dozen or so muscles converge on the outer end of the orbicularis oris. By braiding together with the mouth muscle, they provide a flexible anchorage for it to pull against. The knot also helps define the appearance of the corner. In the closed mouth we see the knot as a crescent-shaped mound just beyond the end of the line between the lips. The mound adds a very subtle extra curve on the far outline in three-quarter views.

ORBICULARIS ORIS: THE LIP TIGHTENER

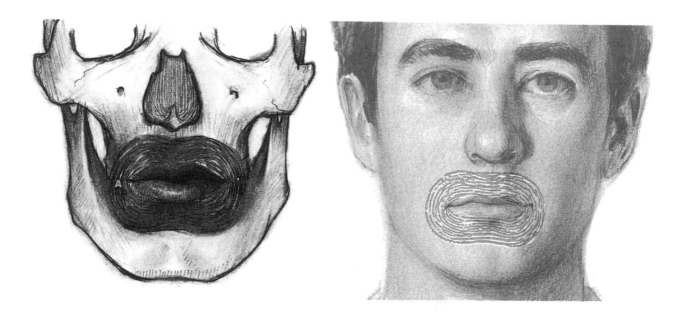

Attachments of orbicularis oris. The orbicularis oris is the most complex muscle on the face. Its fibers circle the mouth and penetrate the lips in overlapping layers. It has no fixed bony origin but is held in place by the muscles of the mouth corners (**A**). With such a free arrangement, it can take an enormous variety of shapes.

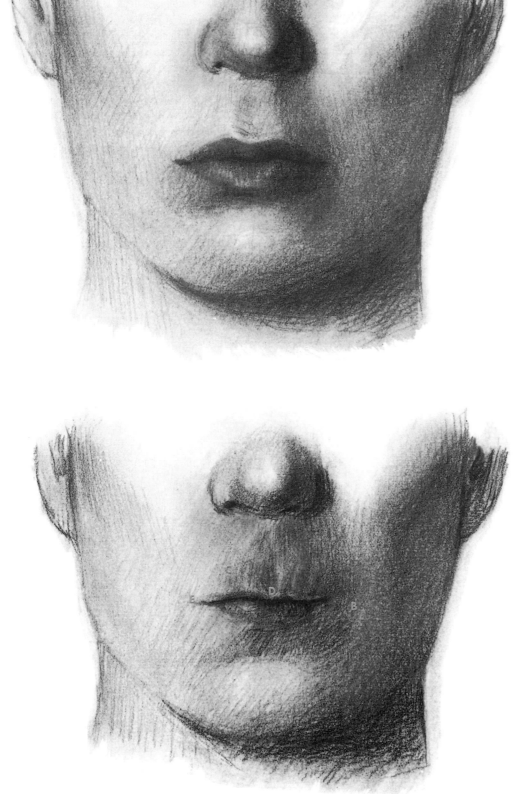

The lips themselves are part of a muscle the orbicularis oris. Like the muscle that circles the eye, the orbicularis oris tightens in on itself when it contracts, narrowing and compressing the lips. Pursed lips appear in suppressed anger, sadness, and simple nervousness. Open, taut lips appear in loud speaking, singing, and angry shouting. The tight-lipped look involves the disappearance of much of the red margin. When both lips tighten with the mouth closed, there is also a bulging-out around the lips, as though we were trying to hold in a mouthful of air.

A. Relaxed mouth.

B. Entire muscle tensed. Lips curl under themselves and tense. Tension straightens LBL slightly; kinks remain.

C. Vertical across-the-pull wrinkles on upper lip. Filtrum disappears.

D. Thicker parts of lip— entire lower lip, middle of upper—still show. With thinner lips, nothing would show.

E. Length of lips doesn't change, only width.

107

Action

When we tense and press our lips in sadness or anger, the lips narrow, but the mouth does not shorten. You can see why if you press your lips together and at the same time probe your cheek with a finger. On the side of your face, you'll feel muscles deep underneath the surface tightening as you press in on your lips. The corner of the mouth is being fixed in place by some of the muscles attaching to it, and the result is it stays put while the rest of the mouth shrinks.

The lips narrow by curling in on themselves, not so much disappearing into the mouth as *condensing*, like a towel being wrung out. The result is two skinny, tightly curved edges, with only a trace of red lip still showing. If you perform the lip press and trace the surface from the base of your nose to the LBL with your finger, you'll feel it curve out and then in again: the *reverse* of its relaxed curve. There's a feeling of fullness to the surface, as though one

were holding a mouthful of air or water. This same description holds true for the surface below the lips, sometimes even more so. This is an important part of the look of pressed lips and helps distinguish an active, tensed mouth from one that merely happens to have thin lips.

Shading the mouth's surroundings so that they look properly curved is the key to capturing the action of the orbicularis oris. Note also the relative brightness of the lower lip compared to the upper lip; as in many of our facial expressions, when the lips are tightened, the upper edge of the lower lip becomes more of a shelf, catching the light from above. The light on the lips changes very sharply from the shadow on the upper lip to the bridge edge of the lower lip.

Very often when the orbicularis oris tightens to compress the mouth, it's joined by the action of triangularis and mentalis. The three muscles complement each other's actions perfectly,

locking the mouth into a vise of muscular pressure. I've dubbed this combination the *three-muscle press*, and it's a key part of the look of suppression in the stifled smile, the stifled sob, and suppressed anger.

Other Functions

There are times when the mouth is open and the orbicularis oris contracts. When that occurs, the effect of its contraction is not to close the mouth, or to press the lips together, but rather to thin the lips by curling them inward and tightening them. This action straightens the inner margin or the lips, particularly the upper lip; it's an important part of the look of the mouth in angry shouting.

The orbicularis oris also has a specialized branch (many anatomists treat it as a separate muscle) that pulls the mouth corners toward each other, as in saying the word *flirt* or *fool*. This *O* shaped mouth is often a part of the expression of surprise.

ORBICULARIS ORIS: THE LIP TIGHTENER

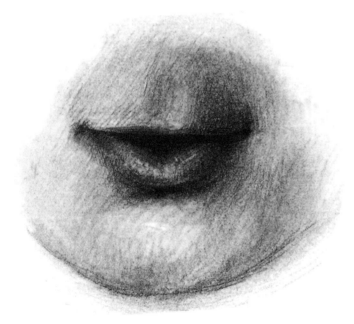

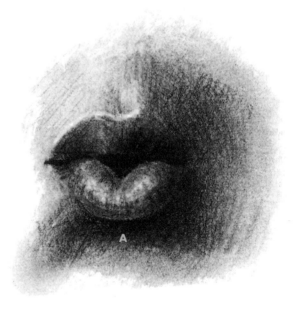

The orbicularis oris may also contract with the mouth open. Either lip may tighten without the other, as in the speaking mouth (**A**), where only the upper lip is tensed.

Another action of orbicularis oris is pursing the lips. This is the work of specialized fibers called *incisivis* that pull the mouth corners together, shortening the lips and pushing them outward. The lips pushed out from the face create a sharp shadow below (**A**).

Attachments of incisivis. The incisivis originates on jawbones above and below the lip (**A**) and attaches to mouth corners (**B**). Basic action is simple: All sections act together, pulling mouth corners toward each other.

There is a muscular knot at the mouth corner thick enough to see and to feel. You can see it in three-quarter views, where it always makes a subtle extra curve at the level of the mouth (**C**). The knot is the group attachment of zygomatic major (**D**), triangularis (**E**), risorius (**F**), and several other muscles to the orbicularis oris, holding it in place. On some faces, the entire oval form of orbicularis can be sensed underneath the surface, like a section of a cone (**G**).

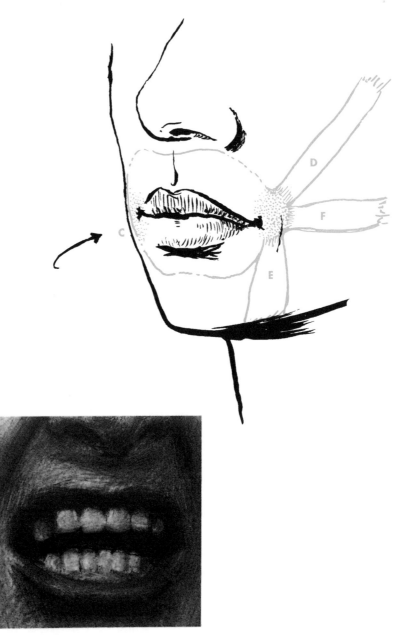

In the shouting mouth, both lips are tight and thin.

The Open Mouth

Most expressions are intensified when the mouth is opened—the mouth is usually opened to add something to a response. The smile, when vocalization is added, becomes the laugh; the frightened mouth opens to emit a scream; the sad mouth utters a cry. Even the relaxed open mouth, depending on the look of the eye and brow, may suggest the face of astonishment or passion. A stroll through the department of primitive art in a large museum reveals that much of the work is in agreement with this principle—in masks, sculptures, and carvings from around the world, few mouths are closed. These are faces full of energy and often strong emotion.

The levator labii superioris (the sneering muscle), the zygomatic major (the smiling muscle), and the risorius/platysma (the lip stretcher), are the key muscles in the creation of open-mouthed expressions. The *depressor labii inferioris*, which pulls the lower lip downward, also plays a minor role.

NEUTRAL POSITIONS

Opportunities for inadvertently replacing one expression with another in the open mouth are numerous, as with the closed mouth. An attractive open mouth can grade into a sneering mouth with very little difficulty; a slight extra bend in the corner can turn a laugh into a scream.

The point of reference for our description of the open mouth is the way it looks when it is *merely* open, with none of the surrounding muscles at work. We'll thus have a basis for comparison with open mouths that are *not* relaxed.

The lips part slightly when we breathe. When people are engaged in physical activity, their lips part more often as their breathing rate rises. The average person, walking, opens the mouth fairly often: the average jogger *keeps* the mouth open. The association of slightly parted lips with sexual activity (which can increase breathing rates quite a lot) is one that has been exploited by advertisers for years.

The Jaw Drops

The dropping of the lower jaw pulls the lips apart. As the lower jaw drops, space appears between the teeth. The corner where the two lips meet is pulled downward slightly and inward. To reach this new joining point, the upper and lower lip alter in shape.

The upper lip, pressed against the fixed upper jaw, changes less than the lower. The moving lower lip has to stretch and bend more to reach the mouth corner. The lip, composed of two sections, tends to bend in the center and curve gently upward toward the two corners, making a V-shape. It also appears thicker: the lifting of the upper lip expose its wide upper surface. The upper lip bends where its three sections meet; the outer wings seem to hinge off the center, making a square-arch shape. The more the mouth opens, the more sharply the wings swing down.

Oval-shaped Opening

The net result is an oval-shaped opening, with just the tips of the teeth showing. This contrasts sharply with the way the mouth is shaped in laughing, crying, or angry shouting, when the inner margin is much more squared-off and angular, and whole rows of teeth, either upper or lower, are exposed. Large areas of teeth showing always indicate an expression in progress.

The dropping of the jaw also affects the shape of the whole lower half of the face. It gets longer, of course, and the outline has a stretched and often hollowed-out look to it, as the skin spans between its points of support on the cheekbone and the chin. The chin has not only moved downward, but backward as well—this is clear from a side view. From in front, the face appears narrower.

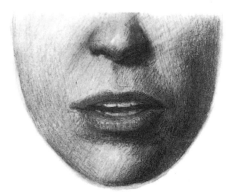 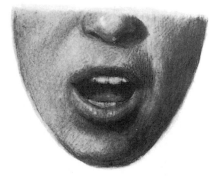 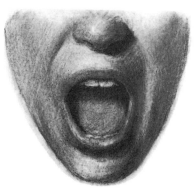

Carefully observing the way the mouth looks when relaxed and open will help us see more clearly the way its shape changes when we're happy, angry, or sad. The oval shape of the opening is the key. In most expressions it squares off dramatically; in none (except surprise) is it oval. Note that as mouth drops, lower lip stretches more than upper, as it follows dropping teeth.

OPEN

Think of the upper lip as divided in thirds. The center third, with dip and peaks, is held in place by teeth. The outer legs "hinge" off the center and angle down to mouth corners. The lower lip appears thicker because the wide upper surface (**A**), normally covered by the upper lip, is exposed. The top *and* front of the lip are seen.

INNER OUTLINE

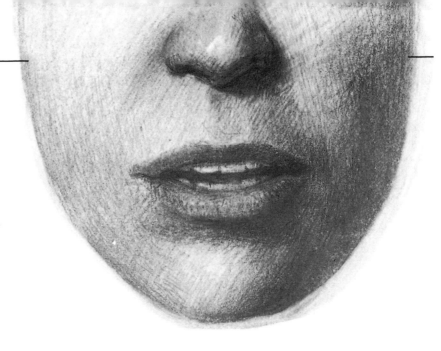

MORE OPEN

There is a sharp break where the inner edges of the two lips meet (**B**). The lower lip tends to bend right in the middle, forming a V or wishbone shape; the legs curve up to corners and are less angular than the upper lip. When the open mouth is relaxed, only tips of the teeth show and only in the center of the mouth.

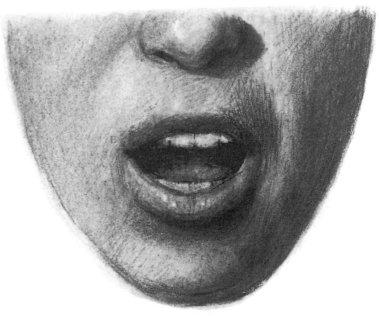

MOST OPEN

This pose suggests singing or yawning. With the jaw opened as much as possible, the cone-like form of the mouth setting is most apparent through stretched skin (**C**). Creases bracket the mouth on either side. Narrowing of the face is made even stronger by the stretching of the skin from cheekbone to chin (**D**). Often the outline here can be concave, with a hollowed-out look.

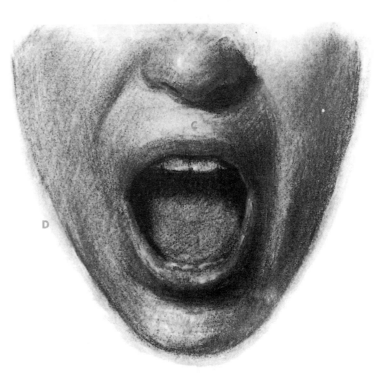

111

If the pull of the sneering muscle, levator labii superioris, is strong enough, the upper lip is lifted up from the lower, exposing the front teeth. The only other expression that fully exposes the front teeth is the smile, and the two can hardly be confused. What can be confused with the sneer, however, is the arched upper lip.

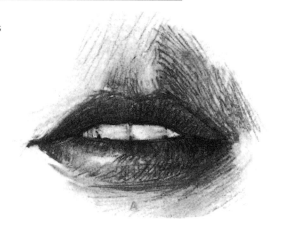

Arched upper lip vs. the sneer. People with arched upper lips form an important minority group, like left-handers. The arch may be fairly high (**A**) or lower, with only a tiny gap between the lips. The center part is never more than one-third the length of the upper lip, and side angles are not steep. The lower lip line is flat. The sneer occurs when the center is elongated and side angles are steep (**B**). The lower lip is unaffected.

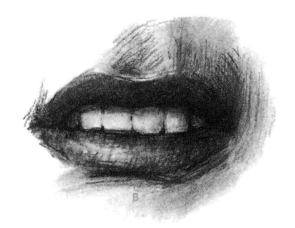

This (**C**) is a sneer created by the middle branch of the sneering muscle. Expressions are often asymmetrical; here pull is stronger on the right. Landmarks: deepened nasolabial fold, especially by nose (**D**); upper lip line with steep outer legs; little curl above lip center (**E**). A sneer may be so asymmetrical that one-half of the lip is totally relaxed, as in (**F**).

THE SNEER: LEVATOR LABII SUPERIORIS

The open-mouthed sneer is actually part of many expressions. Besides its obvious role in the face of disgust, levator labii superioris helps square off the upper lip in the expression of anger and sadness. In the angry mouth, for example, the upper teeth are fully exposed, there's a deep fold alongside the nose, and the upper lip has a square-arch shape—sure signs the sneering muscle is active.

The upper teeth are exposed in the open-mouthed sneer. An extra pull separates the lips, but otherwise acts only on the upper lip, leaving the lower lip relaxed. An entire row of teeth are exposed, as opposed to just tips in the relaxed mouth. In fact, any expression where the full row of upper teeth are showing can only involve one of two muscles: either the sneering muscle or the smiling muscle, zygomatic major. Under most circumstances, the two different actions are unmistakable.

THE SMILE: ZYGOMATIC MAJOR

One can never say too much about the smile. The open-mouthed smile is perhaps the first expression most people attempt to draw. Rendering all those curved surfaces and edges so that they look right takes a fair amount of practice. Having a feeling for the perspective of curves helps, too, when it comes to rendering the smile from various angles.

When we smile with our mouth open, we subject the lower face to changes very similar to those seen with a closed-mouth smile. The muscular action involved, the contraction of the zygomatic major, is exactly the same. Why do we smile sometimes with teeth showing and sometimes without? Perhaps the closed-mouth smile is caused by a very slight contraction of the lip-tightener, orbicularis oris, and its relaxation allows the smile to open.

Of course, the wider the smile, the more likely the mouth is to open. And if laughter is involved, the jaw drops and space appears between the teeth. As the jaw drops in laughter, the main change in the smile is an increasingly vertical direction of the upward leg of the lower lip. Observe this on yourself and notice how stable the shapes are in all the other portions of the lips.

Drawing the Lips

The inner rim of the lips is the key to drawing the open-mouthed smile. In fact, the obvious way to begin to draw the smile is to start with the inner outline, and work outward. Keep in mind as you draw that the edge of the smile is curving sharply around the teeth and being drawn back into the face. The sense of elasticity and stretching, and of turning planes, gives a solid feeling to the smile.

From the front view, the inner edge of the smile is like the bow used in archery, with the upper lip the bowstring, the lower lip the bow. The upper lip tends to be as straight as it is because the muscular pull is at its level on the face. The lower lip, being farther from the direction of the pull, stretches outward and upward. All this angularity contrasts sharply with the oval form of the relaxed mouth.

The smiling upper lip itself becomes a simple shape: two parallel lines, tapering at either end. It's like a piece of red tape stretching around the curve of the teeth. It loses any wrinkles or inner plane turnings it may have had in the relaxed mouth.

The Teeth

The way the teeth show is important. A host of negative expressions—fear, anger, sadness—expose the lower teeth. A smile where we see lots of upper *and* lower teeth may well be a bit on the forced side. Be careful to not overdo the lines between the teeth. They're not nearly as dark as they look, and are best merely hinted at, not drawn in full.

The Smile in Its Surroundings

Both the laugh and the smile are stretched tightly around the barrellike form of the middle face, and both are framed by the nasolabial fold above and the rope-like "chinstrap" below. The net result is that the smile looks as if it were recessed into a thick, angled frame.

This sense of the smile turning within a frame can be expressed by attention to shadows. In fact, the shadow pattern of a smile is so recognizable it can be expressed with just simple black-and-white shapes, defining what faces up and what faces down.

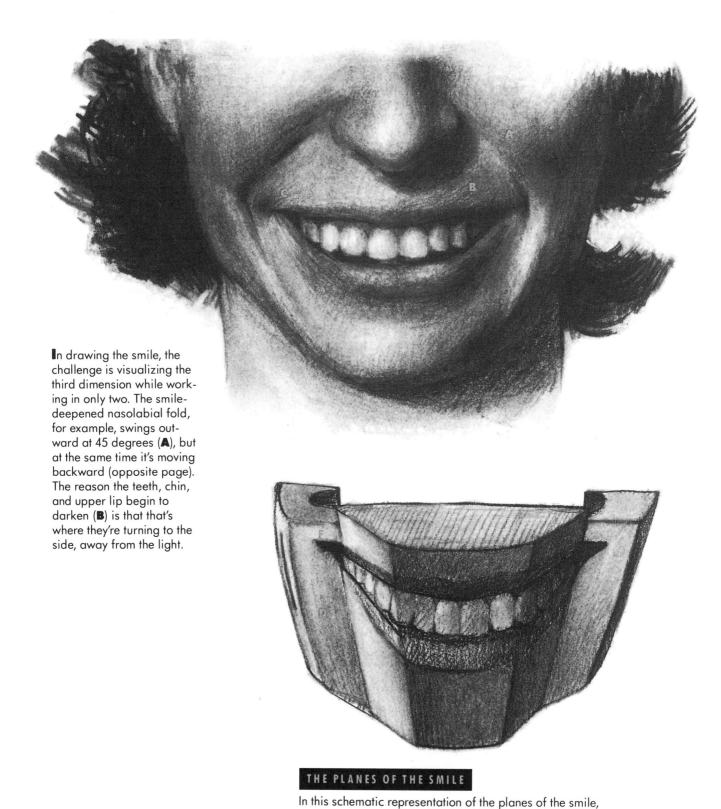

In drawing the smile, the challenge is visualizing the third dimension while working in only two. The smile-deepened nasolabial fold, for example, swings outward at 45 degrees (**A**), but at the same time it's moving backward (opposite page). The reason the teeth, chin, and upper lip begin to darken (**B**) is that that's where they're turning to the side, away from the light.

THE PLANES OF THE SMILE

In this schematic representation of the planes of the smile, the front portion of the smile is relatively flat; the sides angle sharply backward. The "cords" (**D**) that frame the smile can be seen as continuing the front plane of the face, while the dimple (**E**) falls around the corner, on the side of the face. Notch is at (**F**).

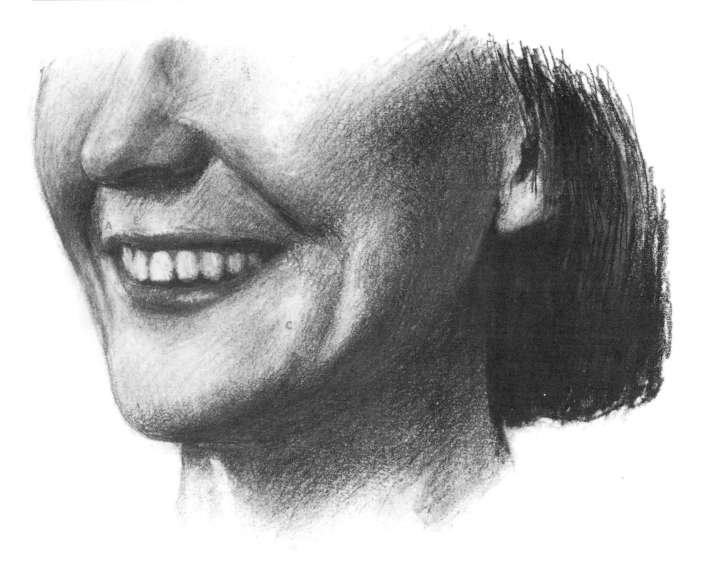

In the open smile, the lips always point in the general direction of the lower part of the ear. A notch extends beyond where the teeth end (**A**); it does *not* follow the curve of the teeth. The lips turn to the side directly below the end of the base of the nose (**B**). One deep, angled crease above the mouth often turns into two shallower creases below (**C**). The smile has a notch in the corner, short, narrow, and bending away from the rest of the lip. It can either angle up or go straight across. It's always in deep shadow and is often crossed at the end by a deep, almost vertical fold, like the bar crossing a *t* (**D**). (**E**) marks the turning on the far side, where teeth and lips are sharply foreshortened.

When the zygomatic major contracts, the oval of the relaxed mouth is stretched into a more angular shape. The smile is the result of the pull of the muscle working against the resistance of the teeth. The teeth keep the smile flat in the middle (**A**); (**B**) lines mark where lips are pulled free of teeth and turn to point back toward the ears, in the direction of the pull. The upper lip is always straighter—the pull is nearly at its height. The lower lip has farther to go, so it angles more. Note difference in the outer legs (**C**).

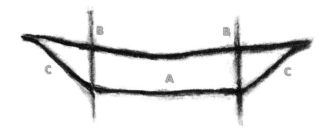

FORMS OF THE UPPER LIP

The upper lip in the smile is basically a simple shape—flat and curved like a piece of tape, tapering at each end. The center part still has its Cupid's bow, stretched wide but not entirely lost. The outer legs move off the teeth and change direction, curving around to the side. Look for subtle break in outline, change in tone.

FORMS OF THE LOWER LIP

The lower lip is much less uniform. The thick, rounded center section contrasts with the thin, angled outer legs. The center part looks thicker because the top surface is exposed. The center can be thought of as two egg forms, side by side, attached to thin handles. The outer legs break sharply with the center directly below a similar break in the upper lip. The upper edge is sharp and often catches bright lights, contrasting with the deep shadow above it.

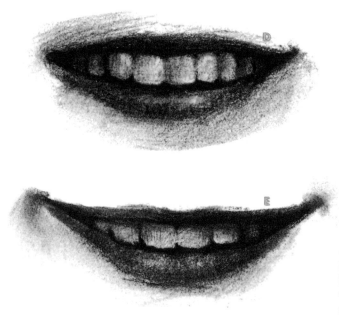

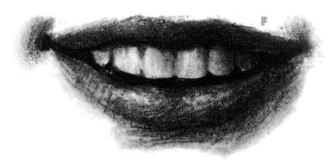

Three types of upper lip line in the smile: (**D**) and (**E**) are nearly straight (**D** curves slightly upward and **E** slightly downward); (**F**) is strongly bowed upward—all have a flat middle section; the variation is in the curve of the outer legs. Remember that perspective will change the apparent direction of these curves.

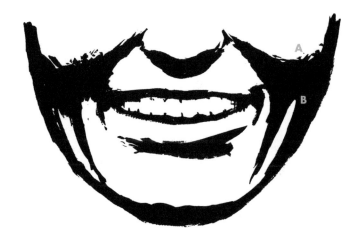

The open-mouthed smile expressed as a pattern of light and dark, the light seen as falling from above. The deepest shadows are planes that undercut; deep shadows also notch at lip corner and under top edge of upper lip. (**A**) shows the undercut of cheek, where the nasolabial fold is deepest. (**B**) shows notch and rope-like mound alongside: (**C**) is a cartoon version of the same thing.

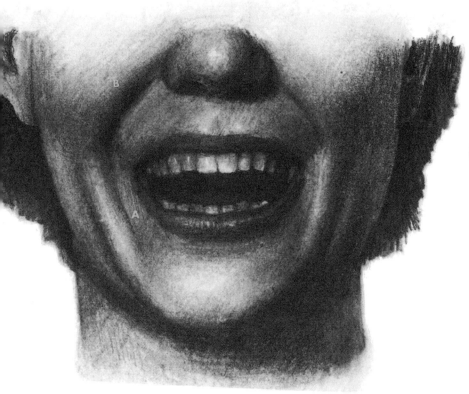

This drawing isolates the frame that frames the laugh. The sense is of two ropes, starting where the nasolabial fold ends and "melting" into the chin. The dimple marks the outside of the frame. The "rope" is more distinct in the laugh. An extra line forms (**C**) as the chin folds against neck.

THE LAUGH

A laugh is a smile with space between the teeth. The one thing about the mouth that is different is the outer legs of the lower lip—these angle upward much more steeply (**A**), as does the nasolabial fold (**B**). The sharp turn in the upper lip is clear in this laugh. Note that the full row of teeth and tips of lower teeth are exposed; a distressed mouth will show a full row of lower teeth.

THE STRETCHED LOWER LIP: RISORIUS (AND PLATYSMA)

You may see people on the street corrugating their corrugators, flexing their frontalis, or even trying out a little one-sided sneering; but don't look for any demonstrations of the *risorius*; that is, unless you're living in a combat zone. The risorius, the muscle of the stretched lower lip, is not only a muscle of the distressed face, it's the only one that appears *only* in extreme distress, and not otherwise. We don't see it in the face of someone who's merely sad for example, but if they get even sadder and begin to cry, that's when the risorius will appear. Just being afraid or angry isn't enough, but we have to be scared out of our wits, or angry enough to be dangerous. It's sort of the ambulance chaser of the facial musculature, waiting for something cataclysmic to occur before it stirs into action.

At one time, risorius was thought to be a muscle of pleasurable expressions. Even now there is no firm agreement among anatomists on the role of the risorius; some say that other fibers, parallel and slightly deeper, do most of the job of stretching the lower lip, and the risorius is a minor player at best. Others say that the risorius is the main agent, and the deeper muscle, the *platysma*, the neck tenser, is the sidekick. Since this is a matter for the anatomists to sort out, we'll compromise, and say that the *risorius/platysma* does the job.

Attachments and Actions

The risorius is quite simple in its construction. It attaches to the muscular knot at the mouth corner, along with the triangularis and zygomatic major. Each of these muscles acts on the corner in a different way: triangularis pulls it down and out, zygomatic major up and back. The risorius pulls the mouth corner toward its own origin, a layer of connective fiber overlaying the back of the jaw.

The platysma, however, is as much a muscle of the neck as of the face. Think

of it as a sort of an unrolled turtleneck, a broad, thin sheath rising up from the collarbones and upper chest and attaching all along the lower part of the face. Actually, it's only the *front* half of the turtleneck. Platysma covers the front half of the neck and shoulders, then stops abruptly before reaching the back. The part we're interested in comes up from the side of the neck and runs underneath the risorius to attach to the mouth corner.

You can see how closely lower-lip stretching and neck tensing are linked

Roman mask of tragedy. Since ancient times the square mouth shape created by risorius/platysma has appeared in art as the personification of horror.

by trying it on yourself. As soon as you begin to stretch your lower lip sideways, you can feel a corresponding tension in the neck; if the action is strong enough, you'll see thin vertical pillars rise up from the surface of the neck folded by the action of platysma.

Effects on the Lip and Its Surroundings

When the lip stretcher contracts, the lower lip is the one most strongly affected. In the smile, the upper lip is stretched straight and the lower lip bends; with the lip stretcher, the *lower*

lip is stretched straight and taut, and the upper lip bends. The sideways pull tends to shove the lower lip back into the face, pressing it up against the teeth and flattening its subtle curves into a single ribbon. The entire lower lip becomes uniform—a straight line above, a nearly parallel straight margin below.

The signature wrinkle of the risorius/platysma is a bracketlike fold that appears under the mouth, starting at either mouth corner. In shape it's like an extremely elongated, square *U*, depressed into the face. It's deepest where it begins at the mouth corner, creating a crease that angles downward. It appears when the action is strong.

A strong action of the lip stretcher, as occurs in crying, will also bunch up the face to either side of the mouth. Two wide, ropelike mounds, similar to those that appear in laughing (but less well defined), frame the mouth and seem to hook underneath the chin.

The Square Mouth

In all the open mouth expressions, the way the teeth show tells you a lot about the nature of the face. The risorius exposes the *lower* row of teeth, not the upper, and these are seen all the way across the mouth, not just in the center. When all the lower teeth are showing, it's a bad sign. The upper teeth, however, remain hidden even if the mouth is open wide. In the expression of anger, where the risorius is active, the upper teeth *are* seen because the upper lip has been lifted by the sneering muscle.

The net result of the actions of the risorius/platysma is to produce the "square mouth" shape that is a crucial component of the faces of crying, fear, and anger. Anatomists have speculated that the lip stretching action is related to the preparation of the mouth for screaming, and that our ancestors long ago found the shape an efficient one to produce a piercing, attention-getting sound.

The risorius/platysma is a muscle of extreme circumstances. The act of stretching the lower lip—creating the "square mouth"—is not one we do casually or conversationally, like lowering the brows. When the lower lip stretches, the neck tenses. This connection has prompted anatomists to consider the link between the risorius and the neck-tenser, platysma. Their respective roles are still uncertain, but one action definitely calls forth the other.

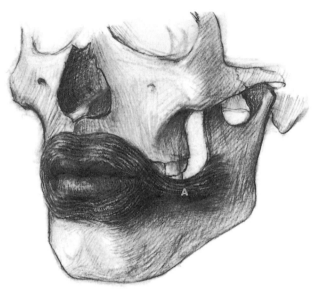

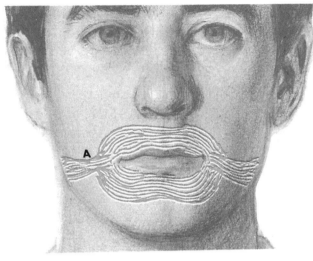

The risorius (**A**) inserts into the muscular knot of the corner of the mouth at the same location as zygomatic major and triangularis. It originates on a connective layer over the upright leg of the jaw. When it contracts, it pulls the mouth corner straight backward.

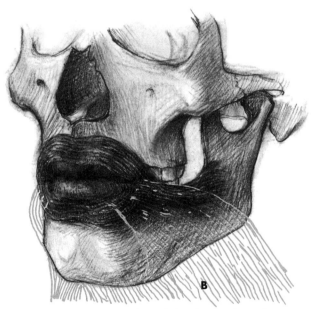

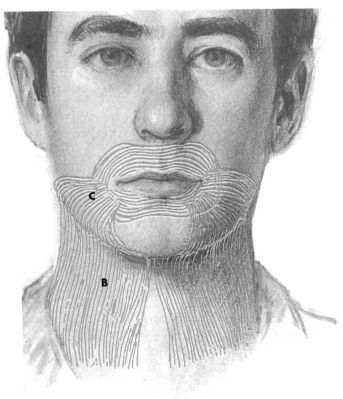

The platysma (**B**) is a thin shroud that hangs down from the lower face and covers the front of the neck. It may extend down past the collarbones onto the chest. The fibers of its side portion (**C**) run parallel and beneath those of the risorius; it too attaches to the mouth corner. Besides pulling the mouth corner straight back, it tenses the skin of the neck, raising thin, vertical wrinkles.

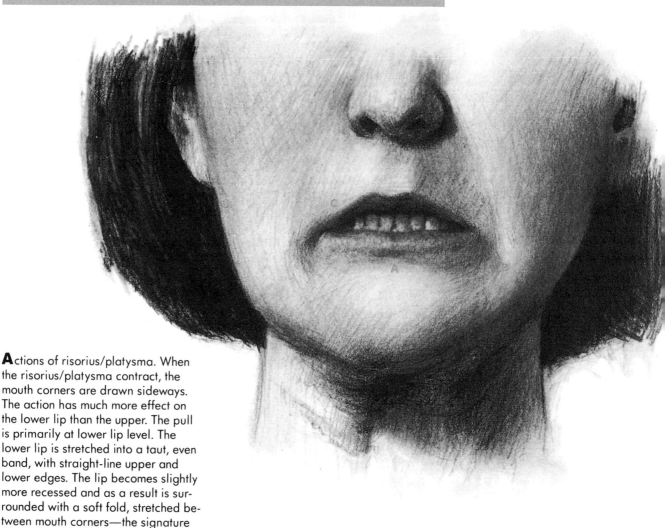

Actions of risorius/platysma. When the risorius/platysma contract, the mouth corners are drawn sideways. The action has much more effect on the lower lip than the upper. The pull is primarily at lower lip level. The lower lip is stretched into a taut, even band, with straight-line upper and lower edges. The lip becomes slightly more recessed and as a result is surrounded with a soft fold, stretched between mouth corners—the signature wrinkle. The entire front row of lower teeth are bared. In the most visible contribution of platysma, raised bands appear on the front and sides of the neck (**G**).

A. Rectangular inset below lower lip, where skin is flattened against chin.

B. Soft, rope-like bulges appear here, extending down to jaw.

C. Middle portion of upper lip mostly unchanged; outer legs hinge outward and stretch slightly down to mouth corner.

D. Wide mouth. Brackets around mouth form when action is strong, deepest at corners. Upper teeth hidden.

E. Inner outline of relaxed mouth.

F. Inner outline of tensed mouth. This is the "square mouth" shape; note corner angle.

LOWER-LIP CURL: DEPRESSOR LABII INFERIORIS

Finally, we arrive at a muscle that has no reputation, few enemies, and not coincidentally a very minor role to play in facial expression. The impressively named *depressor labii inferioris* (depressor of the lower lip) is the muscle that curls the lower lip downward, and if that doesn't strike you as a very dramatic movement, you're correct. I've included it because it is a key muscle in the act of speaking and does appear, in combination with other, more expressive muscles, in a few of the expressions I've illustrated.

There are two strands of this muscle, one on the left, one on the right, and each runs from the lower lip down to the chin. The two strands contract together and curl the entire lower lip straight down, exposing more red area and showing the entire lower row of teeth.

The lower lip forms a thick square *U* with a well-defined edge running along most of its lower margin. The risorius/platysma, which also exposes the lower teeth, stretches the lip and widens the mouth, two things that do not happen with the lower lip curl. The way the teeth are uncovered is different as well: the depressor labii inferioris bares the teeth down to the gums, further than with the risorius.

The chin may wrinkle slightly.

SUMMARY

In this chapter I've laid out the expressive vocabulary we have available to us—the raw materials from which facial expressions are made. At times, just a simple change from the neutral—an open mouth, a downturned eye—can enliven the face enough for some purposes. To understand how the face communicates more complex physical and emotional states—pain, fatigue, sorrow—we will next explore how the various elements combine. In some cases, muscles that have been described in solitary action will be seen teaming up with other muscles, creating facial changes that retain elements of both.

DEPRESSOR LABII INFERIORIS: THE LOWER LIP CURL

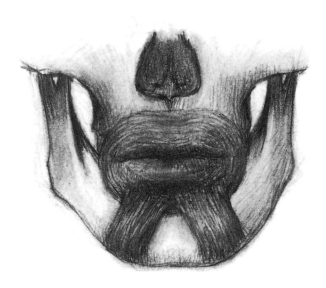 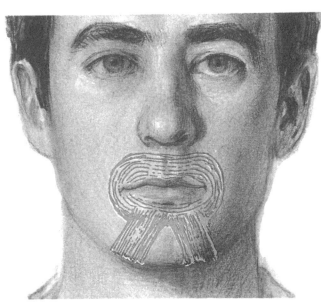

The depressor labii inferioris is designed to pull the bottom of the lower lip straight downward. Its fixed, bony origin is on the edge of the jaw, on either side of the chin. Its other end is stitched into the bottom edge of the lower lip and the lip circling muscle, orbicularis oris. When it contracts, it pulls the lip toward the jaw.

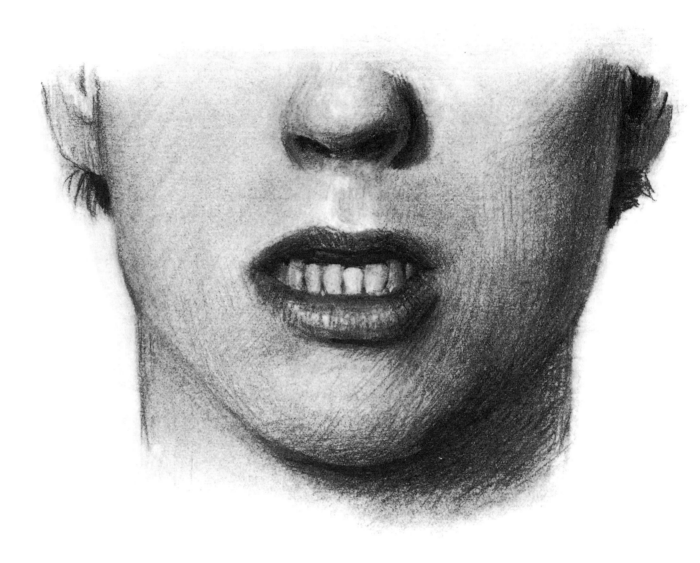

The lower lip curl affects only the lower lip, and neither the upper lip, nor the mouth surroundings are changed (the chin may wrinkle a bit). The lip is gently turned inside-out and takes a shape like half of a doughnut—thicker looking and with a steep undercut beneath. The lip curl is primarily an action of speech.

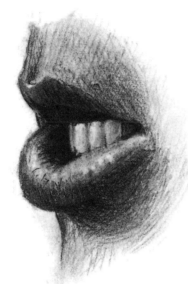

From side view, it's clear how the action of the depressor labii inferioris pulls the lip out from the face, exposing the lower teeth.

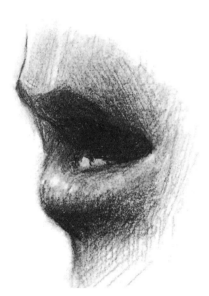

MOUTH RELAXED

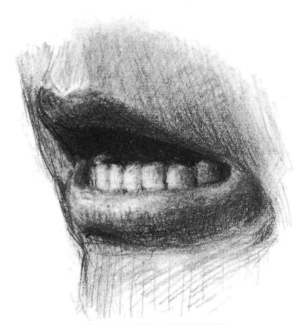

CONTRACTION OF RISORIUS

SIMILAR ACTIONS

The lower lip in the relaxed open mouth looks thicker, but is not curled out from face. Only tips of the lower teeth are exposed. In risorius contraction, a full row of lower teeth are exposed, but the lips are stretched and the mouth widens. Depressor labii inferioris, by contrast exposes lower teeth down to the roots, creates deep overhang under the lip, and doesn't stretch or tighten the lip.

THE

SIX

BASIC

EXPRESSIONS

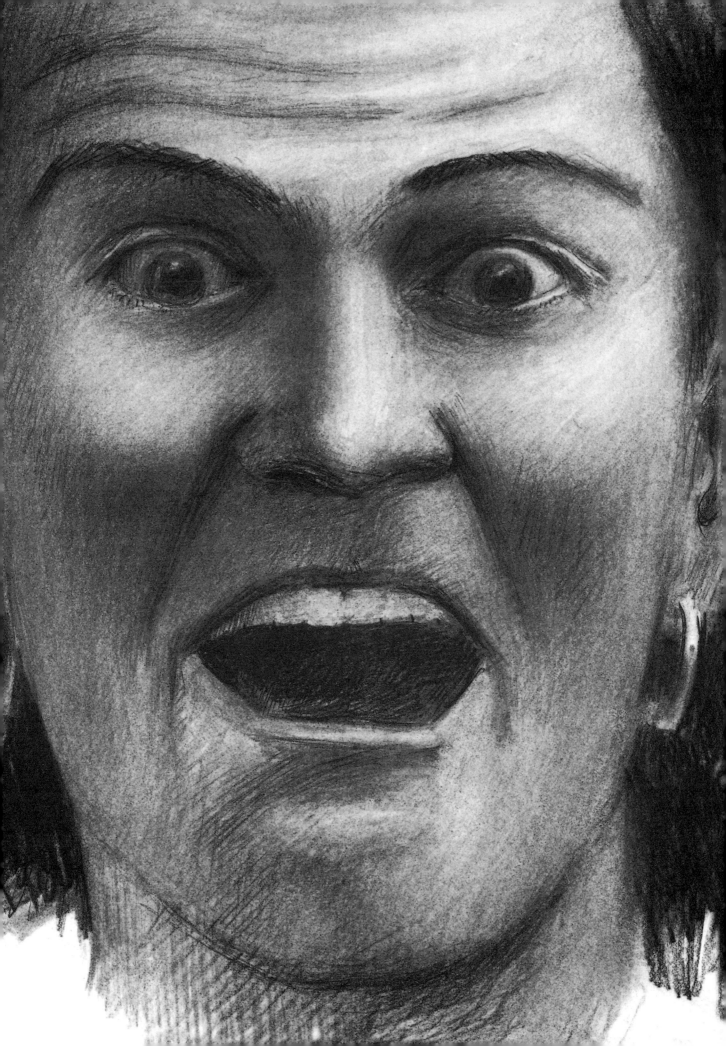

EMOTION AND THE FACE

The relationship of emotion and the face is fascinating and complex. Three questions are worth examining before we look at the specific expressions: What are the main facial expressions? How universal are they? How much can we really tell from the face? Psychologists and anthropologists have had much to say of interest to artists on all these subjects.

THE FUNDAMENTAL EXPRESSIONS

I have shown a lot of pictures of the face to people in the course of writing this book. I wanted to find out if there were certain expressions, of the many I'd collected on file, which would be seen in a similar way. And there were some faces that inspired nearly universal agreement; some were so clear, in fact, that people I showed them to were not only able to pinpoint the emotion, but were able to make some surprisingly good guesses at what was happening when the photos were taken. Even some faces I thought too subtle to be recognized were seen as expressing the same thing by almost everyone.

Asking people their immediate impression of a photograph of a face is, in fact, a basic method psychologists have also used in their investigations. Research has been done not only here, but all over the world, and attempts have been made to compare responses between one culture and another.

Six basic categories

One researcher, Paul Ekman, compiled a list of every study of this kind he could locate. There is a convincing pattern to the result; most researchers conclude that there are certain universal expressions, and over and over again, the same six categories of expression came up: sadness, anger, joy, fear, disgust, and surprise. Photographs that fell into one of these categories were seen in the same way by most people; photographs that showed other expressions were not generally agreed on. As a result of such surveys, most psychologists have concluded that these six categories, and only these six, should be considered as universal.

I also include, in an appendix, descriptions of those expressions that are the product of *physical* states. These include pain, sleepiness, passion, and physical exertion. Like the emotional expressions, these are faces everyone shares, but in terms of instant recognition, they tend to be slightly more ambiguous.

Why certain expressions are left out

There are other expressions that might occur to us that do not seem to fall into any of the above categories. These are mostly of three sorts: (1) subjective and circumstantial; (2) one of the basic six, but by another name; (3) a blend of two of the basic six. Let's look at these groups one at a time.

1. Subjective and Circumstantial

There is a lengthy list of expressions that belong in this category: faces that I'm dead certain I see, but you see as very different. Only including those I have seen described in various books, I could list reverence, greed, vanity, flirtatiousness, suspicion, stubbornness, jealousy, stupidity, shyness, pity, disappointment, expectation, hate, and remorse. Take a picture—of the face only—that you are convinced shows any of the above feelings, show it to twenty people for their impressions, and chances are you will get at least fifteen different responses. There would be no pattern of agreement as you would get with a sad face or an angry one.

Remember that we are confining ourselves to what we can learn from the face *alone*. If you want to depict shyness, for example, and create a sto-

SADNESS

ANGER

JOY

FEAR

DISGUST

SURPRISE

rytelling picture with a young woman with a slight smile and downcast eyes being courted by an ardent young man, you could certainly get the message across. But if you crop the picture so it just shows the girl's face, it becomes impossible to interpret the downcast, smiling look in just one particular way. Out of context, it might be seen as embarrassed or self-satisfied. Bona fide expressions do not need the context to be readable; *circumstantial* expressions do.

2. The Same, but by Another Name

Many of the names for expressions that might occur to us as universally recognizable are simply other names for sadness, anger, joy, fear, disgust, or surprise. Worry for example, is a less intense version of fear. Sternness is a mild version of anger (as is, perhaps, stubborness). Disdain is a restrained version of disgust. Terror, astonishment, and apprehension are all synonyms for fear.

3. A Blend of Two of the Basic Six

Certain fascinating faces may include aspects of more than one emotion. A sad smile may look sensitive, or bittersweet; a surprised smile may look dazzled, or happily amazed. Fear can mix with surprise; anger can mingle with disgust. We know that facial expressions are full of suggestiveness and nuance. It seems, however, that behind this complexity, there is a simple pattern: six fundamental categories that, in their blendings and varying degrees of intensity, account for the complexity we see.

DARWIN AND THE QUESTION OF UNIVERSALITY

Charles Darwin was the first to suggest that facial expression is a universal language.

Darwin prepared a questionnaire on expression, which he sent out to missionaries, teachers, and colonialists in remote parts of the British Empire.

The questionnaire asked respondents to note the expressions of aboriginal peoples. From this survey, along with many years of his own observations, Darwin concluded that

those expressions he observed in England were the same as those described elsewhere. This conclusion has been supported by many recent studies of the subject, some of people who had no previous contact with any outside society.

Why Do We All Smile the Same Way?

Being of a curious and inquiring bent, Darwin then attempted to find out why people with no cultural links vent their emotions in identical ways. He eventually concluded that expressions are innate, rather than learned, behavior. If we had to be *taught* to smile, everyone would do it differently. Smiling, crying, and the other emotional expressions thus fall into the category of instinctive behavior.

According to Darwin, the universal facial expressions can be traced back either to our common prehistoric ancestors or to our infancy, when they performed some useful, instinctive function. Even though they have long ago ceased to be of any use, adults continue to perform these expressions through habit any time the feeling originally associated with the expression arises. Primitive man, for example, snarled when he was angry, because exposing the sharp canine teeth was a way of threatening to bite somebody. Modern people still snarl when angry enough, without the slightest intention of biting anyone or the awareness that biting has anything to do with what's happening to the face.

When Do Babies Recognize Smiles?

According to Darwin, and important to this book, our ability to *perceive* emotion from the face is also innate. We don't have to be taught the connection between a sad expression and a miserable state of mind. We know it without ever having to think about it. In fact, Darwin claims that such a connection can be made by children in the first year of life.

Another crosscultural issue (not mentioned by Darwin) is how people in different societies repress certain emotions and express others. There are many societies where women must repress their anger, for example, but

men are free to express it. It's an interesting and important topic, but one that is beyond the scope of this book. But no matter what a particular society is used to seeing, the recognition of the expressions we discuss will remain unaffected. In a country where public displays of, say, anger are rare, people will still know an angry face when they see one.

How Much Can We Tell from the Face?

Emotions can often be readable from the face; moods are something else again.

Moods are states of mind that we carry with us on a daily basis. Emotions are the intense, often overwhelming bursts of feeling that arise, only occasionally for most of us, in response to some powerful stimulus.

To what extent are these day-to-day moods visible on the face? Let's take the example of fear. It is a fact of nature that if we are terrified enough, in response to some cataclysmic event, our response will be etched on the face. Fear sends a massive, sudden jolt through the nervous system, provoking a host of physical reactions: increased rate of heartbeat and breathing; a fresh dose of adrenaline; and the spasmodic contraction of certain involuntary facial muscles, creating the face of terror.

But how about a long-term mood of anxiety? Well, that depends. As well-socialized adults, we are used to coping; going about our daily life and social activities in spite of a disruptive inner mood of anxiety, or, say, depression. We have a social mask that can pretty well disguise any modest attack of mood. An acquaintance may know we're anxious only by indirect clues: we're not as animated as usual, or we seem nervous or jumpy. It is unlikely to be made so obvious that someone might come up to us and say, "Are you having an anxiety problem or something?"

So the answer to the question, can we read someone's mood in his face, is—sort of. We can interpret a particular emotional expression as suggesting an overall mood: "He looks so glowing and happy, he must be in love."

These two faces (below and right) both demonstrate the expression of surprise, but they are poles apart in every other respect. The photograph (below), with its mechanical recording of detail, exemplifies the literal, unselective approach. By contrast, the shell face (right) has only those details that are essential to identify the expression of surprise. These essential details form the "code" for the expression: an O-shaped mouth and widened eyes.

Both elements of the code must be present for surprise to be recognized. Removing either will drastically change what we perceive. If, for example, the circles around the eyes (**1**) are removed (**2**), the expression is lost. The circles around the dots simulate the surprised eyes' raised lids. In surprise, the eyes have more control over the look than the mouth. When the mouth is widened (**3**), the expression changes little; when the eyes are widened (**4**), the astonishment in the face appears to increase. The mouth is crucial in expressing fear. Fear is seen if a blunt wedge shape is substituted for the circle (**5**).

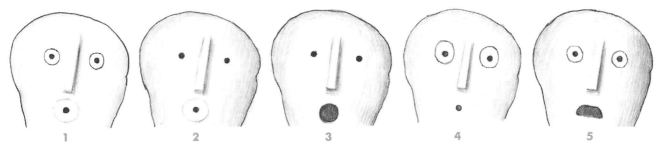

1 2 3 4 5

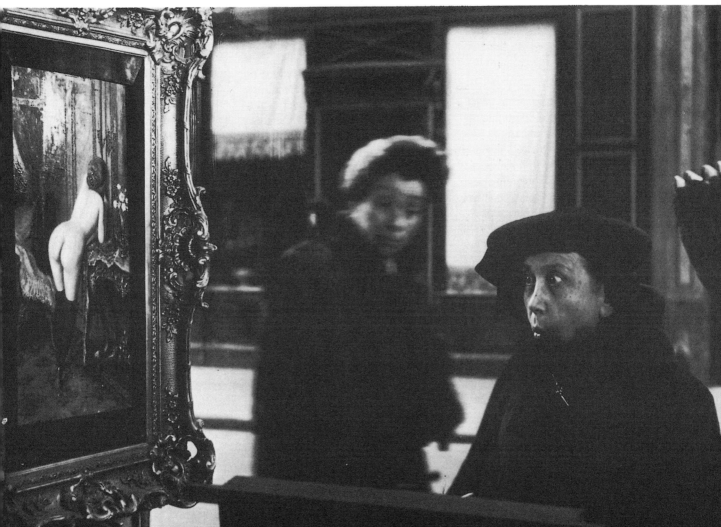

HOW WE RECOGNIZE EXPRESSIONS

The art of *communicating* an emotion does not depend on photographic precision, on the accurate drawing of every wrinkle. Underlying every expression is a sort of code, a limited set of elements that are the real basis of our recognition. For the code to be readable, we do not need to be looking at a detailed rendering of a realistic face, with every feature painted just so. You can make a *potato* look angry with a pen knife and some toothpicks if you know what you're doing!

The genius of cartoonists and primitive artists has often been expressed in the invention of extraordinary and unexpected graphic substitutes for features and their actions—the elements of the code. The variety of solutions that have appeared is worthy of its own book.

But no matter how abstracted or stylized an interpretation of an expression may be, if it works well, it's partly because it's based on the real nature of the face. We can sense the anatomical truths operating behind the scenes. In the same manner, no amount of skill in rendering or finesse will make a face expressive if the insight into what makes an expression work is missing.

Cracking the Code

The code behind a particular facial expression can be seen as the minimum requirements for us to identify it. Not everything that happens to a face in a particular expression is part of the code. For example, though the nose widens whenever we laugh, it is not part of the laugh code. You can leave the nose out of a rendering of the laugh entirely, and the face will look just as amused. A time-honored method for determining what the code is for a particular expression is trial and error, seeing what you can leave out or stylize and still maintain the effect. In this chapter I point out the elements of the code for each expression; in the appendix each expression is drawn with the fewest details necessary.

How Much of the Face is Involved?

An expression will only be clear and unambiguous when there is action in both the eyes/brow and the mouth at once. Draw a face with angry eyes but with a neutral mouth, and it might be interpreted several ways by several observers. One might see the face as stern, another as intense, a third as perplexed. Add an angry mouth, and the message of the face will be universally recognized.

Or look in a mirror and smile. Allow as little change in the area around your eyes as you can—keep them open wide. The face you see reflected doesn't look particularly happy; it doesn't look particularly *anything*, except perhaps silly. An authentic, warm smile combines a smiling mouth with smiling-specific wrinkles around the eyes. If your eyes aren't smiling, you're not happy.

The furrowing of the brow in perplexity or concentration is also a sort of facial expression. In this case, however, the intensity of the emotion involved is hardly of the primal variety. Such everyday expressions almost always involve only part of the face, thus carrying less emotional weight than the six fundamental expressions. The conscious use of the face to help a conversation along also falls into the category of everyday expression and tends to only involve the upper or lower part of the face, not both.

The Issue of Intensity

Is there a code for how *intense* a particular expression appears? For example, does the lowering of the eyebrow control the intensity of an angry face, and will lowering the eyebrows more make the person look angrier? Will opening the mouth wider make a surprised person look more surprised?

In almost every case, both halves of the face do *not* have an equal role in controlling the degree of emotion in a particular face. When it comes to degree, the determining factor is usually the eye. The eye by itself will not make an angry or joyous look, but if the other elements required are present, changing only the eye will generally have a much larger impact on the face as a whole than changing any other feature. You can alter the eye to make a face look angrier and angrier, with very little change to anything else; however, though the happy eye is crucial to the happy face, if you alter it *too* much without changing anything else, it starts to look very peculiar and out of place.

Subtle vs. Extreme

Each of the six expressions are presented in pictures that start with the most intense version and end with the least. As we work with the depiction of varying degrees of emotion, we discover that there are potential difficulties with both the most-overwrought and the least-detectable versions of every facial expression.

At one end, the problem is with *believability*. Disgust and horror, for example, at some of the extreme levels depicted here, are well beyond most of our pictorial needs, as well as most of our personal experience. But such expressions do exist; further, part of my reason for including them is that the most-contorted faces help us recognize the same elements when they are only subtly present in less-active faces. The face of ordinary disdain contains the shadow of the face of outright physical repulsion.

At the just-barely-there end of the scale, the problem is with recognition —at what point is an expression too tenuous to be noticed? It depends on the specific expression, and we will see that some expressions seem capable of much more than others in this regard. Sadness and smiling are both particularly vivid with a minimum of outward signs.

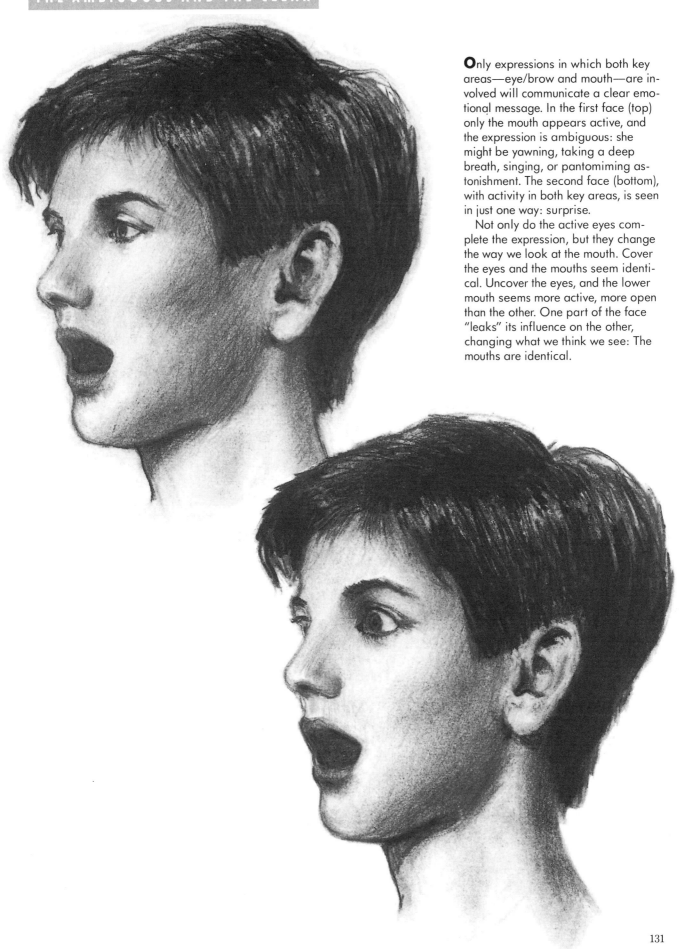

Only expressions in which both key areas—eye/brow and mouth—are involved will communicate a clear emotional message. In the first face (top) only the mouth appears active, and the expression is ambiguous: she might be yawning, taking a deep breath, singing, or pantomiming astonishment. The second face (bottom), with activity in both key areas, is seen in just one way: surprise.

Not only do the active eyes complete the expression, but they change the way we look at the mouth. Cover the eyes and the mouths seem identical. Uncover the eyes, and the lower mouth seems more active, more open than the other. One part of the face "leaks" its influence on the other, changing what we think we see: The mouths are identical.

131

THE EXPRESSION OF SADNESS

Almost all of our adult facial expressions have their roots in our very first expression: the scream we made when we first emerged into this world.

The facial expression of sadness is, of course, the most directly related to our original cry; but certain elements of the baby's scream also appear in the expression of anger, disgust, and fear. Even laughter and joy include certain muscle contractions that we first experience in crying.

The various forms of sadness—weeping, dry-eyed grief, mild distress—differ from each other mainly in intensity. All are closely based on the infant's cry but are progressively more restrained. The long habit—going back to infancy—of connecting any level of distress with crying causes certain muscles of the face to contract involuntarily as though one were going to cry even when we are not. This preparation creates a facial pattern that, even when just barely evident, unmistakably portrays unhappiness.

The subtlety of the sad face makes it particularly interesting. All expressions are clear enough in their most extreme form, but certain sad faces can be universally recognized even when the traces of the sad brow, eye, or mouth verge on the invisible. There is always less agreement about fear, anger, surprise, and even disgust.

THE SCREAMING MOUTH: FROM "AH" TO "WAHHHH"

A crying baby is impossible to ignore. The cry protects it. A less grating noise might be given lower priority by a parent in the hustle and bustle of daily life.

The effectiveness of the square mouth shape all babies rely on can be easily demonstrated. Make an "ah" sound with your mouth in its relaxed, oval position. The sound is pleasant. Now, continuing the "ah," stretch your lower lip off to the sides and bare your upper teeth. The "ah" becomes a "wah," a much harsher sound.

Muscles that Shape the Mouth

The square crying mouth is created by an upward pull and an outward pull. The outward pull, the work of risorius/platysma, is very intense, stressfully tightening and straightening the lower lip. The upward pull of the middle branch of the sneering muscle is much milder, but is still strong enough to square-off the upper lip and create the nose-to-mouth fold. The cheeks puff up smartly, pulled up by both the sneering muscle and the contraction of the muscles around the eye.

The mentalis almost always contracts when we cry as well. This pouting muscle, which normally pushes up the middle of the lips and balls up the chin, has a slightly different effect in the cry; the sobbing lower lip is so tight it can't be moved very much, so the action of the mentalis just bows it upward in the middle.

Because of the upward push of the mentalis, many mistakenly described the unhappy lower lip as having a *downward* pull; in fact, it is being pushed *upward* in the center, then pulled *outward*. If you watch a baby cry, you see the mentalis clench and unclench spasmodically, bowing and unbowing the lip.

The Other Half of the Cry

Mouth squaring plus eye squeezing equals the cry. One-half of the facial expression of crying is based on the changes that occur as the face forces the mouth into a rectangular shape. The other half is created by the clenching of all the muscles around the eye, which occurs as a *response* to what happens with the mouth.

THE CLENCHED EYE

The "clenched eye" is created by the contraction of the orbicularis oculi and part of the corrugator. When these muscles contract, they cause us to squint hard, pressing in on the eye.

We instinctively press in on the eye when it is subjected to certain sorts of stress, like that in crying. When we cry, air is forced from the lungs with more force than usual. A chain-reaction leads from lung to eye, with the end result that the capillaries of the eye become enlarged, creating stress. To counteract this stress we squeeze the eyeball with the orbicularis oculi and corrugator, relieving some of the discomfort.

The more intense the cry, the more intense the contraction surrounding the eyeball. Similar explosions of air, as in sneezing and coughing, create exactly the same response. The action of sneezing is so linked to closing the eye that if you force your eye to stay open you will prevent an oncoming sneeze.

It all begins with the baby's cry. The first expression we make is a statement of pure need, designed to get noticed. The square-mouth shape produces a shrill sound more penetrating than that of a relaxed, open mouth. As the lower half of the face opens up, the top half closes down; the reflexive squinting of the eyes in crying is also instinctive in other expressions where quantities of air are expelled: laughing, sneezing, coughing.

THE TIGHTENED EYE

You can't cry with your eyes wide open, nor can you sneeze. When we do either, air is squeezed from the lungs with great force, putting pressure on tiny blood vessels in the eye. The contraction of orbicularis oculi tightens up the skin around the eye; this seems to relieve some of the pressure. The more energetic the cry, the more tightly the muscle compresses, affecting the rest of the face as well. The full orbicularis oculi contraction in loud crying pulls down the brows, raises the cheeks, and may even help square off the mouth.

THE SQUARE MOUTH

The mouth of crying is square-shaped, the result of the upward pull of the sneering muscle, which squares off the upper lip and etches naso-labial folds in the cheeks, and the outward pull of risorius/platysma, which widens the mouth and stretches the lower lip. The square mouth is often framed, as here, by one long crease from nose to chin, like a tear's path.

The signature wrinkles of full orbicularis oculi contraction—smile-shaped fold (**A**), star wrinkles between the eye (**B**), and lowered brow—dominate the upper face. A single crow's foot wrinkle (**C**) is the precursor of more to come. Dimple (**D**) and bulging (**E**) are characteristic of contracted corrugator. Puffed cheeks and nasolabial folds (**F**) are caused by sneering muscle; bracket folds at mouth corner (**G**) by risorius/platysma.

THE ACTION OF THE MENTALIS

The mentalis is a companion to most of the faces of grief. When someone cries, the mentalis frequently acts with the mouth-stretcher, risorius/platysma. The chin-raising muscle alternately contracts and relaxes, bowing up the center of the lower lip and wrinkling the chin when it contracts (top). On either side of the raised part, the stretched lower lip goes back to being straight. The contraction of the mentalis seems to appear almost every time we're sad, whether we're crying or not.

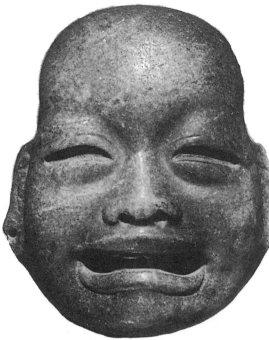

Fifteen centuries before Columbus, this crying infant was carved in stone by an Olmec artisan in Mexico. Such naturalistic depictions of emotion are rare in non-Western art. There is a clear depiction of the upper lip, squared-off and pressed back against the face, of the oblong mouth shape, and of the contraction of mentalis, including the balling up of the chin (**A**). Compare with face above.

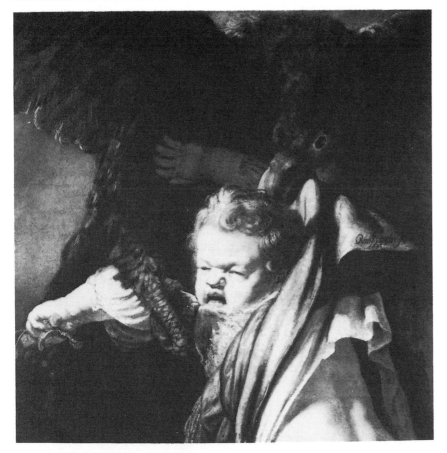

The face of a bawling baby is the focal point for Rembrandt's *Ganymede*, capturing the moment when the child-god is snatched off to Olympus by Zeus in the form of an eagle. Curiously, the expression is more vivid in the sketch (below). The dark, scrawled lines around the eyes—quick notations of the wrinkling of orbicularis oculi and corrugator—and the more open mouth with front teeth bared suggest a much stronger action than that visible in the painting. Nothing is more difficult than retaining the vitality of a sketch in a finished piece.

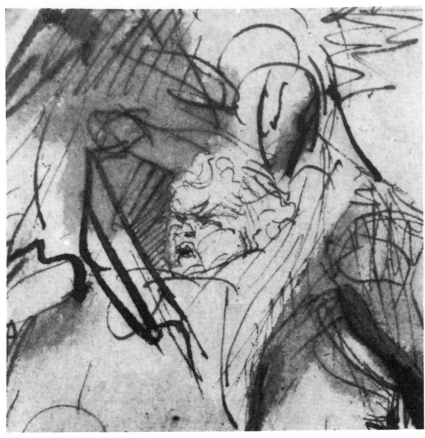

THE OPEN-MOUTHED CRY: ADULTS

Only rarely do adults revert to the fierce unhappy outcry that we associate so strongly with infancy. Fortunately, daily life offers few miseries intense enough to trigger such a vehement response. For most of us, only the death of a loved one or the ending of an important relationship inspire the most fundamental sorrow.

We look the same as a baby when we cry with utter anguish. We energetically vocalize our unhappiness with our mouths widened and squared, our eyes buried under the clenching mass of the upper face.

Only if the pattern is complete does the cry come across in a static, sound-less picture. The tightly closed eyes are the most crucial element, without which the element of loud, demonstrative crying is not apparent. The mouth itself may be open and stretched or closed and stretched, depending on how upset the person is, and how inhibited they are, but the eyes are always narrowed or closed. The tighter the squint, the more intense the cry appears.

Strong Action

Crying is a lot of work, which must be part of the reason it serves so well as an emotional release. You cannot physically stretch your mouth any wider than it stretches when you cry, and the eye squeeze is nearly as strong. We rarely put so much energy into an expression; no other state, with the exception of physical pain, puts the face under such stress. Our face reflects the tension and compression created by these actions.

Besides demonstrating the disappearance of the eye, a faithful depiction of crying renders the curving of all the surfaces of the lower half of the face. Nothing is flat or baggy; like the surface of a balloon after it's inflated, the lower face is everywhere rounded, everywhere taut. As in smiling or laughing, the mouth and its surroundings are inset by being pulled tight against the face; and the inset portion is framed by sharply rounded cheeks and thick cords alongside the chin.

CRYING

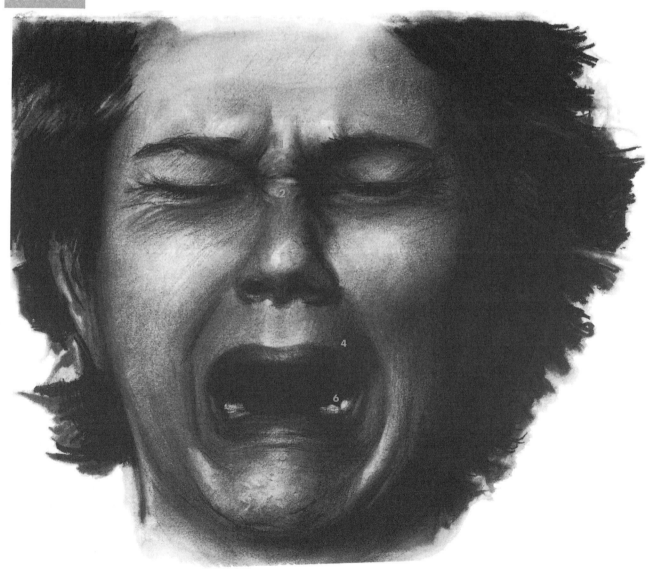

CRYING

Emotional distress triggers intense contraction of the eye and mouth muscles. Deep wrinkle patterns emerge, and a tightly stretched, hill-and-valley landscape arises.

EYES/BROW

1. Brows lowered, especially inner end; vertical wrinkling; smooth forehead.
2. Deep creases out from inner eye corner, across bridge. Crow's feet at outer corner; slight bag below.
3. Nose wings raised slightly. Cheeks tight and rounded.

MOUTH

4. Mouth wraps tightly around cylinder of teeth and jaw. Rope-like cord to both sides, but no dimpling.
5. Stretched lip pushed up in center by mentalis, roughening chin surface.
6. Lower teeth in extreme corner of mouth show owing to sideways pull on mouth corner.

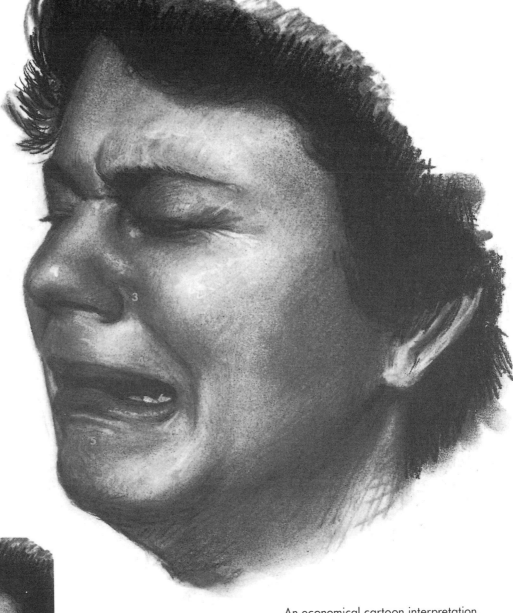

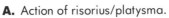

A. Action of risorius/platysma.
B. Action of mentalis.
C. Action of levator labii superioris.
D. Action of orbicularis oculi.
E. Action of corrugator.

An economical cartoon interpretation, suggesting the compressed eye (crow's feet), the widened square mouth, and the bracket fold beyond.

THE CRY AND THE LAUGH

Ironically, laughing and crying are sometimes similar in appearance. Infants and young children can pass almost instantly from tears to laughter with hardly a pause for breath. Even adults occasionally have responses where the two emotions are mixed. Whatever the psychological connection may be, the visual similarities between the two expressions are more numerous than the differences.

Two things that almost always distinguish laughing from crying are the degree of eye compression (much greater when we cry), and the way the lower lip is shaped—stretched in crying, angled upward in the laugh. Since the shape of the upper lip, the bracketing folds alongside the mouth, and the fullness of the cheeks can be very similar in laughing and crying, there are times when you simply cannot tell.

CRYING: MOUTH CLOSED

Most adult expressions appear with at least some degree of restraint. In terms of the face, restraint shows itself in various ways. Often there is a tendency for one part of the face to act at cross-purposes to what is occurring somewhere else. One part of the face may try to *undo* an instinctive action in another part of the face, and all sorts of new forms appear in the tension between the opposing pulls. This tug-of-war is completely involuntary, but it leads to some fascinating expressions.

The first sign of some restraint in crying is the partly closed mouth. The second sign is the appearance of a new pattern in the upper face: the brow of grief, which is created by the contradictory actions of the frontalis (up) and the corrugator (down).

The Partly Closed Mouth

Crying is a complicated, dynamic action, and there really is no single look to crying. Some always cry with their mouths closed, perhaps unconsciously wanting to suppress the sound; others move back and forth between loud, demonstrative crying and stifled sobs, wherein the closed-mouth cry is just one stage in a continuing action. Any picture of an action such as crying is necessarily a frozen moment.

The jaw controls how open or closed the mouth is. As it rises and falls, the mouth opens and shuts. But the secondary agent in closing the crying mouth is more dramatic. One of the most visible movements in crying is the alternate contraction and relaxation of the mentalis, trembling the lower lip. This works against the pull of the risorius/platysma, which is doing its utmost to pull the mouth and lips sideways, stretching the mouth as wide as it will go and making the lip tense.

The upper lip is pulled square in the same way as in the open-mouth cry, by the middle branch of the sneering muscle. As crying becomes less intense, the outer branch, the zygomatic minor, takes over. Its effect is milder than that of the other branches—less of a sneer results.

The Brow of Grief

An aspect of sadness that seems ready-made for artistic purposes is the brow of grief, and artists have interpreted it in many ways and in many forms. Perhaps part of its power is its sheer conflictedness, for it represents the opposition of anguish and restraint.

The brow of grief is the form the eyebrows take when the frontalis attempts to wrest control of their movement from the corrugator, which is pulling them downward. Frontalis is no fool about this, and in the most hysterical stages of crying, when the orbicularis oculi is contracted, and the inner brow is at its low extreme, it is nowhere to be found.

Frontalis makes its appearance only as the contraction of orbicularis oculi diminishes. The corrugator is still active, and the brows are still pulled downward; the frontalis attempts to pull the inner brow upward by the action of its fibers in the center of the forehead. The result is an unpredictable tug-of-war, which neither side ever wins. On some faces the pull of the corrugator is stronger and the eyebrows remain fairly horizontal; on others, the frontalis is stronger and the eyebrows slant dramatically upward. But on every face, there's that little kink, that subtle twist in the eyebrow a third of the way from inner corner to outer, and that's what pulls so strongly at our heartstrings.

Other Forms

There are other forms besides the kink that appear. The frontalis wrinkles the center of the forehead in a few short, horizontal rows, and the corrugator creates its characteristic vertical wrinkles and dimples. Together, the paired vertical wrinkles and horizontal folds make an upside down U-shape in the middle of the forehead.

The brow of grief appears on all the faces of sadness besides out-and-out crying, and occasionally on the faces of people who aren't sad at all. On miserable winter days I often see the grief pattern on faces of people struggling against a bitter wind and driving snow. Under those circumstances, it seems more the sign of distress than grief. Less frequently, the pattern will appear briefly on the face as a conversational gesture—you can see it on the face of certain television newscasters.

Tears

Tears may be a part of any sad face. Tears are a glandular reflex. Happiness as well as sadness may bring on tears. While the term "crying" refers to an audible outcry, and while tears usually go along with this, we may be tearful when we are just *quietly* miserable.

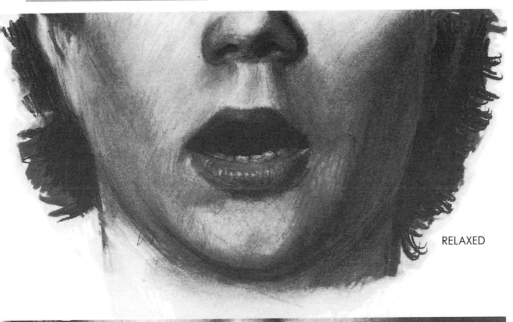

RELAXED

The crying mouth is much wider than a relaxed mouth because of the sideways pull of risorius/platysma. It's rectangular in shape because of the upward pull on upper lip and sideways pull on lower. It's rimmed by stretched, thinned lips with sharp highlights and smoothed surfaces. It's more rounded in skin area above lips (note shadows on right) and framed by raised cheeks and vertical folds from nose to chin.

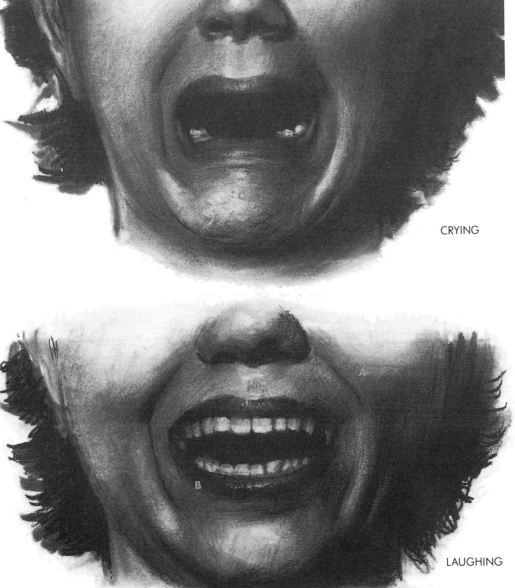

CRYING

LAUGHING

CRYING MOUTH VS. LAUGHING MOUTH

Both the crying and laughing mouths are widened with thinned, taut lips (the upper lip is nearly straight). Both are set into the face, curved tightly against the skull, and framed by long, vertical folds from nose to chin. But nasolabial fold in laughter is more angled (**A**), deeper in lower part versus upper in cry. Upper teeth rarely show in crying; full front row always shows in laugh. Upper lip in crying doesn't taper as much; it's nearly the same width right up to mouth corner. The key to shape difference is where laughing mouth goes up (**B**): crying mouth continues sideways, making opening more square. Note also that mentalis (**C**) never appears during laughter.

In moving from repose to grief, the face embodies the increasing distress. Crying with the mouth closed can involve as many as nine facial muscles —more than any other expression. Adding to the complexity is the activity in the brow, where the eyebrows first move upward (below), then downward (opposite, top), caught between the pull of opposing muscles. Long after the cry has faded, this conflicted brow remains.

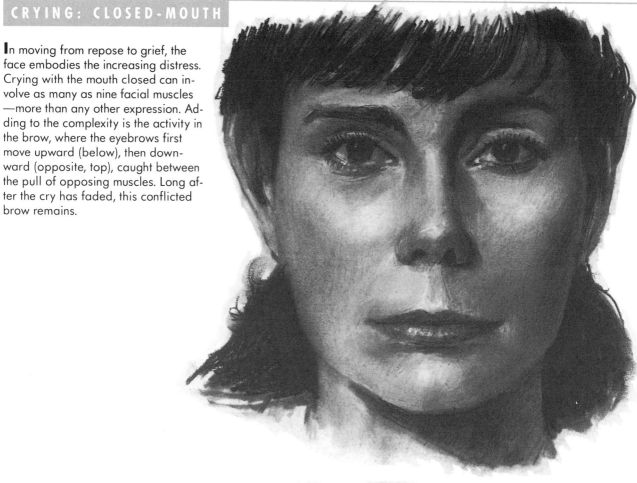

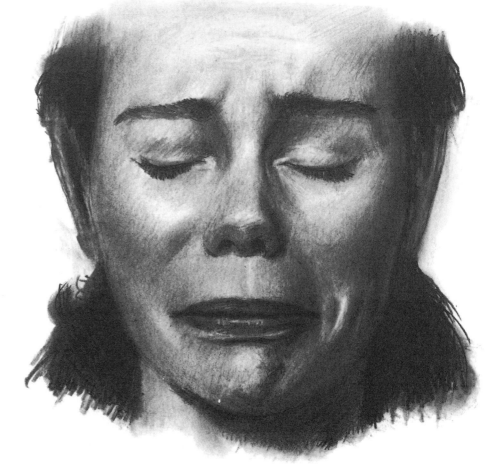

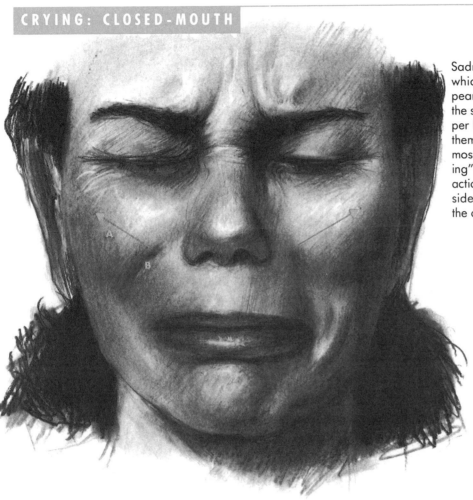

Sadness is the only expression in which the zygomatic minor (**A**) appears. Like the other two branches of the sneering muscle, it thickens the upper lip (middle and below); unlike them it does nothing to the nose. Its most characteristic sign is the "floating" wrinkle (**B**). In the most intense action the cheeks begin to swell, a side effect of the full contraction of the orbicularis oculi around the eye.

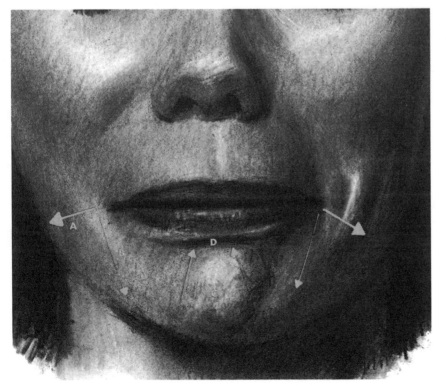

THE MOUTH AND CHIN

Three interacting forces stretch and compress the mouth. The strongest action is that of the risorius/platysma (**A**), making the lips taut as it widens the mouth. The hook-shaped cords beside the mouth corner are the signature wrinkle of the triangularis (**B**), but its downward pull isn't as strong as the pull outward. The action of the mentalis (**C**) balls up the chin (creating the sharp crease [**D**]) and pushes the lips together. Compressed lips do not bow upward (as happens in open-mouthed cry), but lower lip begins to turn outward instead.

Few forms are more suggestive of a particular emotion than the brow of grief is of sadness. The stretched mouth and clenched eye do not by themselves lend the face an unambiguous air of distress. The brow of grief does. The brow of grief is an action of restraint. In the most intense cry, the orbicularis oculi (**A**) is fully contracted, an action that triggers the corrugator (**B**), the frowning muscle. When distress is less intense (bottom), the pull downward on the brow is resisted by the middle fibers of frontalis (**C**), creating horizontal middle-brow wrinkles and pulling up on the inner end of the eyebrow. The relaxed eyebrow never assumes this form. Vertical creases and dimples show that the corrugator is still active.

A

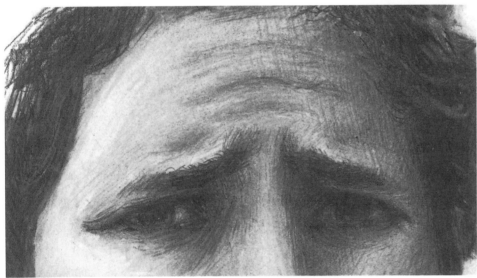

B

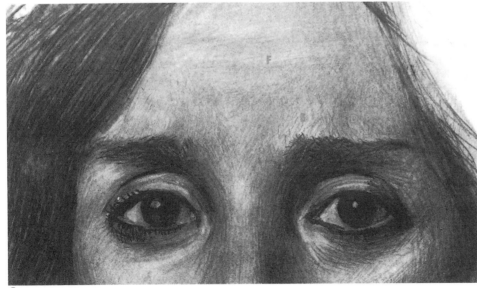

C

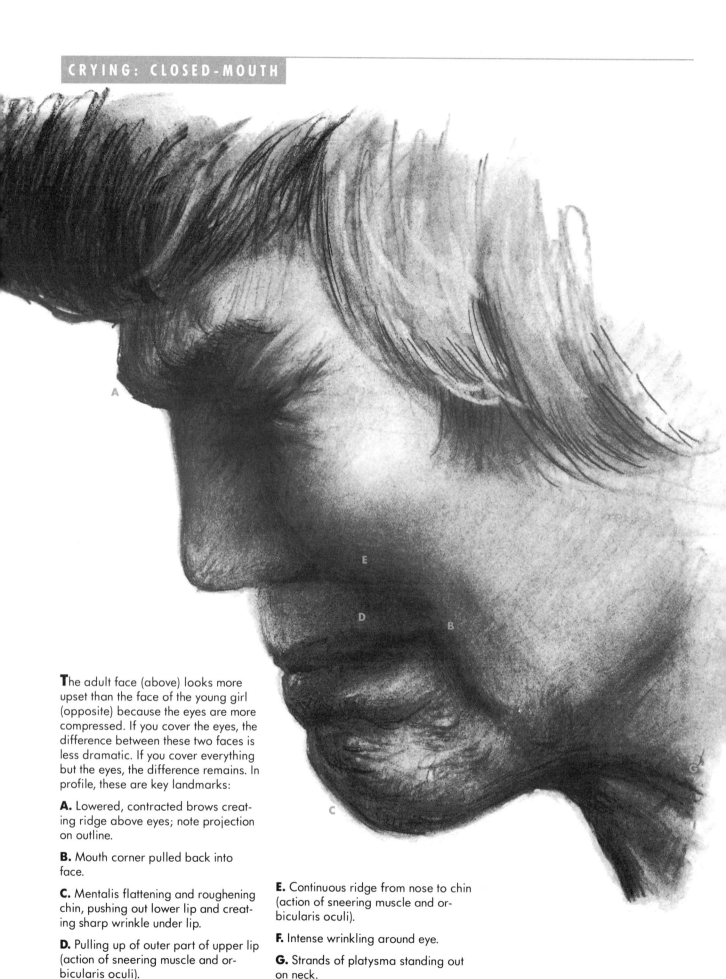

The adult face (above) looks more upset than the face of the young girl (opposite) because the eyes are more compressed. If you cover the eyes, the difference between these two faces is less dramatic. If you cover everything but the eyes, the difference remains. In profile, these are key landmarks:

A. Lowered, contracted brows creating ridge above eyes; note projection on outline.

B. Mouth corner pulled back into face.

C. Mentalis flattening and roughening chin, pushing out lower lip and creating sharp wrinkle under lip.

D. Pulling up of outer part of upper lip (action of sneering muscle and orbicularis oculi).

E. Continuous ridge from nose to chin (action of sneering muscle and orbicularis oculi).

F. Intense wrinkling around eye.

G. Strands of platysma standing out on neck.

Lips appear narrow as well as tight, turned inward and pressed together, with lower lip tucked under upper—action often part of weeping. Frontalis is not active in full-blown crying; forehead above brow is smooth. Middle branch of sneering muscle is active; crease is deep alongside nose.

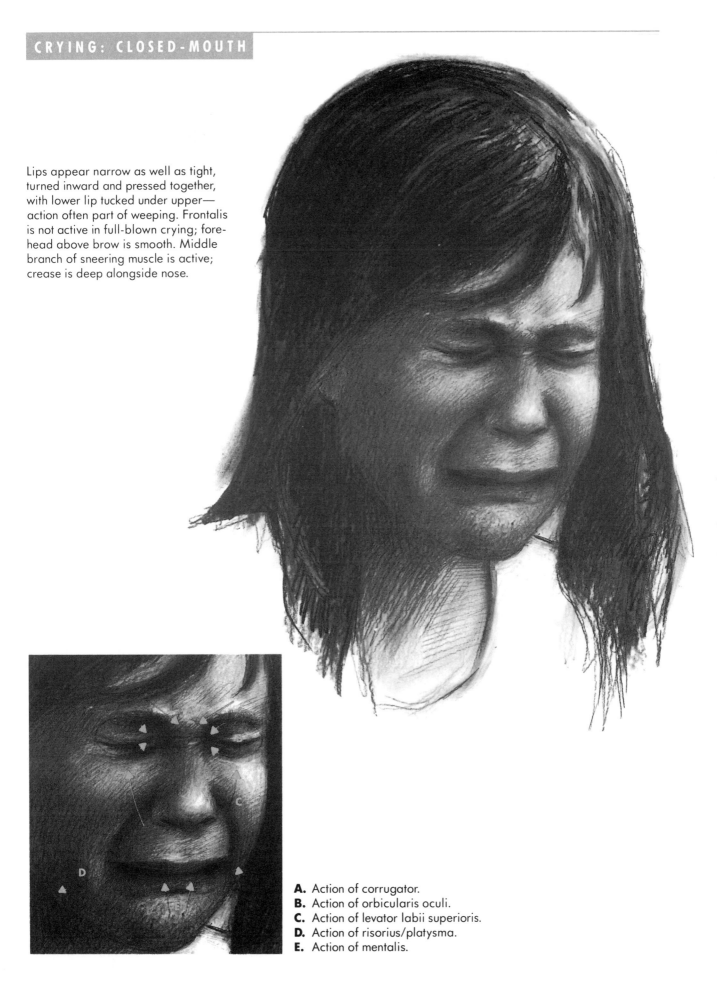

A. Action of corrugator.
B. Action of orbicularis oculi.
C. Action of levator labii superioris.
D. Action of risorius/platysma.
E. Action of mentalis.

SADNESS: UTTERLY MISERABLE

The main element in our perception of faces as utterly miserable is the look of the mouth, stretched and distorted by the same actions, slightly less marked, that we see in crying faces. This, along with the grief-stricken brow and sad-looking eyes, gives the face a look of sadness that may well be on the verge of tears.

When I say "sad-looking" eyes, it's because when the eyes are open, as they are not in weeping faces, the shape of the eye opening itself becomes part of the sadness pattern.

Sad Eyes

When the eyes are open in sadness, their shape is altered both above and below. Above, the upper lid is partly covered by a new skin fold, dragged across the lid by the movement of the brows. As with the kinked brows, the fold moves in an angular direction. The sadness code is based on this angularity; a feeling of "upward toward the middle" is the general theme of the upper face. Often the fold pushes down a bit on the eye, closing the eye slightly making the eye look less alert, more withdrawn. (This is an important distinction between sadness and fear, where the eye is wide.)

The lower lid covers more of the eye than usual as well. The orbicularis oculi is partly contracted, mostly in its lower portion, and this creates the bag under the eye and the lifted, straightened look of the lid.

Sad Mouths

Nearly every sad mouth, be it on the face of someone broken down in tears or on the face of someone in a quiet state of melancholy, bears signs of the action of the mentalis. Every sad mouth has an upper lip reshaped by either the middle or outer branch of the sneering muscle. Many sad faces also show signs of the partner of the mentalis, triangularis. But only on the face of someone crying or just about to cry will the risorius/platysma also be contracted. Risorius is the muscle of the worst states of distress, and as our mood lightens, its actions tails off, then disappears.

In less tormented faces of sadness, the risorius disappears, leaving just mentalis and triangularis to act on the lower lip, the sneering muscle to act on the upper.

THE TIGHT-LIPPED FACE OF RESTRAINT

Embedded in our collective consciousness is the memory of a scene from some movie in which a crusty-but-kind-hearted British officer turns to his young lieutenant who's on the verge of being terribly upset and says, "Keep a stiff upper lip, old chap." This is another one of those stock phrases that seem to hit on an anatomical truth. The upper lip, as we have seen, can indeed betray our emotions, in a way we may not wish to be betrayed. Is it in fact possible, by an exercise of muscular restraint, to prevent the inexorable squaring of the upper lip that precedes crying, in other words, to *keep* a stiff upper lip?

Yes and no. The act of fighting an innate facial movement is often equally if not *more* expressive than the unrestricted movement itself. In fact, you cannot "keep a stiff upper lip" if the emotion you are feeling is strong enough—the instinctive facial movements are too strong to suppress.

When we attempt to stifle a sob, the result is a tremendously strained, tight-lipped look—a pressing inward to combat the pull upward and outward. In life, a mouth suspended in such a muscular tug-of-war would look very unstable, with trembling as particular muscles tightened or loosened.

SIMPLY SAD

Crying, however painful, is usually brief; however, sadness can go on and on. In fact, the less intense the sad look, the more we take it to be a moment in an ongoing mood.

As I mentioned, sadness may be *the* emotion of nuance; it seems to take the least facial activity to suggest. Though the mouth alone cannot unambiguously suggest sadness, the eyes and brow acting alone can, a fact much used by artists.

THE MESSAGE OF THE BROWS

The brows, in fact, are the key to the sadness code. All sad faces have eyebrows with the tell-tale upward twist in the inner end, and in many faces, if you cover the brows, the message of the rest of the face becomes ambiguous.

So powerful is the effect of the brows that we see the other features differently when the brows are active. What this means for the artist is that if we take great care with the rendering of the eyebrows and forehead, we can suggest sadness with the slightest of clues in the rest of the face. The least creasing under the mouth will be taken as the signs of a pout; the least alteration in the line of the upper lid, or downward cast to the eye as a whole, will be seen as a look of utter melancholy.

Though almost seventy years of age separate these two individuals (below), their expressions are strikingly similar. Both seem on the verge of tears. The primal expressions, including sadness, do not vary throughout life.

When all lower teeth show, it's a bad sign. It's also a sign of trouble when the mouth is open and the inner outline, both above and below, is so straight. With such a young face, there's little creasing on the brow, but the faint bumps between the eyebrows, and the oblique direction of their line, indicate clearly the brows of grief. Note the lifting of the lower lid and slight pouch underneath, strong pull of zygomatic minor, creating midway wrinkle (**A**) and puffing the cheeks, and the pull of risorius/platysma (**B**), stretching the mouth.

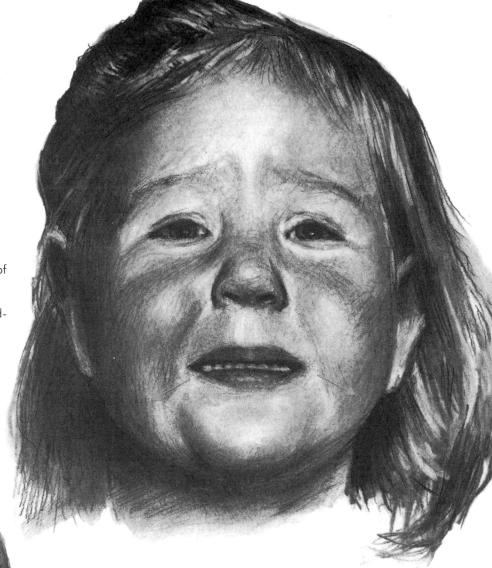

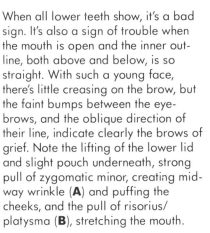

A. Bunching of corrugator, creating crescent-shaped mound around inner eyebrow.
B. Oblique skin fold across upper lid.
C. Mouth stretched sideways, exposing lower teeth.
D. Flattened, rumpled chin owing to mentalis.

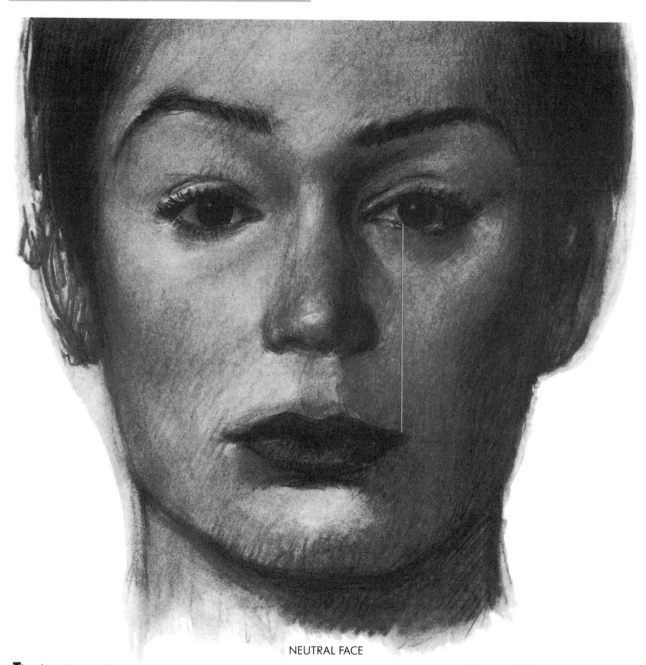

NEUTRAL FACE

The drawings on these two pages seem like a sequence with the last picture missing—the one where she bursts into tears. Unlike the neutral face above, we tend to see the face with so much activity (opposite) as leading up to something. In the final stage, the weeping face, the eyes will tightly shut.

SADNESS PATTERN

THE EYES AND BROW

Sad eyes look out at the world through partly shuttered lids. The or-bicularis oculi is partially contracted, creating crow's feet, raised lower lids (compare sad iris shape with that of relaxed eye above), and fold under the eye. Above the eye, the drag of skin upward and toward the middle creates a new skin fold (**1**), cutting across the upper lid. It hides part of the lid and pushes downward on it, narrowing the eye from above.

The basic sad eye pattern is oblique; brows, upper lid fold, slant at similar angles. Frontalis (green) is under entire forehead, but only central fibers (darkest tone) contract in sadness. At no other time does its central part contract alone.

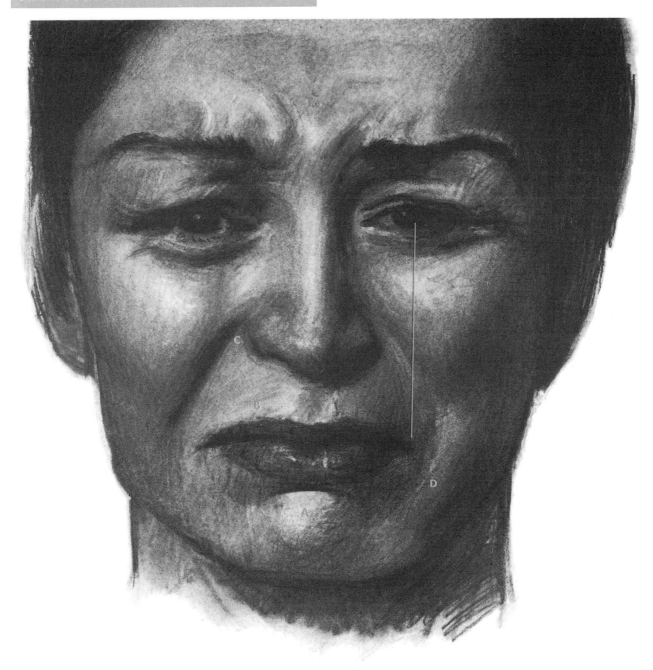

THE MOUTH AND CHEEKS

The mouth is the most transitional element. If it was fully stretched, as in crying, the lips would be thinner and more uniform. In simple sadness, the mouth is not stretched at all. Mentalis and triangularis are active, as is the sneering muscle. The "sneer" element here is strong; the nose is lifted up by the wings, the crease by the nose is deep. Note also the puffing of the cheeks. Vertical line indicates how relationship of eye to mouth corner changes as mouth widens.

A. Balled up chin, crease above due to mentalis
B. Squared upper lip
C. Deep nasolabial fold
D. Wrinkles, down corner of triangularis

Nearly every expression is at times opposed by the muscle of the lips, the orbicularis oris. Its action, tight compression of the lips, is likely both an unconscious effort of restraint and a sheer physical outlet. In suppressed sadness, this action doesn't prevent the other lower-face muscles of grief from contracting, but it partly overcomes their effects—a suppressed expression is often just as expressive as the unrestrained look.

TIGHT-LIPPED MOUTHS COMPARED

In the angry mouth (top), the contraction of mentalis and triangularis is the strongest action, creating the upside-down smile shape. Orbicularis oris is only partly contracted; the lips are not fully compressed.

In the suppressed smile (middle), the orbicularis oris is again only moderately contracted, but this is strong enough to prevent the zygomatic major, the smiling muscle, from lifting the mouth corner. Mentalis aids in compressing the lips (**A**); triangularis aids in holding the mouth corner down (**B**).

In the suppressed sob (bottom), the mouth is similar to that of anger with two key differences: it's stretched sideways by risorius/platysma, and the compression of the orbicularis oris is more intense—the lips are straightened and thinned.

ANGER

SMILE

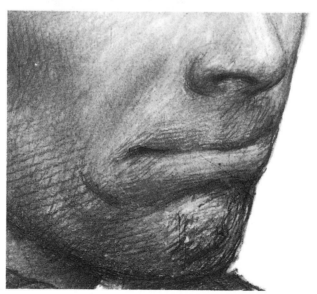

SADNESS

SADNESS: TIGHT-LIPPED

These two men are expressing their sadness quite differently. The sadness in the face of the man on the left is quite subtle. Just enough of the grief pattern is visible in his eyebrows and eyes to suggest his distress; depending on how you see his eyes, his mouth looks either sad or neutral—the cues are ambiguous. The cues are much clearer on the face of the other man, and his look is that of someone whose grief is barely under control.

A. Eyebrows with kink in inner third.
B. Oblique across-the-lid fold.
C. "Floating" crease of zygomatic minor.
D. Compression of orbicularis oris thins upper lip, bulges out lower.
E. Action of mentalis.
F. Mouth widened by risorius/platysma.
G. Signature wrinkle of triangularis.

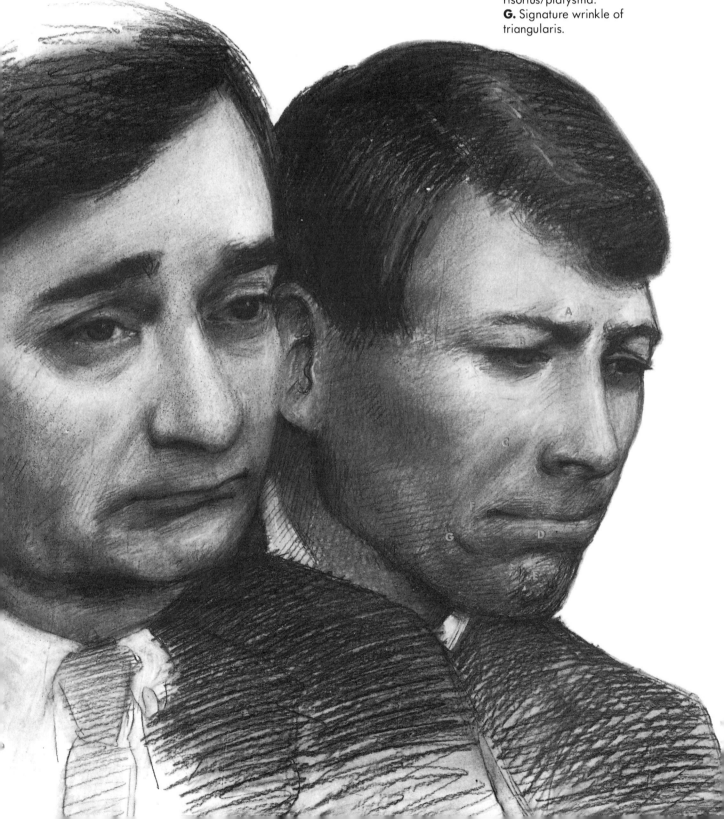

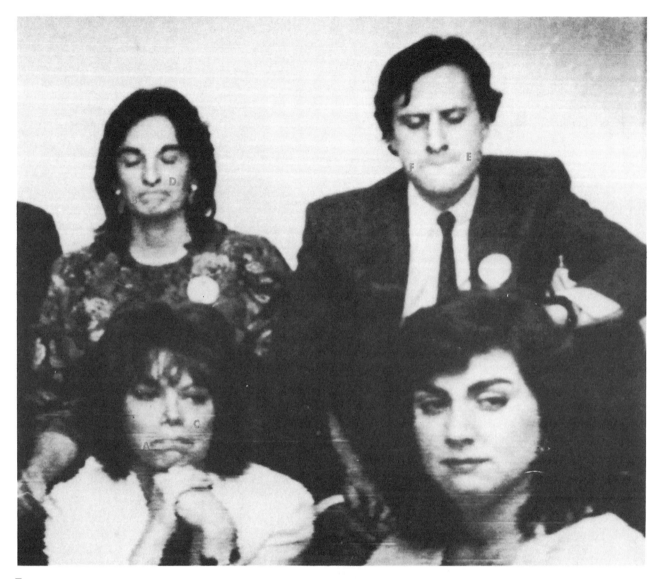

Every person performs learned actions differently; everyone's instinctive actions are the same. Fighting back tears will invariably trigger the muscles that bulge and roughen the chin and the muscle that stretches the lips. Above are several faces where this action is in progress, and the same pattern is strikingly repeated.

Presidential campaigns are times when feelings run high. These four people are staff members watching their candidate give an emotional speech withdrawing from the campaign. They're not happy about it. On each successive face (clockwise from lower right) the lip-pressing conflict of distress and restraint is progressively more intense. The mouth at (**A**) is being stretched and compressed; the pattern below her mouth (raised island of mentalis, with sausage-like bulge above) is precisely repeated at (**B**). At (**C**) and (**D**), crease and puffed cheek of zygomatic minor are barely visible. At (**E**), he's "biting his lip" with so much pressure that it has curled completely under itself. Little curled bulge of triangularis (**F**) is repeated at a similar spot on each face. (But does the woman on the right look sad because she's surrounded by sad people or because of some cue we see in her face?)

When crying fades, the muscles of a sad face gradually relax. First to go is the mouth-stretching risorius/platysma, then the eye-squeezing orbicularis oculi. As the latter goes slack, the cheeks lose their fullness and the lower lid its tension. What lingers is the pout and the grieving brow. Eventually, even the pout relaxes, leaving the twisted eyebrow as the only sign of the last stage of grief. The sad faces on this page have unhappy-looking brows and strong pouts.

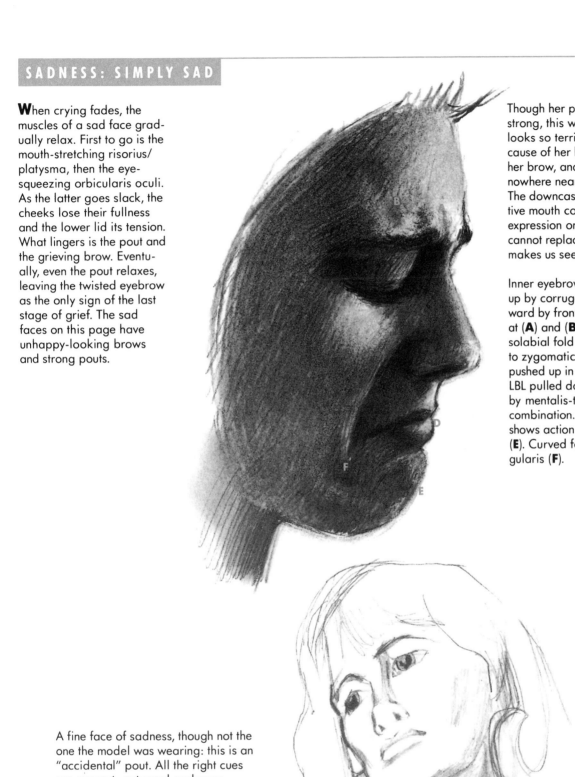

Though her pout is quite strong, this woman (top) looks so terribly sad because of her brow. Cover her brow, and the effect is nowhere near as intense. The downcast eyes and active mouth complement the expression on the brow but cannot replace it; the brow makes us see them as sad.

Inner eyebrow end bunched up by corrugator, bent upward by frontalis; key folds at (**A**) and (**B**). Deep nasolabial fold (**C**) mostly due to zygomatic minor. Lip pushed up in middle (**D**), LBL pulled down in corner by mentalis-triangularis combination. Chin profile shows action of mentalis (**E**). Curved folds of triangularis (**F**).

A fine face of sadness, though not the one the model was wearing: this is an "accidental" pout. All the right cues are present: upturned eyebrows, oblique upper eyelids, lower lip with sharp, straight fold underneath; all, according to the student artist, were unintentional. "Mistakes" can sometimes lead to interesting results.

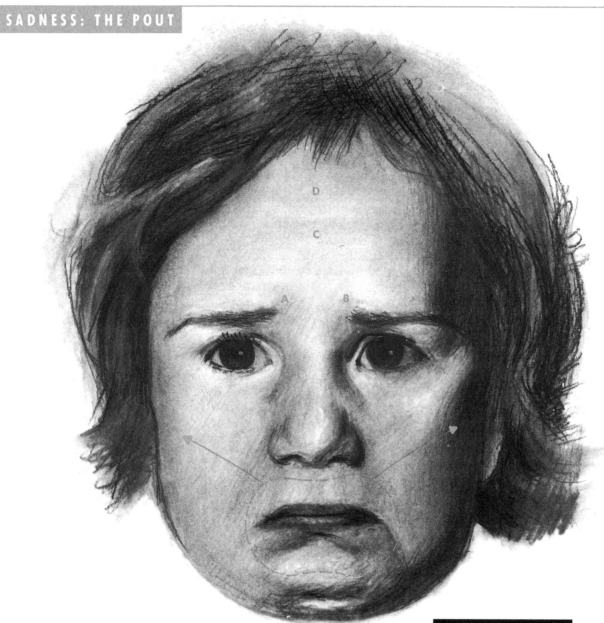

Much is expressed in the face of this sad little girl, but little is actually visible. Sadness can be a powerful presence, even when the signs are so subtle. Surprisingly, the eyes in isolation (bottom) are not sad but appear sad beneath the kinked brow (top). Little creasing is visible on so young a face, but soft darkening at (**A**) and (**B**) is spot where frown lines will probably appear when she's older; darkening at (**C**) and (**D**) is beginning of worry lines.

ACTION OF THE POUT

In the pout, center section of upper lip and LBL is unnaturally long, and drops off quickly at corners. Upper lip is an even width across. Shape's due to pull of zygomatic minor (arrows) on rim of orbicularis oris (circle), changing upper lip indirectly. Lower lip is slightly thinned. "Platform" underneath sharply defined, with deep, curved middle crease, all due to mentalis.

Of all the expressions, sadness requires the fewest movements to suggest. The least twist of the brow in an otherwise relaxed face will do, even without the accompaniment of wrinkles in forehead or changes in eye. But when an expression is so subtle, the message it carries is altered: we sense an ongoing mood rather than a moment of crisis. This stage of sadness—the look of melancholy, resting entirely in upper face—is most often portrayed by artists.

The action (left) is in the top half of the face, though at first glance it seems otherwise. Isolated from the brow, the mouth has no particular expression (right). Only in the face as a whole do we notice the upper-lip shape and the crease in the cheek, which we interpret as part of the sad look. With facial expression, it's important to know what leads and what follows.

Mouth alone appears neutral; action of zygomatic minor may be present but is so slight as to be debatable.

Her brows (right) make the rest of her face look sad. Emphasizing details—the platform under the lips, darkness under the eyes—suggest activity in otherwise neutral features.

Mouth alone (below) appears neutral; dark platform beneath suggests pout. Faint, horizontal middle-brow folds (**A**). Dimple appears where corrugator attaches to skin; kink in brow begins at that point (**B**). Slight change in value defines bulge at inner brow end (**C**); no vertical crease in this slight action.

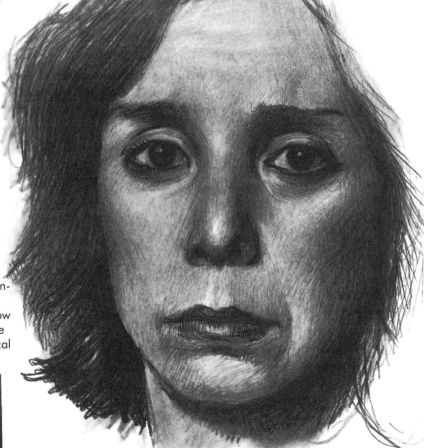

Sadness and the Art of Portraiture

Because the expression of sadness can be so slight, it crosses that imaginary line that separates expressions of crises and extremity from those that seem more commonplace, more part of a long-term mood. Sadness would not seem out of place in a formal portrait the way fear or surprise might.

It would certainly have a compelling effect. Part of the fascination of a portrait is our interest in drawing conclusions from the face about personality of the sitter. This does not happen if an extreme expression is portrayed, as we often see intense expressions as temporary events, in a sense *masking* the person beneath. With slight sadness, we feel the personality lies much closer to the surface. (Even a perfectly neutral, relaxed face will inspire all sorts of conjecture about the personality of the subject. The artist has limited input about the form such conjecture might take; with no expression visible, a face becomes a blank slate for the observer to project on: compassion, anger, intelligence, passivity—whatever mood the observer might be feeling at the time.)

Extreme expressions are responses to extreme events. Passionate faces full of anguish or anger appear in narrative, action paintings. Portraits, focusing as they usually do on individuals in a neutral setting, suggest a quieter expression. A touch of melancholy hovers over all the following faces. It is an expression that seems at home in a portrait, suggesting the course of thought of someone left to oneself, to one's own sad musings.

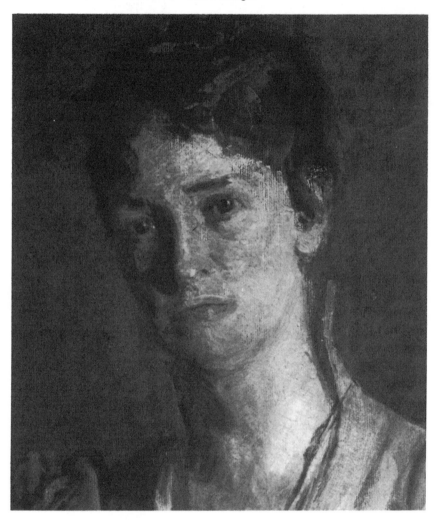

When do we cross the borderline from "slightly sad" to "neutral"? This portrait by Thomas Eakins is on the margin between the two and is capable of being viewed either way, depending on who is doing the viewing and in what particular mood the viewer is. Many of Eakins's portraits have a similar air of vague, undefined distress about them—part of the reason we find them so fascinating (and part of the reason he was not a sought-after portrait painter). Here the puzzle revolves, as usual, around the brow and mouth—is the brow on the right upturned; is the mouth slightly pressed upward from below?

Mary Cassat's portrait of a little girl depicts a very distinct pout. And yet the mouth has very little to do with it. The mouth is ambiguous—the lip line is wrong for a pout (it doesn't rise in the middle); the under-the-lip detail is more suggestive. What clinches the expression is the eye on the right and its brow. Looked at by itself, the eye and brow appear sad—the brow is upturned, the upper lid oblique. The other eye and brow are neutral (the brow is borderline); but in this case, one active side is enough.

How clearly the image of the elderly Rembrandt, weighed down (we suppose) by his domestic and financial difficulties, is embedded in our minds. This is one of the sadder of the late self-portraits; I find something terribly affecting about the tired, sagging lines under his eyes. The movements and wrinkles of the brow of grief are painted with a knowing eye.

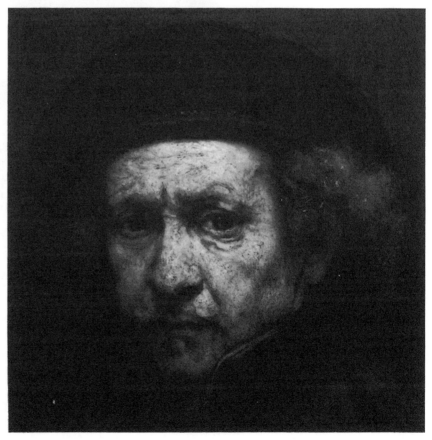

A. Shallow, diagonal crease due to corrugator.
B. Dimple at corrugator skin insertion.
C. Horizontal middle-brow folds.
D. Frown lines.

Sadness lends itself well to understatement, and understatement works well in portraiture. This portrait by Hilary Holmes has no pout, no signature wrinkles, and only one feature that is not neutral—the two, slightly bent eyebrows. The artist said he perceived an expression of "noble melancholy" after the sitter lost a close friend.

In Caravaggio's interpretation, the response of Christ to his betrayal is sadness. His passive acceptance of his arrest and downward gaze lead us to see resignation in his face as well. Deep shadows filling his eye sockets make more emphatic the angular direction of the brows above; horizontal frontalis creases appear across his middle brow (**A**). The expression of Judas, giving the kiss, is harder to read; his brow and forehead suggest fear—his eyes do not.

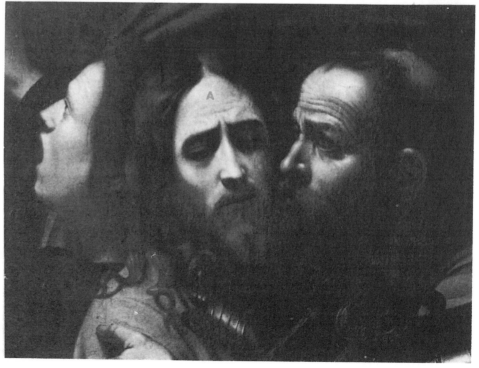

This sculpture, part of a series of remarkable self-portraits by Nancy Fried, is an excellent example of the open-mouthed cry.

SUMMARY

Sadness is the most lingering emotion in more ways than one. Emotionally, it can take a long, long time to get over a great loss, like the death of a loved one. No other emotion can stay with us so tenaciously. Sadness can also be persistent as an expression, resting like a shadow on the face, long after other, more fleeting expressions have faded.

The eyebrows are involved in every level of sadness. In sadness, they're bent upward, in crying pulled downward. But when sadness is at its most extreme, the eyes are the key feature —how tightly they're squeezed determines the intensity we sense in the cry. Though the eyes are always squeezed shut, only rarely do we cry outright, with mouth wide. More typical of the act of weeping is a closed mouth with tight lips pressed from below, pulled toward the sides, and lifted from above. Crying is a spasmodic action, and the mouth takes the brunt of its force.

As the cry ceases, the first thing on the face to relax is the eye-circling muscle, the oribicularis oculi. When it slackens, the forehead muscle, frontalis, contracts, and the forehead becomes creased and troubled looking, the result of the frontalis and corrugator pulling at the inner end of the eyebrow in the opposite directions.

For a time, the lip-stretching muscle —risorius/platysma—refuses to relax, giving the face the look of someone about to burst into tears. When we've calmed enough for it to lose its tension, the pout and squared upper lip remain, along with the troubled brow. The strong pull of the brow may reshape the upper eyelid, and the lower lid may be slightly raised; the narrowed lids give the eye a withdrawn, inward look. Downcast eyes are also common.

Finally, all outward signs disappear from the face except the changes in the eyebrow. The slight, sudden twist upward at its inner end is different with every face; just on its own, it can make the entire face look gloomy.

The basis of the crying code is a stretched mouth and compressed eyes; the sadness code is based on the pout and the upturned eyebrow.

THE EXPRESSION OF ANGER

Anger is a flash emotion, one that can arise and depart suddenly. It often requires a physical outlet, some action to serve as an energy release, even if it is just letting loose verbally. No other emotion is so closely tied to strong physical action, and no other emotion, in its extreme form, is so potentially dangerous.

Surprisingly, for such a blatant, physical emotion, the look of anger in the face depends on a tiny detail—the wideness of the eye. There is a direct, simple relationship between the lifting of the upper lid and the perception of anger: the higher the lid is raised, the angrier we look. When seen with the lowered brow, the eye acquires a penetrating, intense look—the glare. No other aspect of anger has anywhere near as much control over the intensity we see on the face, but the glaring eye alone won't do it; it must be combined with an angry mouth for anger to be evident.

SUPPRESSING ANGER

It is entirely possible to be angry without it being evident in our face. In our society, there are very complicated rules for when it is and is not appropriate to express anger. Factors like sex, social class, temperament, relationship to the object of anger, and fear of retaliation, all act to inhibit the free expression of our angry feelings. There are far fewer restrictions inhibiting the expression of many other emotions, like surprise, laughter, or sorrow.

As a result, many people, even when enraged, rarely if ever show "full-face" anger. If anger is partly suppressed, it may be evident only in part of the face or not at all.

What Parts of the Face Can Show

When a person is angry, someone who knows that person well will certainly be aware of it, no matter what shows on the face. The first sign of anger is often a change in tone of voice. Actions may be more abrupt, posture more tense. Clear signs of anger in the face may appear only when someone is *really* angry.

Subtle anger can be shown in a picture if the action and context is very clear; that is, if we expect to see anger, we will read anger into a face in which we observe only part of the pattern—a lowered brow, a raised eyelid. In a portrait, however, just a lowered brow, just a firmly set mouth, or just widened eyes may be interpreted in a variety of ways, anger being low on the list of possibilities. Even if several anger cues are present, portraits of subtle anger are often seen more as a description of personality rather than expression; we see someone who is ill-tempered, grim, or *very* serious. When the anger signs are visible in only part of the face, interpretations range even further afield. An otherwise neutral face with lowered brows might be seen as thoughtful, perplexed, or intense—all states of mind well removed from the realm of emotion.

It's All in the Timing

In looking at photographs of people in clearly hot-tempered situations, it is striking how often there are few faces with clear signs of anger. Considering that such signs, particularly the widened, glaring eye, are often instantaneous events, it makes sense. It is chance whether or not the photographer captures the most telling moment; the painter, of course, can *choose* to capture it. Timing is an area where the painter has a clear advantage over the photographer.

THE FACE OF RAGE: OPEN-MOUTHED ANGER

You can be shouting mad, and you can be tight-lipped mad. The most fearsome angry faces are those with the mouth open in a snarl or shaped around a scream of fury.

Rage—anger at its peak—seems almost inseparable from the action of expressing it, either verbally, physically, or both. The impulse to do something, to lash out, is likely a throwback to more primitive times, when anger may have led to physical struggle more often than now.

Because being enraged is such an energetic state, the expression of it is never static. The features are in constant motion, particularly when the angered person is shouting. This creates a situation where the pictorial artist must choose the most telling moment out of a succession of moments, each one somewhat different in appearance. When speaking or shouting, the mouth takes on a variety of positions. The various positions of the mouth have certain things in common, particularly the tenseness of the lips and the exposure of the teeth.

The upper face also goes through many changes in the course of, say, an angry tirade. At times it may be tightened in by the eye-clenching muscle and the lowered brow; at other times the eye may be open wide and glaring. Artists most often choose the face of rage with wide, glaring eyes and a square, shouting mouth.

The expression of anger revolves around the eyes. The eyes widen in anger, and the wider they open, the angrier we look. What complicates matters slightly is the effect of the brow on the widened eye. Once the artist learns to account for this, great control over the expression of anger follows.

THE BROW VS. THE EYE: WHAT MAKES THE EYES LOOK INTENSE

1. Neutral. A man's eyes, with heavy eyebrows quite close to the top of the upper lid.

2. Brow down. Simple contraction of corrugator, pulling the brows slightly closer together and downward. Brows are lower than top of upper lid. This pushes down on upper lid, narrowing eye.

3. Eyes widened. The eyelid lifter has contracted. Its lift is strong enough to partly counteract the pressure of the brow, and eye opens wider. The combination of lowered brow plus widened eye creates the angry glare.

The glaring eyes of a woman. It is not necessary for white to show above the iris to recognize a glare—the iris, though, must be less than three-fourths covered by the upper lid. Upper eyelid line seems to run into eyebrow.

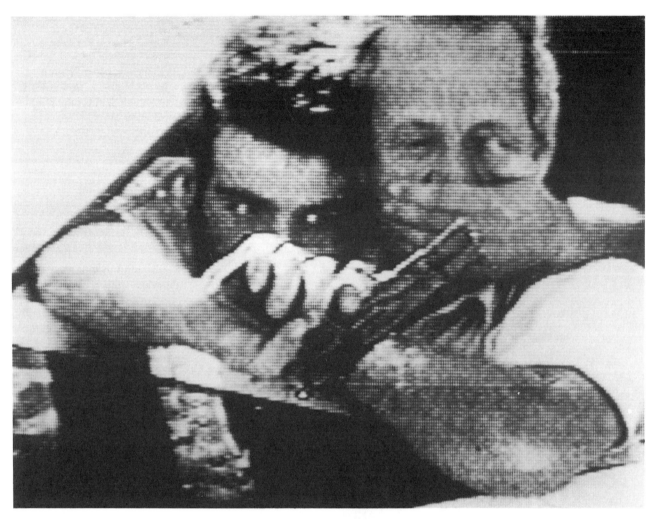

We don't need a lot of detail to read the expression in the gunman's eyes. They seem to glow out of the television fuzz, making even more sinister a sinister scene. Instinctively, we are reading the negative shapes of the eye whites as the signal of menace. The high contrast of the whites to the dark center of the eyes, and to the dark eyelid margin, allows the expressive shapes to communicate even at a distance.

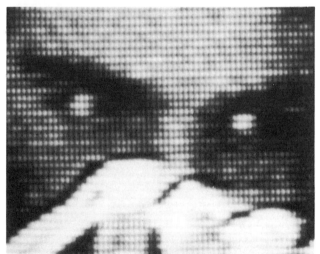

SHAPE OF EYE WHITE

NEUTRAL SHAPE

ANGRY SHAPE

SHAPE ALONE INDICATES WIDENED EYE,
LOWERED BROW, STRAIGHT LOWER LID.

The Face of Rage

In the most characteristic face of rage, three actions combine: (1) the brow lowers; (2) the upper eyelid opens wide, and the lower lid is tense; (3) the mouth is open and shouting, with a snarl in the upper lip and taut edges throughout

THE GLARE

The fact that the brows lower in anger must be one of the most commonly known facts about facial expression. According to Darwin, the lowering of the brow is a sure sign of an encounter with some difficulty. Darwin speculates that the gesture goes back to our primitive forebears, who used it to reduce glare when they were having difficulty seeing, and by extension this expression became a habit when encountering an obstruction of any sort.

Lowering the brow alone will not make the face look very angry. The unadorned frown can mean a lot of things: someone's confused (I see this on the faces of students when I haven't explained something very well), thoughtful, *or* angry. To create the face of anger, the lowered brow must be accompanied by a widened eye. The combination of the two elements creates the glare, and the glare is the key to how *angry* anger looks.

The glare widens the eye in spite of the upper lid being pushed down at the same time by the corrugated brow. When we look at an angry face, we unconsciously allow for the extra effort involved in raising the upper lid in anger. If iris is just barely or not quite covered by upper lid, we spot the glare.

An occasional feature of the angry eye, a taut, straightened lowered lid, seems to intensify and harden the gaze even further. When all three factors are at work—widened eye, lowered brow, tightened lower lid—we get the most malevolent effect.

THE OPEN MOUTH OF ANGER

What happens with the mouth in anger is a bit more complicated and a bit more variable. Complicated possibilities for lip positions abound. In spite of these variations, there are certain overall things about the mouth's appearance that will always be true:

1. The upper lip is lifted in a sneer. Dogs do it, cats do it, is there any reason why people shouldn't do it? The snarl of a dog or cat is equivalent to a police officer patting his or her billy club. By exposing their sharp teeth in the corner of the upper jaw, they're warning a potential opponent, "You see these?" Our angry sneer accomplishes much the same thing. Human canine teeth are passably sharp, and a strong action of the levator labii superioris exposes them to any and all interested parties. Open angry mouths are *always* lifted in a strong sneer.

In crying there's a sneer element too, but it's not the same sort of sneer. The cry involves the outer branch of the three-branched levator labii superioris, and that branch has a weaker action, one that avoids the nose and tends not to expose the upper teeth. The angry snarl uses the middle branch and some fibers of the inner branch, a much stronger pull that drags the upper lip straight up and back into the face and bares the upper teeth. Often the lift will be strongest directly above the canine teeth.

2. The lips are tightened, stretched, or both. The muscle of the lips, orbicularis oris, tightens the edge of the lips in loud speaking. Angry shouting is no different, and the lip muscle adds its action to the other actions present. You can demonstrate on yourself what happens if you sneer, then tighten the lips—the overall shape is maintained, but the red part of the lips shrinks, and the margins become much straighter. When the action of the orbicularis oris is strong, the lips will curl under themselves and become thinner.

The lower lip is often stretched horizontally by the risorius/platysma. The risorius/platysma and the orbicularis oris do not seem to contract strongly at the same time; if the action of one is intense, the contraction of the other is weak. When the risorius/platysma is weaker, the lower lip dips downward; when it's stronger, the lower lip is straight across.

3. The lower teeth are exposed. Often, the lower lip depressor pulls the lip down, showing the lower teeth. This is another action linked to speech. If the lip depressor isn't showing the lower teeth, risorius/platysma will be.

4. The corner of the mouth stays low. In a smile, the corner of the mouth is pulled sideways, back into the face, and upward; in the angry mouth, no matter which version, the corner is pulled sideways, and somewhat back, but not at all *up*. The corner stays low, around the level of the lower row of teeth.

5. The overall shape is square, with lots of teeth.

Keep in mind that none of these actions, by themselves, will clearly suggest anger. In combination with the glaring eyes and brow, the open, tensed mouth, with its strong sense of a snarl, presents us with what we recognize as the face of rage.

OPEN MOUTH, CLENCHED TEETH

Since anger is so closely related to physical effort, there are times when the anger pattern in the upper face is combined with the clenched-teeth pattern in the lower. There are only two situations in which clenched teeth appear in expressions: physical pain and strenuous physical effort (the two are closely related). Gnashing the teeth together seems to release tension.

Showing the teeth when the jaw is *shut* takes a fair amount of muscular effort (and it is also uncomfortable). If you stand in front of a mirror and try it, you'll discover that you automatically enlist the sneering muscle to bare the upper teeth—there's no other way to do it. And you'll find there are only two ways to show the lower teeth—using the lower lip depressor to pull the lower lip down or using risorius/platysma to stretch it sideways—or some combination of the two. The clenched-teeth look combines with the glare when someone is enraged and engaged in a physical struggle.

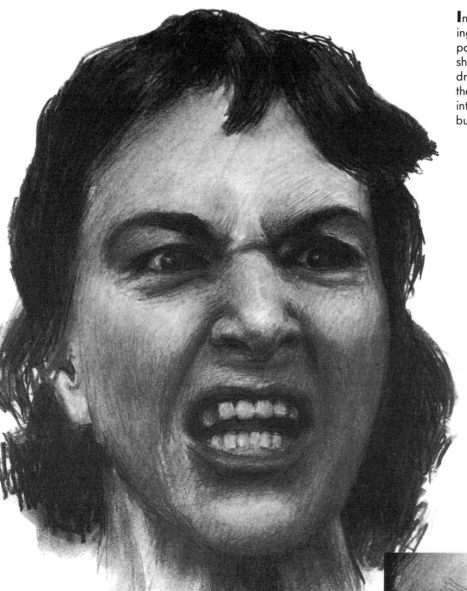

In the expression of rage, fierce, glaring eyes are almost always accompanied by a mouth shaped for shouting: lips tensed, teeth bared, jaw dropped. Even the nose contributes to the angry look. Not only is it distorted into a sneer by the sneering muscle, but its nostrils have flared.

MUSCLES INVOLVED

A. Corrugator.
B. Orbicularis oculi (eyelid portion).
C. Levator palpebrae superioris.
D. Levator labii superioris.
E. Orbicularis oris (lip portion only).
F. Depressor labii inferioris.

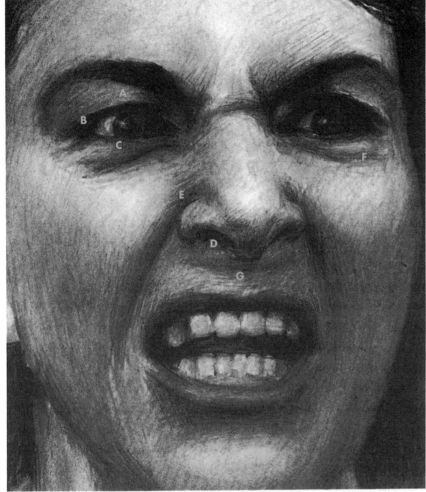

ANGER

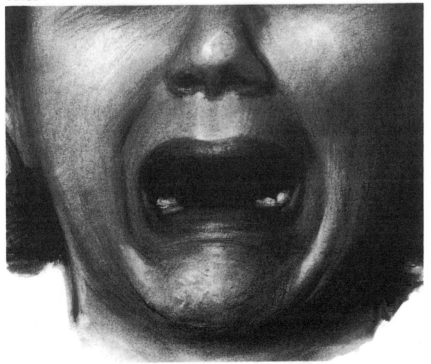

SADNESS

THE EYES AND BROW

Corrugator contraction pulls a horizontal fold (**A**) across the upper lid. (A similar fold in sadness angles upward.) Though the upper lid (**B**) line is cut off by the across-the-eyelid fold, we mentally complete its arc, observing that if extended, it would pass well above the iris. The straightness of the lower lid (**C**) adds a harsh, staring quality to the eye. Its shape is due to the contraction of the eyelid portion of the orbicularis oculi.

THE NOSE AND CHEEKS

There are three branches to the sneering muscle. In crying, most of the work of lifting the upper lip is done by the cheekbone branch, which avoids the nose. In the mouth of anger, the lift shifts to the middle and inner branches. The nose is completely reshaped, lifted up into a sneer by the wings, giving it a pointed look. Nostrils are flared (**D**). A deep crease with pocket above appears alongside (**E**). The cheeks puff; bags appear under the eyes (**F**), and a little wrinkle appears above the upper lip (**G**).

THE SHOUTING MOUTH: VERSION 1

When someone is angry and shouting, the mouth seems to compromise between the proper shape for the production of lots of noise and a desire to expose the upper, biting teeth. "Biting" involves the sneering muscle (top)—the upward pull of the lip off the upper teeth. This may have evolved from a real threat to use the teeth, as in the lip-curling snarl of an angry dog or cat. "Producing lots of noise" requires shaping the lips for speech. The depressor labii inferioris and the orbicularis oris are working together here (bottom). The depressor labii is pulling the lower lip down in a U shape, exposing the lower teeth and gums. The orbicularis oris is contracting, giving the lips a straight, tight edge, important in loud speech. It curls the lips in on themselves; their tension makes both the sneer (top) and the lower-lip pull (middle) less obvious than otherwise.

ACTION OF SNEERING MUSCLE

ACTION OF LIP DEPRESSOR

Shouting mouth version 1: The angry mouth shows lots of teeth.

You don't need two eyes to look angry. The basic anger code—wide eyes, lowered brow, and shouting mouth—is equally as recognizable on the face of a one-eyed monster as on a human face. Legendary animator Ray Harryhausen's cyclops resembles the woman pictured below; its single eyebrow, for example, looks like hers would if they were joined in the middle. The exaggerated glare is calculated; cover the upper rim of the iris and note how much less furious the cyclops seems.

Using anatomy as a decorative element, this mask from the Japanese Noh theater makes a design out of the signature wrinkles of the corrugator. The V shape in the center of the forehead is a designer version of the frown lines. The cashew-shaped bulge at the inner end of the eyebrow is interpreted as a sweeping, curved form, repeated in the moustache and nose curves. The mouth is speaking in anger, with lip edges thinned. The widening of the eyes under the lowered brow is clear.

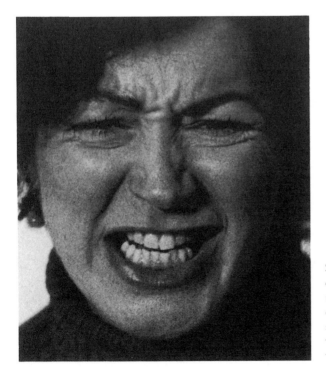

Simply because an expression exists does not mean that it's effective in a picture. Though this is a picture of an angry person, she is captured at a stage of shouting, with eyes squinting, where our most important cue, the widened eyes, is missing.

THE SHOUTING MOUTH: VERSION 2

Though the eyes vary little in rage, the mouth takes a variety of positions. In every case, the upper lip is lifted in a sneer, exposing the upper teeth. The lower teeth show as well, either by the dropping of the lower lip or by the sideways stretching of the lower lip. The net effect is always the same: a squarish mouth, bristling with teeth and with a strong sense of a snarl, framed by continuous nose-to-chin folds.

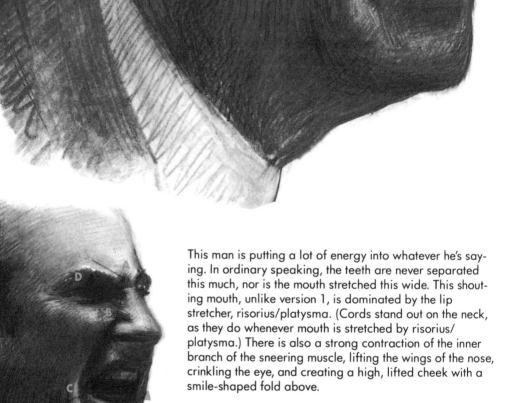

This man is putting a lot of energy into whatever he's saying. In ordinary speaking, the teeth are never separated this much, nor is the mouth stretched this wide. This shouting mouth, unlike version 1, is dominated by the lip stretcher, risorius/platysma. (Cords stand out on the neck, as they do whenever mouth is stretched by risorius/platysma.) There is also a strong contraction of the inner branch of the sneering muscle, lifting the wings of the nose, crinkling the eye, and creating a high, lifted cheek with a smile-shaped fold above.

A. Action of corrugator.
B. Action of levator labii superioris (middle and inner branches).
C. Action of risorius/platysma.
D. Action of levator palpebrae.

THE SHOUTING MOUTH: VERSION 2

The stretched-mouth shout has a shape that apparently lends itself to simplification—in the hands of a cartoonist, it becomes a rectangle with teeth. Real life is more complex; the little girl (below) shows an angry mouth that compromises between versions 1 and 2.

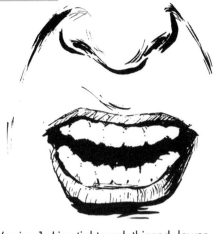

Version 1: Lips tightened, thinned; lower lip pulled downward. Slightly oval look to mouth shape.

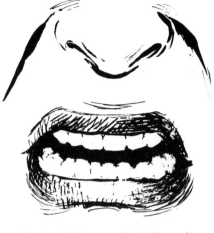

Version 2: Lips stretched; lower lip stretched sideways, not downward. Squared-off look to mouth shape.

Copyright © 1985 Marvel Entertainment Group, Inc. All Rights Reserved.

The square shape of the shout is nearly rectangular in this simplified version, with clear nasolabial fold. Upper lid arches high and disappears behind lowered brow. Vertical, not horizontal, forehead folds are in anger pattern.

Drawing by Stevenson; © 1984 The New Yorker Magazine, Inc.

The face of a furious four-year-old. Both risorius/platysma and lip depressor muscles are active, but neither is fully contracted. Mouth takes compromise position—note dip downward in lower corner (**A**), shown nicely in cartoon mouth at (**B**).

One form stands for two: lowered eyebrow is combined with across-the-lid fold. Note also (**1**) suggestion of tight lower lid.

"Wrong number? This never happened with Ma Bell!"

Same expression—even simpler square mouth. Outer curve of the eyeline, rising as high as it does (**2**), cleverly suggests and exaggerates effect of raised, partly hidden upper eyelid. This is the rage pattern reduced to absolute essentials.

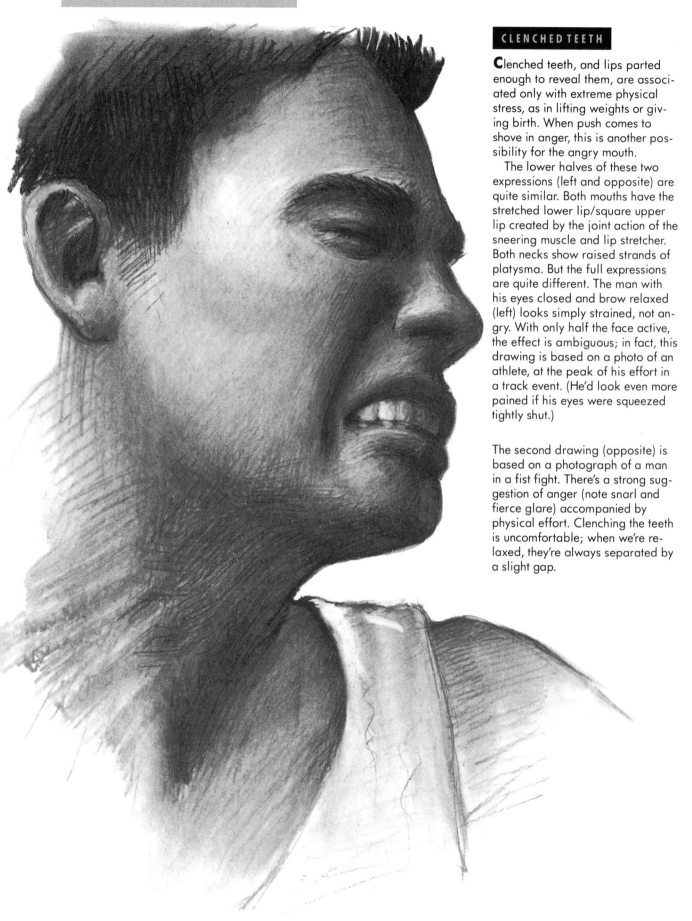

CLENCHED TEETH

Clenched teeth, and lips parted enough to reveal them, are associated only with extreme physical stress, as in lifting weights or giving birth. When push comes to shove in anger, this is another possibility for the angry mouth.

The lower halves of these two expressions (left and opposite) are quite similar. Both mouths have the stretched lower lip/square upper lip created by the joint action of the sneering muscle and lip stretcher. Both necks show raised strands of platysma. But the full expressions are quite different. The man with his eyes closed and brow relaxed (left) looks simply strained, not angry. With only half the face active, the effect is ambiguous; in fact, this drawing is based on a photo of an athlete, at the peak of his effort in a track event. (He'd look even more pained if his eyes were squeezed tightly shut.)

The second drawing (opposite) is based on a photograph of a man in a fist fight. There's a strong suggestion of anger (note snarl and fierce glare) accompanied by physical effort. Clenching the teeth is uncomfortable; when we're relaxed, they're always separated by a slight gap.

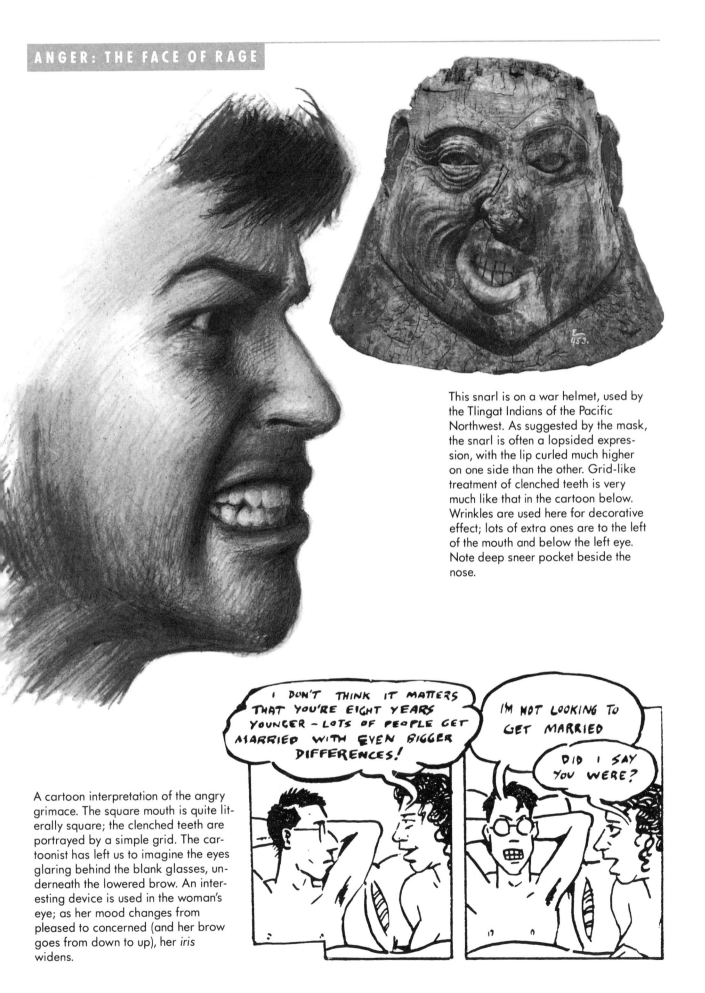

This snarl is on a war helmet, used by the Tlingat Indians of the Pacific Northwest. As suggested by the mask, the snarl is often a lopsided expression, with the lip curled much higher on one side than the other. Grid-like treatment of clenched teeth is very much like that in the cartoon below. Wrinkles are used here for decorative effect; lots of extra ones are to the left of the mouth and below the left eye. Note deep sneer pocket beside the nose.

A cartoon interpretation of the angry grimace. The square mouth is quite literally square; the clenched teeth are portrayed by a simple grid. The cartoonist has left us to imagine the eyes glaring behind the blank glasses, underneath the lowered brow. An interesting device is used in the woman's eye; as her mood changes from pleased to concerned (and her brow goes from down to up), her *iris* widens.

I DON'T THINK IT MATTERS THAT YOU'RE EIGHT YEARS YOUNGER – LOTS OF PEOPLE GET MARRIED WITH EVEN BIGGER DIFFERENCES!

I'M NOT LOOKING TO GET MARRIED

DID I SAY YOU WERE?

With anger, you either capture it precisely or not at all. Bearing that in mind, it's instructive to compare these two copies of a lost Leonardo painting, one by Lorenzo Zacchia, the other by Peter Paul Reubens. Reubens clearly was far more familiar than Zacchia with the key element of anger—the aroused, widened eye.

THE DIFFERENCE IN THE EYES

Reubens's copy captures the emotion of rage by paying attention to detail; Zacchia's lackluster copy glosses over the fine points. Zacchia's soldier (**A**), for example, merely has his mouth open with his eye vague. The same eye in Reubens's (**B**), with its intense glare, energizes the entire expression. The difference between the horses' eyes is even more striking. Reubens has achieved furious looks at (**C**) and (**D**) by showing lots of eye white above the iris, while at the same time suggesting an eyebrow (which horses actually lack), lowered and overlapping the top of the eye. Compare with the dead looks at (**E**) and (**F**).

THE DIFFERENCE IN THE MOUTHS

It's also instructive to compare the two artists' treatment of the angry mouth and cheeks. In Reubens's drawing, the mouth (**G**) is far more stretched sideways (by risorius/platysma) with a far more evident sneer than Zacchia's rendering (**H**). Note also Reubens's careful suggestion of the upper and lower teeth, missing in Zacchia's, and the glowering eye of the same face—it has a lowered brow but no fire at all in Zacchia's. It is no coincidence that the greatest painters have also been the most skillful masters of facial expression.

SCREAMING MEN

Dramatic confrontations and screams of rage. Sadness is a solitary, withdrawn emotion; being furious is a state of engagement and conflict. We express rage with our entire body—head thrust forward on the neck, arms and hands gesticulating. These images have those things and more in common—the mouth shapes, the brows, and in two of the images, the ridge-lined necks.

Messianic would be a good word to describe the face of the angry John Brown in John Stuart Curry's mural. Not only the face and arms but the beard and hair become part of the expression, their agitated waves repeated in the flag and sky. Curry was well aware of the power of the whites of the eyes; in a mural meant to be seen from a distance, he exaggerated their size and shape, and lightened their tone, making their contrast with the dark brows the most intense spot, and therefore the focal point, of the entire painting. Anatomically, we might question two details: the missing upper front teeth (which always show in the angry shout) and the emphatic horizontal brow ridges. The brow creases may be meant to repeat yet again the wave motif.

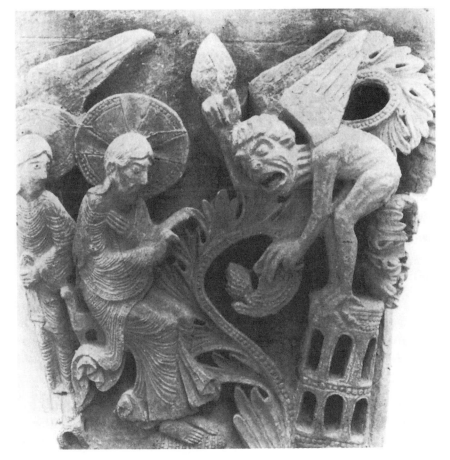

Medieval art is full of surprises. This Romanesque carving, a column capital from twelfth-century France, has a threatening, furious devil. Most curious is the way the artist has depicted the ridges of platysma in the neck (it always contracts in a wide-mouthed shout) as square-sided, decorative bands (**A**). The expression of Christ, whose stone face is much the worse for wear, is indecipherable; his disciple, however, looks a bit nervous.

The power of a vivid expression can produce an image that, in its intensity, becomes part of our collective experience. Of course, this picture has more than expression going for it; the composition would do an old master proud: the line of the billy club leading up to the contorted face and hands; the way the very expressive hands emerge out of the dark background; the faceless bulk of the policeman in the foreground—everything works. Note the sharp columns of the contracted platysma in the demonstrator's neck.

Action of the inner branch of sneer muscle is strong—note the squinting eyes and sharp folds under lids (**B**). The mouth shows strong action of the orbicularis oris (taut lips), lip depressor, and lip stretcher, whose action triggers cords in neck (**C**).

CLOSED-MOUTH ANGER

When we aren't yelling at somebody we're furious with, we're going to be showing that anger nonetheless. All that energy has to go somewhere. Rather than baring our teeth in a snarl, however, we're more likely to be pressing our lips together in a fashion almost as threatening: the tight-lipped look. Though less is happening verbally when we're glowering at someone with our lips pursed, the sense of an impending explosion can be strong; in some ways, that may be worse.

When tight lips combine with glaring eyes, we might describe the resulting face as furious, irate, or just plain angry.

The Irate Look: Compressed Mouth

In the irate look, we again confront muscular effort being expended in an effort to *prevent* something from happening—to prevent the mouth from opening into a shout. This is an unconscious effort, of course. The mentalis, the triangularis, and the orbicularis oris work together to compress the mouth. The "three-muscle press" that results narrows the lips, wrinkles the chin, and creates a sense of bulging all around the mouth, especially below.

The sneer aspect of anger is here very subtle; that is, it's not very strong. The sneer muscle is only active enough to slightly deepen the crease alongside the nose.

The Irate Look: Glaring Eyes

By now it should be clear that the main variable in the eyes of anger is *not* the strength with which someone pulls down the eyebrows; in fact, so long as there is a noticeable contraction of the corrugator, no extra amount of contraction will make any difference, as far as the expression goes. If you're a parent scolding a child, don't waste your time furrowing your brow extra hard if you want to make an impression; it won't make your threats any more threatening. Nor will you frighten your child with an extreme version of the lip clench; combining a stern lowered brow and a tight lip clench might just get you laughed at.

The only thing capable of tipping the scales and really putting the fear into a loved one (and sending him or her running to clean up their room) is the little levator palpabral—the muscle that puts the extra lift on the upper lid, widening the eye in combination with the lowered brow, creating the baleful glare.

ANGER: COMPRESSED LIPS

We can understand why when mothers get angry with children, there's a level of restraint in their expression of anger. Restraint as expressed in the face usually means the strong, lip-pressing contraction of orbicularis oris. But the compressed mouth may also relieve nervous energy in the same way as clenched teeth or a squinting eye.

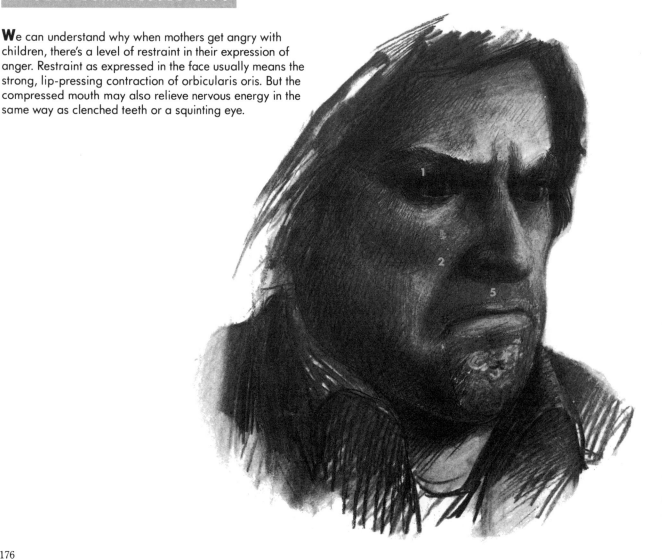

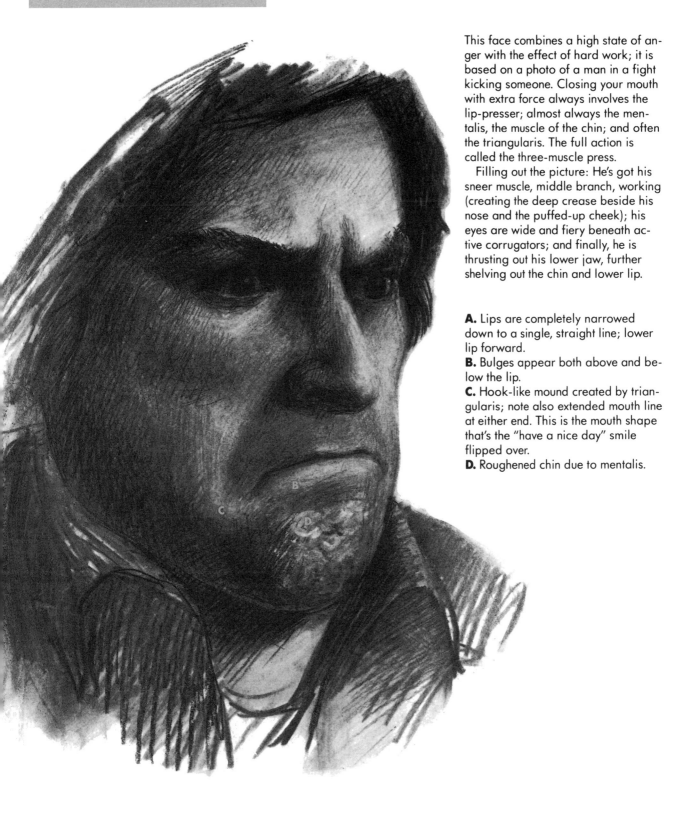

This face combines a high state of anger with the effect of hard work; it is based on a photo of a man in a fight kicking someone. Closing your mouth with extra force always involves the lip-presser; almost always the mentalis, the muscle of the chin; and often the triangularis. The full action is called the three-muscle press.

Filling out the picture: He's got his sneer muscle, middle branch, working (creating the deep crease beside his nose and the puffed-up cheek); his eyes are wide and fiery beneath active corrugators; and finally, he is thrusting out his lower jaw, further shelving out the chin and lower lip.

A. Lips are completely narrowed down to a single, straight line; lower lip forward.
B. Bulges appear both above and below the lip.
C. Hook-like mound created by triangularis; note also extended mouth line at either end. This is the mouth shape that's the "have a nice day" smile flipped over.
D. Roughened chin due to mentalis.

1. Action of levator palpebrae.
2. Action of levator labii superioris.
3. Action of triangularis.
4. Action of mentalis.
5. Action of orbicularis oris.
6. Action of corrugator.

Though the sneer is almost gone, the anger remains. But tight-lipped anger could be tight-lipped anything without the widened eyes and the lowered brow. By itself, the mouth of the woman (right) could be that of nervousness or concentration. Add lowered brows, and she might look determined; the full expression requires the glaring eye.

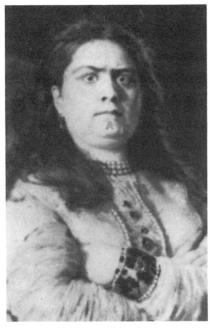

Ilya Repin painted Sophia Alexeevna glowering from the shadows, expressing her mood with lowered brow (note frown lines) and glaring eyes. Her mouth is less compressed than that in the picture above, but the expression in her eyes is so strong we assume her mouth is tight, taking the hints of bulging below and slight pushing forward of her lower lip (**A**).

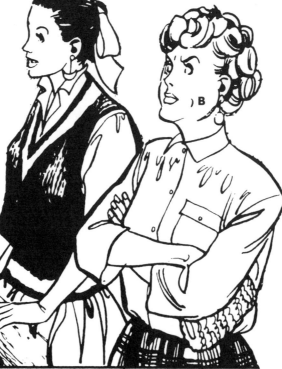

An irate woman from the newspaper comic strip *Mary Worth*. Besides the tucked-in arms, the artist has emphasized her anger with her stiff posture and out-thrust chin. Wide eyes and corrugated brows are clear, but the mouth is nearly neutral, with slight squaring of upper lip, and a suggestion of the triangularis bulge (**B**).

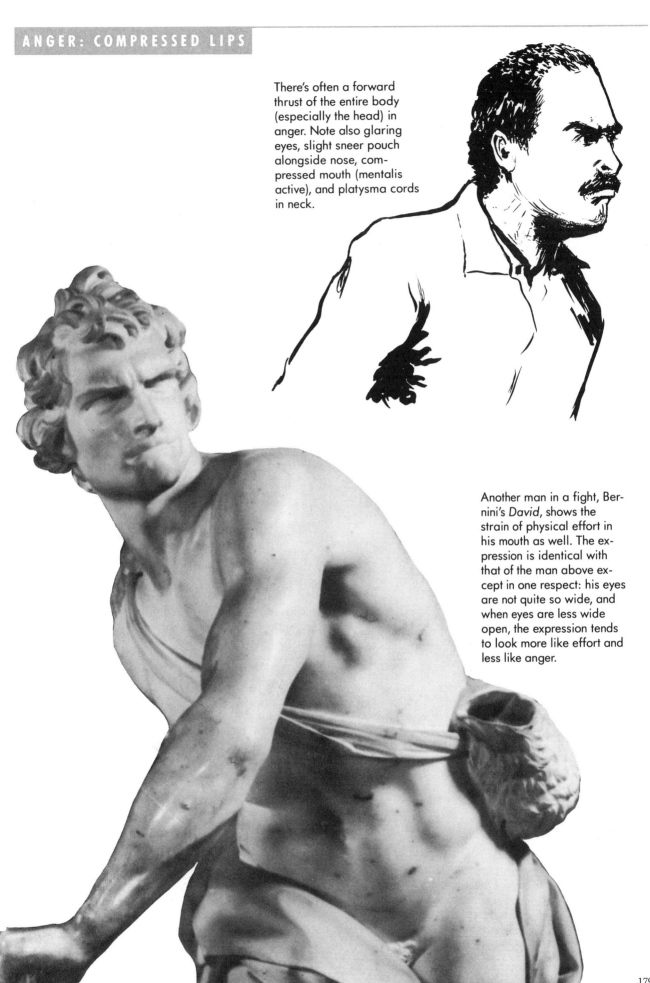

There's often a forward thrust of the entire body (especially the head) in anger. Note also glaring eyes, slight sneer pouch alongside nose, compressed mouth (mentalis active), and platysma cords in neck.

Another man in a fight, Bernini's *David*, shows the strain of physical effort in his mouth as well. The expression is identical with that of the man above except in one respect: his eyes are not quite so wide, and when eyes are less wide open, the expression tends to look more like effort and less like anger.

179

Anger on the wane? As shouting dies down and the mouth relaxes, it becomes harder to tell from a picture if someone's angry. Here, we retain the flashing eyes, but lose the matching level of intensity in the mouth. Because there is less agreement between mouth and eyes, the face looks more ambiguous, less mad.

The woman below is seen by many people as angry, although it is often expressed as anger *and* something. The message is mixed because the eyes carry the weight: her mouth may be angry; then again, maybe not. Also, there's no action of the sneering muscle, so no nasolabial fold, no puffed cheeks.

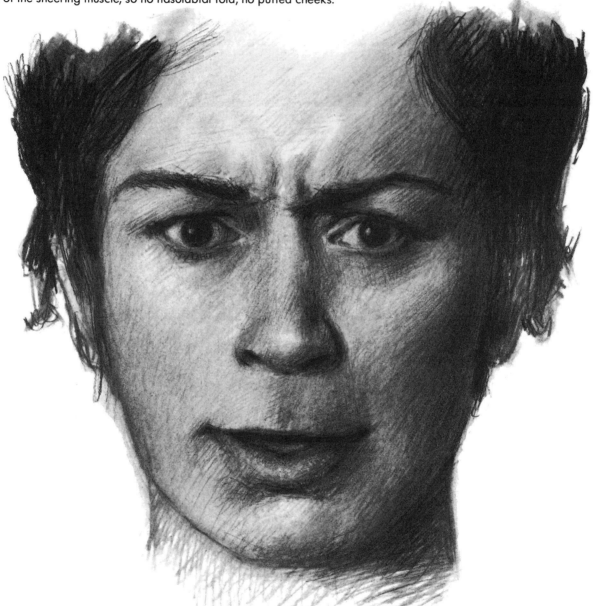

THE MOUTH

In faces of rage, the open mouth is pulled upward by the sneering muscle and down- or outward by risorius/platysma or the lip depressor. Here the mouth's open only a bit; clearest change from a neutral open mouth is narrowed upper lip, owing to contraction of just half of orbicularis oris. Her mouth doesn't look too angry; cover the eyes and she could just be having a conversation.

THE EYES

The eyes tip the scales. The brows are very strongly contracted, and the upper lids are partly covered by the horizontal across-the-lid fold. Given the strong lowering activity of the brow, the irises appear particularly intensified. And since the mouth could be speaking in anger, we tend to interpret it as angry. This is another example of one feature weighing our emotional perception of another.

"Get that person out of here!" This drawing is based on a backstage photo of a performer demanding to be rid of an unwelcome visitor. The suggestion of sneer in the upper lip is strong enough, however, so that some have read this first as disgust, second as anger, but in disgust, the eyes are neutral. Here, we clearly read the presence of corrugator contraction from the trajectory of the eyebrow; that, combined with the white showing above the iris, leads us to see her eyes as glaring and her face as angry. Thus the sneer becomes a snarl; in fact, this is a picture of the moment before a scream, with the lip caught in the first stage of its lifting action. Note crease alongside nose created by contraction of sneering muscle.

The eyes make this warrior mask look fierce. The relaxed brow may slant downward, but never enough so that it crosses below top of the eye. The eyebrow slant is combined with eyes with plenty of white above the iris. Eyes this intense, combined with the aggressive gesture, don't need much assistance from the mouth; it's slightly squared, as with woman above.

Anger at its Minimum: Is it or Isn't it?

People who are mad, but not furious, often have expressions that are harder to read. All the faces up to this point have included intensified, widened eyes. When the little upper-lid muscle loses its extra tension, and the upper lid its extra lift, faces with the other characteristic signs of anger—lowered brows and pressed lips but no widened eye—are seen somewhat differently. Without the glare, we might still feel a face looks angry; but what's even more likely is that we sense instead a mood with a *potential* for anger.

The Shape of the Mouth

The face of threshold anger is based on the combination of lowered eyebrows with compressed lips. If either element is missing, the effect is lost. The lowered brows caused by the contraction of corrugator are simple enough, but the compressed mouth, as usual, can take a variety of forms.

The mouth's form depends on the relative strength of the contraction of the three muscles that can compress the lips: mentalis, orbicularis oris, and triangularis. In the facial shrug, for example, the mentalis and the triangularis contract strongly, while the orbicularis oris remains relaxed. In the expression of threshold anger, a far more common combination is the strong contraction of the mentalis, and a moderate contraction of the or-bicularis oris, particularly in the upper lip, with a very weak triangularis action. The result of this muscle interaction is a thin, straight upper lip, a lower lip raised and forward and slightly pulled down corners of the mouth.

Men To Be Reckoned With

Unlike fury, the stern or forbidding look of threshold anger can be portrayed plausibly on the face of someone sitting for a portrait; like slight sadness, it's an expression we can imagine on the face of someone lost in thought. There is a long history, in fact, of this particular expression appearing in official portraits of men in authority. The English language is full of descriptive words for the image their portraits seem to convey: adamant, strict, dour, harsh, severe, stern, autocratic.

There's no doubt that the propaganda value of being a ruler with such an image is considerable. Nowadays we seem to prefer more genial public figures, but during times of war there is obviously more of a need to feel that someone tough is in command. During World War II, the Canadian photographer Yousef Karsh was so intent on eliciting a tough scowl from Winston Churchill that he took the enormous risk of leaning forward and yanking Churchill's cigar from his mouth as a provocation. Down came the eyebrows, up came the lower lip, and the resulting "bulldog" portrait made Karsh famous and was reproduced around the world. "Bulldog" portraits have been around since the time of the Roman empire. Busts of prominent Romans show men posed with contracting corrugators and compressed lips; these men obviously *wished* to be seen with such expressions. The Romans clearly thought there was something noble and impressive about the scowl; with such images of power empires are held together.

The ardent classicist Mantegna, whose Renaissance murals and paintings celebrate everything Roman, chose to do his self-portrait in a manner that seems inspired by the Roman portrait busts; the image of grim austerity seems also to agree with descriptions of his personality. More recently, the spirit of those tough-looking Romans has been used in the faces of anthropomorphic animals, like the proud lions on the front steps of the New York Public Library.

Rodin's *Thinker*, which appears on the front steps of more than one museum, demonstrates what happens when the scowl of anger/sternness becomes a little less pronounced: the face looks thoughtful, not angry. Without the cue of head on hand and meditative pose, the face looks perplexed. Even the perplexed look is linked to anger; the corrugator seems to act whenever we feel thwarted or frustrated, whenever we encounter some difficulty. Anger is merely a more intense version of being perplexed.

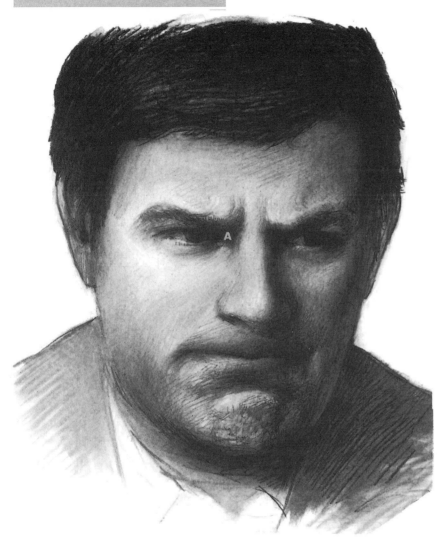

Like most expressions, anger at its least marked appears more like a mood than a momentary passion. The widened eye, the controlling feature of intense anger, doesn't last very long; changes expressive of mild states of anger, like a lowered brow and thinned lips, are more lingering. To most people, the man in the drawing (left) looks mad in a smoldering, frustrated way. The expression of the man below looks more like a permanent condition: we read the anger cues in his face as signs of a harsh, unyielding personality.

THE EYES

The irises are slightly more than half-covered by the upper lid. This is normal when the brows are lowered and the upper lid is not retracted. Note deep shadow (**A**), below shelf where contracted brow is most raised off surface of face.

THE MOUTH

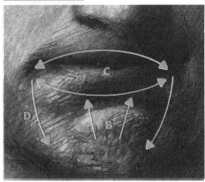

This is another example of the three-muscle press: mentalis in the chin (**B**), orbicularis oris curling the lips in on themselves and creating the bulge below (**C**), and the weak action of the triangularis (**D**), pulling the LBL corners down slightly.

STERN/HARSH

The grim face is that of Thaddeus Stevens, the Republican Speaker of the House who was most responsible for the severe treatment of the South after Lincoln's assassination. Perhaps he put on his nastiest scowl for the camera. The contraction of the corrugator in the brows is slight on our left, stronger on our right. The contraction of the mentalis, clearly visible in the chin (**A**), has pushed the lower lip upward and forward; the triangularis is pulling down the LBL corners (**B**); all this is being resisted by the upper half of the lip muscle thinning the upper lip (**C**) and keeping it straight.

183

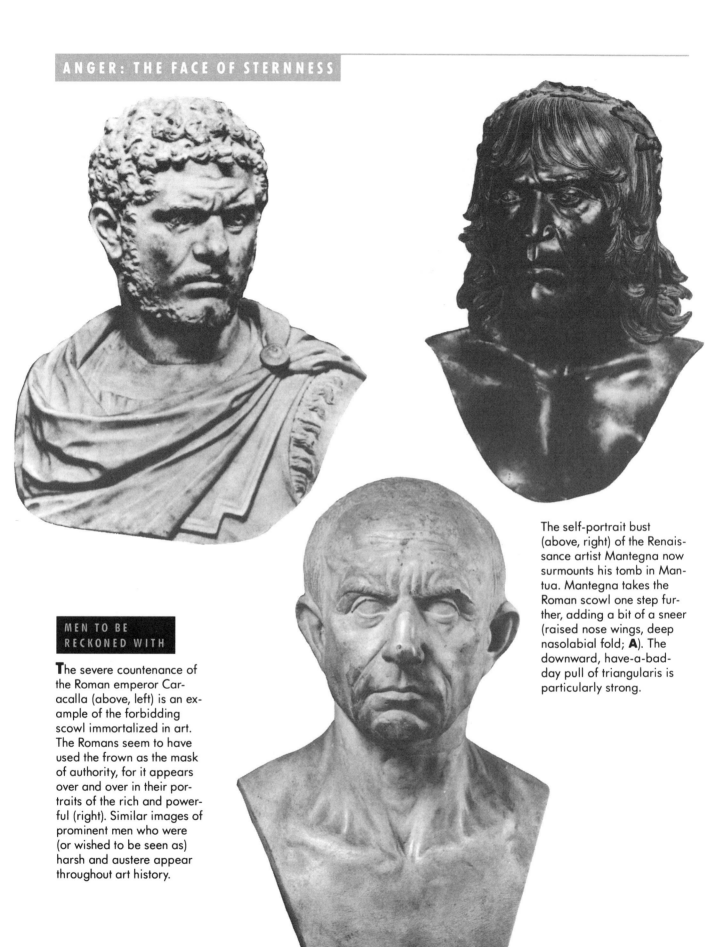

The severe countenance of the Roman emperor Caracalla (above, left) is an example of the forbidding scowl immortalized in art. The Romans seem to have used the frown as the mask of authority, for it appears over and over in their portraits of the rich and powerful (right). Similar images of prominent men who were (or wished to be seen as) harsh and austere appear throughout art history.

The self-portrait bust (above, right) of the Renaissance artist Mantegna now surmounts his tomb in Mantua. Mantegna takes the Roman scowl one step further, adding a bit of a sneer (raised nose wings, deep nasolabial fold; **A**). The downward, have-a-bad-day pull of triangularis is particularly strong.

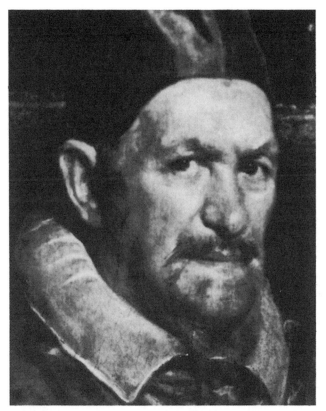

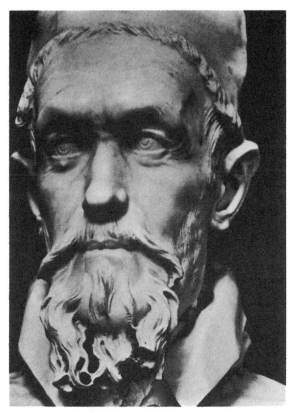

What's good enough for an emperor should be good enough for a Pope. Velázquez captured a face of powerful, calculating authority with his famous portrait of Pope Innocent X (left). It has the classic lowered brow and compressed lips. The action of these two elements is rather subtle; we know the brows are lowered because of their shape (too extreme to be natural) and because of their height (below the upper eyelid threshold). The mouth is even subtler: the middle of the lower lip disappears sud-denly, complementing a similar narrowing in the middle of the upper lip. The pressure of the lips is thus mostly in the middle; the visual clues are just enough to recognize the mouth as a participant in the face of sternness. In the Bernini portrait of the same Pope (right) the relaxed lips and neutral brow completely defuse the personality captured by Velázquez; the result is a bland "official" portrait. Ironically, Bernini was a great master of the sculpted expression.

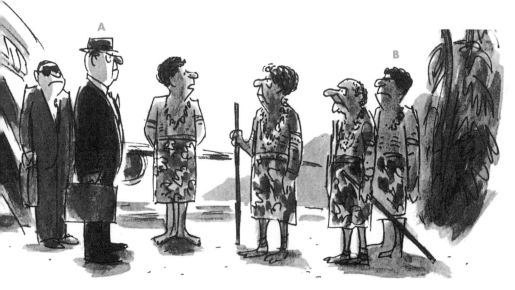

A cartoon version of authority figures wearing the stern/angry face. The artist, James Stevenson, clearly subscribes to the idea of the universality of expression, at least on both sides of the Pacific. Note the projection of the lower lip forward of the upper (the opposite is usually true) on figures **A** and **B**; this occurs when mentalis action is strong.

"The Ambassador says he does not care what we have heard—he speaks for both Secretary Weinberger and Secretary Shultz."

Drawing by Stevenson; © 1984 The New Yorker Magazine, Inc.

185

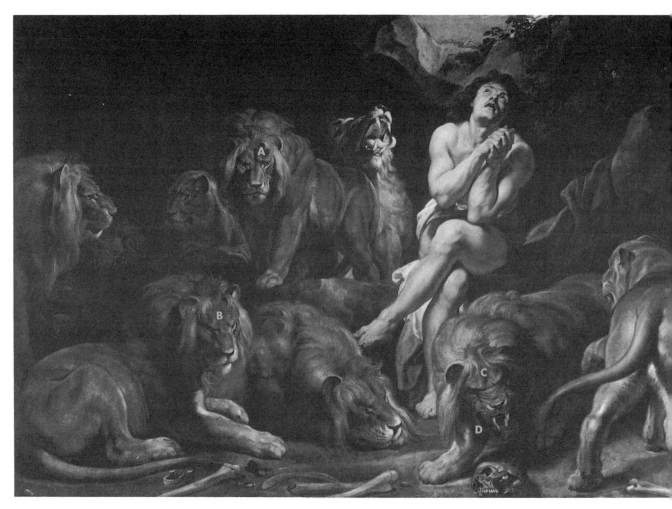

It's only natural (though incorrect) to assume that animals smile and scowl the same way we do. These are examples from the long, long history of transferring human expressions to the faces of beasts; in fact, there are no expressions (except, perhaps, the monkey's grin) that look just the same on them as on us.

It's a fair bet that neither Reubens nor any of his contemporaries had any idea what wild lions really looked like. We're still ready to find his lions fierce and threatening and may see nothing strange in the close resemblance to human faces of anger. The main device he uses is the suggestion of contracting corrugators and lowered brows (**A**, **B**, and **C**). No matter that lions don't even have such a corrugator. Snarl (**D**) is also closely based on a human model.

Though far less fierce-looking to our eyes, this is how an angry cat really looks. According to the artist, Charles R. Knight, an enraged tiger flattens its ears, opens its eyes wider, and snarls—it does not lower its brows.

THE SCOWLING BEAST

If you were an artist assigned to create a coat-of-arms for a beer label topped by a regal head of a horse, what better model for noble bearing (or noble arrogance) than the Roman portrait busts? The artist has solved the technical problem of clearly suggesting the frown by inventing heavy eyebrows for his imaginary horse to contract. Real horses (as in the Charles Knight drawing right) lack eyebrows entirely.

If a lion and a horse can do it, why not an eagle? Few animals are exempt from our humanizing impulse. This fierce, frowning eagle is a relic of New York's grand old Penn Station. The lowered brow has a curved, stylized line reminiscent of midcentury streamlining. Like the lowered brow on a human face, it throws the eye below into shadow.

SUMMARY

The main constant through all the faces of anger is the lowered eyebrows; nearly *all* angry faces have lowered eyebrows in common. The main variables are the wideness of the eyes and the openness or tightness of the mouth. The openness of the eye, as we've seen, is the crucial intensity control, and no depiction of anger can be convincing without special attention to the detailing of the eye. In rage, the upper lid has to have a high enough arc so that it clears, or nearly clears, the top of the iris. The wider the eye, the angrier the look; but given equally wide eyes, people who are shouting mad generally look angrier than people who show anger with tight lips.

At the lowest levels of full-face anger, the eye is no more than ordinarily opened, and the combination of lowered brow and compressed lips tends to be read more as a sort of strength of character than as out-and-out anger; this kind of expression of sternness/anger has appeared most often in portraiture. Any expression with a less-than-glaring eye may be interpreted as determination or thoughtfulness.

The angry mouth is the most tricky element to pin down. In shouting anger, the open mouth can take a variety of forms depending on what's being said. The lower lip varies the most; the upper lip is always raised in a snarl. The stretched lower lip position is the one that is the most clearly recognizable and simplest to depict. In closed-mouth anger, the mouth is compressed rather than stretched, and either the mentalis or the orbicularis oris will be dominant. If the orbicularis oris is stronger, the lips curl inward on themselves and disappear; if the mentalis is stronger, the lower lip becomes extra-prominent and is pushed upward and forward. The resistance of the orbicularis oris in the upper lip keeps the lips from being pushed up into a pout.

The key elements in the anger code are: lowered brows (which must drop below the top edge of the upper lids); widened eyes (to appear glaring, the iris must be no more than a quarter covered by the upper lid); and an active mouth, either open and showing lots of teeth or closed and tight.

THE EXPRESSION OF JOY

Babies may scream first, but they smile *second*. Infants generally begin to smile before they are quite two months old, making the smile the second human facial expression to appear. By the time a baby is conscious of its surroundings and learns to use its arms and legs, it has already mastered the facial responses expressive of the two most fundamental emotional states: pleasure and pain.

As we've seen, the baby's expression of pain and displeasure—the scream—is modified as a child matures into related but rather different ways of expressing anger and sadness. The smile that appears on the face of the two-month-old infant, however, does not differ in any significant respect from the smile of an eighty-five-year-old. Once we begin to smile, we always smile in the same fashion and always as a response to the same general state of mind.

Not only is the smile the expression that we carry the most intact from infancy to old age, it is also the facial expression that is the most universally appreciated and encouraged in all human societies. Though all six facial expressions can be said to transcend the barriers of language and culture, it is the smile and the laugh that will help us the most in virtually any cross-cultural encounter.

The smile is also *the* expression of nuance. There are more, and more subtle, emotional shadings possible with a smile than with any other expression. Smiles can contain elements of other expressions like sadness or anger, creating faces of fascinating ambiguity and complexity.

Like sadness, smiles can register as a powerful expression even when just barely visible on the face. Smiles can send a strong sexual message or tell us that the smiling person is drunk, or nervous, or even quite mad. Sometimes, smiles mean nothing at all. Unique among facial expressions, the smile is put on at appropriate occasions as a social gesture (though we know from photos where we have tried to smile on command how silly it can make us look) or as a professional pose.

Finally, some smiles are so subtle as to elude explanation; they mark the limit beyond which our cool analysis cannot go. We look at portraits by Vermeer or Rembrandt, and though the sensation we get is unmistakable, there are tantalizingly few apparent reasons for our responses, no easy way to explain the difference between a Vermeer smile and that of a near-imitator. We can illustrate certain things with our diagrams and descriptions, but mysteries, thank goodness, remain.

THE SMILE: HOW MANY MUSCLES?

Smiles are an efficient expression: no matter whether we are talking about a broad smile or a full-throated laugh, the same number of muscles are always involved: two.

And which two muscles, exactly, make a smile a smile? A specialist and a generalist. The specialist is the zygomatic major, which has the narrowest job description of any muscle of expression; its only function in the face is to pull the mouth into a smile. The generalist is the great circular muscle of the eye, orbicularis oculi; it plays many roles in many different expressions, such as crying, anger (tight lower lid), disgust, and pain. In the smile, the orbicularis oculi has an indispensable role: if it isn't part of the smile, the smile won't look happy. If we smile with just our mouth and our eyes are neutral, something is missing, something crucial to the warmth and charm of the expression.

THE SQUEEZED-UP EYE

Why is the crinkled-up eye so important to the sincerity of a smile? Because it tells the truth, and the mouth can lie. The narrowing and wrinkling of the eye is an *involuntary* action, in the category of sneezing or shivering, while the pulling of the mouth into a smile is a direct, *voluntary* action. We can smile no matter how we are feeling, but we can no more crinkle our eye on demand than cry on demand. That is, *most* of us cannot cry or laugh on cue; those that can have usually had professional training.

For the rest of us, the question then becomes, why does squinting have any connection at all to smiling? Why can't we smile a happy smile without a squint? Because we have a *reflex* that makes us squint when we laugh, and merely being pleased stirs the same reflex into action. The reflex is based on the role the contraction of orbicularis oculi, which creates the squint, plays in protecting the eye from inner stress.

The crucial part of this for artists is that we don't have to wait for the laugh to see the squint. The reflex loop is triggered whenever we feel pleased enough that a laugh may follow; in actual practice this means just about any time we're happy. But the sensation must be there or the reflex won't happen—we can't fool our own body. I can't sit here and create a happy squint just by thinking about it. But if a good friend or loved one walked into the room, smiling and joking, the reflex loop would click on, and the orbicularis oculi would begin to tighten in my eye, with all its characteristic forms and signature wrinkles. It's fascinating to watch this happen on people's faces and to watch the transformation that occurs.

The Key Elements in the Laugh and the Smile

A laugh is a smile with the mouth dropped open and the eyes closed. Because the expressions are so similar, we can look at them together. The key elements in both are the clenched eye, the stretched mouth, and the bunched cheeks.

THE EYE

As soon as a smile starts to happen, the eye starts to squint, and every stage of the smile and laugh is accompanied by a corresponding level of contraction of the muscle that squeezes the eye. If the squeeze isn't tight enough for the degree of the smile, we instinctively reject the smile as "phony." If the squeeze is too tight (very rare), the smile looks very peculiar as well.

In the full-blown laugh, the eye is squeezed shut gently by the contraction of the orbicularis oculi. In crying, the entire muscle is contracted, and the squeeze is not so gentle. The eye is surrounded by a "stress pattern" of deep wrinkles, both at the outer corner and between the eyes. In laughing, only the inner, eyelid portion and the lower half of the muscle act, and the result is that the eye is squeezed shut mostly from below. In drawing the laugh, care should be taken to keep the eye narrow, because if the eye looks too open, the laugh looks less wholehearted.

In the smile, the same portions of the eye muscle are contracted, though not quite as strongly. This is why the eyes are *open* when we smile, not when we laugh. The contraction of the eyelid portion affects the lower lid the most, and its position in the smiling eye is crucial to the look of the smile. Whenever we smile, the lower lid shortens, straightens, and slides upward on the eye. The reason for its movement is the same as the reason for the shape of the smiling upper lip; in both cases, tension at the ends of a curve makes the curve straighten. Look for the lid to rise to just below the bottom edge of the pupil.

Besides the shape of the eye itself, there are two very important accompanying forms: the crows feet growing out from the outer corner of the eye and the deep, smile-shaped fold underneath the eye. Both these forms always appear in the smile *and* the laugh.

THE MOUTH

The mouth widens when we smile, and the upper teeth are prominent. The upper teeth are so white, and the mouth behind them so dark, that the carrying power of teeth framed by the mouth is considerable. It must be more than a coincidence that an expression as important as the smile comes equipped with an unmistakable pattern that can be recognized from a hundred feet away. If it's blown up to billboard size, those teeth can broadcast their message for a good quarter mile. There is no other expression (other than the less-sincere smile) that can be confused with the smile. Show those upper teeth, and the whole world will take note.

A broad, open smile stretches the lips and their region tight around the barrel-like form of the skull, and though the laugh is a slightly tighter action, there is only so much further things can go. The forms are set when we smile; the changes in the laugh are all rather subtle ones. In the laugh, the jaw drops, and the smile is stretched a bit wider, but the upper teeth still show the same way and the mouth shape is much the same. The extra tightening that occurs in the laugh also sharpens the highlight on the lower lip; the smoother the surface, the sharper the highlight.

THE CHEEKS

The cheeks are really at the center of the changes in the smile and the laugh. Both the orbicularis oculi and the zygomatic major bunch up the cheeks when they contract individually, so when they act together, the cheeks are subject to a double compression. The thickening and rounding off of the cheek is one of the most characteristic forms of the smile, and one that is sometimes neglected. It starts to appear strongly even at early stages of the smile. By the time someone is smiling broadly, the balling up of the cheeks is the largest, most well-defined form in the entire face, besides the features.

This is one form you can learn a great deal about just with your sense of touch. Smile broadly, and feel the mound in the cheek that results. Note the point where it's thickest, at about the level of the nose wings and facing out at about 45 degrees to the front of the face. You can feel clearly where the surface drops off sharply from this mound (and where shadows are likely to form as a result); the sharpest undercut is directly below, above the corner of the mouth. Underneath the eye, there is also a well-defined edge, but the edges alongside the nose and to the outside are much smoother and more gradual, like ramps instead of stairs.

The cheek is the area of the face with the most subcutaneous fat, and the fat is movable—it's what bunches up when we smile. It's a little like reshaping a sandbag—the mass is the same, but the arrangement of the sand in the bag is different.

These descriptions could apply to either the smile or the laugh. Just looking at the cheeks, it would be impossible to distinguish between the two, but there are subtle differences: in the laugh, the extra compression of the eye muscle pulls up on the nose wings, pointing the nose; in the laugh, the nasolabial fold is pulled outward more; and in the laugh, the cheek is a little tighter, the highlight a little more sharp.

The expression of joy is not only pleasant to look at, it's efficient. All the changes in the face below are the work of just two muscles, the zygomatic major, which pulls on the mouth, and the orbicularis oculi, which narrows the eye. This team action is the essential mechanism in the smile; unless both muscles are active, we don't look happy. Both muscles contract in even the slightest shy grin.

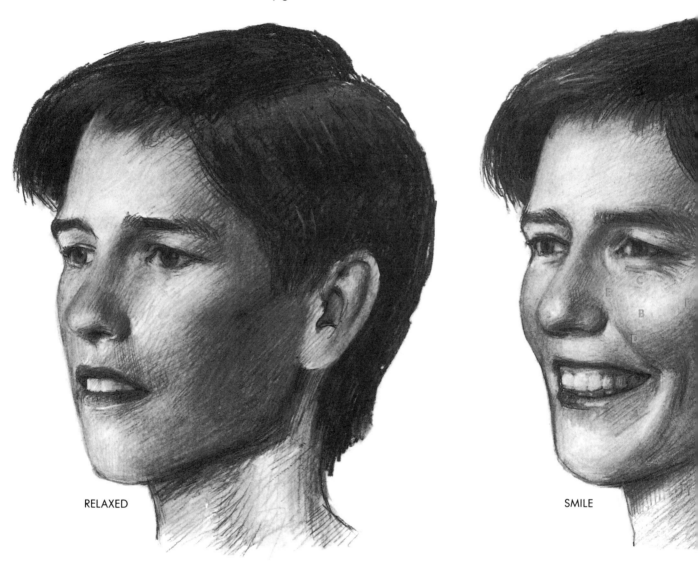

RELAXED

SMILE

THE EYES

These faces show the link between the degree of eye narrowing and the action of smiling. The laugh produces the most squint; a slight smile produces less of a squint; the relaxed face none at all.

When we simply smile, a weak contraction of orbicularis oculi is always triggered, preparing for a laugh that never comes; compare with relaxed eye (left). The lower lid bulges, shortens, and rises up on the eye, covering part of the iris; crow's feet wrinkles appear at the outer eye corner; cheek bunches up below eye, with smile-shaped wrinkle between cheek and lid.

In the laugh, the eye is closed more from below. The upper lid moves downward only slightly; the lower lid tightens and slides further up the eye. The lid's direction may even seem to reverse and arc upward slightly. Crow's feet deepen. The nasolabial fold swings further out than in the smile, and the cheek tightens more, making a sharp highlight (**A**).

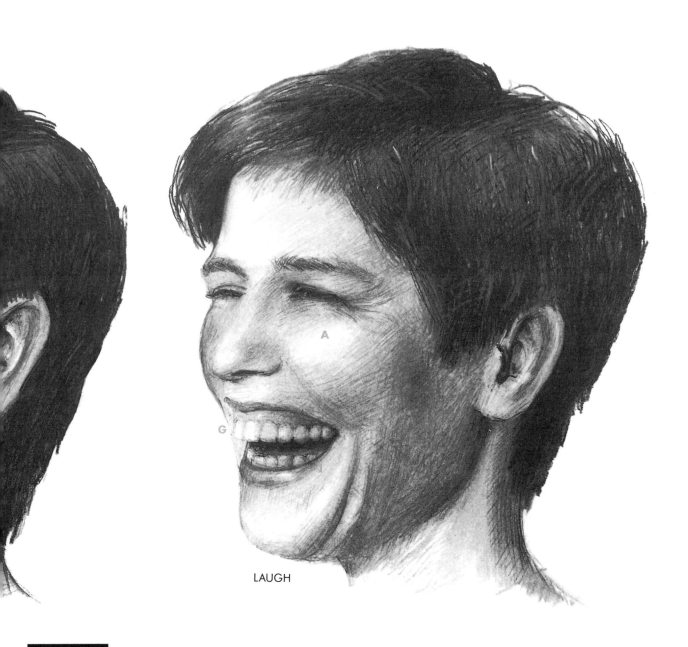

LAUGH

When we begin to smile, the cheek swells and the skin on the surface tightens. The thickest bulge is the "apple" form centered at the level of the nose wings (**B**). The bulge has steep edges above (**C**) and below (**D**), a gradual dropoff at (**E**) and (**F**). This form is less full in insincere smiles (without squint).

This relaxed mouth has an arched upper lip, so the smiling lip will ride higher than usual on the teeth.

The jaw drops in the laugh, stretching skin. Note straighter outline (**G**) with "hollowed-out" look. The chin moves down and back, pushing up "chinstrap" folds between chin and neck (**H**). The mouth is more stretched in the laugh. As a result, the laughing lips, particularly the upper one, are more thinned and stretched; upper lip has also slid further up the teeth. The lower lip is less changed—the sharp highlight indicates a tighter surface. Counterfeit laughs often lack this level of lip-thinning. Inner outline stays much the same from the smile to the laugh except for sharper angle (**I**) where outer leg turns upward.

191

In spite of the differences in age, sex, and body type, virtually every major form in the face of the elderly gentleman is repeated in the face of the woman. Notice how laughter pulls the mouth and its region tight against the skull, shoving the cheeks out of the way.

A. Eye closed with mild force; prominent bulge below.
B. Steep edge of cheek.
C. Nose wings pulled upward in laugh, not in smile.
D. Deep, angled edge.
E. Lips and skin around mouth follow teeth.
F. Chin is smooth.
G. Chinstrap folds.

1. Action of orbicularis oculi.
2. Action of zygomatic major.

In the broadest sense the laugh and the cry are similar—both are convulsive, vocal actions that drop the jaw, stretch the mouth, and squeeze tight the eye and cheeks. But the differences, particularly the degree of tightening around the eyes and the shape of the mouth, are usually dramatic enough to make the distinction clear. The look of the cheeks is quite similar, but the cry has harsher lines around the eye and a flatter line to the lower lip.

The reflexive closing of the eye in the laugh is necessary to make the laugh appear genuine and is gentler than the closing of the eye in a crying face. The laugh is gentler because only part of the eye muscle is contracted—the upper portion is relaxed.

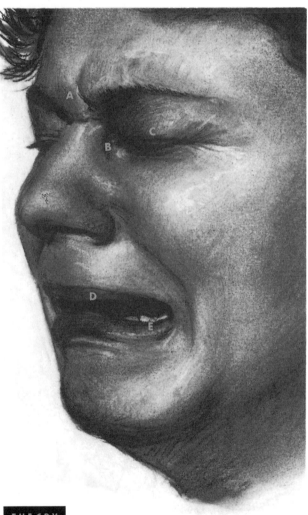

THE LAUGH

A. Forehead smooth, brows relaxed.
B. Eye gently squeezed shut, upper lid moves less.
C. Mouth shows upper teeth from tip to base.
D. Mouth corner sideways and back toward ear.
E. Lower lip shows tips of teeth only, and none in corner.

THE CRY

A. Corrugator contracted, frown lines and lowered brow.
B. Stress pattern of eye wrinkles, inside and out.
C. Upper lid pulled down tightly.
D. Upper teeth show only tips or not at all.
E. Lower lip stays low, even if mouth opens wide, showing teeth in corner.

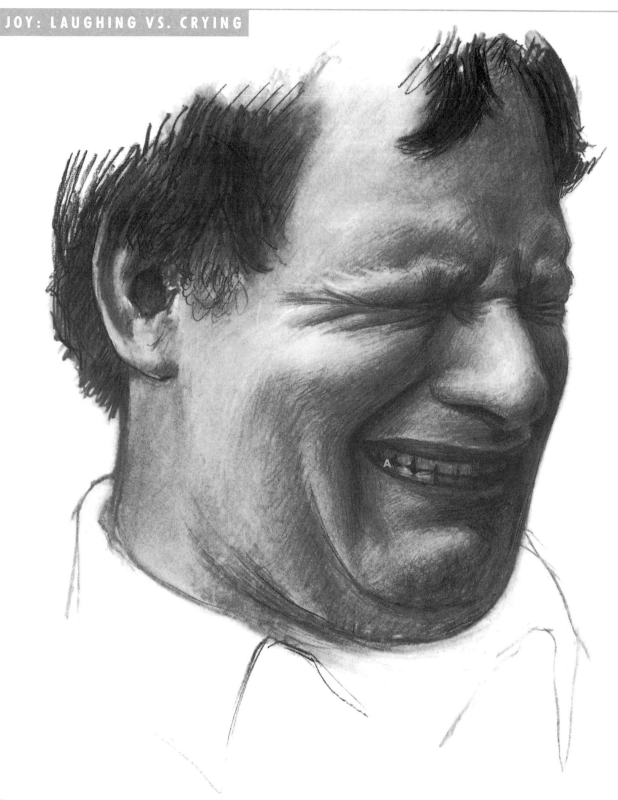

This is a less clear-cut case. The most confusing feature is the mouth, because the upper teeth show and the corner seems to be pulled up. The eyes here are the key. Intense compression of full orbicularis oculi creates a stress pattern that would never be this deep or widespread in laughter. The eye is so tight that the mouth corner is dragged upward, indirectly mimicking action of zygomatic major, which is not active.

The mouth by itself isn't quite right for a smile—the upper lip should be higher, showing full height of teeth, and teeth at (**A**) shouldn't show. But it's close.

The problem with photography is that it can capture an in-between moment, when an action is not fully resolved and then present it as the "truth." That's exactly the case here. I was there—she was laughing. But you wouldn't know it from the picture—this expression is exactly on the borderline between the look of joy and pain.

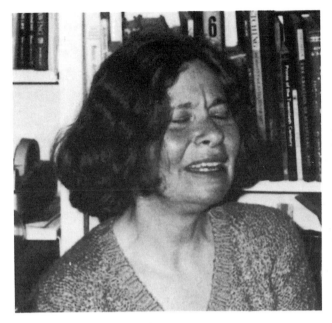

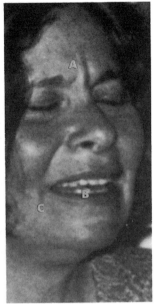

Part of the confusion is the prominent frown lines (**A**), which the camera has emphasized, making them seem active (they are not). Mouth is captured midway to smile position, so upper teeth (**B**) are not fully shown—next moment they would be. And corner (**C**) is perfectly ambiguous— neither angled upward enough for laugh, nor sideways enough for cry.

A similar question is posed, but much more cunningly, in this drawing by Sidney Goodman. On the surface it's a cheerful enough domestic scene, but something draws one's eyes to the man's face, so hidden in the shadows. Goodman has obscured just that part of the face where we get our clues as to the laugh or the cry. We can tell from what we see that it's one or the other: the cheeks are full and the nasolabial fold is pulled back—but ambiguity remains. A related study seems to reveal what the artist had in mind (left). With more detail in the shadows, the expression is identified—a rather pained grimace, with contracted brows and tight mouth.

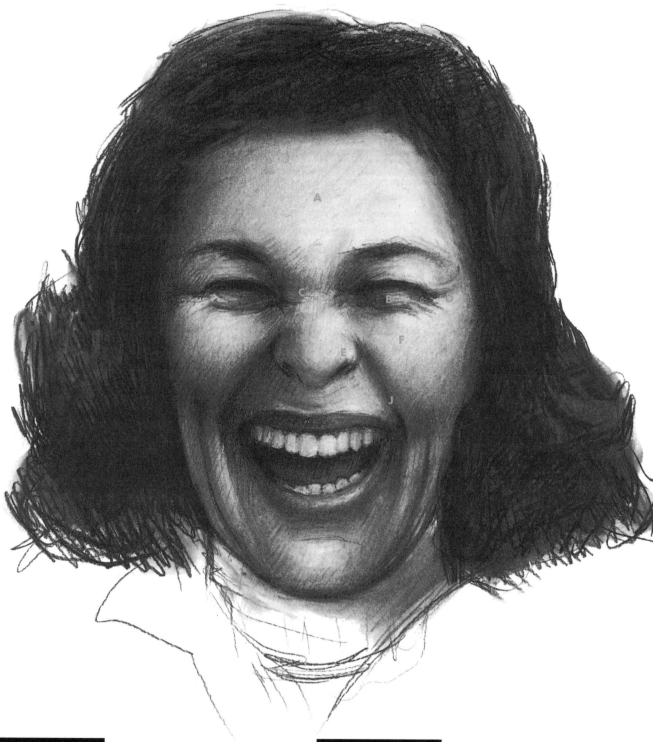

EYES AND BROW

A. No muscle contraction above lid line, so brow is relaxed, smooth.

B. Lower lid slides up on eye, meeting upper lid halfway—higher than when eye simply closes.

C. If action is strong enough, some wrinkles may form from inner eye corner.

D. Crow's feet curve around to side, fade out; one at level of lid is usually deepest.

CHEEKS AND NOSE

E. Strong contraction of orbicularis oculi pulls up on wings of nose; nose broadens as well.

F. Cheek is highest, roundest, as at point **G**.

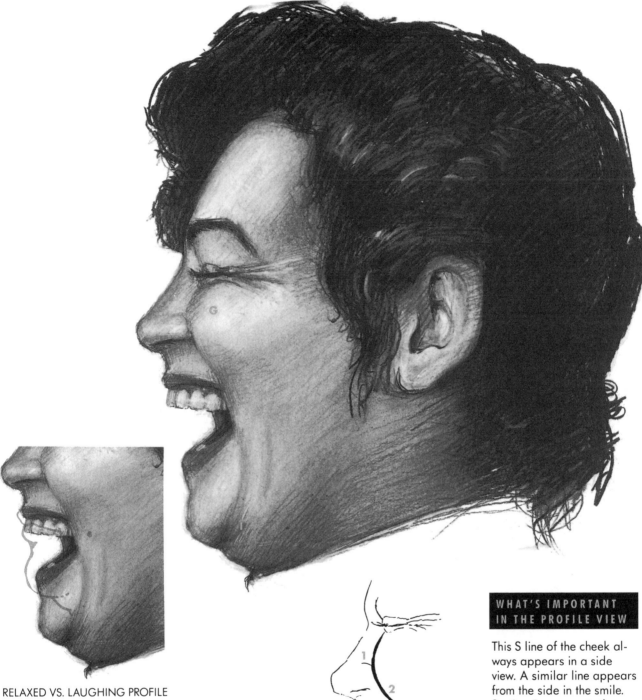

RELAXED VS. LAUGHING PROFILE

THE MOUTH

H. Outer part of lower lip must rise at steep angle when jaw drops.
I. Chinstrap cords mark turn from front to side—dimple is on the side; chinstrap actually wraps underneath chin in the laugh, not in smile.
J. Mouth widens in laugh, even more than in smile.

WHAT'S IMPORTANT IN THE PROFILE VIEW

This S line of the cheek always appears in a side view. A similar line appears from the side in the smile. Section **1** represents the edge of the rounded cheek, section **2** the nasolabial fold, and section **3** the edge of the cord that frames the chin. Dimple **4** runs parallel. Line indicates closed position of chin; dot is location of corner of mouth, hidden by cheek. Relaxed corner of mouth indicated by line.

Throwing the head back in laughter is a natural reflex; the exact opposite of the forward slump of sadness. Lash line in laugh is exactly midway down the eye; when the eye shuts normally, the upper lid drops much lower, making a downward curve. A continuous crease runs from nose to chin in the laugh as in the cry, or in shouting anger, but in the laugh it gets shallower as it approaches the nose. Deepest part of crease is at level of mouth corner. Sharp inner edge always appears at (**A**), and it often has a strong light against the dark of the mouth. Teeth fade into shadow well before they reach corner of mouth (**B**).

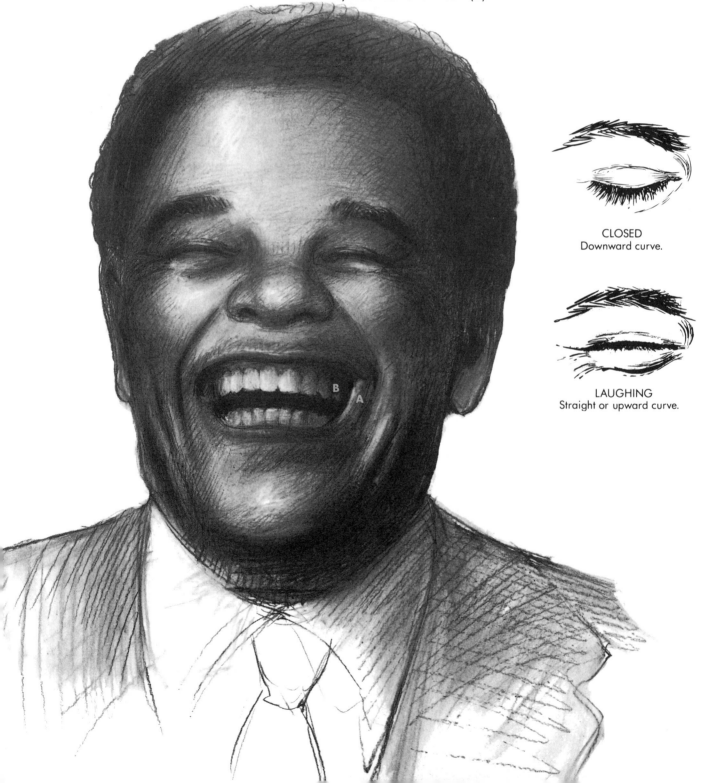

CLOSED
Downward curve.

LAUGHING
Straight or upward curve.

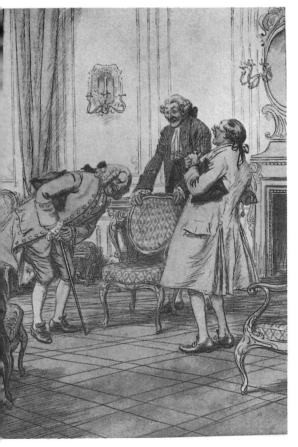

Three very different laughs. Only the doubled-over man is drawn with an uninhibited laugh. When we're convulsed with laughter, we're liable to make any number of spasmodic movements. The deepest undercut under the bunched-up cheek (**A**) is a key to the laugh and broad smile. The lash line is correctly curved upward at (**B**), an important detail compared with the lash line at (**C**). The second man's smile (right, center) is more of a polite titter. He's not doing as much, and his lash line is curved down, suggesting an eye that's simply closed, not contracted closed. The last gentleman's laugh (right, bottom) is the least wholehearted. His mouth is barely widened, and his eyes are open and observing. When we're really laughing, we're not looking at anything.

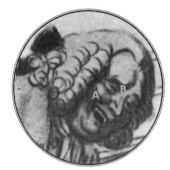

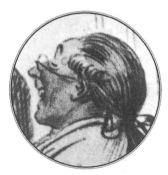

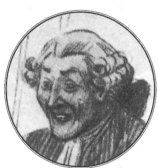

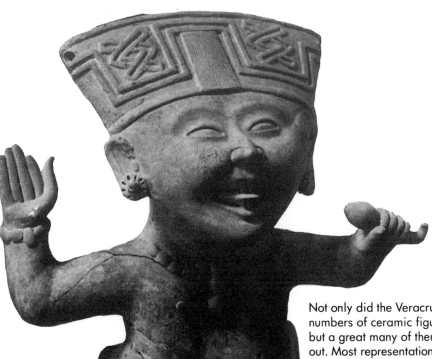

Not only did the Veracruz culture in Mexico produce large numbers of ceramic figures with this wholehearted laugh, but a great many of them also have their tongues sticking out. Most representations of laughs and smiles in so-called primitive art are quite attentive, as this one is, to the straightness of the lower lid. A great deal is also made of the crucial thickness of the cheeks and the sharp crease below.

States of high spirits, like those of the people pictured here, are also states of high energy; when we're sad or depressed, our energy seems to ebb away, and the body and the face sag. Being overjoyed is almost, as the word suggests, too much for the nervous system to handle. The overloaded nerves pour the energy into frantic physical action: overjoyed people shout, jump about, throw things in the air. The laugh is stretched to its maximum; in the man's face (opposite), his eyebrows are literally dancing for joy.

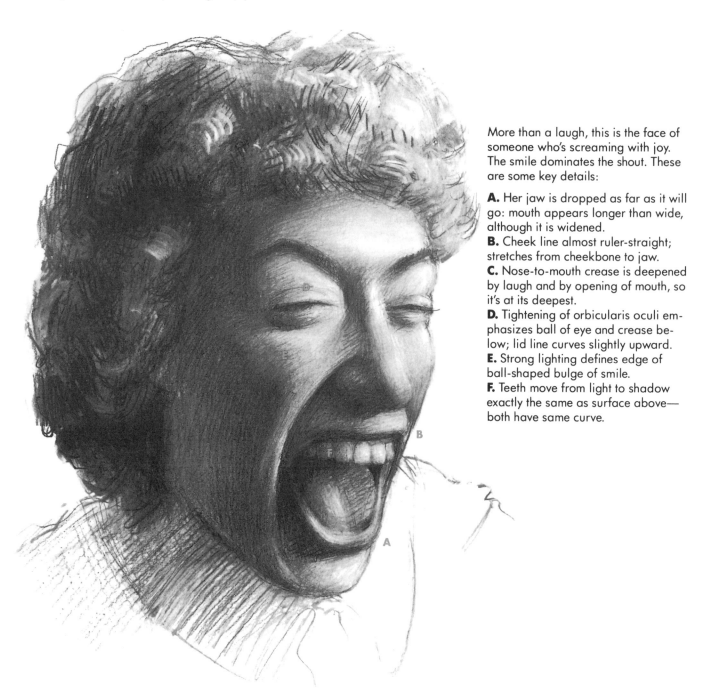

More than a laugh, this is the face of someone who's screaming with joy. The smile dominates the shout. These are some key details:

A. Her jaw is dropped as far as it will go: mouth appears longer than wide, although it is widened.

B. Cheek line almost ruler-straight; stretches from cheekbone to jaw.

C. Nose-to-mouth crease is deepened by laugh and by opening of mouth, so it's at its deepest.

D. Tightening of orbicularis oculi emphasizes ball of eye and crease below; lid line curves slightly upward.

E. Strong lighting defines edge of ball-shaped bulge of smile.

F. Teeth move from light to shadow exactly the same as surface above—both have same curve.

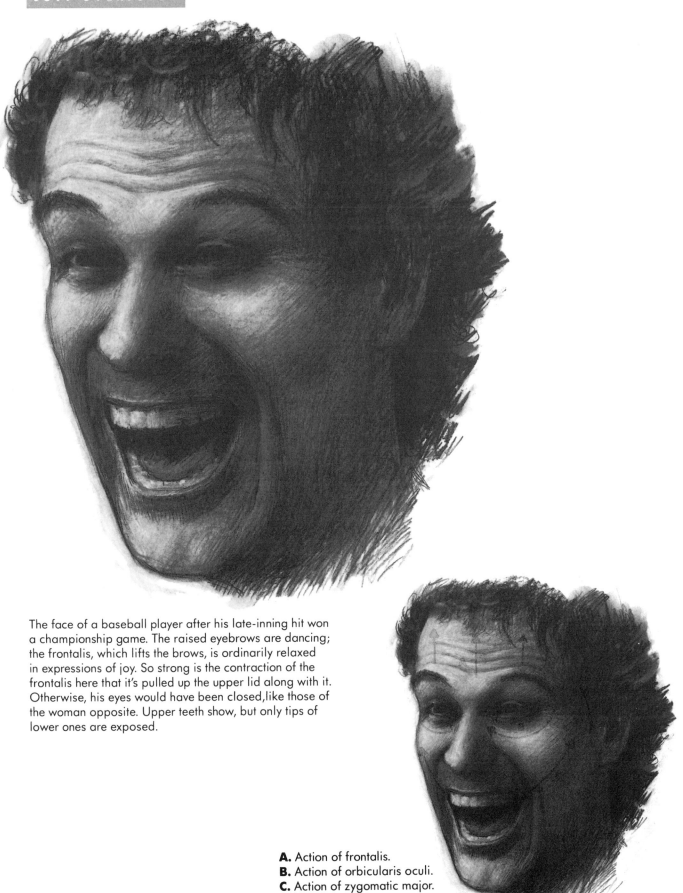

The face of a baseball player after his late-inning hit won a championship game. The raised eyebrows are dancing; the frontalis, which lifts the brows, is ordinarily relaxed in expressions of joy. So strong is the contraction of the frontalis here that it's pulled up the upper lid along with it. Otherwise, his eyes would have been closed, like those of the woman opposite. Upper teeth show, but only tips of lower ones are exposed.

A. Action of frontalis.
B. Action of orbicularis oculi.
C. Action of zygomatic major.

KEEPING THE SMILE BALANCED

Both the strong contraction of the zygomatic major and the eye-crinkling action of the orbicularis oculi are necessary for the creation of the warm smile. What's so challenging about depicting the smile is that the two actions are so closely linked. In the face of anger, by contrast, the glare of the eye and the press of the lips are really independent actions, and the intensity of the one has little to do with the intensity of the other.

In the smile, the happier we are, the stronger the *joint* action of the two muscles; in other words, the broader the smile, the narrower the look of the eyes, and the more full the cheeks. As the smile fades, the tension in the eye muscle relaxes, and the iris is more-fully revealed.

It's a very subtle balance. You can't force the eyes to crinkle just the right amount to go with the width of your smile—but if the feeling is there, it happens automatically. Our perception of the smile is also automatic, which is why we instinctively respond the most warmly to the smile that looks "right."

A grinning mouth combined with completely deadpan eyes still looks like a smile. It's not until you compare it with a bona fide expression that you fully appreciate the loss. And it's hard to verbalize what the difference is; it's a little like coming up with words to describe the qualities of a color or a taste. With the smile we're limited to saying such things as the narrowed eye version is warmer, friendlier, or happier looking. Even then we haven't quite said it, but we wouldn't mistake one for the other.

THE FADING SMILE

We tend to associate very lively and amused states of mind—for good reason—with active, social situations. Slight smiles involve less facial activity than broad smiles or laughs, thereby communicating a quieter message of a friendly or contented state of mind. This is the sort of smile that is typical in formal portraits, either photographic or painted, where a broad smile might seem a bit too intense, not to mention being impossible to hold over a period of time. Further, a broad smile entails fairly major facial changes; a slight smile is far less drastic an event, and it makes it easier to keep a likeness.

The principle that the smile must involve the whole face is no less true as the smile fades from the broad grin to the flicker at the corner of the mouth. The challenge to the artist is to maintain a consistent degree of activity throughout the face. The tightness of the smile should always reflect and be reflected by the degree of wrinkling around the eyes.

At the threshold of a smile, the activity in the upper face is so subtle as to practically defy analysis. Up to the most fleeting smile, however, the relationship between facial activity and smile "temperature" is fairly straightforward.

The last show of teeth

The gentler the pull of the mouth-stretching zygomatic major, the less likely the lips are to part in the smile. When the teeth disappear varies from individual to individual—some people rarely show teeth in a smile, while others (particularly those with arched upper lips) always do.

When the pull of the zygomatic major is gentler, the clenching of the orbicularis oculi around the eyes is a milder action as well. Full cheeks, angled folds framing the mouth, and bagging and narrowing around the eye all occur, but the forms are not as full, the edges not as defined, the narrowing not as extreme. Moderate and slight smiles tend to be asymmetrical. At lower levels of activity, one side of the zygomatic major tends to contract a little more than the other; even the Mona Lisa has a smile that is somewhat lopsided.

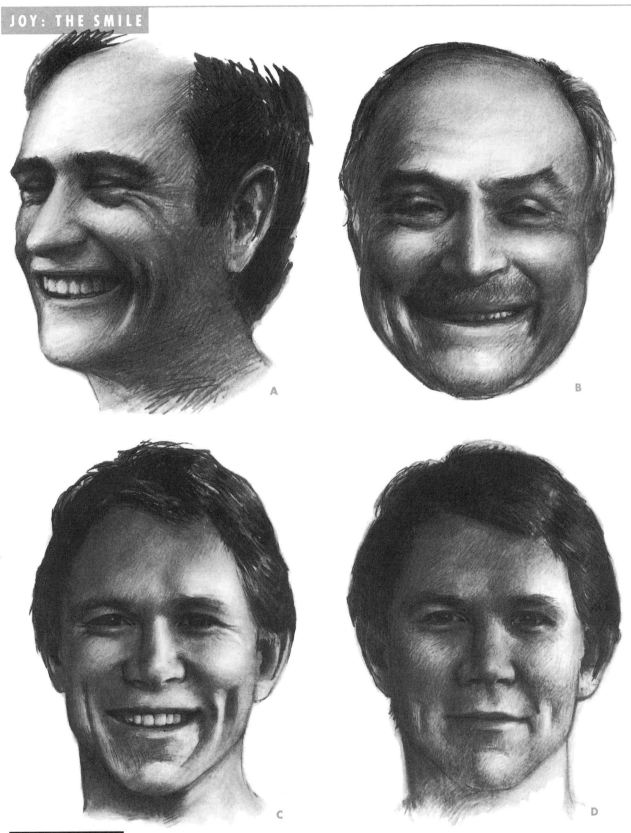

JOY: THE SMILE

THE WHOLE FACE

The action in the lower half of the face is matched by the action in the upper in all these warm, engaging smiles. This is because of the reflex that links smiling and squinting. Pick any part of the face and notice how it changes as you move from the elated gentleman (**A**) to the pleased man

(**D**). The lower lid steadily slides down the front of the eye; the cheeks slowly lose their roundness. The challenge in depicting the smile is to keep the parts in harmony and to think of the whole face as smiling; there really is no one part that is more important than any other.

203

JOY: THE SMILE

ELATED

You can't be any happier than this and not be laughing. The elated grin stretches the lips as far as they'll go; the wrinkles pile up ahead like shock waves. His wrinkles are unusually deep—some faces are more susceptible to wrinkling than others.

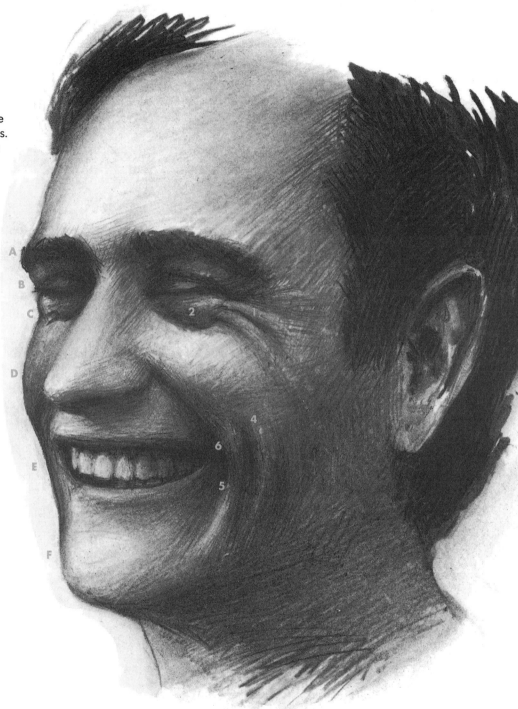

LANDMARKS ON THE OUTLINE

A. Eyebrow ridge.
B. Edge of bony orbit.
C. Curve of the fullness of lower lid.
D. Curve of the fullness of cheek.
E. Stretched plane between cheek and chin.
F. Smooth chin.

LANDMARKS ON THE FACE

1. Crow's feet.
2. Smile-shaped fold, cup-like form of lower lid.
3. Ball-like form in full cheek centered here (faces directly out in three-quarter view).
4. Dimple falls from bottom of ball of cheek.
5. Cord of cheek frames smile, links with nasolabial fold above.
6. Widened mouth in smile falls under outer corner of eye; relaxed mouth would be under center of eye.

The broad, exuberant smile usually cannot be produced on demand. Pulling the mouth into a smile is easy, but contracting the muscle circling the eye is not. Rounding of the cheeks, narrowing of the eyes, and the creasing surrounding the mouth are most intense when both muscles are active.

THE TWO MUSCLES OF THE SMILE

The actions of orbicularis oris and zygomatic major are both separate and overlapping. Orbicularis oris alone tenses the lower lid and narrows the eye. Zygomatic major alone widens the mouth. But both muscles bulge the cheeks (**A**), create wrinkles around the eye (**B**), and deepen the nasolabial folds (**C**). Together they create stronger forms than either would create alone.

HAPPY

Eye detail is not important in the depiction of the exuberant smile; the shape of the eye is. The lower lid here is nearly ruler-straight, narrowing the eye from below (**D**); from above, the upper lid is slightly lowered. The shape that results, with its full lid and wrinkle below, is the eye of joy. The narrowness of the smile here is unusual—his lip muscles may be tightened slightly, keeping the upper lip from rising further up the teeth.

THE UP-CURVED LOWER LID

The tightening of the lower lid is an especially important part of the expression of joy. Like a line of latitude around the globe, the lower lid will follow the ball of the eye no matter how tight or loose it is. When relaxed, the lid dips downward; when tightened, it rises toward the middle, or "equator" of the eyeball. Though it never rises above this equator, it appears to curve upward when the head is tipped back. This is clear in the face of the smiling little girl. The Japanese mask has precisely the same eye shape, and even though it is somewhat exaggerated, its effectiveness is obvious. The planes of the cheek are also clear. I particularly like the stylized little dimples on either side of the mouth, and the stretched and flattened nose.

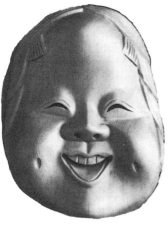

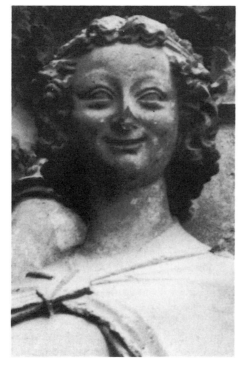

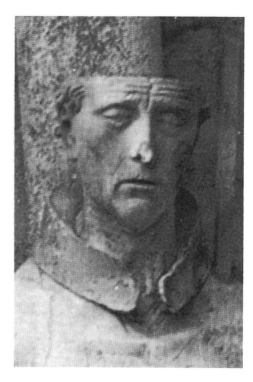

"The smiling angel" (right) is the popular name for this thirteenth-century stone figure from the Cathedral of Rheims in France. His neighbor (far right) also wears a strong expression, quite the opposite—the brow of grief.

This Punic mask, from the territory that is now Tunisia, has a charming smile. The backward curve of the lower lid (**A**) is an interpretation of the detail (**B**) that appears on the face of the smiling little girl (opposite, top) The cheeks and mouth of the mask bear a resemblance to those of the smiling man (below). The smiling upper lip can be up-curved as on the mask and below, down-curved as on the little girl, or straight across.

If you squint and look at the man's face below, the shadow pattern that you see summarizes all the important forms of the smile: the thinned eye with raised lower lid, the smile-shaped fold under the eye, the cheek with its angled lower crease and roundness, the dark gap of the stretched mouth.

The only good thing about this smile (below) is the little serifs on the end of the curve. They are an honest simplification of the dark vertical slash that often ends the mouth when we smile, which is itself the meeting point between the curve of the mouth and the frame raised beyond.

The have-a-nice-day smile may get a certain symbolic message across, but as a description of the form of the smile, it leaves something to be desired. The broad smile is neither curved up in an arc, nor accompanied by eyes like vertical ovals. Sideways ovals would be more like it, but even then, the eyes would be missing the crucial smiling element—the tight, raised lower lid. The man (right) comes much closer to the truth. The smile isn't simply a curve on a face but a complex three-dimensional event full of alternating patterns of tension and compression.

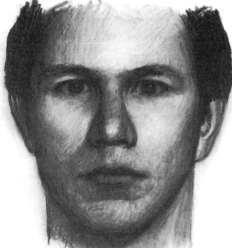

NEUTRAL FACE

HOW THE FACE CHANGES WHEN WE SMILE

This friendly, deep-dimpled smile shows clearly how radically the face changes in a smile. Though every smile is different, the basic elements listed here are part of every smile. Below is an important comparison: how the tensed-lower-lid eye of smiling differs from the simply narrowed eye.

PARTLY-CLOSED EYE
Pupil blocked.

SMILING EYE
Pupil clear.

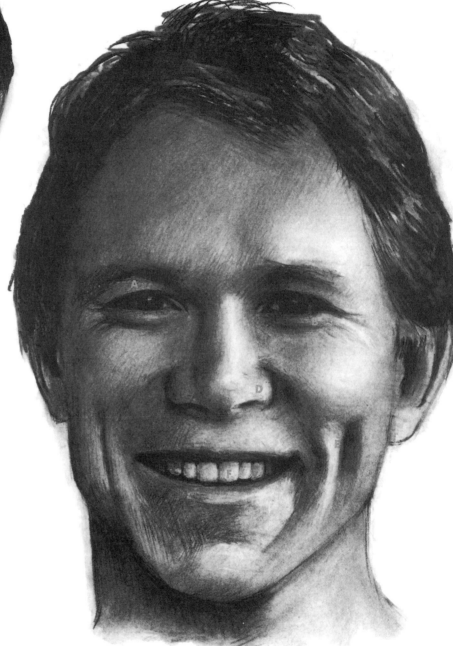

A. The eye narrows: Lower lid rises, upper lid drops slightly.
B. Lower lid swells: smile-shaped fold appears underneath.
C. Cheeks become full: cheek fat is bunched together.
D. Nose broadens: not pulled upward, as in laugh.
E. Mouth is framed by folds. Dimples appear beyond and are always asymmetrical.
F. Mouth widens into smile. Upper teeth show from tip to base.

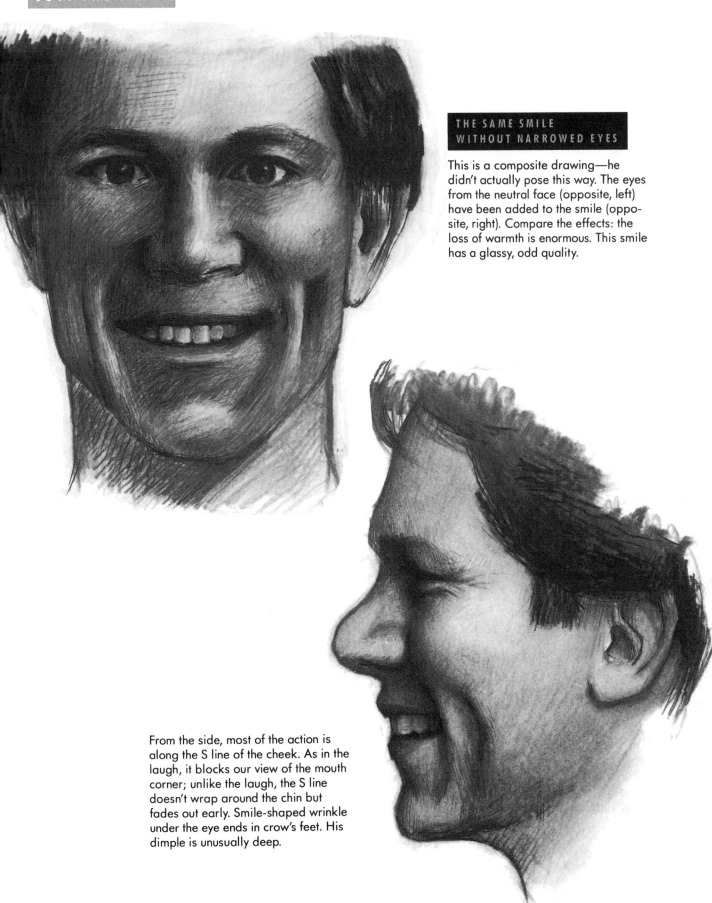

THE SAME SMILE WITHOUT NARROWED EYES

This is a composite drawing—he didn't actually pose this way. The eyes from the neutral face (opposite, left) have been added to the smile (opposite, right). Compare the effects: the loss of warmth is enormous. This smile has a glassy, odd quality.

From the side, most of the action is along the S line of the cheek. As in the laugh, it blocks our view of the mouth corner; unlike the laugh, the S line doesn't wrap around the chin but fades out early. Smile-shaped wrinkle under the eye ends in crow's feet. His dimple is unusually deep.

The smile of the woman on this page looks quite natural and sincere and also quite moderate. Compared to those on previous pages her face shows less muscle pull, less bunching of the cheek, and less creasing. But the changes are consistent. A second version of the same smile (right), shows what happens when changes are not consistent, when eyes and lower face don't match.

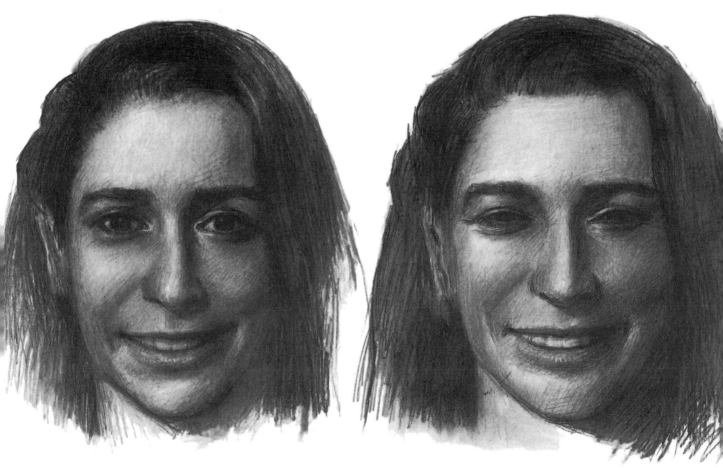

Note the softness of the crease running from her nose to her mouth as opposed to deeper crease in laugh below. Her slightly lopsided smile is common with less than full smiles. There's no rule for when action is too slight to part lips, but this is near the minimum.

The eyes that seem so natural in her laugh (right) make no sense at all in her smile. By contrast, the glare of anger can be equally well maintained in a face that is otherwise neutral—it's not linked by a reflex to the rest of the face the way the smile and the eye are linked.

SAME SMILE WITH EYES FROM THE LAUGH

The effect is distinctly unnatural in this version of the smile, where her eyes are squinting. We have trouble placing this expression; it doesn't look like anything. Eyes that go perfectly with one stage of joy can seem completely out of place with another. The link between the contraction of the eyes—orbicularis oculi—and the degree of the smile—zygomatic major—is the key. They should always move in step with each other.

THE THRESHOLD SMILE: "MONA LISA TERRITORY"

Finally, having started with uproarious laughter, we arrive at "Mona Lisa Territory"—the flicker of a smile. The real mystery lurks in the fact that so little movement can be so enormously evocative. Looking at pictures of faint smiles (like those of Da Vinci) one is almost forced to conclude that there is some secret way the soul can communicate through the face beyond the simple physical changes.

You cannot understand the threshold smile unless you've studied the broad smile. All the forms that are major facial events in the broad smile are faintly visible in the threshold smile, like the first buds on the trees in the spring. But many are so subtle you might overlook them, like the slightly raised lower lid, the slightly balled-up cheeks. When you know what you're looking for, you see it much more readily.

Examples from Art

Patrons of portrait artists have occasionally been portrayed as angry or sad (presumably without their having requested it), but the perennially favorite expression has always been the threshold smile. I suspect that there aren't even more portraits of smiling people in existence because of the risk involved—it's easier to portray a deadpan face than to take a chance that a smile will go wrong (or a likeness be lost).

But it's worth it to try; so much can be suggested by a face where the smile is just a glimmer—everything from wistfulness, slyness, sexuality, to simple warmth and openness. It is true, however, that you reveal something about yourself at the same time, for it is your judgment when it works and when it doesn't, your sensitivity that decides when you've captured what you want about that person.

I've included some examples of some threshold smiles, and explained why I consider some more, and some less successful, but everyone won't agree on such a thing. As always, we project more onto the face when there's less there to see, and different people will project different things.

A NOTE ON THE VIEW FROM BEHIND

Further evidence of the importance of the cheeks and the eyes in the smile is furnished by looking at a smile from behind. Everyone can recognize a smile from behind (when the mouth is hidden), and nobody knows they can. We do recognize this expression without thinking about it.

The bunched cheek in the smile is a large form—actually, it is larger than anything on the face besides the nose (in fact, this important part of the smile blocks the nose from view from this angle).

The bunched cheek changes the rear profile so drastically that the resulting shape is unmistakable—there's no other expression that the resulting shape could be mistaken for.

We also have the eyes as a cue to the smile; in a broad smile, we can see the curling of the crow's feet around the edge of the orbit and onto the side of the face, and depending on our angle we may also be able to see the full lower lid as well.

The threshold smile is probably the most mysterious and elusive of all facial expressions. Like sadness, warm, pleasurable feelings can make themselves clearly felt through remarkably small changes in the features. But while just the eyebrows can tell us someone is sad, joy requires coordinated activity throughout the face. Ultimately, it is the artist's sensitive eye that decides when the little curl in the corner of the mouth or the look in the eyes is right.

The mouth is the most subtle form—lips are slightly stretched and narrowed, and LBL has a sharp terminal angle (right) and deepened dent at mouth corner. All other effects of the broad smile are still present—just barely.

Focusing on volume, this medieval artist has overemphasized those parts of the face that become rounded in the slight smile. The smile is no less appealing for the exaggeration. Shadow spots at (**A**) and (**B**) probably suggest the smile as much as the shape of the mouth (which here could be just a trifle wider).

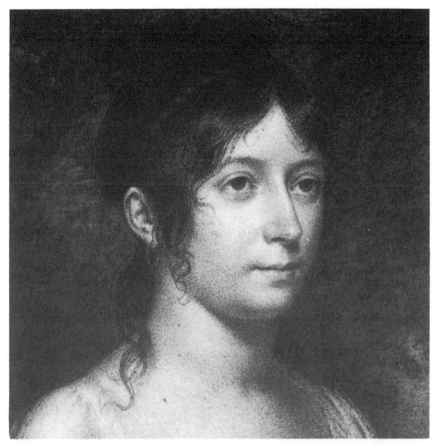

Why do some portrayals of smiles strike a sympathetic chord and others leave us cold? With the slight smile, the dividing line between the charming and the vacant is impossible to precisely define.

UNSUCCESSFUL EXAMPLES

Many a portrait artist has hoped to obtain a smile simply by twiddling with the corner of the mouth. The fallacy of this approach is illustrated by this charming but rather lifeless portrait of a young woman by John Vanderlyn, an early nineteenth-century American painter. This slight smile is not accompanied by any changes in cheeks and face. We never see space below iris (**A**) in a true smile; it's covered by a tensed lower lid. These missing features seem to leave the smile stranded and rob it of any warmth.

The naturalistic portrayal of facial expression was not a priority for nineteenth-century neoclassical artists. Jacques-Louis David viewed his figures in a cool, remote fashion; his narrative paintings usually represent feelings with stylized, theatrical gestures. But taken strictly on its own merits, this particular smile falls short: There's a problem with the LBL; by the time it's angled up this much (**A**), its entire length should be tightened and straightened —the lips and LBL at (**B**) would be thinner, not as kinked. Angle of rise at (**A**) is also too abrupt; compare with Leonardo (next page). Gaze is also a handicap; her eyes have drifted apart, out of convergence.

213

SUCCESSFUL EXAMPLES

Unsuccessful smiles are easier to criticize than successful smiles are to explain. This one by the American John LaFarge has qualities that are particularly elusive. What is it that gives this smile its gentle, sensitive quality? The upraised eyes are a factor suggesting other-worldly concerns (and freeing the iris of the high lower lid); in fact, this is a portrait of a priest.

The world's most famous smile has inspired wild adulation, wild conjecture, and at least one outright burglary. The conjectures have focused on everything from the identity of the sitter (never determined conclusively) to the asymmetry of her smile (said to be the source of its mystery). What can't be denied is that it is a truly evocative expression. In the world of facial expression, slight *anything* is generally more evocative than the same expression in the extreme, because it leaves more to our imagination while still provoking our interest.

 Portrayed is the moment of the slightest noticeable movement. LBL has just crossed smile threshold (end [**B**] has moved above center [**A**]) and begun to tunnel upward into cheek. Smile is stronger on right (slight smiles are usually asymmetrical). Shading at (**C**) and (**D**) hints at balling of the cheeks; wrinkling of lower lid and masking of iris is consistent with mouth action. Off-to-the-side gaze adds to active, elusive quality of expression.

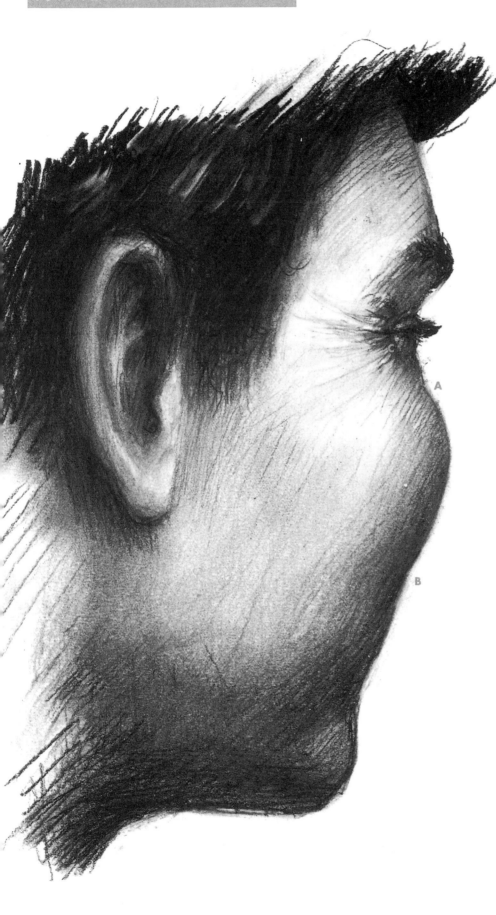

You don't need to see the smile to know that someone's smiling. The rounded cheek is as important to our recognition of the expression of joy as the stretched mouth, and in this view it *is* the smile. It's all the cue that we need. It's also helpful that there's no other expression that looks like this from behind.

The entire form from (**A**) to (**B**) has been added on to the profile. Its most projecting point is at about the level of the nose wings. Bulge fades out gently as it approaches the ear. Note also the crow's feet, which in their curving describe the forms they cross—the edge of the orbit (**C**) and then the top of the bunched cheek. Note also slight hollow below full cheek (**B**) and separate direction of chin.

Complex Smiles

The smile is unique in how it can convey a complex emotional state. Joy can be nuanced with hints of nearly every other emotion. I don't know of a face that plausibly combines disgust and pleasure, but there are faces in which pleased feelings mingle visibly with elements of fear, anger, sadness, or surprise. In these faces it is usually the smile that dominates; it's never anger with a little smile, but it's a smile with a slightly dark nuance. Cartoonists, at least, have explored these variations for years; they're the eyebrow experts, and since the smile is the *only* expression in which the eyebrows are inactive, almost any suggestion of activity in the brows is going to change the nature of the smile. Pull them straight up, and we look happy/surprised; slant them down and we look happy/mad; give them a little kink and we look happy/sad; lift the eyebrows up while kinked, and we get a sheepish smile.

THE STIFLED SMILE

If you're with a group of close friends who begin complementing you, your reaction might very well be a stifled smile. You're terribly pleased, but at the same time ever so slightly embarrassed. You resist, on some level, the impulse to break into a broad smile, and that resistance is clearly visible on your face. But rather than looking odd, or ambiguous, the smothered smile carries with it an enormous charm. The smile that's trying not to be one is in some ways more pleased-looking than an ordinary, uncomplicated smile.

Nearly every expression has a suppressed variation. The lip muscle is usually involved in the struggle not to let an expression appear. But usually it's not just the orbicularis oris; in this case, the smile is such a powerful action that other muscles in the vicinity end up involved in the battle to halt the up-and-back pull of the zygomatic major. Often the antagonists are so well matched the lips are frozen in a middle position and surrounded by a complex muscular landscape.

The suppressed smile goes by many names. It is often described as smirking, impish, contented, jovial, or self-satisfied.

Although it's a universal, emotionally expressive face, the stifled smile seems to have appeared rarely, if ever, in works of art. Advertisers, however, with their particular interest in human behavior and motivations, frequently focus on it.

Details of the Stifled Smile

All the reasons why the stifled smile appear are hard to say, but it's easy enough to analyze its outward signs. Look in a mirror, and smile a broad smile. The eye is narrowed, the cheeks puffed, the mouth raised and stretched, framed by cords and creases. Now pull down on the smile. You'll naturally put into action some variation of the three-muscle press: that is, you'll use orbicularis oris, triangularis, and mentalis to keep the mouth in place. Their joint action is strong enough to cancel the upward pull of the zygomatic major, but it is not enough to cancel many other of the smiling effects—the upper half of the stifled smile is identical in appearance to the upper half of a broad smile.

The key to rendering this particular variety of smile seems to be based on getting two things right: the modeling of the cheeks and lower eyelid, making their rounded forms clear; and the shape of the lips and the planes immediately around them, indicating both the stretching of the lips and the sharp, curling planes around the mouth corner. This smile represents a particular challenge, because the usual clue of the upturned mouth is missing.

JOY: 5 COMPLEX SMILES

Practically anything that occurs with the eyebrows will change the message of the smile. Since the smiling brows are normally relaxed (the only expression where this is the case), activity in the brows suggests something extra going on, something that complicates the meaning. The smile is so adaptable that nearly every combination with the brow from other expressions works in suggesting a certain new shade of meaning.

THE SMILE IN COMBINATION WITH VARIOUS BROW POSITIONS

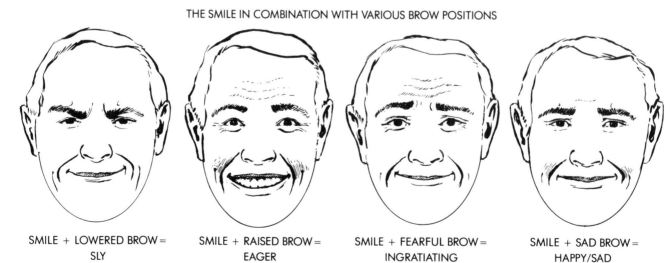

SMILE + LOWERED BROW =
SLY

SMILE + RAISED BROW =
EAGER

SMILE + FEARFUL BROW =
INGRATIATING

SMILE + SAD BROW =
HAPPY/SAD

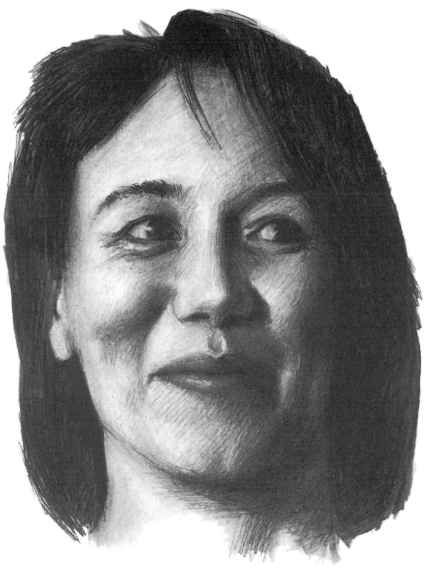

One of the most endearing of all expressions, the stifled smile is the result of a failed effort to keep a smile from happening. It comes with an element of self-consciousness; we're terribly pleased but trying not to show it. Or perhaps we are; we're complex enough that we may be fully aware of how charming a smile it is. It's a tricky expression to render, because the mouth isn't in the shape we associate with a smile, and though it's enormously popular with advertisers, it almost never appears in art.

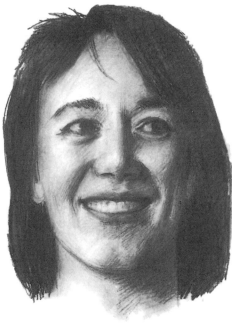

BROAD SMILE FOR COMPARISON

THE STIFLED LAUGH

It takes a truly heroic effort of the three-muscle press to try to stop a laugh, and from the looks of the soldier on the left, the smothering is going to fail at any moment. If you cover his upper face, his mouth is so compressed it doesn't look the least bit happy. The look of the mouth—completely thinned lips with bulging forms above and below—is the result of the three-muscle press with orbicularis oris dominant, similar to look of mouth in stifled anger and suppressed sob. It's what is above the mouth that makes him look so amused. The other expressions are charming too: the broad grin on the far right and the stifled smile in the center.

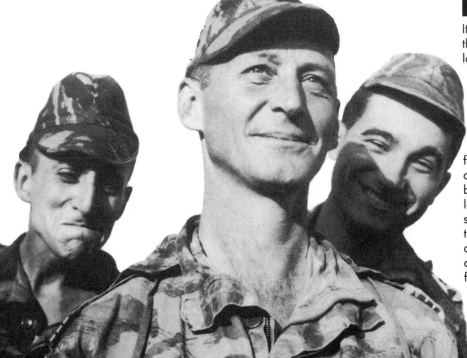

217

THE UPPER FACE IS THE SAME

1 is her upper face in an ordinary broad smile, and **2** is her upper face in a stifled smile. The stifled smile involves exactly the same action around the eyes and in the upper cheek as the ordinary smile—the zygomatic major and orbicularis oculi are equally active in both cases.

BUT THE CHEEKS ARE DIFFERENT

An obscure anatomical quirk shapes the cheeks in the stifled smile. The little edge at (**A**) is created when just the upper layer of the zygomatic is contracted; the lower layer is prevented from contracting by the triangularis. Every stifled smile has this soft, angled edge across the cheeks. Note also how the nasolabial fold fades out at (**B**); it too is dependent on the lower layer of the zygomatic major.

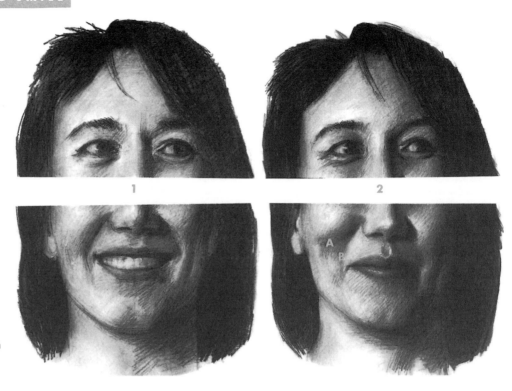

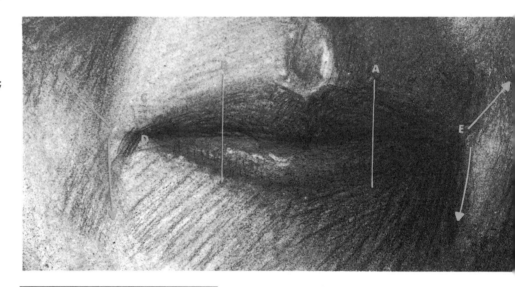

AND THE MOUTH IS DIFFERENT

To stifle a smile, the mouth corner must be kept from rising by using the triangularis (**Y**), which attaches to the corner at the same spot as the zygomatic major (**X**) and pulls it in the opposite direction. The result of the tug-of-war is a tense stalemate with these features:

1. The mouth starts out in a smile—from (**A**) to (**B**) the lips and LBL are a stretched, up-angled V, as in a closed-mouth smile.
2. And then changes direction—between (**B**) and (**C**), where instead of rising upward, LBL continues as horizontal line.
3. Corners end up level with middle of mouth, instead of higher; just as in neutral mouth. There is a slight curl downward at (**D**).
4. Corner is pulled deep into face (**E**) and toward the ear as in the ordinary smile.
5. Lips are narrowed and tightened by two other actions as well; the upward press of mentalis and the inward press of orbicularis oris. Neither is strong here.

This genial smile is another compromise between contradictory muscle pulls. He's smiling what would be a pretty broad smile were it not for the locking action of the three-muscle press—triangularis, mentalis, and orbicularis oris. Their pull is so closely matched to that of the zygomatic major that the LBL is left perfectly straight. But the strong action in the upper face is completely uninhibited.

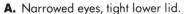

A. Narrowed eyes, tight lower lid.
B. Smile-shaped fold.
C. Full cheeks.
D. Cheek cut off here in stifled smile.
E. Deep corner, pulled toward ear.
F. Curved folds of triangularis.
G. Strong action of mentalis.

1. Action of orbicularis oculi—crinkles the eye.
2. Action of zygomatic major—pulls corner up.
3. Action of orbicularis oris—narrows lips.
4. Action of triangularis—pulls down corner.
5. Action of mentalis—pushes up lower lip.

IN ADVERTISING

Advertising models are for-ever smiling. The smothered smile, with its suggestions of conviviality and self-effacing charm, has lots of commercial potential, as demonstrated by this ex-cerpt from a vodka ad. Her stifled smile is lovely— more convincing than the standard-issue models' smiles of her companions. Models are generally not trained as actors and have a terrible time when re-quired to do anything be-sides smile—like laughing, for instance. Her lips are pressed very thin, stretched wide, with LBL slightly an-gled up. **A** is wrinkled chin of mentalis; break in outline at **B** only appears in stifled smile—it's where cheek suddenly stops being round.

The effect of each of these smiles is quite different; the stifled smile of the woman on the left is the one we are the most drawn to. Like a broad smile, the stifled smile is difficult to pose—if there's not feeling behind it, it doesn't work. Note paral-lel arcs of triangularis on the left (**A**).

THE HAPPY/SAD SMILE

The relationship of joy and distress is enormously complicated. It sometimes seems as though very young children can flow between laughter and tears without a pause for breath, and the expressions themselves—even the sounds of laughing and crying—can be quite similar. We all experience moments of pleasure tinged with grief, or sadness that is not entirely unpleasant. Perhaps the tears we shed at the theater or in the movies fall into this category, for we know that we aren't really suffering and at times even enjoy having our emotions stirred up.

There is a category of smile that reflects this finely divided balance. We've all looked into the face of someone who was smiling at us in that particular sweet-and-sour way, perhaps after making up from a quarrel or saying goodbye. We see the mouth curled up in a slight grin, and the eyes tinged with sadness. Anatomically, it's easy to see how the two expressions can coexist; the expression of sadness centers on the brows—the smile rests primarily on the lower lids, cheeks, and mouth. It's the combination of the two that produces the happy/sad look. And there's enormous difference in emotional shadings possible, depending on the strength of the smile and the level of distress in the eyes and brows. If we can recall a time when we've seen such an expression, we probably also can recall how strong an effect it can have.

Laughing Through Our Tears

In tragic, woe-is-me weeping and wailing, there's intense compression of the eyes and maximal stretching of the mouth. When people laugh or smile through their tears, the look of the cry is nowhere near as cataclysmic, and depending on the moment we look, we might see either a tearful smiling person or a crying person who looks as if he or she might break out smiling at any moment.

"Gentle, sensitive face of a prince or cultured young nobleman, often one who died in battle." So the Noh mask above is described. Here there is nothing particularly subtle about the suggestion of sadness in the upper face—the eyebrows with their strong upward slant and kink are quite straightforward. The smile is also clear. Although every Noh theater in Japan uses the same characters, every mask is unique. Other versions of this mask, called Chujo, establish the sensitivity and gentleness of the character with the same happy/sad formula, but with both the smile and the sorrow less pronounced.

HAPPY/SAD

The emotions of pleasure and distress have a complicated relationship. There are certain circumstances where we experience both—intensely—at once, as when some tremendous passage from one part of our life to another is occurring. Weddings, births, airport reunions and separations all can elicit feelings of overwhelming joy and pain. The convoluted faces that result can resemble both the look of crying and of laughing (which are not so different themselves), depending on which moment you look. I've illustrated a face precisely on the cusp between the two.

This woman is expressing her feelings on being reunited with her son after years of wartime separation. If all you see is someone crying, look again. Strongly marked signs of both sadness and joy are present. Above, there are clear signs of grief, especially the kinked eyebrow on the left, and the faint traces of the corrugator. Below, her mouth shape is a compromise: in the crucial lower corner (**A**), it's 75 percent angled up in the smile, 25 percent pulled sideways in the cry. But it's enough of a smile that, combined with the sharply angled nose-to-mouth fold and smooth chin, we read the expression for what it is: the joy of a long-suffering heart.

A subtle face, this is such a slight smile, and such a subtle show of sadness, that many people disagree on what it represents. That sadness is present in her brow is clear from a comparison with her relaxed eyebrows (below); both are slightly curved upward at their inner ends. Her threshold smile is so wan that some see it as a shrug rather than a smile. The clear message here is that she's simply smiling but is wistful, or regretful, like someone seeing a lover off for a long trip.

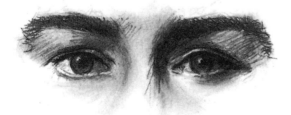

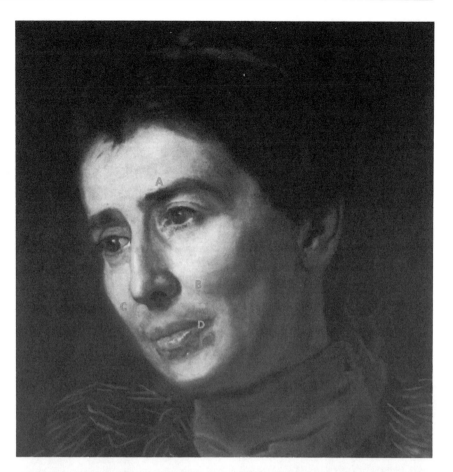

The slightest hints of mingled pleased and pained feelings give this portrait by Thomas Eakins an air of sensitivity and compassion. Notice the very slight kink in the eyebrow at (**A**); the stretch in the LBL is faint but unmistakable. Cheeks are rendered to suggest beginning of smile forms at (**B**) and (**C**). Corner has moved back into cheek; in her relaxed mouth it would be at point (**D**), without stretching of red part of the lips above and below. But Eakins has chosen not to stress the upward part of the movement, leaving it a smile trembling on the edge of becoming.

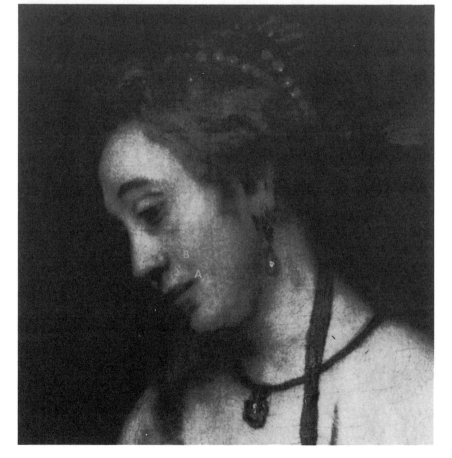

Beyond what we see, Bathsheba is holding a letter from King David, asking her to appear at his palace. In Rembrandt's well-known painting, she's portrayed responding to the king's proposition with a mixture of pleasure and distress. That it's partly pleasure we see in the corner of her mouth, curved up at (**A**) in a threshold smile (outer end above the middle). Crease at (**B**) is just beginning. In her eyes, the downcast gaze and uptilted eyebrows suggest sadness, although anxiety (kinked and raised brow) is another possible interpretation.

THE EAGER, INGRATIATING, DEBAUCHED, SLY, AND COY SMILES

If you arrive home some evening, open your front door, and thirty-five people jump out at you shouting "Surprise!" your eyebrows and upper eyelids are likely to shoot upward in response. A week later, describing the event to someone, you might say, "Was I surprised!" and you might *act out* the same expression, creating the equivalent muscle movements voluntarily. The difference between these two similar appearances of the expression is the difference between the conversational and the innate. The first is an uncontrolled, instinctive response to an emotional state; the second is a sort of expressive gesture, like nodding the head in agreement or pointing your finger.

Natural or Theatrical?

Sometimes a fine line separates the natural from the theatrical. That's particularly true with these last five smiles. The eager smile seems authentic enough. A sheepish smile or a closed-eye smile might be something we *learned* to do, perhaps by imitating someone, and therefore carries an entirely different emotional weight than, say, the look of anger or even of laughter. They seem like the sort of thing F. Scott Fitzgerald was referring to when he wrote that personality was "a series of successful gestures"; that is, mannerisms someone might develop over time to provoke a certain response.

But our attitude in this book has been less "what is the person really feeling?" than "what does it look like they are feeling?" When someone smiles with eyes half-closed, for example, most people seem to draw the same conclusions about state of mind; the same is true of someone smiling with brows raised and kinked. If these expressions mean the same thing to most people, they are obviously part of the wordless language of the face.

Smiling is the only expressive action that normally leaves the eyebrows and forehead completely smooth. When the smile combines with the eyebrow pattern associated with another expression, the net effect is a smile that takes on some of the meaning of the action in the brows. The melancholy smile is such a case, with sadness in the brows and a smiling face below; the following are five other possibilities.

The Eager Smile

In many expressions—anger, fear, surprise—the eye opens wide when the emotion is intense. Even a calm face seems heightened by the lifting of the upper lid and the appearance of white above the iris. Smiling too has a phase where the upper lid flies upward (normally it drops somewhat), resulting in a face that seems happy in an enthusiastic, effervescent sort of way. The eager smile works if the smiling pattern is complete; that is, if the lower lid with its pouch and horizontal edge appears as a complement to the upper lid with its high arch. Sometimes the eyebrows will be lifted straight upward, combining the look of mild surprise with that of the smile.

The Ingratiating Smile

There's a way we lift our brows when we're worried or anxious—it's a combination of the brow-lifting of the frontalis and the little inner-brow twisting of the corrugator. The ingratiating smile is the result of this worried brow appearing along with the smile. The overall effect is the equivalent of saying, "See how worried I am you won't forgive me? But aren't I charming anyway?" And it seems to work.

The Sly Smile

The lowered brow gives an air of conniving, or even villainy, to the smile. It's the trademark expression of bad guys in the comics; they perpetually stroll through life with their corruga-tors contracted and a threshold smile playing maliciously about their lips. Depending on the context, good guys can wear this smile too—if it doesn't appear cunning, it can just seem shrewd. Of all the smiles, this one seems the most stylized, the least "natural."

The Debauched Smile

The smile seems almost infinitely variable. Dropping the upper eyelid more than usual makes the smile appear half-intoxicated, or seductive; closing the eye entirely gives yet another effect, one of embarrassed pleasure.

The upper lid closes slightly when we smile, but stops short of covering any of the pupil. The debauched smile is what happens when the little levator labii superioris (the lid lifter) is so relaxed that the upper lid drops below the alert threshold, blocking part of the pupil. The most common way for this to occur is if we're drunk, or sleepy. Few of us smile when we're sleepy, but drunks have been know to smile quite a bit, and our first interpretation of the droopy-eyed smile is that someone's intoxicated. A secondary possibility with this same smile is that someone is smitten with sexual desire, and versions of this seductive smile appear in advertising and the movies; it's the expression of the femme fatale and the satyr.

The Coy Smile

This last variation on the smile is related to the stifled smile. Like the stifled smile, it's a failed attempt to hide the fact that we're smiling, with the added desire in this case to avoid meeting the eyes of the persons who are making us smile. If it's done naturally, we would refer to it as an act of modesty or embarrassment; but done as a conscious gesture, it becomes coy, or coquettish. It makes no difference if the eyes are closed or merely directed downward—the effect is the same.

EAGER

The eye opens wide when we're excited and closes when we smile. When we're pleased and excited, both actions can combine. The lifting of the upper lid is added to the other natural movements that occur when we smile, producing an eye that is widened above, narrowed below, and a face with an enthusiastic look.

A presidential campaign produced this turned-on look. From the iris on down, the look is of a broad smile, with a full, contracted lower lid and swelling cheeks. What sets the look apart is the lifting of the upper lid (**A**), exposing white above the eye, making her seem excited as well as joyful.

Cartoonists specialize in suggesting anatomical forms without necessarily fully describing them. Here, tightened lower lid is shown as simple straight line (**B**). On her right eye, the suggestion's most economical: lower portion of iris is simply left out. Swelling of cheeks is implied by lines (**C**) and (**D**), as is rest of nasolabial fold.

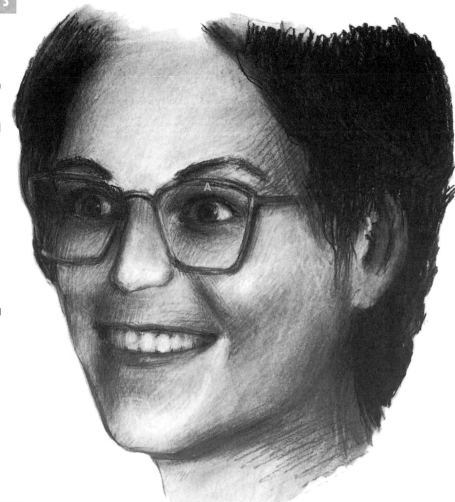

Many cartoon characters have permanent eager smiles. Animal characters are often made to seem cheerful and frolicsome by the addition of white above the eye. Elsie the cow is an excellent example of this sort of expression. Her raised upper lid and very arched eyebrows are joined with a well-observed shorthand version of the smiling lower lid: it's clearly straightened, with bulge underneath.

INGRATIATING

There are times when we smile in an attempt to win over someone who's going to take a little convincing. If we want to graphically demonstrate how worried we are that we won't be forgiven, we can smile in a way that combines the fear brow with the smiling eyes and mouth. The resulting slightly abashed look can be disarming under the right circumstances.

There's quite a lot going on in this particular ingratiating smile: (1) Head tipped forward, giving the expression a slightly deferential look. (2) Stifled smile, with the little curl of triangularis (**A**), sharp cut-off of cheeks (**B**), and mouth corners pulled deep into the face. Smile would be wider otherwise. (3) Fear configuration in brow, a combination of overall brow lift (note horizontal wrinkles) and extra kink and curl upward at inner brow ends.

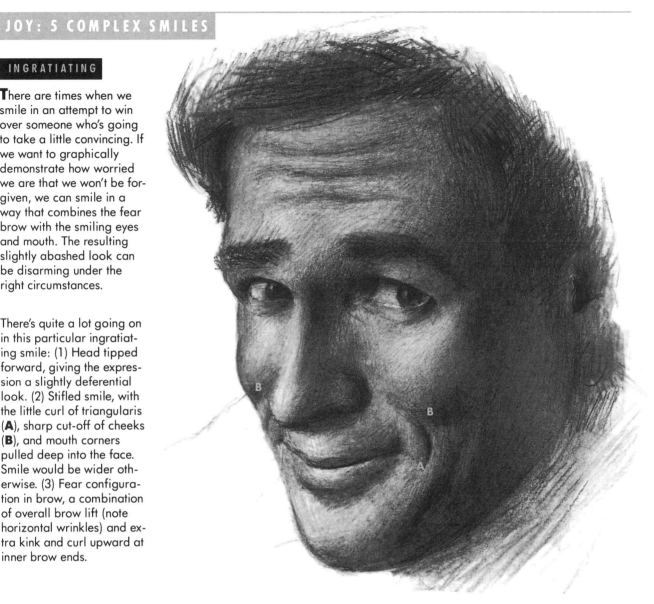

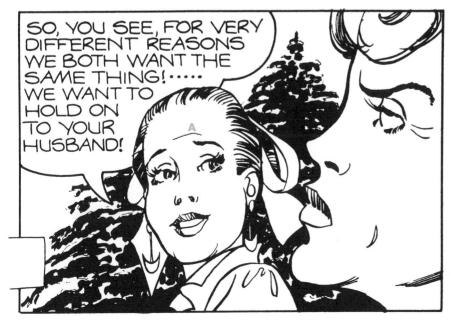

SO, YOU SEE, FOR VERY DIFFERENT REASONS WE BOTH WANT THE SAME THING!····· WE WANT TO HOLD ON TO YOUR HUSBAND!

Using the ingratiating smile in an effort to defuse her companion's anger, this woman from the comic *Mary Worth* demonstrates the same brow pattern as the man above, rendered in typical cartoon shorthand. One horizontal brow fold (**A**) stands in for many; eyebrows are clearly lifted and kinked. Her mouth shape is a compromise between talking and smiling. The forward-thrusting, pouting anger of the woman in the foreground is equally effective, as is the device of having her gaze to the side being suggested by her iris's having rolled right out of our view.

SLY

This version of the smile is a curious case. We have no trouble getting the message of the villainous, crafty grin on the cartoon character below—based on the combination of the lowered brow and the smile—but do such expressions appear in real life? Many of us do use our corrugator when we are being thoughtful (or crafty), so the source of the association is clear; but how often do people smile while they are being thoughtful? Is this a gesture, or an expression? The face at the right is based on a photograph of an actor in a comic movie. The sly grin is the sort of gesture that works well in comedy, where things tend to be played in a broad, stylized fashion. This particular expression is a combination of the slightly lowered brow and the threshold smile.

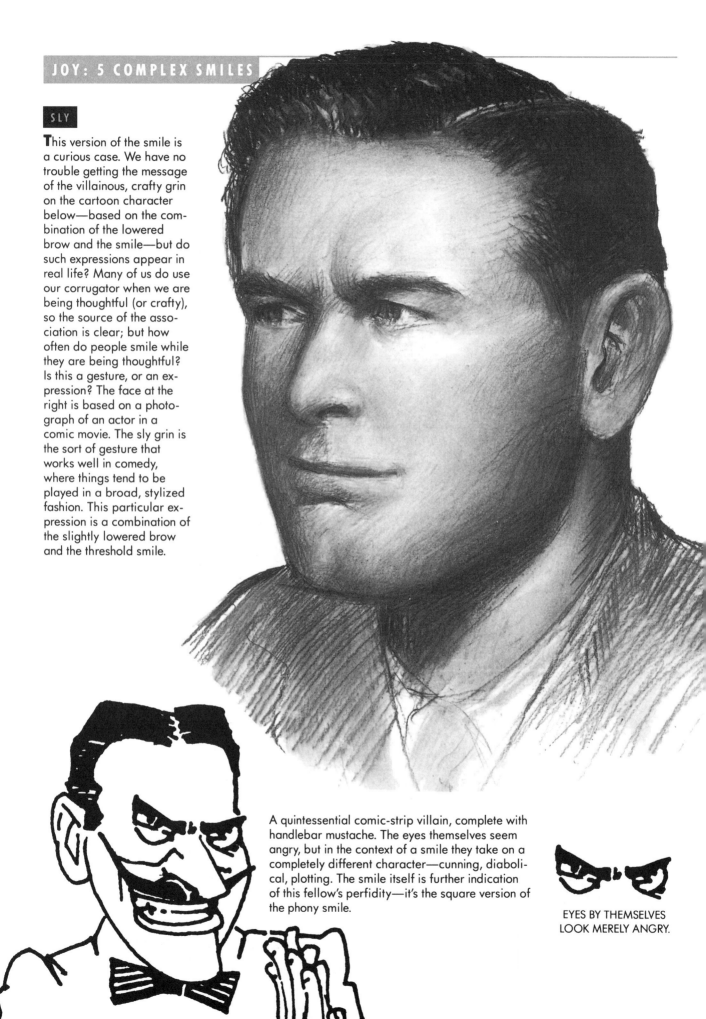

A quintessential comic-strip villain, complete with handlebar mustache. The eyes themselves seem angry, but in the context of a smile they take on a completely different character—cunning, diabolical, plotting. The smile itself is further indication of this fellow's perfidity—it's the square version of the phony smile.

EYES BY THEMSELVES
LOOK MERELY ANGRY.

"They're the Veterans of the Cabbage Patch Doll Wars."

Drawing by W. Miller; © 1984 The New Yorker Magazine, Inc.

SLY

There seems to be a fine line that separates the villainous from the merely shrewd. These individuals are meant to be seen as cunning and pleased with themselves. (The reference is to a particularly poplar toy that was in short supply one Christmas).

What distinguishes the cunning from the dull? In this case, the look of the brows and upper lid. This sly smile combines the lowered brow (**A**), with a raised upper lid (cut off by lowered brow at [**B**]) and slight grin. The high upper lid gives the expression an extra intensity. The dull smile (**C**) is a version of the debauched grin—low upper lid, sometimes (as here) with a raised brow. The drummer with the low upper lid could look drunk instead of slow, but here context suggests otherwise.

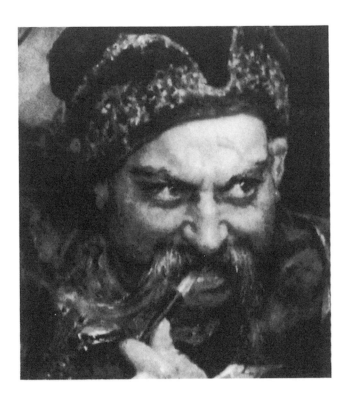

This is one pleased Cossack. As painted by the Russian Ilya Repin, this is the most vigorous of the shrewd grins I've reproduced. Besides the strongly lowered eyebrows, the face includes full eyelid pouches, full cheeks, heavy nasolabial folds, and every indication he'd have a broad smile if he didn't have his lips around that pipe!

DEBAUCHED

When the upper lid droops, covering a bit of the pupil, it makes us look sleepy, intoxicated, or even dull-witted. Combine this effect with a smile, and the net result is an expression suggestive of intoxicated pleasure—the look of a satyr.

This gentleman looks drunk. Both eyes contribute to the effect, even though only one lid is drooping. The other lid (**A**), is in an ordinary, alert position, but only because it's being lifted by his left frontalis (**B**). Sleepy people often employ the brow-raising muscle in an attempt to keep their lids from falling; here it merely adds to the intoxicated effect. Slight smiles are usually asymmetrical.

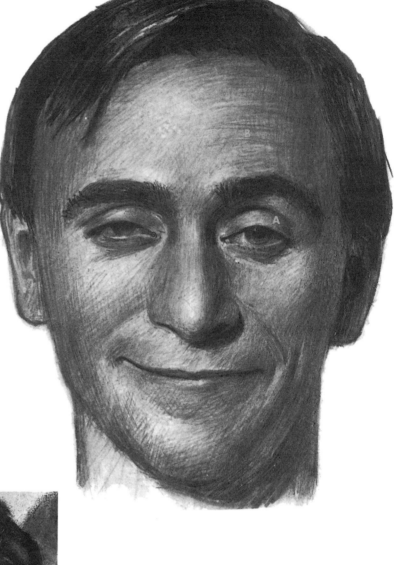

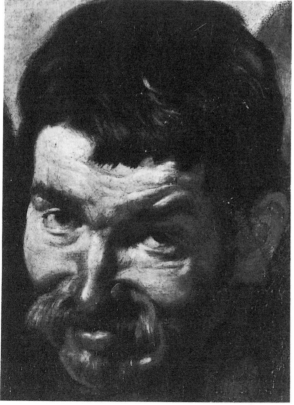

The head of a drunken peasant from *Bacchus* by Velázquez. The same combination of elements are present: closed-mouth, asymmetrical smile; one lid drooping, the other lifted by half of frontalis. The eyes seem oddly out of convergence.

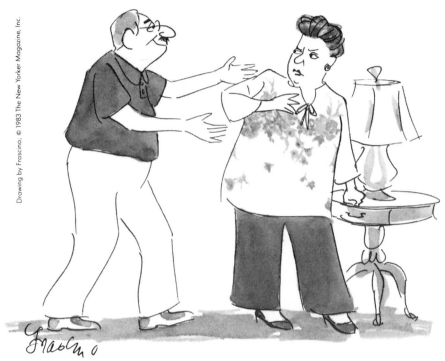

"Don't 'Oh, baby' me!"

DEBAUCHED

In the right setting, we may also see the drooping-lid smile as an indication of heightened sexual desire, another sort of intoxication. If the man in the cartoon was sitting at a bar, we would see him as contentedly tipsy; here we interpret his look as amorous. His (presumed) wife really doesn't look very angry—it's all in her gesture and the context. You have to look carefully here to sort out what line does what—the cartoonist has used one continuous line for the nose and the eyeglass stem; the low upper lid is a separate stroke at (**A**).

A come-hither look, but oh-so-polite and refined, in the context of a society portrait. Her upper lids droop just below the alert lower limit; her smile is just past the smile threshold.

231

CLOSED-EYE

The look of the closed-eye smile is the look of someone who's just been stroked. Like the stifled smile, it has a charming, slightly abashed quality to it; we're pleased with the attention and at the same time trying not to show it. When seen on a head that is tilted forward or to one side, there is an added sense of slight embarrassment or shyness.

Presented with a compliment, we sometimes react by closing our eyes and smiling, as this woman is doing. The closed-mouth smile is slightly more modest than the broad, toothy smile; it may be that a slight, invisible action of the three-muscle press keeps the lips from separating in smiles like these. The effect would be exactly the same if her eyes were looking downward instead of being closed.

Drawing by Stevenson; © 1983 The New Yorker Magazine, Inc.

"*Before Reagan came along, you never used to twinkle and say 'Well . . .'*"

A very similar note is struck by the tipped head and closed eyes of the gentleman in this cartoon. Note carefully the economical strokes on the left side of his face; in combination with the ink-wash shading, they successfully suggest his rounded cheeks and crow's feet. For good measure (and not really necessary) the cartoonist has added raised eyebrows.

THE COUNTERFEIT SMILE

Artists need to discriminate between true and false in portraying smiles. It is easy enough to get practice in comparing the real with the phony—we are daily bombarded with images of people who wish to be perceived as happy—politicians, models in ads, celebrities.

We always draw conclusions about someone's smile, whether we're aware of it or not. We know a false smile when we see one, but it's all instinct. Here's some tell-tale signs of the counterfeit smile:

Lack of eye/mouth agreement

The wider the smile, the more crinkled the eyes. When someone flashes a lot of teeth, and there isn't a heavy pouch under the eyes, deep crow's feet, and a straight, high-riding lower lid, the smile lacks warmth and charm.

Flat cheeks

The bunching of the cheeks is created by the joint action of the eye muscle and the smiling muscle. If only the smiling muscle is active, the cheeks won't be as full, and the smile won't look right.

Too Toothy

Somewhere along the line, certain individuals get into the habit of displaying their lower teeth as well as their upper when they smile. This can only be done with the added pull of the lip stretcher, and it gives a strained, false quality to the smile. Besides showing the lower teeth, the sideways pull also creates a longer flat section in the middle of the lower lip and a square corner. This sort of smile is common among people who are constantly in the spotlight—politicians and celebrities—and who are used to making an extra effort for the cameras.

THE COUNTERFEIT LAUGH

Laughing when you're not amused is a much more difficult proposition than smiling when you're not happy. Most of us have little reason to even try, but situations do arise, particularly if you're in the modeling or performing business. No matter what your business, if you try to feign laughter, you have to begin by smiling and dropping your lower jaw, creating space between the teeth.

What all ersatz laughs lack is the reflexive crunching of the eye and the skin around it. That reflex is very hard to trigger without stimulation of the energy burst that precedes a laugh. The difference between just closing the eyes and having them forcibly shut is clear in the direction of eyelids and the appearance of the skin around the eye. A real laugh creates a major pouch below the eyes and lots of wrinkling out from the corner. The lid lines are changed drastically—the lower lid pushed up, the upper lid pulled down. What looks particularly bad in a laugh is if the person laughing is looking at something. When we laugh, it takes over, and we momentarily lose consciousness of our surroundings. If you're looking at something while you laugh, you're not really laughing.

Here the pull of the lower lip stretcher, risorius/platysma, has been added to the pull of the smiling muscle, and while it does make the smile toothier, it doesn't make the smile nicer. Compared to the sincere smile, the toothy smile shows more of the lower teeth, and the lower lip is flatter, with a square-shaped corner. The resulting smile looks tense and unnatural. With the faces on page 234 we'd also expect to see their eyes more compressed.

A B

A. Zygomatic major only.
B. Zygomatic major plus action of lip stretcher.
C. Pull of risorius/platysma squares corner.

What do con men, socialites, politicians, salespeople, relatives at a family reunion, and people posing for group photos all have in common? They are all expected to smile whether they're happy or not. Smiles are alone amongst expressions in being a requirement in certain situations, and we all have experience at having to smile when we'd rather not. In social encounters, we're usually too preoccupied to notice whose smile is sincere and whose is not, but when we are presented with a picture of a smile, and the time to look closely at it, we have strong opinions on the subject.

The too-toothy smile (above and left). People who smile for the camera may develop the habit of stretching the mouth as wide as possible in an effort to enhance their smile. It doesn't necessarily work. The ordinary smile uses only one muscle to stretch the mouth, zygomatic major, and that accomplishes the task nicely.

TODAY, I, *BILL BYTE*, FLOPPYSOFT V.P. FOR P.R., BEGIN MY PERSONAL SELL JOB ON *CHERRY DOOBIE!* HEH, HEH.

SAY, CHERRY, WHY DON'T WE PLAY SOME *TENNIS* THIS WEEK?

SURE, BILL! I'LL CHECK MY SCHEDULE...

HMMM... THIS EVENING I HAVE KARATE CLASS, TUESDAYS AND THURSDAYS I *JAZZERCIZE*...

WEDNESDAYS I'VE GOT FRENCH LESSONS, AND FRIDAY I'M ATTENDING AN *INVESTMENT* SEMINAR...

SATURDAY I'M GOING *HIKING* AND SUNDAY I'LL BE *WINDSURFING*...

I *RUN* EVERY MORNING AND I'M HAVING LUNCH WITH CLIENTS EVERY DAY BUT *THURSDAY*...

THAT'S IT! WE CAN PLAY *THURSDAY!*

THAT'S ASSUMING MY DATE FOR RACQUETBALL *FIZZLES OUT!*

An excellent cartoon send-up of the too-toothy smile is provided by this excerpt from the strip *Boomer's Song*. It's the sort of expression we associate with a particular sort of extroverted insincerity, personified here by the young executive on the make. Most instructive is the panel enlarged at left—the sincere smile (hers) is seen in the same view as the phony smile (his). Note the corners (**A**) and (**B**); his is square, hers is angular. We see his full row of lower teeth, not hers. Note also eager smile (**C**) and ingratiating smile (**D**). Being able to handle the nuances of the smile is a real bread-and-butter skill for a cartoonist.

All of us are required to smile at one time or another; only some of us are ever required to laugh. Forced laughter is a speciality of advertising models, and we're daily surrounded with examples of insincere laughs in cigarette ads and the like. Actors may also be seen laughing without much conviction. What separates the genuine laugh from the posed variety is simple—the degree of contraction of the muscle surrounding the eyes, orbicularis oculi. No contraction or a weak contraction means no laugh. Neither of these women is laughing. They are both smiling with their jaws dropped, something only people trying to pose laughter will do.

Problem with the eyes. There is a subtle, but unmistakable difference between the eyes pressed shut by the contracted orbicularis oculi and the eyes merely shut by the lowering of the upper lid. Her lash line curves downward; in a true laugh it is curved straight or upward. Eyes also lack pouching of lower lid (sign of eye muscle contraction) and crow's feet. Real laughter puts an intense squeeze on the eyes.

Problems with the eyes. She's looking at us. True laughter is a momentary explosion, leaving us blind to the world around us. She lacks pouching under the eye, crow's feet, and raised lower lid. *Problem with the cheeks.* When only the zygomatic major contracts, half of the force that bunches the cheeks is missing—the contraction of the orbicularis oculi.

If you suspect that beneath the surface of those happy 1950s families something else lurked, this ad illustration may offer some confirmation. Besides the odd, spasmodic gestures (and no one is looking at anyone else), every jaw is dropped in a hollow laugh. The man on the left demonstrates the impossible combination of eager smile—raised eyebrows, white above iris—and laugh; the effect is silly, not cheerful. Laughter isn't possible with a wide eye, and the jaw doesn't drop that far in ordinary smiling. The woman's laugh has no eye contraction at all, no cheek bunching. Even if she were smiling and not laughing, the eyes and cheeks would look radically different if she was sincere. (And why isn't she watching what she's doing?) The boy's cheek bulge is far too low on his face. It should be centered alongside the nose (see p. 197).

SUMMARY

The expression of joy is by far the most complex of any we've examined. The smile can be associated with an enormous variety of moods, ranging from total euphoria to melancholy. Smiles even appear on the face when we're not feeling any emotion at all as a sort of all-purpose social mask.

The pure smile is straightforward, the work of only two muscles—the zygomatic major and the orbicularis oculi. As long as we're really happy, a precise coordination exists between their action. A strong burst of feeling will stimulate strong contractions of both; a slight tingle of pleasure will create a full-face movement with hints of all the same changes. We instinctively smile in this particular way, and we instinctively recognize when someone else is smiling with sincere feeling.

When we laugh, the same muscles, and the same movement, are activated. In depicting laughter or smiling, an awareness of the rounding out of the upper face and tightening up of the lower is essential in making the smile look "right." A broad smile, particularly, is a major facial event; few expressions move so much face around and create such a pronounced "hill-and-valley landscape." A clear understanding of the role of the lower lid in adding warmth and sincerity to a smile is also crucial. In general, if you don't have bags under your eyes, you're not happy!

Skill at drawing things like stripes on beachballs and rings around barrels is directly related to skill at drawing the lip portion of a smile; one must feel clearly the line of the lips traveling around the smooth cylinder of the teeth. Observation and practice get the other parts of the smile to look right.

There's no limit to the emotional nuances a smile may express. Artists have particularly focused on the slight smile and the melancholy smile; cartoonists routinely combine the smile and active eyebrows to achieve a much broader range of possibilities.

Ultimately, looking at smiles suggests how limited our understanding of the whole phenomena of smiling really is; no one fully understands how we physically create the smile, let alone how we perceive such an enormous range of meanings from it. Like people, smiling may be ultimately too complicated and subtle to ever analyze fully or comprehend. The artist proceeds by trial and error and by celebrating, not avoiding, the mystery.

THE EXPRESSION OF FEAR

Fear is both the most remote and the most familiar of emotions. Abject terror is the sort of emotion the psyche reserves for truly life-threatening situations. It is the response of people facing firing squads, ship sinkings, and house fires (extremities that are fortunately beyond the experience of the vast majority of us), and it is an expression not many of us will have ever seen.

A much more familiar variety of fear lies in the background of daily consciousness, like static on a radio, haunting and delimiting our lives. We are afraid, but in a subdued, controllable way, of many things: change, rejection, failure, loss of people close to us, disease, old age. Not to mention mundane things like dentists or snakes.

The relationship between this potpourri of feared things and our actions and expressions is as complex as human nature. What interests us here, of course, is how much of this low-level fear or anxiety "leaks" in a recognizable way onto the face. As in most of the other expressions, there is a family resemblance between the lowest levels of expression, the worry and anxiety we just referred to, and the catastrophic faces of terror and horror. We learn the pattern by studying the most extreme faces, then looking for traces in faces that are much more relaxed.

The basic pattern of fear has three main elements: raised brow, wide eyes, and opened, stretched mouth.

THE BROW OF FEAR

In both fear and surprise the entire brow is lifted and the eye is widened. Sudden alertness is the common element; in both expressions, the brow lift of the frontalis is used as a means of opening the eye all that much quicker.

The added element of distress distinguishes fear from surprise. Surprise is neither pleasant nor unpleasant; fear is almost always disagreeable. When we are distressed by being afraid, the broadly raised brow of frontalis is modified by the downward and inward pull of the corrugator.

The result is that the eyebrows and forehead in fear are a cross between the brow of grief and the brow of surprise. The eyebrows are neither as oblique as they are in sadness nor as high as they are in surprise. The eyebrows are lifted and kinked a bit. Look at these differences on your own face. Lift the eyebrows up as high as you can, then maintain the upward pull while trying to pull them downward and together. You'll see the eyebrows lowering on the face a bit, vertical folds appearing between them as they approach, and the shape of the eyebrows themselves changing—the arched

shapes of surprise gives way to a much straighter eyebrow line, with a slight bending upward in the inner third. If you relax your forehead, then pull your eyebrows into the distress pattern, you'll notice how much lower the eyebrows are on the face and how the horizontal wrinkling only appears in the middle of the forehead, unlike fear; the kink in the inner end, however, may appear quite similar.

The fear pattern differs greatly from person to person, and the difference between the look of fear and sadness diminishes as the intensity level drops.

THE WIDENED EYES

When we're afraid, we experience a heightened awareness of our surroundings. Our entire nervous system focuses on what might be threatening in our immediate vicinity. The heightened awareness is particularly visible in the appearance of the eyes, which widen, sometimes to the greatest possible extreme.

The wider the eyes in a frightened face, the more afraid we look. In this way fear is similar to anger and surprise, the other two expressions where the wideness of the eye is like a valve, whose opening and closing controls the expression of the entire face. Under certain circumstances, just seeing greatly widened eyes can lead

us to see a face as terrified. In a less cataclysmic state of fright, such as worry and anxiety, the eye is not so wide that white appears above the iris, but merely neutral. The eye in fear must never be partly closed; that happens only in the expressions of joy, sorrow, and disgust.

Although frightened faces always have alert eyes, certain other details are more inconsistent. In some faces, the lower lid will tense, as it does in anger, sadness, and joy, and make a straight line high across the bottom of the iris. Often, a shallow version of the oblique upper lid fold that always appears in sadness will be present. Both these details seem to heighten the look of fear and may be added to a depiction as clarifying elements.

THE STRETCHED MOUTH

In fear, the mouth drops open and is stretched a bit to the side. Darwin suggests two reason for this: when we're afraid we instantly begin breathing harder—preparing to flee—and the mouth opens wide to accommodate; when we're scared we also tend to shudder, and the skin tension that accompanies a shudder activates the risorius platysma, stretching the mouth.

The look of the frightened mouth is far easier to describe and depict than the mouth of anger, sadness, or joy—there's much less stretching involved, and the action of only the risorius/platysma is present. There is nothing approaching the full contraction of the risorius/platysma, even in extreme terror. In less intense fear, the lip stretcher may contract very slightly or not at all.

The most typical pattern for the open mouth of fear is the shape of a capital D on its back. The lower lip is straight across, displaying the lower teeth, and the upper lip is relaxed, arching down to mouth corners.

TERROR: THE AWFUL MOMENT

Terror is the expression of someone facing a sudden, overwhelming catastrophe. Most of us only catch glimpses of what it might be like; it's hard to imagine any other emotion that would be so shocking to the entire nervous system. Like most extreme emotions, terror is unpredictable in its effects: at its most extreme, people faint and can even die from terror; hair may stand on end; sweat covers the body; and we may be either thrown into an uncontrolled panic or rooted to the spot, unable to move.

The eyes are widened to their greatest extreme, and the mouth is dropped open and stretched sideways. The brows are usually raised in the fear pattern, although terrified faces sometimes appear with relaxed brows.

Horror is much less altering of the face than crying or laughing. In the faces of people who are very frightened, the cheeks are perfectly flat, the upper lip and its surroundings relaxed. A shallow version of the nose-to-chin fold appears, but it is nowhere near as strongly marked as in anger, sadness, or joy. All of this makes fear a somewhat more subtle expression that relies primarily on the look of the eyes (and eyebrows when the eyes are less extreme) to make itself clear.

WORRY AND ANXIETY

There are very specific nouns in English for different degrees of fear-related feelings. In order, terror, fear, anxiety, worry, and concern express the idea of related emotions and de-creasing intensity. Other emotions, such as sadness, have fewer distinguishing labels between one level of feeling and another.

But clear as the terms may be, fear is one of the expressions, like anger or surprise, that becomes increasingly ambiguous as its traces on the face grow fainter. As the clues become slight, the same face might be interpreted by one person as worry and another as sadness; the expression of sadness is most likely to be confused with that of fear when there is no appreciable widening of the eyes.

The worry pattern is basically fear without the widened eyes—the upper lid is not especially high, but crosses the iris in the normal alert position. The forehead is visibly creased by wavy folds that cross the brow, but the eyebrows may not be lifted very high. The eyebrows themselves have a straightened look with a slight bit of upward bending at their inner end. There may be a shallow diagonal fold across the upper lid.

The mouth may drop open in worry with some of the sideways stretching of terror still visible; we can also see worry in faces where the mouth is neutral, when the pattern in the upper face is clear enough. (The expression of worry also often includes the bringing of the hand to the head. This gesture often accompanies the expression of worry in illustrations—see page 251 below.)

Alternatively, worried people may press down nervously on their lips. There probably isn't one of us who doesn't do some fidgety thing with our mouth when we're particularly anxious, but it only works as a pictorial representation of anxiety if the compressed mouth is combined with the worried eyes and brow.

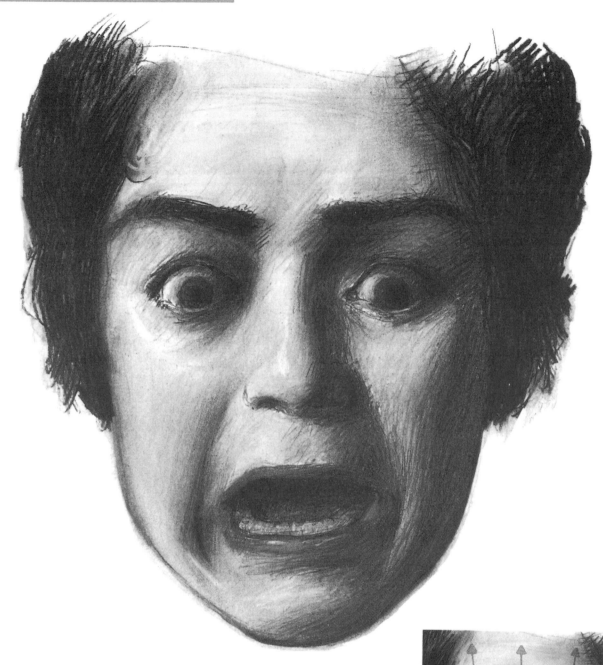

The changes that take place in the face seem minor by comparison to the effects of terror on the body, but they are striking, nonetheless—the eyes open wide, the brows are bent and pulled upward, and the mouth drops open, showing the lower teeth. Fear shares with surprise the look of sudden alertness and with sorrow the look of distress.

A. Action of frontalis.
B. Action of corrugator.
C. Action of levator palpebrae.
D. Action of risorius/platysma.

FEAR

SADNESS

ANGER

THE MOUTH

The mouth drops open when we're frightened, because we breathe much harder. Surprise is nearly the same, but with one crucial difference—the action of risorius/platysma. The lip stretcher acts when we're afraid and not when we're merely surprised. The result: a completely relaxed upper lip and a horizontally-stretched lower lip.

In fear only the risorius/platysma is operating on the mouth. The contraction is less intense than in sorrow.

In sorrow the risorius/platysma acts with the mentalis and the zygomatic minor. The upper lip is square, but not sneering.

In anger the risorius/platysma acts with the sneering muscle.

THE EYES AND BROW

The eyes in fear control the intensity. They open as wide as possible. The wider they open, the more frightened the look. Even in faces that are merely anxious, the eyes are noticeably more alert looking than in the otherwise similar expression of sorrow. Sometimes the lower lid may rise in tension, or the eyes themselves may bulge.

The eyebrows in a frightened face are a cross between surprise and distress. In surprise (top), the full frontalis contracts and the eyebrows are pulled straight upward. In sorrow (bottom), the middle frontalis contracts and the corrugator acts; the eyebrows are pulled closer together, and their inner ends bend upward. When we're afraid (middle), the corrugator and the full frontalis contract: the eyebrows rise half as high as in surprise (the corrugator is pulling them downward), the inner end bends half as much as in sorrow.

In fear, horizontal wrinkles (**A**) often appear across full forehead; they appear only in the center in sorrow. The eyebrow (**B**) is more straight than arched. The inner eyebrow end is usually (but not always) kinked. (**C**) Brows are also closer together; bumps appear between them.

SURPRISE

FEAR

SADNESS

EYES ONLY

One way to depict terror is to hide part of the face and show just the widened eyes. This is a technique regularly used in ads for horror movies. We tend to see the eye from the top poster as frightened, even though it could just as easily be the eye of surprise—we can't see enough of the eyebrow to tell if it's lifted and bent or just lifted. The face below (middle) is even less likely a candidate to look terrified—the eyebrows are neither lifted nor bent. The widened eyes and dramatic lighting lead us to read the face as that of terror.

Part of the reason the movie posters work is that occasionally it is only the eyes that register our facial response to fear. This drawing (left) is based on a photo of a rural Indian boy about to receive a typhoid shot. Though most of his face is relaxed, we have no trouble determining what his state of mind must have been at that moment. There is the strong possibility that the eyeball is pushing outward in response to the boy's panic, showing more white and bulging out the lower lid.

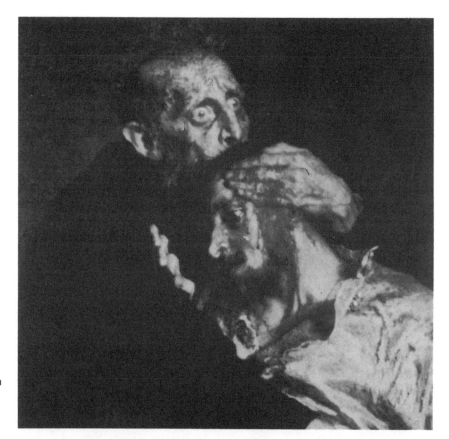

The expression on this face is one of the most literal depictions of terror in the history of painting. Ivan the Terrible is portrayed after having mortally wounded his son in an outburst of rage. The fury has passed; it has been replaced by abject horror. Though Ivan's mouth is hidden, his eyes are explicit.

Repin has made two major changes in the expression between the study (right) and the painting. **1.** The eyes are wider and more bulging. In fear, wider eyes intensify the expression. The severity of the lower lid pouch suggests that eyeballs are also pushing forward in their sockets; this is rare, but possible under such extreme emotion. **2.** The brow of fear is much more explicit. Relying on his knowledge of the expression (and likely posing it himself), Repin has added creases of frontalis (horizontal) and corrugator (vertical) to the smoother brow of his model. Such changes are often necessary to get an expression to "read."

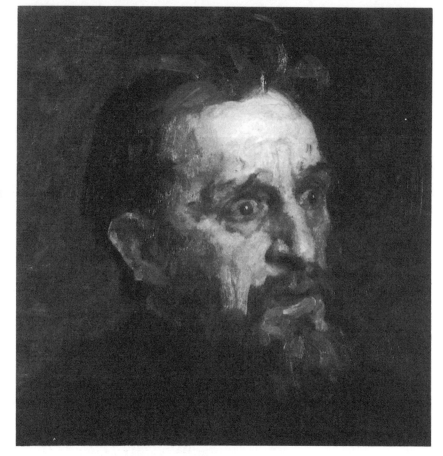

FEAR: THE FACE OF TERROR

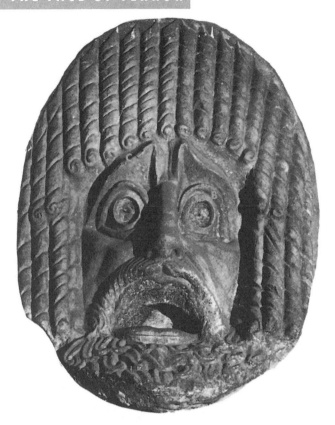

No actual masks of tragedy from the ancient stage have survived; their materials, like wood and canvas, were too perishable. But copies like this Roman carving, intended for display, not use, are thought to be quite accurate. This mask would have been worn by a tragic hero, like Oedipus. Though quite stylized, and likely a "copy of a copy of a copy," the message of unadulterated horror is stark and compelling. The D-on-its-back mouth (**A**) is identical with that in the Kollwitz lithograph; the eyes show plenty of white above the circular iris (**B**). Most stylized are the eyebrows and the vertical corrugator folds. The maskmaker has exaggerated the ordinarily slight up-tilt of the brows (**C**) and joined the corrugator ridge (**D**) to it for decorative effect. Decorative, but without losing the emotional impact.

Somewhat less literal than the painting opposite is the portrayal of the woman in *Death Clutches a Woman* by Käthe Kollwitz. But even without the intense detail of the Repin, and partly shaded as it is, the woman's face is no less evocative of terror. Some details: (**A**) lifted brow and widened eye; (**B**) relaxed upper lip, tensed and stretched lower; (**C**) bracketing crease of risorius/platysma.

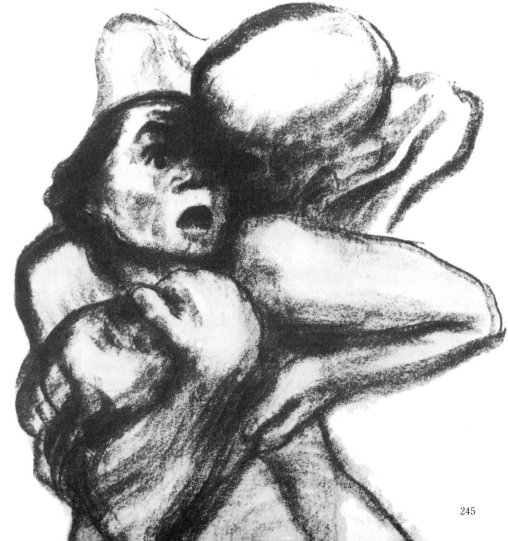

245

How frightened someone looks depends on how frightened the eyes look. In the most extreme terror, there's always white showing above the iris. With the brows raised, the mouth opened and stretched, and the eyes not quite as wide, the face still looks very fearful, but without the same edge of intensity.

The mouth is probably the least important element in fear. This woman's mouth is dropped open, but the sideways stretching of the risorius/platysma is very slight—just enough to expose the lower teeth. The message of her upper face, however, is very clear. Her eyebrows and forehead are marked by both the full upward pull of the frontalis and the downward resistance of the corrugator—note the variation in the shape of her two eyebrows, one straight, one kinked. Her eyes are opened slightly wider than normal.

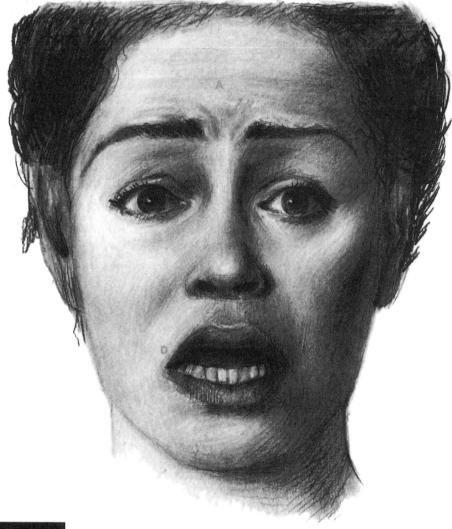

A. Horizontal creases of frontalis.
B. Vertical creases of corrugator.
C. Suggestion of oblique, across-the-lid fold.
D. Upper lip relaxed, lower lip a bit stretched.

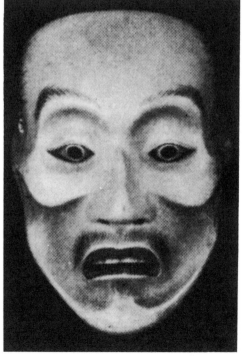

This Noh mask, Yase-otoko, is said to indicate the state of an old man in death. Like the woman above, he looks terribly afraid. The mouth shape, like a D on its side, is very characteristic of the mouth of fear, with a bit more sideways stretch than the woman. Note stylization of top rim of eye-sockets and bottom rim of cheekbones meant to suggest hollowing out of the face that takes place with aging.

HORROR ANCIENT/ HORROR MODERN

The look of fear seems the same whether one is frightened at something threatening or reacting to an awful sight. The man (right) is one of the spectators of the explosion of the space shuttle *Challenger*. His expression of horror is indistinguishable from that of someone fearing direct harm. Compare this to the gargoyle with a look of horror (below). This stone carving is from the facade of the great medieval cathedral of Rheims. Was the gargoyle supposed to be watching horrible things or anticipating imminent harm to itself?

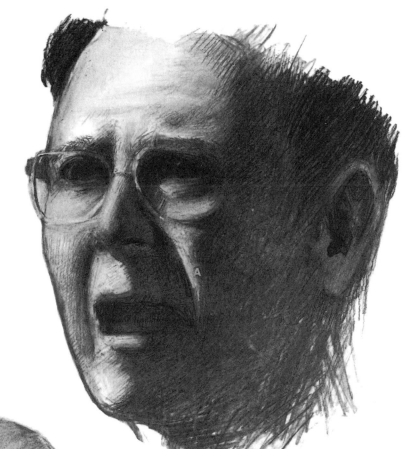

DETAILS OF THE EXPRESSIONS

The degree to which the brows lift in fear varies greatly from person to person. On the man (above) the brow lift is very slight. We see him as horrified, not grieved, because of the shape of his mouth and the wideness of his eyes. The creases we see running down both faces (**A**) appear in many expressions, whenever the mouth is both opened and stretched. In fear the folds are shallow, the cheeks relatively flat. Note also oblique upper lid fold on the gargoyle (**B**), a form that always appears in distress, sometimes in fear.

Fear can be seen on the face even if the eyes are only ordinarily wide, and the eyebrows are only a bit lifted. What distinguishes these more subtle faces of fear from sadness is the fact that the eyebrows are lifted across their full length and the eyes are alert looking—not shuttered as in distress.

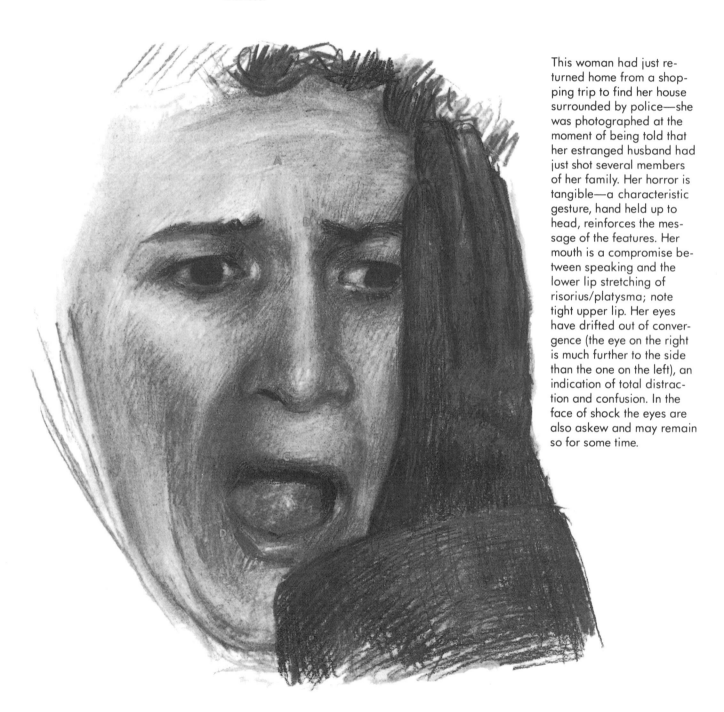

This woman had just returned home from a shopping trip to find her house surrounded by police—she was photographed at the moment of being told that her estranged husband had just shot several members of her family. Her horror is tangible—a characteristic gesture, hand held up to head, reinforces the message of the features. Her mouth is a compromise between speaking and the lower lip stretching of risorius/platysma; note tight upper lip. Her eyes have drifted out of convergence (the eye on the right is much further to the side than the one on the left), an indication of total distraction and confusion. In the face of shock the eyes are also askew and may remain so for some time.

A. Action of frontalis, raising brow.
B. Action of corrugator, bringing brows together.
C. Action of orbicularis oris, tightening upper lip.
D. Action of risorius/platysma, stretching lower lip.

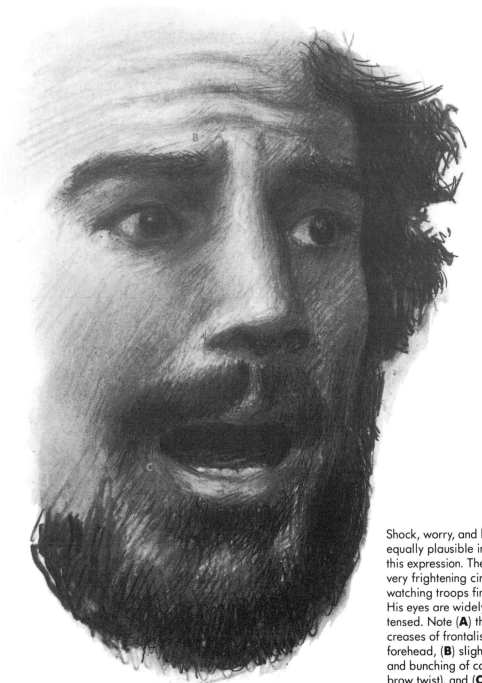

Shock, worry, and horror are all equally plausible interpretations of this expression. The man is in fact in very frightening circumstances: he's watching troops firing into a crowd. His eyes are widely open; his mouth is tensed. Note (**A**) the horizontal creases of frontalis across the full forehead, (**B**) slight vertical creasing and bunching of corrugator (with eyebrow twist), and (**C**) mouth that has a just-dropped-open look, with slight sideways stretching of risorius/ platysma.

This expression seems closer to daily life. It could be the face of someone talking on the phone who's just heard some disturbing news. The mouth is on the borderline between slightly stretched and neutral; the eyes are neutral, with a suggestion of the oblique lid fold **A**. The eyebrows and forehead are the clearest cues; eyebrows raised overall and kinked at **B** and **C**, forehead creased with full horizontal folds **D** and vertical corrugator folds **E**.

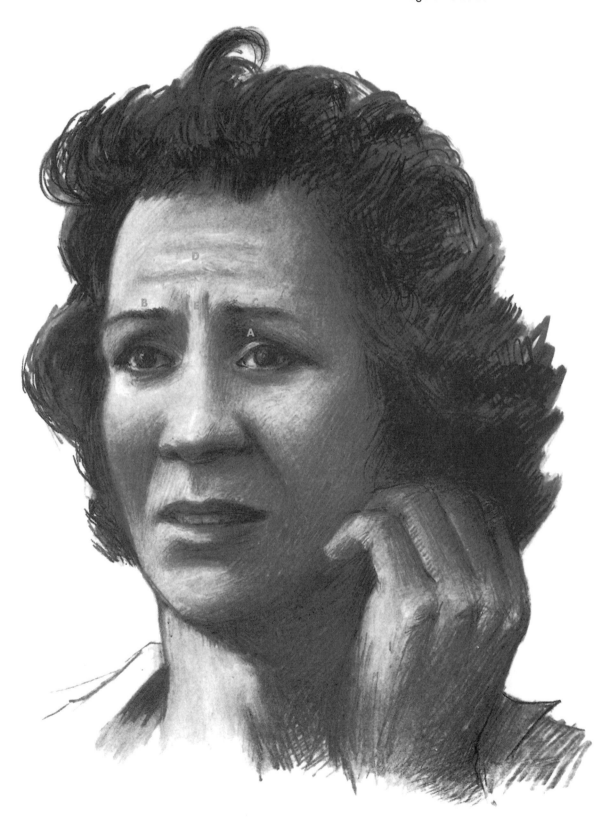

WORRY: A VARIATION WITH COMPRESSED LIPS

Nervous people tend to fidget, and mouth-pressing is an important form of nervous fidgeting. Watch people waiting in line to buy tickets for a train or a bus about to depart—the variety of lip-chewing or lip-pressing actions to be seen are countless. When compressed lips are seen with a worried brow, a strong picture of anxiety emerges.

This quintessential portrayal of wedding day jitters is activated by a vivid expression, but it's really our ready identification with the plight of the groom that makes it work. The utterly deadpan face of his bride is the perfect foil for his discomfort. The groom's lips recall the lip shape in faces of repressed anger or sadness. (Note orbicularis oris bulge at **A**, triangularis bulge at **B**.) But here, he's not trying to prevent anything from happening; he's just using the mouth as an outlet for tension. The picture is completed by the lifted, wrinkled brow, and the disappearance of the red portion of the lips.

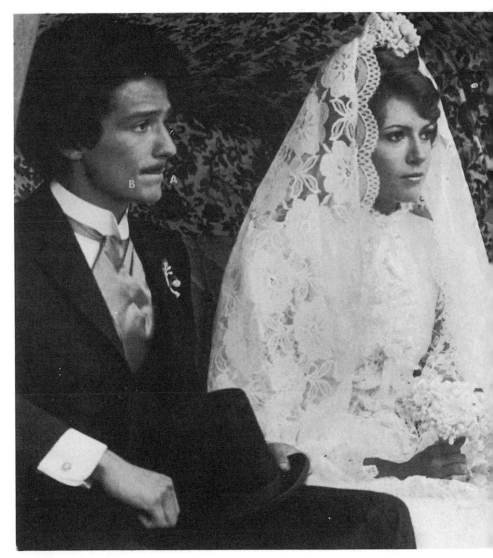

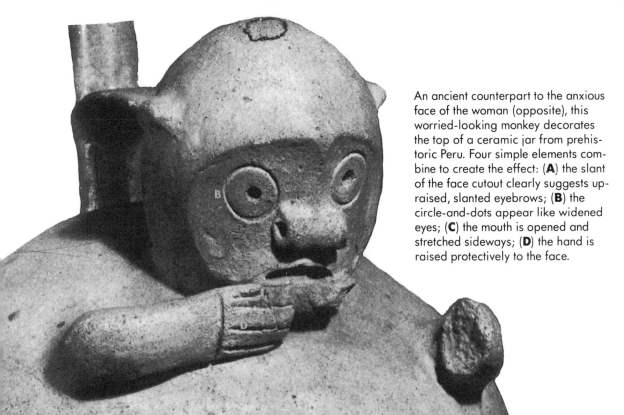

An ancient counterpart to the anxious face of the woman (opposite), this worried-looking monkey decorates the top of a ceramic jar from prehistoric Peru. Four simple elements combine to create the effect: (**A**) the slant of the face cutout clearly suggests upraised, slanted eyebrows; (**B**) the circle-and-dots appear like widened eyes; (**C**) the mouth is opened and stretched sideways; (**D**) the hand is raised protectively to the face.

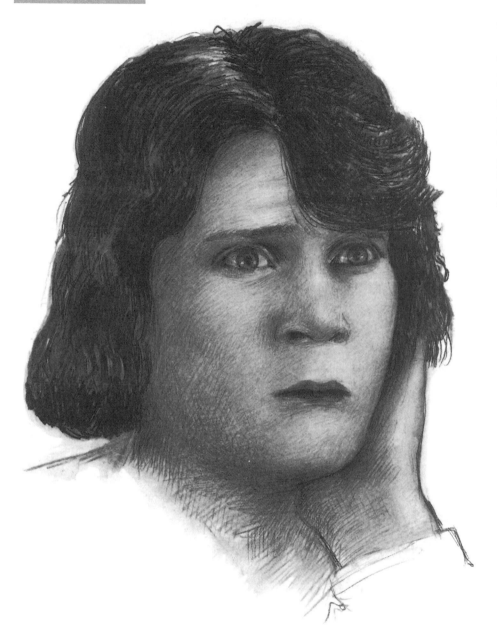

When subtle fear appears just in the eyes, we perceive that someone is worried, concerned, or anxious. Worry can be successfully portrayed if the eyes are clearly alert and the brows are clearly lifted and bent. The action in the eyes is especially important because the action in the mouth is missing; the eyes lack the wide, staring look of terror.

In silent movies, facial expression was especially important as a way to communicate the characters' state of mind. This 1920s film heroine is obviously feeling a bit threatened. Her fear is shown in her eyes; they're opened extra wide, and the lower lid is straightened. The brow alone wouldn't carry the message—it's so low that it could be the brow of fear or sadness. But sad eyes would never be that wide. Sadness is an inward-looking expression; fear is a greatly heightened looking-outward.

In Donatello's vision (opposite, bottom), St. George is hardly a macho warrior, but rather a sensitive youth. As he stands bolt upright, poised to defend the faith, his face wears an expression of manly concern. Note the bunching of skin around eyebrow at inner end, characteristic of corrugator action (**A**). Upper eyelid is slightly above normal alert threshold—if eyes were partly closed, he might look sad. Frontalis is also active (**B**).

FEAR: WORRY

In this poster, three nervous nurses wonder if they have what it takes to get their licenses—but the nurse in the middle seems to be wondering the most. Her eyebrows are the most up-slanted, her eye is the most wide opened. Oblique upper lid fold is a helpful detail. Though her mouth looks worried too, it's only by association with the upper face—her mouth, and those of the other two nurses, is neutral. The eyebrow shapes of the others border between neutral and afraid—not enough upward twist at inner end, no signature wrinkles.

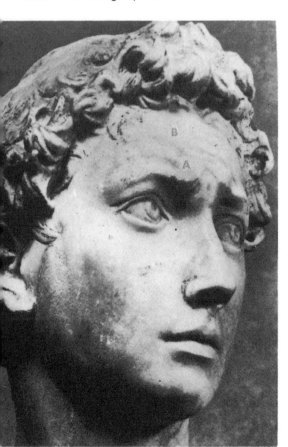

SUMMARY

Whether we call a face terrified, afraid, or just worried seems to depend mostly on the wideness of the eyes. If the eyes are wide enough, the message of horror comes across, even without much activity elsewhere in the face. In faces that are less afraid, the eyes are only a little bit wider than normal and must combine with a raised, slanted, or kinked eyebrow to be read as frightened. To show worry, the active brow must be combined with at least one other clue—slightly widened eyes, open mouth, or mouth pressed tightly closed.

The one generalization that will hold true for all the fear-related expressions is that if the upper lid is at all droopy, as it is in sadness, one will not conclude that any fear or worry is present, no matter what the rest of the face is doing. But even with the eye somewhat widened, fear becomes ambiguous as the amount of activity decreases.

In fact, the expression of fear on the face is really like the tip of a great iceberg of worry. There is far more anxiety in the world than ever appears on the face—most of us keep it buried deep inside, invisible perhaps even to ourselves. It takes truly extreme circumstances before we look as afraid as we sometimes feel. This is not counting the innumerable little nervous mannerisms that each of us enacts in our daily life as a sort of ongoing release for our fears and anxieties, only some of which involve the face, and most of which are unpaintable!

THE EXPRESSION OF DISGUST

We are repelled by many things in life, animate and inanimate. As much difference as there may be between our distaste for an ex-lover and our feelings about, say, rotting food or animal excrement, our facial response may be the same. Raising the middle of the upper lip and nose wings ever so slightly, the basis of the expression of disdain, is merely a refined and polite version of what someone does before he retches. Disgust is disgust whether the repulsion is intense and physical or decorous and intellectual. It is a certain frame of mind, and we instinctively react to it in a particular way, whatever the cause.

PHYSICAL DISGUST: PREPARING FOR THE WORST

At the root of the expression of disgust is an extreme physical act: vomiting. In the same manner as the face visibly prepares itself for a sneeze or a laugh that may never come, whenever we get a sensation that may lead to regurgitation, a particular facial mechanism is triggered. The disdainful sneer of someone who disapproves of me is really a facial hint that I make them want to vomit. They're not aware of that anymore than I'm aware of wanting to bite them if I raise my lip in an angry snarl in response, but that's the deep-seated association.

The act of expelling something disagreeable requires that the mouth be opened wide, the lips retracted, and the eyes tightly shut. Extreme disgust is expressed with nearly the same pattern, with two modifications: the mouth is usually not opened or not opened very wide, and the lower lip is relaxed.

Actions

What lies behind these facial appearances is primarily the action of the levator labii superioris. Its middle branch and inner branch are involved in the expression of disgust. In extreme physical disgust the inner branch is dominant, but as we are less revolted by something, the milder action of the middle branch takes over.

By itself, the inner branch pulls the upper lip sharply back into the face, squares its corners, and pulls the nose up by its wings; in combination with the corrugator and the orbicularis oculi (whose contraction it triggers), it pulls down the eyebrows, squints the eyes, and puffs up the cheeks.

The nose has very little to do with our perception of most expressions, but with extreme disgust we note an exception. The reshaping of the nose that takes place, along with the deep "sneer pocket" that appears above and to the sides of the nose wings, is a unique part of this particular action— no other expression creates the same forms. We can easily recognize from these forms alone the disgust in the face of a gentleman whose upper lip is entirely hidden by a moustache.

The Offending Inspiration for Disgust

Without going into too much detail, we must mention that out-and-out disgust can only be inspired by something terribly offensive to our sense of taste or our sense of smell. And it's not necessarily something putrid; rather, it depends on what you're used to: Charles Darwin reports a native of Tierra del Fuego being utterly disgusted by the texture of some canned meat that he was eating. If something makes us sick once, like drinking too much wine, the mere smell of wine may inspire disgust long afterward.

What's curious about disgust is that it's not an emotional state in its extreme stages—it's a physical instinct, like pain or sleepiness, although its occurrence is modified by cultural conditioning. It's only in its milder forms— disdain, scorn, and contempt—that it seems to belong in the category of an emotional response.

Mild Disgust

When our sensibilities are a bit less offended, the action of disgust shifts from the inner branch of the levator labii superioris to the middle branch, resulting in a less-contorted-looking face. The middle branch of the sneering muscle is more discreet in its impact. We end up with a squared-off upper lip and twisted-up nose, bordered by a deepened nasolabial fold, and little else.

There's an interesting borderline between disgusted faces that seem to be responding to something stomach turning and disgusted faces that could be merely expressing extreme disapproval.

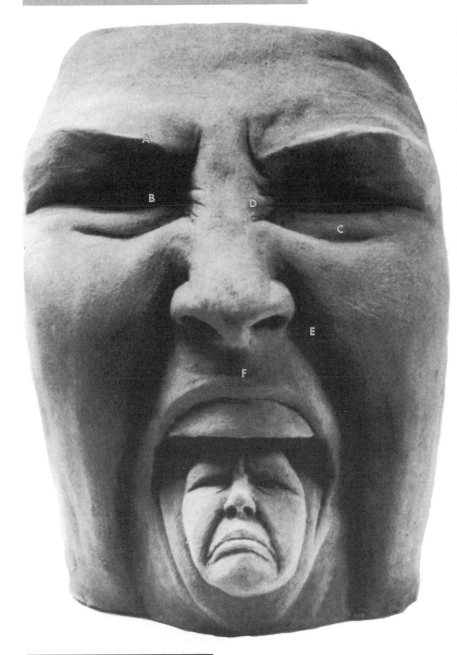

Disgust is a curious expression. No act is so purely physical and visceral as to retch in response to something we find stomach turning. Though a far cry from such untidiness, the sneer of disdain and turned-up nose of contempt are merely socially acceptable versions of the same action. At its heart, every expression of disgust is an attempt to eject something distasteful, an action that centers around the nose and mouth, and almost always brings on a frown.

EXTREME DISGUST: RETCHING

This unflinching, allegorical portrayal of the retch, by Nancy Fried, is in a category all its own—perhaps the only time this particular expression has been depicted in a sculpture. This contorted expression lies at the root of even the most discreet sneer. The act of ejecting something unwanted brings into play the powerful levator labii superioris, the sneering muscle. It pulls back the upper lip, raises up the cheeks, and triggers the squinting of the eyes and the lowering of the eyebrows. Less intense faces involve a different section of the same muscle. This remarkable sculpture is part of a series of self-portraits in which the artist sought to explore and exorcise a variety of troubling emotions. The expression on the smaller face is somewhat ambiguous; it's somewhere between sternness/anger and the pout.

ACTIONS OF INNER BRANCH OF SNEERING MUSCLE— DIRECT AND INDIRECT

A. Brow lowered—indirect.
B. Eyes squinted—indirect.
C. Curved fold under eye—direct.
D. Inner star-wrinkles—direct.
E. Creases alongside nose, deepest here—direct.
F. Upper lip squared, pulled into face—direct.

With no need of a nose at all, this face contains the four elements defining the retch: frown; closed eyes; raised upper lip; prominent tongue.

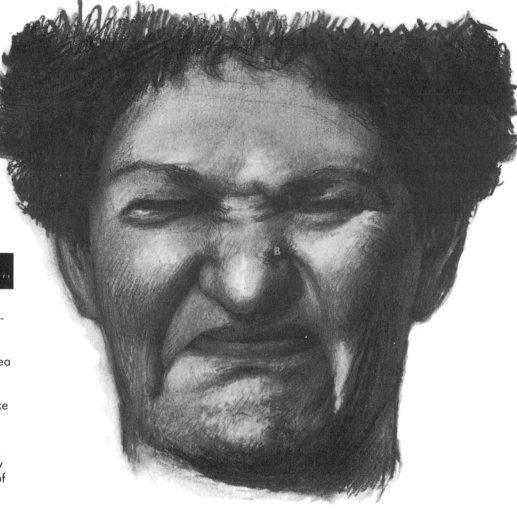

EXTREME DISGUST: THE FACE OF "YECCH"

This woman is reacting to something that strongly offends her sense of taste, touch, or smell. We may sneer when we find the idea of something distasteful, but our gut must be involved to inspire a face like this. Most of the facial actions of the retch (previous page) are present, but the mouth remains shut (partly aided by the contraction of mentalis); the face is preparing for final stage that never comes.

The upward pull of the sneering muscle brings the upper lip closer to the nose and fills out the lip corners at **A**. Note pulling upward of the wings of the nose and deepening of creases alongside the nose (already present)—especially deep "sneer pocket" at **B**.

RELAXED MOUTH FOR COMPARISON

DISGUST: PHYSICAL REPULSION

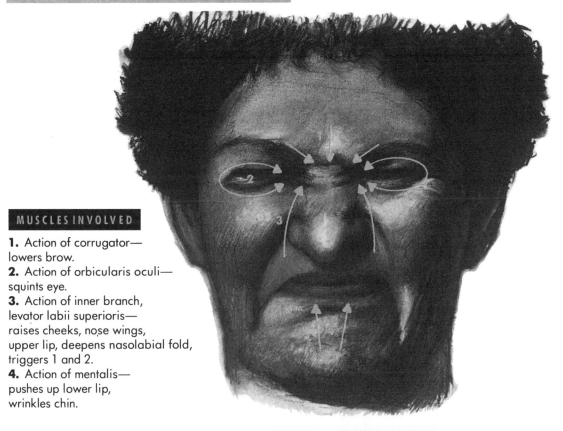

MUSCLES INVOLVED

1. Action of corrugator—
lowers brow.
2. Action of orbicularis oculi—
squints eye.
3. Action of inner branch,
levator labii superioris—
raises cheeks, nose wings,
upper lip, deepens nasolabial fold,
triggers 1 and 2.
4. Action of mentalis—
pushes up lower lip,
wrinkles chin.

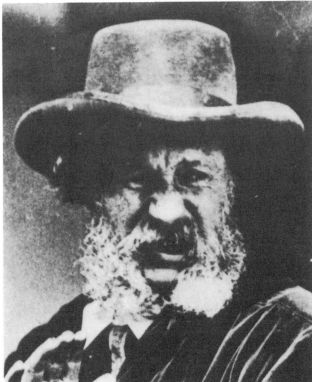

Extreme disgust may be perceived without the upper lip being visible, as these posed expressions from Darwin's *Expression of the Emotions in Man and Animals* indicate. The deep creases around the nose wings and the pointing of the nose, combined with the squint and frown, are sufficient evidence. Gesture reinforces the idea of holding something repellent at bay.

Offended senses or offended sensibilities? The face of disgust grades into the face of disdain as the action shifts from the inner branch of the sneering muscle, which distorts much of the face, to the middle branch, which affects mainly the nose and mouth.

DISGUSTED

A sneer this strong is most likely a response to something physically repulsive, but it's right on the edge of being a sneer of disdain. With the middle branch of the sneering muscle active, the squinting and frown disappear, focusing the action on the pointed nose, the lifted and creased cheeks, and the squared-off upper lip. The action around the nose is a key part of the pattern; in disdain, a similar square lip is joined with a less pulled-up nose.

Note change in shape in nose, deepening of sneer pocket alongside nose wing, and widening of corner of upper lip. Action of mentalis (**A**) pushes up lower lip—otherwise lifting of the upper lip would bare the upper row of teeth.

RELAXED MOUTH FOR COMPARISON

Some terrible irony is suggested by this unhappy self-portrait of Nicolas Poussin. The world of his paintings is one of chill, classical perfection—scenes of an ideal and imaginary antiquity. Nothing so tortured looking and down to earth as this expression is even hinted at in his work. In many ways identical to the expression opposite (down to the balling of mentalis in the chin), this face nonetheless suggests mental discomfort as opposed to physical. The "sneer" in the nose is less pronounced; the activity in the brows and forehead is ambiguous—perhaps a frown, perhaps even a suggestion of sadness.

DISDAIN, SCORN, CONTEMPT

The real territory of disapproval is that of faces with no appreciable action around the nose, but with a distinct squaring of the upper lip.

The look of disdain (or scorn or contempt) is a facial expression that combines an instinctive element—the squaring of the upper lip—with more voluntary, reinforcing facial gestures. In this case the reinforcements come in two forms: the lowering of the upper lid and the turning away or lifting up of the head. There has been speculation that when we perform these actions, we're making the nonverbal statement that the person we disdain is beneath notice, not worth acknowledgement.

As with any marginal expression the subtlest flicker of the sneer on the upper lip—which we might pass over otherwise—can be made unambiguous if combined with one or two of these reinforcing elements, as a slightly sad brow is made less ambiguous by downcast eyes and a slumped posture.

SUMMARY

Disgust, disdain, contempt, sneering, all are names for the same general category of facial expression. Central to them all is the action of the sneering muscle, the levator labii superiorus. Only in the most extreme version is the inner branch of the muscle involved. Otherwise, the more moderate middle branch is active. As the intensity of the expression diminishes, it goes from being a full-face expression, with changes visible from upper cheek to chin, to an expression that is mainly visible in the flat shape of the upper lip.

With a wave of her manicured hand, the well-dressed woman below seems to dismiss our existence. The slight sneer is an expression more of disapproval than disgust. This is the expression of the snob.

The upper lip of the subject of this photo, Hollywood gossip columnist Hedda Hopper, is slightly but unmistakably squared off and pulled back into her face by the sneer muscle (with no corresponding change around the nose); her lower lip is pushed up by the mentalis to meet it.

The pose, the expression, and the effect are very much the equivalents of the picture above. A useful rule is that if the thicker middle portion of the upper lip is more than three-quarters of its length, a sneer is perceived, even without the pointing of the nose and creasing of the cheeks.

RELAXED

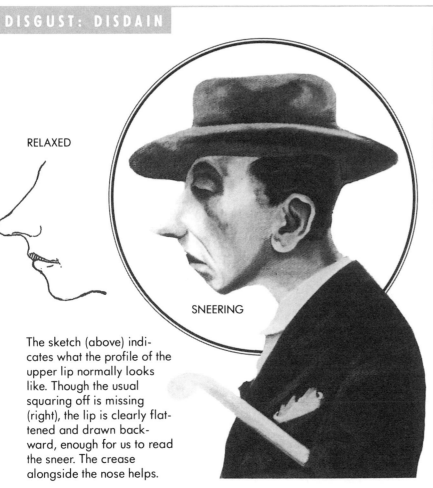

SNEERING

The sketch (above) indicates what the profile of the upper lip normally looks like. Though the usual squaring off is missing (right), the lip is clearly flattened and drawn backward, enough for us to read the sneer. The crease alongside the nose helps.

The acerbic social commentary of George Grosz is here focused on an interaction between a well-heeled Berliner and the crippled soldier from whom he's buying matches. The theme of social isolation and cruelty is reinforced by the strongly marked expression of disdain. The gentleman neither looks at nor seems to acknowledge the soldier; his face is dominated by his narrowed eye and vaguely sneering upper lip.

"This is the Sandra Hollingsworth. The 'the' is underlined."

Another snob. Context means a great deal in interpreting expression. Here the right setting (urban sophisticates) and the right characters (elderly gentry) make it easy for the cartoonist to get us to see the look of the grey-haired lady on the couch as comically disdainful. Her square lip appears a bit more arched than we'd expect (strong mentalis action, perhaps), and her nose seems no different from anyone else's; no matter—her narrowed-eye haughtiness is unmistakable.

THE EXPRESSION OF SURPRISE

There is less to say about surprise than any other facial expression of emotion. This reflects the paucity of material (surprise is very rarely photographed and even more rarely depicted in art), the simplicity of the expression itself, and the modest importance of surprise in the larger scheme of things, as compared to, say, anger or joy.

Perhaps all these reasons derive from one fact: surprise is the most instantaneous of all emotions. Its duration on the face is measurable in fractions of a second, and its appearance and disappearance as an expression is probably too quick to observe from life. It is almost by definition an expression that is impossible for an actor to create; while a good actor can work himself into a state of sadness or fear, no one can sneak up on himself by surprise. And if it's not unexpected, it's not surprise.

Surprise, however, is probably the easiest expression to pantomime. All the facial movements involved are easy to produce voluntarily, and at least part of the surprise pattern—wide eyes, raised brow—is universally employed as a conversational gesture, meaning "Oh really?" or "Wow!"

ACTIONS

Surprise is reflected in the face by two events: the eyes widen and the mouth drops open. The opening of the eyes is aided by a lifting, straight up, of the eyebrows, the work of the frontalis. This action helps us quickly raise the upper lid. The mouth, however, merely falls open, with none of its surrounding muscles contracted, or the lips are pursed together in a manner similar to whistling, with the mouth opening a small O.

According to Darwin, the two factors that always accompany surprise are a desire to see quickly what it is that we have been surprised by and a preparation for possible swift activity, which requires a deep inhalation through an opened mouth.

VARIATIONS

The most important variable in surprise is the wideness of the eyes. As in anger and fear, the eyes are crucial to our evaluation of the intensity of the expression: the wider the eyes, the more surprised someone looks. No one can look surprised unless his eyes are widened.

When we're surprised by some absolutely sensational piece of news, like the fact that we've just won a lottery or a beauty contest, surprise and pleasure may be visible at once. When pleasure dominates the look of surprise, the result is the "eager smile," with surprise mainly visible in the widened eyes. When surprise is paramount, the signs of joy will be subtle: a mouth that is not completely relaxed, showing a bit of angularity and widening at the corners, and a cheek that is beginning to show roundness.

It's also possible to recognize surprise in just the eyes and eyebrows, if the lifting of the brows and the widening of the eyes are extreme enough.

Surprise is by far the most fleeting of all facial expressions. Though we all recognize surprise easily, most of us have never actually seen it other than in pictures. To be surprised means to be startled. As our sophistication increases, our ability to be surprised decreases. Children are easier to surprise than adults.

The French photographer Robert Doisneau took a series of photographs from a hidden camera of passersby reacting to this painting. There are two variations of the surprised mouth—either dropped open and relaxed (oval shaped) or O shaped with pursed lips, as here.

A. Action of frontalis: raises eyebrows, creating horizontal forehead wrinkles.
B. Action of levator palpebrae: raises upper eyelid, exposing white above iris.
C. Action of orbicularis oris: incisivus portion pulls corners of mouth together, creating O shape and protruding lips.

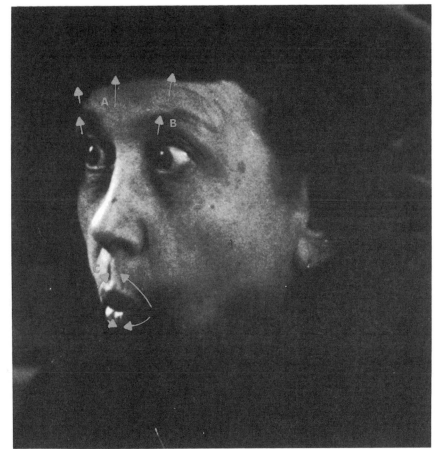

An "oh" from prehistoric America. This piece speaks volumes about the power of artistic economy, the skill of a lost, indigenous culture, and the universality of the face of surprise. Like many such faces, this one was a motif, repeated innumerable times—for what purpose, no one knows. Most striking is the way the mound around the circular mouth precisely duplicates the look of the protruded lips of the woman above, adding considerably to the evocative power.

MOUTH DROPPED OPEN

Darwin offers an interesting explanation for why the mouth drops open in surprise, as in the face of the beauty contest winner below. When we're suddenly fixated on something, he writes, "the other organs of the body [i.e., muscles] are forgotten and neglected," and the jaw drops of its own weight. This also allows the deep intake of breath that follows a sudden shock—a preparation for "jumping away from the danger, which we habitually associate with anything unexpected." That she's not frightened we judge from her relaxed mouth and un-kinked eyebrows. Her smooth forehead shows no wrinkling of frontalis, though her eyebrows appear to be lifted; this is not uncommon.

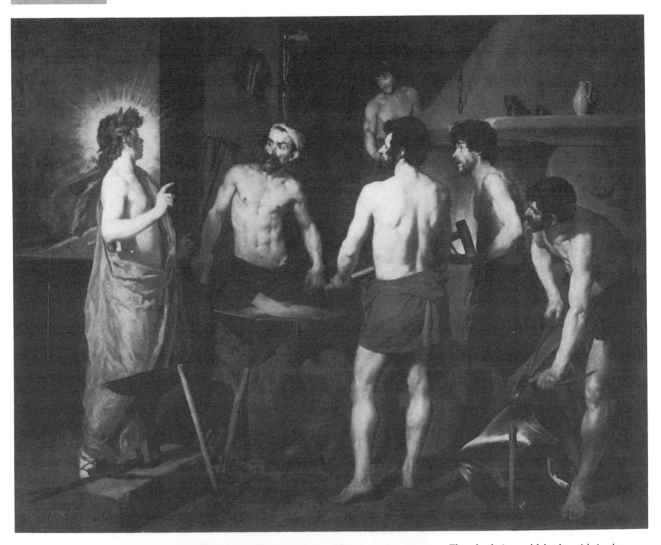

The slack-jawed blacksmith in the middle is staring at the sudden appearance of a god—Apollo has just materialized in his forge. Surprise, like anger and fear, is dominated by the eyes. The wider the eyes, the more surprised the look. Velázquez has chosen to make his blacksmith only appear moderately surprised—the effect of the open, relaxed mouth, raised eyebrows, and eye only a bit wider than normal. If we were to see white above his iris, he would look much more amazed.

THE STARTLED STATUE

Attentive readers of the New York Times of January 18, 1989, noticed something distinctly odd about an otherwise routine photo of the President-elect and Vice-President-elect and their wives, taken during a pre-inaugural ceremony. The colossal statue of Abraham Lincoln, for most of this century a thoughtful and remote presence in its memorial, appeared for all the world to have awakened with a start, betraying the utmost astonishment at the goings-on at its feet. What accounted for this strikingly lifelike transformation? Was the Times trying to make a covert political statement? Were statues learning to walk?

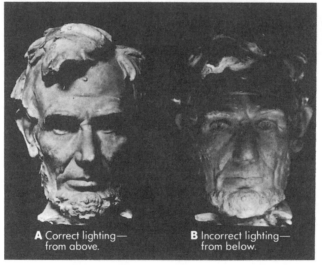

A Correct lighting—from above.

B Incorrect lighting—from below.

The "startled" statue is an accidental effect of light and shadow. The sculptor of the Lincoln Memorial, Daniel Chester French, was so concerned about the potential of light to alter Lincoln's expression that he sent the commission responsible for the memorial a photo showing: (**A**) how it should be lit, and (**B**) how it should under no circumstances be lit. In the early

1920s spotlights were installed to light the statue from above, as French wished, but for the Bush-Quayle inauguration, it was decided to temporarily light the statue from below, leading to just the change in expression French had warned against. Lit correctly, Lincoln wears what French described as the expression of "confidence in his ability to carry the thing through."

In correct lighting, eyebrows cast shadow at **1**, giving impression of lowered, thoughtful brows. Incorrect light from below casts shadows at **2**, which appear like raised, arched eyebrows; edge **1** disappears. Eyelids repeat pattern—real edge **3** is washed out; shadow at **4** makes upper lid appear enormously high above iris; raised eyebrow plus widened eye equal surprise.

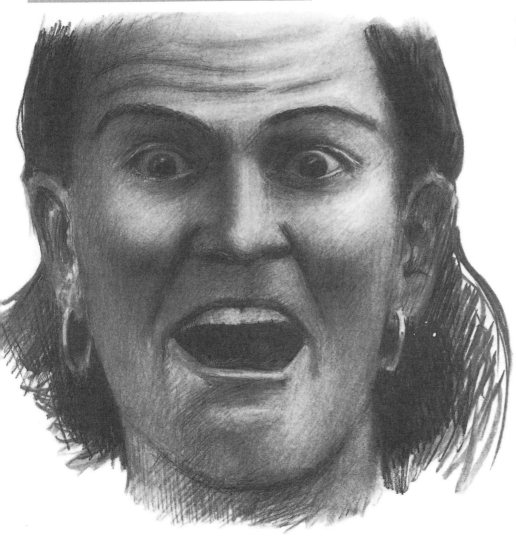

When we're surprised by something pleasant, surprise may be tinged with joy. We're aware of the joy primarily because of two elements, normally absent in the face of surprise: a slightly tensed, widened mouth and a slight bulging in the cheeks.

This woman has just won a contest—in this case a golf tournament. Her mouth shape is midway between the relaxed oval of pure surprise and the bow shape of the laugh. Her lower cheeks have begun to fill out under the influence of the zygomatic major, but her upper face is all surprise (as you can see by covering her mouth and cheeks). This face is closely related to the "eager smile"; there, pleasure was dominant, here it's surprise.

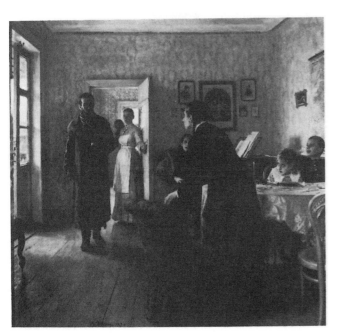

Here the pleasure component is more subtle. This painting by Ilya Repin concerns the unannounced homecoming of a man returning from Siberian exile. Though the action around the mouth of the surprised girl (**C**) is slight, the widening and turning upward at the corner, combined with beginning of bulging and creasing in the cheeks, is sufficient for us to see her as pleased and surprised. The risen, older woman shows no expression at all; even from the rear, we would see her smile by a bulge at **A**; we'd see her eyebrows lifted at **B**.

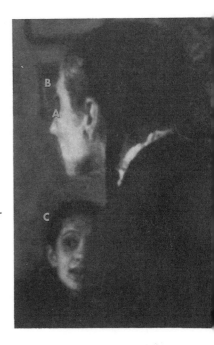

CONCLUSION

Those significant little twitches that we call facial expressions are both simple and complex, easy to understand and impossible to ever fully grasp, just like people themselves. We're all experts at identifying them and rank amateurs at understanding them or depicting them.

That is, *most* of us are. Certain artists have shown an enormous ability, in all ages and all locales, in observing the range of emotions and translating them into works of great beauty and emotional power. Since virtually anything with the two-hole/one-hole pattern can be seen as a face, artists have had great latitude in choosing how realistic, or how stylized, they wished their representations of expression to

be. Carved with skill and discrimination, three holes in a shell can be as evocative as a completely literal rendering in stone or paint.

The safest route for an artist is to avoid expressions entirely. Most painted faces, in fact, have little to show in the way of emotion; the odd smile, the occasional laugh. It's no easier to handle expressions well than it is to act well—the same sort of judgement and taste is demanded, as well as an intuitive sense of how people respond to each other. And painted expressions that are exaggerated or vacant looking make us at least as uncomfortable as does a badly delivered monologue on stage. But the potential rewards seem worth the risk.

Whether we are aware of it or not, there is nothing that interests us more or is capable of moving us more deeply, than the face. For an artist, anything that potent carries enormous possibilities. Mona Lisa's smile or Munch's supercharged scream of pain are imbedded in our collective sensibilities for a reason. For no matter how fashions in art change, there's unlikely to be much change in our deepest emotional yearnings or our deepest emotional fears. We will always be responsive to what happens in those twenty-five square inches between the chin and forehead, and artists will always be trying to find new ways to provoke that response, while in the process discovering more about their own humanity.

Two self-portraits by the Austrian artist Egon Schiele. In the drawing (left), the artist portrays himself with the quintessential self-portrait expression: intensity/attention. Frowning is a natural accompaniment to the hard, concentrated work of drawing; just as natural is a slight widening of the eyes, as seen here, that marks extra-alertness. A large number of artists' self-portraits betray some degree of the thoughtful frown.

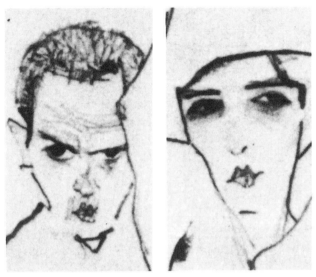

The expression of Schiele's mouth here, however, is unique; it's pursed up in what appears like a whistle. This is another category of non-emotional expression, the sort of nervous movement of the mouth that many people make when they're hard at work. His model wears quite another kind of face: her narrowed eyes and slight grin suggest the seductive smile (p. 231).

In the painting (right), Schiele has chosen to portray his face with the gesture of the raised brow. The simple raised brow may indicate a mood of heightened attention; that seems to be its meaning here. The distant, self-absorbed look of his wife is the combined result of her downward gaze and her eyes being slightly out of convergence.

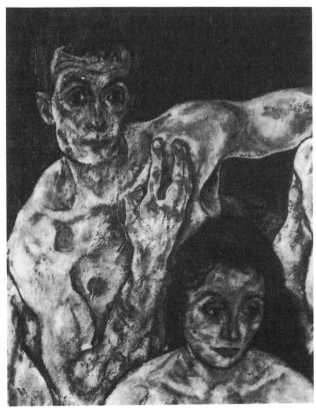

Expressions in Brief

CRYING: OPEN-MOUTHED

EYEBROWS
Entire brow lowered, especially inner corner, which is angled sharply downward. Roll of skin piles up above brow.

EYE
Reduced to nearly a single line by compression of orbicularis oculi. The stronger the action, the straighter and thinner the line of the joined lids.

MOUTH
Open moderately wide and stretched sideways as far as possible. Overall shape is rectangular. Upper lip squared off at corners; lower lip straight, often bowed up in the middle. Both lips smooth and taut.

SIGNATURE WRINKLES
1. Crow's feet and lower lid fold
2. Star-wrinkles from inner eye
3. Vertical lines between eyebrows, dimples above
4. Joined crease from nose to chin
5. Mentalis bulge
6. Cord-like folds alongside chin

SIMILAR TO
LAUGHING: No wrinkles 2 or 3; mouth stretched up, back, not out. Upper teeth show from tip to base. PAIN: Eyes may be open, or less tightly shut; mouth in shout position.

CRYING: CLOSED MOUTH

EYEBROWS
Entire brow lowered, especially inner corner, which is angled sharply downward. Roll of skin piles up above brow.

EYE
Reduced to nearly a single line by compression of orbicularis oculi. The stronger the action, the straighter and thinner the line of the joined lids.

MOUTH
Stretched as wide as possible and closed with moderate force. Sharp fold under lower lip; it may turn outward. Tautness, trembling of lips.

SIGNATURE WRINKLES
1. Crow's feet and lower lid fold
2. Star-wrinkles from inner eye
3. Vertical lines between brows, dimples above
4. Nasolabial fold, deepest in mid-cheek
5. Mentalis bulge
6. Hook-shaped folds by mouth

SIMILAR TO
STIFLED LAUGH: No wrinkles 2 or 3; less sneer in top lip or side stretch in both lips. Eyes slightly open. PAIN: Eye clenching more extreme, cheeks not as rounded. No mouth stretching or wrinkles 5 and 6.

SUPPRESSED SADNESS

EYEBROWS
Inner third (closest to middle of face) bent upward or at least kinked. Skin below piles in kidney-shaped knob.

EYE
Slightly narrowed by downward pressure of oblique above-the-lid fold and upward movement of lower lid. Bag under eye.

MOUTH
Squeezed tight by the three-muscle press. Lip margins disappear, LBL straight, puffiness around lips.

SIGNATURE WRINKLES
1. Horizontal across-the-brow folds (middle of forehead only)
2. Vertical lines between eyebrows, dimples above
3. Smile-shaped fold under lower lid
4. Oblique above-the-lid fold
5. "Floating" crease of zyg. minor
6. Hook-shaped fold alongside mouth
7. Barbell bulge under mouth
8. Mentalis bulge

SIMILAR TO
SUPPRESSED ANGER: Mouth is not stretched; eyes opened wider, with eyebrows down, not up. EXERTION: Mouth not stretched; eyebrows down, not up. Eye may be clenched tightly shut.

NEARLY CRYING

EYEBROWS
Inner third (closest to middle of face) bent upward or at least kinked. Skin underneath piles up in kidney-shaped knob.

EYE
Slightly narrowed by downward pressure of oblique above-the-lid fold and upward movement of lower lid. Bag under eye.

MOUTH
Moderately stretched, with strong sneer in upper lip. Sharp fold under lower lip.

SIGNATURE WRINKLES
1. Horizontal across-the-brow folds (middle of forehead only)
2. Vertical lines between eyebrows, dimples above
3. Smile-shaped fold under lower lid
4. Oblique above-the-lid fold
5. "Floating" crease of zygomatic minor
6. Hook-shaped fold alongside mouth
7. Barbell bulge under mouth
8. Mentalis bulge

SIMILAR TO
No expression is similar.

MISERABLE

EYEBROWS
Inner third (closest to middle of face) bent upward, or at least kinked. Skin underneath piles up in kidney-shaped knob.

EYE
Slightly narrowed by downward pressure of oblique above-the-lid fold. Lower lid may move up, accompanied by bag under eye.

MOUTH
Pouting. Upper lip squared off— center section extra long. Sharp fold under lower lip.

SIGNATURE WRINKLES
1. Horizontal across-the-brow folds (middle of forehead only)
2. Vertical lines between eyebrows, dimples above
3. Smile-shaped fold under lower lid
4. Oblique above-the-lid fold
5. "Floating" crease of zygomatic minor
6. Mentalis bulge

SIMILAR TO
WORRY: Eyes are wider, eyebrows are usually higher. No pout or wrinkle 4.

SAD

EYEBROWS
Inner third (closest to middle of face) bent upward, or at least kinked. Skin underneath piles up in kidney-shaped knob.

EYE
Slightly narrowed by downward pressure of oblique above-the-lid fold and upward movement of lower lid. Bag under eye.

MOUTH
Relaxed.

SIGNATURE WRINKLES
1. Horizontal across-the-brow folds (middle of forehead only)
2. Trace of vertical line between eyebrows, dimples above
3. Oblique above-the-lid fold
4. Smile-shaped fold may appear under lower lid

SIMILAR TO
WORRY: Eyes are wider, eyebrows may be higher. At times may appear very similar.
NEUTRAL: Eyebrows are relaxed, forehead is smooth.

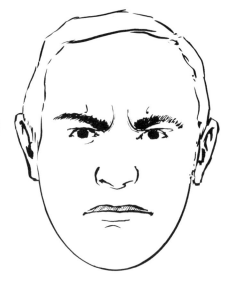

ENRAGED: SHOUTING

EYEBROWS
Inner corner pulled downward and toward the center of face. Lower edge of eyebrow falls below level of upper lid.

EYE
Opened extra-wide, though pressure of descended brow prevents white from showing above the iris. Upper eyelid rises at angle greater than 45 degrees. Lower lid tight.

MOUTH
Opened and stretched sideways, with overall rectangular shape. Upper lip squared-off in a sneer, lower lip margin straight. Both upper and lower teeth show.

SIGNATURE WRINKLES
1. Vertical lines between the eyebrows, dimples above
2. Horizontal above-the-lid fold
3. Smile-shaped fold below lower lid (may not show)
4. Joined crease from nose to chin
5. Bracket folds at mouth corners

SIMILAR TO
No other expression is similar.

ENRAGED: COMPRESSED LIPS

EYEBROWS
Inner corner pulled downward and toward the center of face. Lower edge of eyebrow falls at or just below level of upper lid.

EYE
Opened extra-wide, though pressure of descended brow prevents white from showing above the iris. Outer eyelid angle greater than 45 degrees.

MOUTH
Tightly compressed. Lips narrowed to thin lines and surrounded by bulging skin, especially below.

SIGNATURE WRINKLES
1. Vertical lines between the eyebrows, dimples above
2. Horizontal above-the-lid fold
3. Smile-shaped fold below lower lid (may not show)
4. Hook-shaped fold alongside mouth
5. Barbell bulge under mouth
6. Mentalis bulge

SIMILAR TO
SUPPRESSED SADNESS: Mouth is stretched; eyes narrowed, with eyebrows up, not down.
EXERTION: Eyes are narrowed, not widened.

MAD

EYEBROWS
Inner corner pulled downward and toward the center of face. Lower edge of eyebrow falls at or just below level of upper lid.

EYE
Opened wide, though pressure of descended brow prevents white from showing above the iris. Outer eyelid angle greater than 45 degrees.

MOUTH
Upper lip may be slightly squared off or slightly compressed.

SIGNATURE WRINKLES
1. Vertical lines between the eyebrows, dimples above
2. Horizontal above-the-lid fold

SIMILAR TO
INTENSITY/ATTENTION or PERPLEXED: Both are half-face expressions with mouth relaxed. Both involve less widening of the eye.

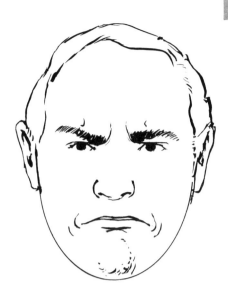
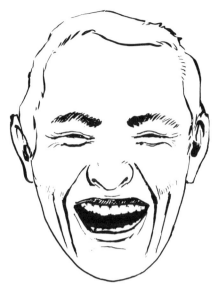

STERNNESS/ANGER

EYEBROWS
Inner corner pulled downward and toward the center of face. Lower edge of eyebrow falls at or just below level of upper lid.

EYE
Opened normally but appears narrower because of downward pressure on upper lid.

MOUTH
Compressed in a sort of pout. LBL arched like upside-down smile, with narrowed upper lip and pushed up lower. Sharp crease under lower lip.

SIGNATURE WRINKLES
1. Vertical lines between the eyebrows, dimples above
2. Mentalis bulge
3. Hook-shaped folds alongside mouth

SIMILAR TO
INTENSITY/ATTENTION or PERPLEXED: Both are half-face expressions with mouth relaxed. May be quite similar.

UPROARIOUS LAUGHTER

EYEBROWS
Relaxed.

EYE
Squeezed shut by compression of orbicularis oculi, but without strained look of crying. The stronger the action, the straighter and thinner the line of the joined eyelids.

MOUTH
Opened and widened. High corners; straight upper lip, lower lip straight in middle with almost vertical outer legs. Most of upper teeth revealed; tips of lower teeth may also show.

SIGNATURE WRINKLES
1. Crow's feet and lower lid fold
2. Star-wrinkles from inner eye corner
3. Joined crease from nose to chin
4. Chinstraps

SIMILAR TO
YAWNING: In yawn, cheeks are not full, mouth is taller than wide, and upper teeth don't show. Eyebrows are usually active, either pulled up or pulled down.

LAUGHTER

EYEBROWS
Relaxed.

EYE
Closed or very slightly opened; lids meet in a gently bowed line; full lower lid.

MOUTH
Widened and opened. High corners; straight upper lip, lower lip straight in middle, sharply angled outer legs. Upper teeth show, tips of lower only.

SIGNATURE WRINKLES
1. Crow's feet and smile-shaped fold under eye
2. Joined crease from nose to chin
3. Chinstraps

SIMILAR TO
CRYING: In crying: corrugator contracts, lowers eyebrow; full orbicularis oculi contracts, clenching eye shut with stress pattern of wrinkles; only tips of upper teeth usually show; lower lip stays low, exposing teeth in mouth corner.
FALSE LAUGHTER: In false laughter, eyes are more widely opened, and cheeks less full, without wrinkles 1.

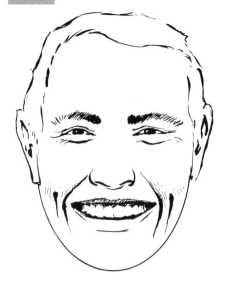

SMILING: OPEN-MOUTHED

EYEBROWS
Relaxed.

EYE
Crescent-shaped. Upper lid lowered slightly; lower lid straight and high with fullness underneath.

MOUTH
Widened with corner pulled back toward ear. Upper lip straight, showing upper teeth, lower lip straight in middle, angled outer legs.

SIGNATURE WRINKLES
1. Crow's feet and smile-shaped fold under eye
2. Joined crease from nose to chin
3. Dimples

SIMILAR TO
FALSE SMILE: In false smile, degree of smile is not matched by degree of contraction around eye—eye is wider, lower lid not as tight, cheeks not as full.

SMILING: CLOSED-MOUTH

EYEBROWS
Relaxed.

EYE
Crescent-shaped. Upper lid lowered slightly; lower lid straight and high with fullness underneath.

MOUTH
Widened with corner pulled back toward ear. LBL taut with overall V shape. Lips smooth and thinned; both lips move upward and press tighter against skull.

SIGNATURE WRINKLES
1. Crow's feet and smile-shaped fold under eye
2. Deepened nasolabial fold
3. Dimples

SIMILAR TO
FALSE SMILE: In false smile, degree of smile is not matched by degree of contraction around eye, so eye is wider, lower lid not as tight, cheeks not as full.

STIFLED SMILE

EYEBROWS
Relaxed.

EYE
Crescent-shaped. Upper lid lowered slightly; lower lid straight and high, with fullness underneath.

MOUTH
Widened, tensed, and narrowed. Middle of lips smile, but outer legs curve back toward ear and do not rise; they may even bend slightly downward. LBL straightened and lengthened.

SIGNATURE WRINKLES
1. Crow's feet and smile-shaped fold under eye
2. Nasolabial fold, deepest near mouth and ending abruptly
3. Dimples
4. Hook-shaped folds alongside mouth
5. Mentalis bulge

SIMILAR TO
EXERTION: Eyes are either squeezed shut or squinting without fullness of lower lid; cheeks are flat, not full; mouth is more thinned and not widened, with no wrinkle 2.

EYEBROWS
Inner third (closest to middle of face) bent upward or at least kinked.

EYE
Slightly narrowed. Upper lid lowered slightly; lower lid straightened and higher with fullness underneath.

MOUTH
Widened with corner pulled back toward ear. LBL taut with overall V shape. Lips smooth and thinned; both lips move upward and press tighter against skull.

SIGNATURE WRINKLES
1. Slight signs of crow's feet and smile-shaped fold under eye
2. Deepened nasolabial fold
3. Dimples
4. Horizontal brow folds in middle of forehead
5. Oblique above-the-lid fold

SIMILAR TO
SAD: Mouth in sadness does not curve upward; nasolabial fold is deeper closer to nose, and mentalis bulge appears on chin. However, melancholy smile may be interpreted as being more sad than happy because of powerful effect of sad eyes.

EYEBROWS
May be raised straight up.

EYE
Crescent-shaped with upper lid lifted extra high, perhaps showing white above iris. Lower lid straight and high with fullness underneath.

MOUTH
Widened with corner pulled back toward ear. Upper lip straight, showing upper teeth, lower lip straight in middle, angled outer legs.

SIGNATURE WRINKLES
1. Crow's feet and smile-shaped fold under eye
2. Deepened nasolabial fold
3. Dimples

SIMILAR TO
FALSE SMILE: In forced smile, upper lid and eyebrows are sometimes lifted, but are not matched by fullness in cheeks and lower lid.

EYEBROWS
Similar to fear. Overall lift with extra curl and kink at inner end.

EYE
Crescent-shaped. Upper lid lowered slightly; lower lid straight and high with fullness underneath.

MOUTH
Widened with corner pulled back toward ear. LBL taut with overall V shape. Lips smooth and thinned; both lips move upward and press tighter against skull.

SIGNATURE WRINKLES
1. Horizontal wrinkles in middle of forehead
2. Vertical folds between the eyebrows
3. Crow's feet and smile-shaped fold under eye
4. Deepened nasolabial fold
5. Dimples

SIMILAR TO
No other expression is similar.

SLY SMILE

EYEBROWS
Inner corner pulled downward and toward the center of face. Lower edge of eyebrow falls below level of upper lid.

EYE
Narrowed from above by downward pressure of brow and from below by slight contraction of muscle of lower lid.

MOUTH
Widened with corner pulled back toward ear. LBL taut with overall V shape. Lips smooth and thinned; both lips move upward and press tighter against skull.

SIGNATURE WRINKLES
1. Vertical lines between the eyebrows, dimples above
2. Smile-shaped fold under eye
3. Deepened nasolabial fold
4. Dimples

SIMILAR TO
No other expression is similar.

DEBAUCHED SMILE

EYEBROWS
Vary. May be lifted overall in effort to forestall drowsiness, or lift may be asymmetrical, as here.

EYE
Upper lid droops over iris, covering part of pupil. Lower lid may be tightened and higher with fullness underneath. May drift out of convergence.

MOUTH
Widened with corner pulled back toward ear. LBL taut with overall V shape. Lips smooth and thinned; both lips move upward and press tighter against skull.

SIGNATURE WRINKLES
1. Horizontal wrinkles across part of forehead
2. Crow's feet and smile-shaped fold under eye
3. Deepened nasolabial fold
4. Dimples

SIMILAR TO
No other expression is similar.

CLOSED-EYE (ABASHED) SMILE

EYEBROWS
Relaxed.

EYE
Eyes may be gently closed or looking downward.

MOUTH
Widened with corner pulled back toward ear. LBL taut with overall V shape. Lips smooth and thinned; both lips move upward and press tighter against skull.

SIGNATURE WRINKLES
1. Crow's feet and smile-shaped fold under eye
2. Deepened nasolabial fold
3. Dimples

SIMILAR TO
No other expression is similar.

 FALSE SMILE

EYEBROWS
Usually relaxed, though may also be raised as in eager smile.

EYE
Slightly narrowed, but not narrowed enough to match wideness of smile.

MOUTH
Widened with corner pulled straight back, not upward toward ear. Upper lip straight, showing upper teeth. Lower lip has extra-long straight middle section, showing lower teeth and lower mouth corner. Mouth shape is squarer than in relaxed smile.

SIGNATURE WRINKLES
1. Crow's feet and slight smile-shaped fold under eye
2. Deepened nasolabial fold
3. Dimples

SIMILAR TO
OPEN-MOUTHED SMILE: In natural smile, eyes are narrowed, with cheek and lower lid more full. Shape of mouth in natural smile is more angular in lower half, not as square—lower teeth don't show.

FALSE LAUGHTER 1

EYEBROWS
Relaxed.

EYE
Narrowed by lowering of upper lid and raising of lower, but iris is still clearly visible, looking outward.

MOUTH
Widened and opened. High corners; straight upper lip, lower lip straight in middle, sharply angled outer legs. Upper teeth show, tips of lower only.

SIGNATURE WRINKLES
1. Only slight crow's feet and shallow smile-shaped fold under eye may be entirely absent
2. Joined crease from nose to chin
3. Chinstraps/dimples

SIMILAR TO
LAUGHTER: When laughter is sincere, eye is almost entirely hidden between tightened lids and bordered below by full lower lid. Balled-up cheek is crossed by deep crow's feet wrinkles.

FALSE LAUGHTER 2

EYEBROWS
Relaxed.

EYE
Closed and relaxed, with simple curved lash line and few wrinkles.

MOUTH
Widened and opened. High corners; straight upper lip, lower lip straight in middle, sharply angled outer legs. Upper teeth show, tips of lower only.

SIGNATURE WRINKLES
1. Only slight crow's feet and shallow smile-shaped fold under eye may be entirely absent.
2. Joined crease from nose to chin
3. Chinstraps/dimples

SIMILAR TO
LAUGHTER: When we laugh with our eye closed, contraction around eye makes joint lid line much straighter. Cheeks and lower lids are much more full, with deep network of crow's feet wrinkles.

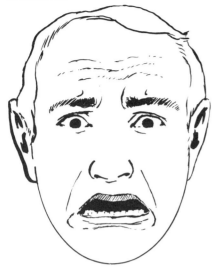 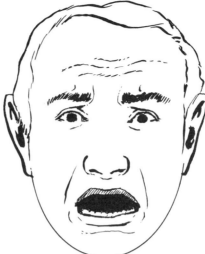 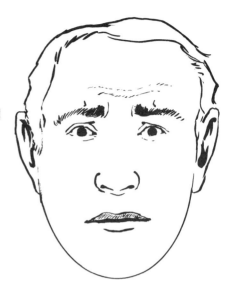

TERROR

EYEBROWS
Lifted straight up and pulled closer together, with innermost third of eyebrow bent upward or at least kinked. Eyebrow appears more straight than arched.

EYE
Opened as wide as possible, often with taut, raised lower lid.

MOUTH
Opened and widened. Most of the widening is at the level of the lower lip, which is stretched straight and tight. Upper lip is relaxed. Upper teeth hidden or show only tips; lower teeth exposed from corner to corner.

SIGNATURE WRINKLES
1. Horizontal brow folds
2. Vertical lines between eyebrows, dimples above
3. Oblique across-the-eyelid fold
4. Shallow, straight nasolabial fold
5. Bracket folds alongside lower lip

SIMILAR TO
SURPRISE: Surprised mouth is completely relaxed—oval in shape rather than rectangular. Surprised eyebrows lifted straight up without kinking or wrinkles 2.

VERY FRIGHTENED

EYEBROWS
Lifted straight up and pulled closer together, with innermost third of eyebrow bent upward or at least kinked. Eyebrow appears more straight than arched.

EYE
Opened very wide.

MOUTH
Opened and widened. Most of the widening is at the level of the lower lip, which is straightened somewhat. Upper lip is relaxed. Upper teeth hidden or show only tips; lower teeth exposed from corner to corner.

SIGNATURE WRINKLES
1. Horizontal brow folds
2. Vertical lines between eyebrows, dimples above
3. Oblique across-the-eyelid fold
4. Shallow, straight nasolabial fold
5. Bracket folds alongside lower lip

SIMILAR TO
SURPRISE: Surprised mouth is completely relaxed—oval in shape rather than rectangular. Surprised eyebrows lifted straight up without kinking or wrinkles 2.

AFRAID

EYEBROWS
Lifted straight up and pulled closer together, with innermost third of eyebrow bent upward or at least kinked. Eyebrow appears more straight than arched.

EYE
Alert, but not opened much wider than usual.

MOUTH
May be slightly dropped open or slightly dropped open and stretched sideways.

SIGNATURE WRINKLES
1. Horizontal brow folds
2. Vertical lines between eyebrows, dimples above
3. Oblique across-the-eyelid fold

SIMILAR TO
SADNESS: In sadness the eyes are always narrowed, not widened. The eyebrows kink, but do not lift. Mouth is often in pout, with "floating" wrinkle of zygomatic minor appearing between nose and mouth. However, there are times when the expressions seem indistinguishable, particularly if eyes aren't especially widened.

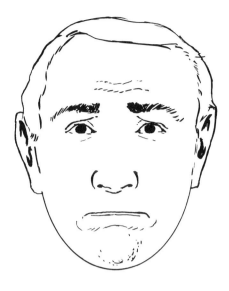
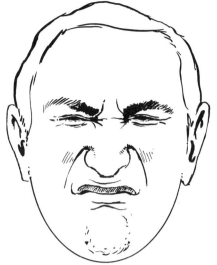
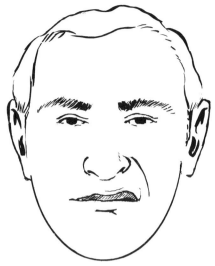

EYEBROWS

Lifted straight up and pulled closer together, with innermost third of eyebrow bent upward or at least kinked. Eyebrow appears more straight than arched.

EYE

Alert, but not widened.

MOUTH

Squeezed tight by the three-muscle press. Lip margins disappear, LBL straight, puffiness around lips.

SIGNATURE WRINKLES

1. Horizontal brow folds
2. Vertical lines between eyebrows, dimples above
3. Oblique across-the-eyelid fold
4. Hook-shaped fold alongside mouth
5. Barbell bulge under mouth
6. Mentalis bulge

SIMILAR TO

SUPPRESSED SADNESS: In sadness, mouth is stretched sideways as well as compressed. Eyes are narrowed, not widened, and eyebrows aren't lifted upward. Nasolabial fold appears deepened in suppressed sadness, and cheeks may swell.

EYEBROWS

Entire eyebrow lowered, especially inner corner, which is angled sharply downward.

EYE

Partly shut in a squint. Further compressed by downward pressure on upper lid of frowning brow.

MOUTH

Upper lip raised and flattened in an intense sneer. Lip is squared-off in shape and may show upper teeth. Horizontal crease appears above lip. Lower lip pushed upward slightly.

SIGNATURE WRINKLES

1. Vertical lines between brows
2. Crow's feet, lower lid crease
3. Star-wrinkles from inner eye corner
4. Nasolabial fold (deepest alongside nose, where it curves in a hook)
5. Mentalis bulge

SIMILAR TO

No other expression is similar.

EYEBROWS

Relaxed.

EYE

Relaxed. May be slightly narrowed.

MOUTH

Upper lip raised and flattened in a sneer—lip is squared-off in shape. Slight sneer often asymmetrical, with one half of upper lip active, other half relaxed. Lower lip neutral.

SIGNATURE WRINKLE

1. Nasolabial fold (deepest alongside nose)

SIMILAR TO

No other expression is similar.

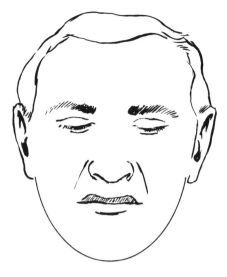

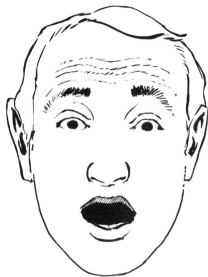

DISDAIN

EYEBROWS
Relaxed.

EYE
Relaxed. Often partly closed or looking down.

MOUTH
Upper lip raised and flattened in a sneer—lip is squared-off in shape. Slight sneer often asymmetrical, with one half of upper lip active, other half relaxed. Lower lip neutral.

SIGNATURE WRINKLE
1. Nasolabial fold (deepest alongside nose)

SIMILAR TO
No other expression is similar.

SURPRISE

EYEBROWS
Often raised straight up as high as possible; may also be relaxed.

EYE
Opened as wide as possible, with lower lid relaxed.

MOUTH
Dropped open, but without any muscle tension. Oval in shape.

SIGNATURE WRINKLE
1. Horizontal across-the-brow folds

SIMILAR TO
FEAR: Mouth in fear is opened, but not relaxed. Contraction of risorius/platysma stretches mouth sideways, giving it squarish shape. Equally important, contraction of corrugator modifies eyebrow lift in fear, kinking eyebrows and creating between-the-eyebrow wrinkles.
DROWSINESS: Eyes are narrowed, not widened.
SINGING: Eyes are not widened, eyebrows are not lifted.
BROW LIFT: Eyes aren't widened to the extreme they are in surprise, and mouth isn't dropped open.

Expressions of Physical States

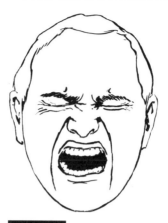

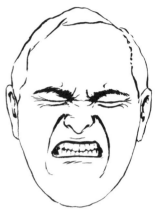

This book is primarily concerned with the expression of emotion on the face. Obviously, there is an enormous range of facial expressions that are not directly related to emotion. For artists, perhaps the most important of these are the expressions of physical states like pain, extreme effort, and sleepiness. Several of these are illustrated and discussed below. Also included are a few of the most common conversational expressions, which we all use as a sort of mime act to accompany our speech. There are three things all these expressions share with the expressions of emotion: (1) the eyes exercise decisive control over the overall effect; (2) full-face expressions are less ambiguous than expressions that involve only the mouth or only the eyes; (3) they are universal, and many are universally recognized.

PAIN 1

EYEBROWS
Entire brow lowered, especially inner corner, which is angled sharply downward. Roll of skin piles up above eyebrow. (Action of corrugator.)

EYE
Reduced to single line by compression of orbicularis oculi. Stronger action makes straighter line.

MOUTH
Opened in clenched-teeth grimace, with lips stretched up and sideways to the limit. (Action of risorius/platysma and levator labii superioris.)

SIGNATURE WRINKLES
1. Crow's feet, lower lid fold
2. Star-wrinkles from inner eye
3. Vertical lines between brows
4. Joined crease from nose to chin

COMMENTS
Extreme pain needs physical outlet. Face sort of spasms; eye muscles reflexively clench in full contraction, creating deep creases out from both inner and outer corners, like stress pattern. Mouth is usually stretched open, teeth ground together. Platysma cords arise in neck.

SIMILAR TO
CRYING: Usually less extreme, teeth not clenched.
LAUGHING: No wrinkles 2 or 3; mouth stretched up and back, not out.
EXERTION: Eyes may be open, or less tightly shut.

PAIN 2

EYEBROWS
Entire brow lowered, especially inner corner, which is angled sharply downward. Roll of skin piles up above eyebrow. (Action of corrugator.)

EYE
Reduced to single line by compression of orbicularis oculi. The stronger the action, the straighter the line.

MOUTH
Opened in a shout. Upper lip stretched high above teeth; lower lip pulled down below teeth and tightened. Entire mouth widened. (Action of risorius/platysma and levator labii superioris.)

SIGNATURE WRINKLES
1. Crow's feet, lower lid fold
2. Star-wrinkles from inner eye
3. Vertical lines between brows
4. Joined nose to chin crease

COMMENTS
Sudden, unexpected pain may be expressed in a shout. Otherwise the entire face is clenched. The greater the eye compression, the greater the appearance of pain.

SIMILAR TO
CRYING: Mouth shape not as open, more side stretch.
LAUGHING: No wrinkles 2 or 3; less sneer in upper lip, less sideways stretch in lower lip.
EXERTION: Eyes may be open, clenching less extreme.

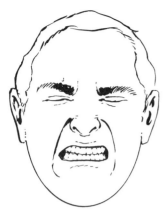

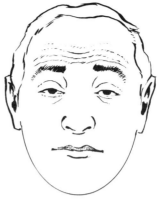

EXERTION 1

EYEBROWS
Inner corner pulled downward and toward middle. With less intense exertion, brow may be relaxed or even raised. (Action of corrugator.)

EYE
Clenched, but not to the maximum; lash line curved, not straight. In less intense actions eye is open, but squinting. (Action of orbicularis oculi.)

MOUTH
Mouth takes brunt of action. Teeth are tightly clenched, lips are stretched to maximum. Upper lip lifted. (Action of risorius/platysma and levator labii superioris.)

SIGNATURE WRINKLES
1. Vertical lines between brows
2. Lower lid crease
3. Deep nasolabial fold joins wrinkle
4. Bracket folds beside mouth

COMMENTS
There is a large area of overlap between the expressions of pain and physical effort, because effort can cause distress. The mouth is stretched in a grimace quite similar to that of pain. But the eyes almost never clench as tightly and often will remain open, somewhat narrowed.

SIMILAR TO
PAIN: Can be identical; in extreme pain eye squeeze is greater.
ANGER: Much stronger sneer in upper lip; glaring eye; shout.
LAUGHING: Teeth parted, mouth up/back, cheeks full.

EXERTION 2

EYEBROWS
Entire brow lowered, especially inner corner, which is angled sharply downward. (Action of corrugator.)

EYE
Clenched, but not to the maximum; lash line still curved, upper lid line still visible (disappears with more intense contraction). (Action of orbicularis oculi.)

MOUTH
Squeezed tight by the three-muscle press. Lip margins disappear, LBL straight, puffiness around lips. (Joint action of orbicularis oris, triangularis, and mentalis.)

SIGNATURE WRINKLES
1. Vertical lines between brows.
2. Crow's feet, lower lid crease.
3. Hook-shaped fold alongside mouth.
4. Barbell bulge under mouth.
5. Mentalis bulge, shield-shaped with rough skin on chin.

COMMENTS
Lip pressing and grimacing are equally common responses to physical effort. The three-muscle press squeezes the lips down to a narrow line and creates bulging around mouth.

SIMILAR TO
PAIN: Can be identical; in extreme pain eye squeeze is greater.
SUPPRESSED LAUGH, ANGER, AND CRY: All involve three-muscle press, but all have open eyes—squinting, glaring, or sad.

DROWSINESS 1

EYEBROWS
Raised straight up in effort to keep lids lifted. (Action of frontalis.)

EYE
Closed past normal alert position: iris at least 50 percent covered by upper lid with part of pupil blocked.

MOUTH
Relaxed.

SIGNATURE WRINKLES
1. Horizontal across-the-brow folds
2. Bag under the eye
3. Furrow of inner orbit

COMMENTS
With drowsiness, the levator palpebrae relaxes, and upper eyelid drops. We often attempt to keep the eye open by raising our forehead, which indirectly drags the eyelid upward. Usually, the lift is not enough to pull upper eyelid to fully awake position, but only to keep it part-way raised with pupil still blocked. Expression gives the impression of being momentary state before individual succumbs to sleep. Deep fatigue also causes general relaxing of muscle tension, leading to sagging of skin, deepening of bags and folds.

SIMILAR TO
SURPRISE: Eyes open much wider, mouth drops open.
FEAR: Eyes open extra-wide, brows with kink, mouth open.

DROWSINESS 2

EYEBROWS
Relaxed.

EYE
Closed past normal alert position, so that iris is at least 50 percent covered by upper lid. Pupil partly blocked.

MOUTH
Relaxed.

SIGNATURE WRINKLES
1. Bags under the eye
2. Furrow of orbit may be clearer

COMMENTS
Drowsiness is marked by a period of wavering consciousness, when the eyelids droop and vision becomes blurred. The eyes may briefly close and open again in quick succession as sleepiness comes and goes. Any position of the upper lid lower than halfway down the iris will make the eye appear drowsy; position illustrated here represents someone just barely awake.

SIMILAR TO
No other expression is similar.

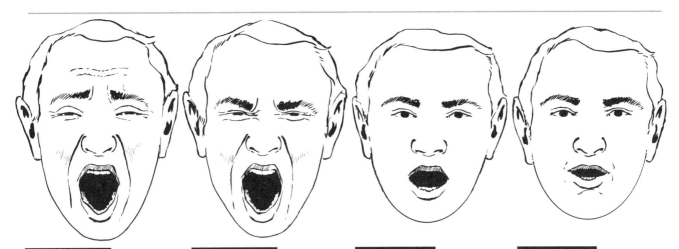

YAWNING 1

EYEBROWS
Pulled together and lifted upward, particularly at the inner end, which may bend upward in a kink. (Action of corrugator and middle fibers of frontalis.)

EYE
Partly shut in a squint; upper lid exposed by lifting of brow. (Action of orbicularis oculi.)

MOUTH
Jaw dropped as far as possible, with mouth opening maintaining an oval, relaxed shape. Tips of upper and lower teeth may show. (Action of levator labii superioris.)

SIGNATURE WRINKLES
1. Horizontal middle-of-the-brow folds
2. Dimple above eyebrow
3. Vertical folds between the brows
4. Crow's feet, lower lid crease
5. Joined crease from nose to chin

COMMENTS
General clenching of facial muscles. Contraction of circular eye muscle helps lift upper lip, as does mild contraction of sneering group. Also the mouth opens as wide as possible, stretching the entire lower face. There are many variations.

SIMILAR TO
SINGING: Combination of squinting eyes and raised brow would never appear in singing.
SHOUTING: Combination of squinting eyes and raised brow would never appear in shouting.

YAWNING 2

EYEBROWS
Entire brow lowered, especially inner corner, which is angled sharply downward. (Action of corrugator.)

EYE
Partly shut in a squint, as well as by downward pressure of the inner brow. (Action of orbicularis oculi.)

MOUTH
Jaw dropped as far as possible, with mouth-opening maintaining an oval, relaxed shape. Tips of upper and lower teeth may show. (Action of levator labii superioris.)

SIGNATURE WRINKLES
1. Vertical lines between brows
2. Crow's feet, lower lid crease
3. Star-wrinkles from inner eye corner
4. Joined crease from nose to chin

COMMENTS
Brows as often lowered as raised in yawn. Upper face is in motion, but direction of motion seems quite variable. Squint is important; it's related to the squint of actions where air is quickly expelled from mouth.

SIMILAR TO
SINGING: Can be identical. Singing usually looks less distressed as corrugator/squint combination this intense rarely occurs in singing.
SHOUTING: This is quite similar to shouting, but shouting eyes are usually much wider, without wrinkles 2 or 3. Shouting mouth usually more square, less open.

SINGING 1

EYEBROWS
Relaxed.

EYE
Relaxed.

MOUTH
Opened, with lower lip slightly turned out. (Action of depressor labii inferioris.)

SIGNATURE WRINKLES
None.

COMMENTS
Only two of the many possible mouth positions are illustrated. In general, singing involves only the lower half of the face. The lips may be tightened along their inner edges, turned outward, or stretched wider, or all three at once. Typically, only the tips of the teeth are exposed. Singing 1 illustrates the singing of the sound "ah."

SIMILAR TO
SURPRISE: Eyes in surprise are extra-wide, often with raised brow.

SINGING 2

EYEBROWS
Relaxed.

EYE
Relaxed.

MOUTH
Opened, with corners pulled inward, lips turned outward. (Action of incisivis branch of orbicularis oris and depressor labii inferioris.)

SIGNATURE WRINKLES
None.

COMMENTS
Many vowel sounds, sung and spoken, involve the action of that branch of the lip muscle that purses the lips, the incisivis. Singing 2 illustrates the singing of the sound "eeeee," with the lip corners pulled inward toward each other, and the lips slightly turned out. In louder singing, squinting and frowning may appear in upper face.

SIMILAR TO
No other expression in this book is similar.

SHOUTING

EYEBROWS
Pulled slightly downward and inward, mostly at inner end. (Action of corrugator.)

EYE
Narrowed slightly by squint—both from above and below. (Action of orbicularis oculi.)

MOUTH
Opened, with raising of the upper lip and sideways widening of the lower. (Action of risorius/platysma and levator labii superioris.)

SIGNATURE WRINKLES
1. Vertical lines between the brows
2. Crow's feet, lower lid crease
3. Joined crease from nose to chin

COMMENTS
Shouting is usually accompanied by squinting, and frequently by a squaring off of the lower lip and raising of the upper. The louder the shout, the wider the mouth, and the more squinting the eye. Lips may also be tightened, both above and below, by edge fibers of orbicularis oris. Loud singing and shouting can be identical in appearance.

SIMILAR TO
SINGING: Identical to loud singing in appearance.
YAWNING: Eyes are usually much narrower in the yawn, often with raising of the brow. Mouth in yawn is much wider and not as tensed.

PASSION/ ASLEEP

EYEBROWS
Relaxed.

EYE
Closed and relaxed.

MOUTH
Slightly open and relaxed.

SIGNATURE WRINKLES
None.

COMMENTS
The combination of slightly opened mouth and closed, relaxed eyes is subject to many possible interpretations. One possibility is the face of sleep, another a kind of stupor. One of the more common ways we read this face is as the face of sexual passion.

SIMILAR TO
SINGING: We expect most singing to be done with open eyes.

INTENSITY/ ATTENTION

EYEBROWS
Inner corner pulled downward and toward the center of face. Lower edge of eyebrow falls below level of upper lid. (Action of corrugator.)

EYE
Opened extra-wide, though pressure of descended brow prevents white from showing above the iris. Outer eyelid angle greater than 45 degrees. (Action of levator palpebrae.)

MOUTH
Relaxed.

SIGNATURE WRINKLES
1. Vertical lines between the brows
2. Dimple above middle of eyebrow
3. Horizontal above-the lid fold

COMMENTS
When not seen as sternness/ anger, with which it is easily confused, the combination of lowered brows and widened eyes gives the face the appearance of intense concentration and interest. This is the expression frequently worn by artists in their self-portraits.

SIMILAR TO
STERNNESS/ANGER: When sternness/anger involves tightening or pouting of the lips, there is no possibility for confusion. But sternness/ anger may involve just the eyes; in such a case the expression can be identical to intensity/attention.

BROWS DOWN/ PERPLEXED

EYEBROWS
Inner corner pulled downward and toward the center of face. Lower edge of eyebrow falls at or just below level of upper lid. (Action of corrugator.)

EYE
In normal alert position, but slightly narrowed by downward pressure of brow.

MOUTH
Relaxed.

SIGNATURE WRINKLES
1. Vertical lines between the eyebrows
2. Dimple above middle of eyebrow

COMMENTS
Though it may be confused with sternness/anger, the simple act of lowering the brows has several other more common interpretations. We tend to see a slightly frowning face as puzzled, thoughtful, or frustrated; in social situations we recognize the brief frown as a mere conversational gesture, like a hand movement.

SIMILAR TO
STERNNESS/ANGER: We tend not to see a face as angry unless the eyes are opened extra-wide under the lowered brows. The relaxed mouth also makes anger less likely as a perception.

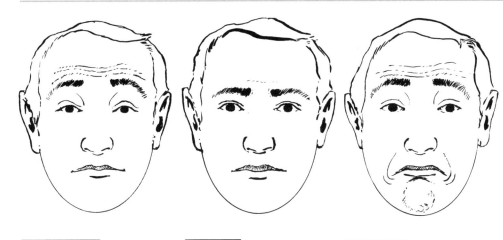

BROWS UP

EYEBROWS
Raised straight upward with rows of chevron-shaped, horizontal folds above. (Action of frontalis.)

EYE
Relaxed. Action of brow lift may raise upper lid slightly and expose surface of upper lid.

MOUTH
Relaxed.

SIGNATURE WRINKLE
1. Horizontal, across-the-forehead folds

COMMENTS
The brow lift is one of the most common of all conversational expressions. We use it to signal that something surprises us, to emphasize a point, to show that we're interested, or with no particular reference but simply out of conversational habit. It can be the nonverbal equivalent of "you don't say!" or "I doubt that." It can also be the nonverbal equivalent of "hello!"; people around the globe raise their eyebrows as a way of greeting an acquaintance.

SIMILAR TO
SURPRISE: In surprise the mouth is always dropped open, and the eyes are always extra-wide.

SHOCK

EYEBROWS
May be slightly raised and pulled together, particularly in the center, with an upward kink at the inner end. (Action of middle fibers of frontalis and corrugator.)

EYE
Extra-wide and out of convergence (irises asymmetrical) with a staring quality. (Action of levator palpebrae.)

MOUTH
Relaxed.

SIGNATURE WRINKLES
1. Vertical lines between the eyebrows
2. Middle-of-the-forehead horizontal folds

COMMENTS
Shock is closely related to fear, which it may follow. As a state of extreme distress, and detachment from normal consciousness, shock may be marked by distress movement in the eyebrows, as well as widened, askew eyes, which, ironically, see nothing at all.

SIMILAR TO
FEAR: Fear generally involves a stronger lifting and kinking of the eyebrows, as well as an opening and/or stretching of the mouth. In fear the eyes do not move out of convergence; we are too intent on our surroundings to allow ourselves to be detached.

FACIAL SHRUG

EYEBROWS
Raised straight up, as in surprise. (Action of frontalis.)

EYE
May be opened slightly wider by raising of brow; upper lid may be more exposed.

MOUTH
Strong pout, with corners pulled down. Lower lip pushed upward with steep shelf underneath; upper lip thinned and stretched. (Joint action of triangularis and mentalis.)

SIGNATURE WRINKLES
1. Horizontal, across-the-brow folds
2. Deep undercut beneath lower lip
3. Hook-shaped folds alongside mouth corners
4. Mentalis bulge, shield-shaped with rough skin, on chin

COMMENTS
The facial shrug is the facial equivalent of shrugging the shoulders—a gesture of resignation. It appears like an exaggerated sad pout, with the lower lip pushed outward, the LBL radically bent downward, and the skin on the chin roughened. The brow raise is optional; the movement in the mouth is the key. In conversation a guttural exclamation often accompanies the facial shrug.

SIMILAR TO
SADNESS: Pout in sadness is more subtle and always is accompanied by distress movements in the eyebrows and eyes.

INDEX

Credits

Page 10—Jacques Louis David, *The Death of Socrates*; 1787; The Metropolitan Museum of Art, Wolfe Fund, 1931. Catherine Lorillard Wolfe Collection. 11—Rembrandt van Rijn, *Self Portraits*; 1630. 12—Rembrandt van Rijn, *The Naughty Child*; c. 1635. Staatliche Museum, Berlin. 13—Denis Diderot, "Drawing: Expression of the Emotions"; 1762-67; *Encyclopedia*. 14—Victor Perard, "Facial Expressions"; 1928; *Anatomy and Drawing*, Pitman Publishing Co. 17, top—Gustave Courbet, *Portrait of Jo*; 1866. The Metropolitan Museum of Art, bequest of Mrs. H. O. Havemeyer, 1929. The H. O. Havemeyer Collection. 17—Gustave Courbet, *Portrait of Jo*; 1866. The Nelson-Atkins Museum of Art, Kansas City, Missouri (Nelson Fund). 24—John Hesselius, *Mrs. Richard Brown*; c. 1760. National Museum of American Art, Smithsonian Institution, purchased in memory of Ralph Cross Johnson. 25, top—Edgar Degas, *Self Portrait*; c. 1863. National Gallery of Canada, Ottawa. 25—Anonymous, "Edgar Degas"; c. 1855-60. Bibliotheque Nationale, Paris. 40—Leonardo Da Vinci, Study for the Head of the Angel in the *Virgin of the Rocks*; c. 1485. Royal Library, Turin. 55—Leonardo Da Vinci, Study of Head, Arms and Hands; c. 14. Windsor Castle, Royal Library. © 1989. Her Majesty Queen Elizabeth II. 56, top—G. B. Duchenne, frontispiece; 1862; *Mecanisme de la physionomie humaine*, Atlas. 56, left—G. B. Duchenne, "Terror"; 1862; *Mecanisme de la physionomie humaine*, Atlas. 56—Charles Darwin, "Anger"; 1872; *Expression of the Emotions in Man and Animals*, D. Appleton and Co. (1965; University of Chicago Press). 68—Henri de Toulouse-Lautrec, *La Goulue at the Moulin Rouge*; 1892-92. Collection, The Museum of Modern Art, New York. Gift of Mrs. David M. Levy. 69—Henri de Toulouse-Lautrec, *Troupe of Mlle. Eglantine*; 1896. Collection, The Museum of Modern Art, New York. Gift of Abby Aldrich Rockefeller. 79, top—Artist unknown, *The Language of Eyes*; no date. 79—El Greco, detail from *Christ on the Cross*; 1541-1614. Louvre Museum, Paris. 87—Jacob Eichholtz, *James Buchanan*; 1834. National Museum of American Art, Smithsonian Institution, Harriet Lane Johnston collection. 96—Artist unknown, *Paradise*; 1983. 118, 245—Artist unknown, Roman, Mask of Tragedy; c. 100. National Museum, Rome. 129, top—Pre-Columbian Mexican, ornamental mask; 10th century B.C. The Metropolitan Museum of Art, The Michael C. Rockefeller Memorial Collection of Primitive Art, Gift of Nelson A. Rockefeller, 1963. 129, 263—Robert Doisneau, *The Offended Woman*; c. 1956. Robert Doisneau/Rapho. 135, top—Rembrandt van Rijn, *The Abduction of Ganymede*; c. 1635. Staatliche Museum, Dresden. 135—Rembrandt van Rijn, Study for *The Abduction of Ganymede*; 1635. Staatliche Museum, Dresden. 143—Jack Hamm, *Melancholy*. Drawing by Jack Hamm reprinted by permission of Grosset & Dunlap from *Cartooning the Head and Figure* by Jack Hamm, copyright © 1967 by Jack Hamm. 152—"Resignation of Gary Hart: Staff Reacts"; 1987. Wide World Photos, Inc. Associated Press. 153—John Lukovits, drawing; c. 1985. Courtesy of John Lukovits. 156—Thomas Eakins, detail from *The Black Fan (Portrait of Mrs. Talcott Williams)*; c. 1891. Philadelphia Museum of Art. Gift of Mrs. Thomas Eakins and Miss Mary Adeline Williams. 157—Mary Cassatt, *Child in a Straw Hat*; 1886. National Gallery of Art, Washington, D.C.; Collection of Mr. and Mrs. Paul Mellon. 157—Rembrandt van Rijn, *Self-Portrait*; 1659. National Gallery of Art, Washington, D.C.; Andrew W. Mellon Collection. 158, top—Hilary Holmes, *Renee*; no date. Courtesy of the artist. 158—Michelangelo de Carravaggio, *The Arrest of Jesus*; 1570-1610. Odessa Museum. 159—Nancy Fried, *Peeling Back the Pain*; 1988. Courtesy of the artist. 162—Steve Hocklin, "Hijacking of TWA Flight 847"; 1985. ABC News photograph reprinted by permission. Copyright 1985 American Broadcasting Companies, Inc. All rights reserved. 167, top—Ray Harryhausen, Cyclops from *Seventh Voyage of Sinbad*; 1958. Columbia Pictures Industries, Inc. All rights reserved. 167—Noh mask, *Akujo*; no date. Courtesy of Tatsuo Yoshikoshi. 171, top—Tlingit Indians, carved wooden helmet; 19th century. Neg. no. 128008—Tlingit helmet. Courtesy Department of Library Services, American Museum of Natural History. Photograph by Arthur Singer. 171—David Celsi, excerpt from *David Chelsea in Love*; 1987. Courtesy of the artist. 172—Peter Paul Rubens, Drawing after the Central Group of Leonardo's *Battle of Anghiari*; c. 1600. Louvre Museum, Paris. 173—Lorenzo Zacchia, Engraving after the Central Group of Leonardo's *Battle of Anghiari*; 1558. Albertina Museum, Vienna. 174—John Stuart Curry, *The Tragic Prelude*; 1938-40. State Capitol, Topeka, Kansas. Copyright Photo 1. 175, top—Artist unknown, Temptation of Christ; 12th century. St. Lazare, Autun, France. 175—"Dirty Fascist"; 1967. UPI/Bettmann Newsphotos. 178, left—Ilya Repin, *Sophia Alexeevna*. Tretyakov Gallery, Moscow. 178, 227—William Ziegler, *Mary Worth*; 1986. Reprinted with special permission for NAS, Inc. 179—Gian Lorenzo Bernini, *David*; 1623-24. Galleria Borghese, Rome. 181—Artist unknown, *Kitoku*; no date. Photograph courtesy of Suenobu Togi. 183—Brady-Handy Studio, "Thaddeus Stevens"; c. 1860-68. Courtesy of Library of Congress, Washington. 184, left—Artist unknown, Portrait Bust of Caracalla. Courtesy of the Archeological Superintendence of Naples. 184—Mantegna, *Self-Portrait Bust*; 1480-90. San Andrea, Mantua. Photograph by Giovetti Studio Fotografico. 184, bottom—Artist unknown, Portrait Bust of Cato "Uticensis." Capitoline Museum, Rome. Photograph by Oscar Savio. 185, left—Don Diego de Velazquez, *Portrait of Pope Innocent X*; 1650. Galleria Doria Pamphilj, Rome. 185—Gian Lorenzo Bernini, *Bust of Innocent X*; 1598-1680. Galleria Doria Pamphilj, Rome. 186, top—Peter Paul Rubens, *Daniel in the Lions' Den*; c. 1615. National Gallery of Art, Washington, D.C.; Ailsa Mellon Buce Fund. 186—Charles R. Knight, *Siberian Tiger*; no date. Courtesy of Rhoda Knight Kalt. 187—Charles R. Knight, *Bellini*; 1945. Courtesy of Beatrice M. Febula. 187—Kaliber trademark. Courtesy of Guinness Import Company on behalf of Guinness PLC. 187, bottom—Artist unknown, Eagle from Old Pennsylvania Station, New York; no date. 195, top—Photograph courtesy of Kay Hazelip. 195—Sidney Goodman, *Father and Son*; 1988. Permission of artist. 195, bottom—Sidney Goodman, Head Study, Rising S.G.; 1988. Permission of artist. 199, top—Hugh Thomson, "I Never Laughed More in My Life"; no date. *School for Scandal*, Hodder & Stoughton Ltd., London, 1911. 199, left—Mexican primitive, Smiling Figure; c. 7th-8th century. The Metropolitan Museum of Art, The Michael C. Rockefeller Memorial Collection, Bequest of Nelson A. Rockefeller, 1979. 206—Artist unknown, Angel of the Annunciation; 13th century. Cathedral at Rheims. 206, right—Artist unknown, Saint Nicaise; 13th century. Cathedral at Rheims. 206—Noh mask, no date. 207—Punic mask, Tunisia. Courtesy New York Public Library, Astor, Lenox and Tilden Foundations. 212—Artist unknown, Head of Reglindis; 13th century. Naumberg Cathedral. 213, top—John Vanderlyn, *Elizabeth Maria Church*; 1799. The Metropolitan Museum of Art, Bequest of Ella Church Strobell, 1917. 213—Jacques Louis David, *Comtesse Daru*; 1748-1825. Copyright The Frick Collection, New York. 214, top—John La Farge, *Portrait of Father Baker*; 1863. The Art Museum, Princeton University. Gift of Frank Jewett Mather, Jr. 214—Leonardo Da Vinci, Mona Lisa; c. 1513-16. Louvre Museum, Paris. 217—"Soldiers of French Foreign Legion"; no date. Courtesy of Marie-Genevieve Vandesande. 220, top—Courtesy of Heublein Inc. 220—Excerpt from ad. Courtesy of Wm. T. Thompson Co. 221—Noh mask, *Chujo*; no date. Photograph courtesy of Tatsuo Yoshikoshi. 224, top—Thomas Eakins, *Addie*; 1900. Philadelphia Museum of Art, Gift of Mrs. Thomas Eakins and Miss Mary Adeline Williams. 224—Rembrandt van Rijn, detail from *Bathsheba*; 1654. Louvre Museum, Paris. 226, left—David Celsi, excerpt from *David Chelsea in Love*; 1987. Courtesy of the artist. 226—Francesco Gianinoto, Elsie the Cow; c. 1935. Courtesy of Borden, Inc. 228—David Celsi, sketch; 1984. Courtesy of the artist. 229—Ilya Repin, *Zaporozhye Cossacks*. The Russian Museum, Leningrad. 230—Don Diego de Velazquez, detail from *Bacchus*; 1628. Copyright © Museo del Prado, Madrid. All rights reserved. 231—Irving R. Wiles, *Miss Julia Marlowe*; 1901. National Gallery of Art, Washington, D.C.; Gift of Julia Marlowe Sothern. 235—David Horsey, excerpt from *Boomer's Song*; 1986. Reprinted by permission: Tribune Media Services. 237—Coolerator ad; 1950s. Coolerator Corporation. 243, top—Excerpt of ad for *Dead of Winter*. 243—Excerpt of ad for *The Hitcher*. 244—Ilya Repin, Study for *Ivan the Terrible*. Tretyakov Gallery, Moscow. 245, bottom—Kaethe Kollwitz, *Death Seizes a Woman*; 1934. Courtesy Galerie St. Etienne, New York. 246—Noh mask, *Yase-otoko*; no date. 251, top—Peter Menzel, "Guadalajara Bride and Groom"; 1979. Courtesy of Peter Menzel. 251—Pre-Columbian, head of bridge and spout vessel; c. 200 B.C. The Metropolitan Museum of Art, gift of Nathan Cummings, 1962. 253, top—Excerpt of ad. Courtesy of Helen Feuer Nursing Review Inc. 253, left—Donatello, detail of *St. George*. 253—Donatello, *St. George*. 255, top—Nancy Fried, *Life's Bitter Pill*; 1988. Courtesy of the artist. 255—Seattle Poison Center emergency symbol. Seattle Yellow Pages. 257—Charles Darwin, "Repulsion"; 1872; *Expression of the Emotions in Man and Animals*, D. Appleton and Co. 259—Nicolas Poussin, *Self Portrait*; 1594-1665. British Museum, London. 260, top—Alfred Eisenstadt, "Hedda Hopper, 1949, Laguna Beach." Alfred Eisenstadt, Life Magazine © Time Inc. 260—Charles Darwin, "Disgust"; 1872; *Expression of the Emotions in Man and Animals*, D. Appleton and Co. 261—George Grosz, *Street Scene*; 1893-1959. Thyssen-Bornemisza Collection, Laguna, Switzerland. 263, bottom—Artist unknown, carved shell from Brakeville Mound, eastern Tennessee; c. 1000-1600. Peabody Museum of Harvard University, Cambridge. 265—Don Diego de Velazquez, *The Forge of Vulcan*; 1630. Prado, Madrid. 266, left—Michael Geissinger, "Lincoln Memorial." Michael Geissinger/NYT PIX. 266—Daniel Chester French, "Abraham Lincoln"; 1914-22. Chesterwood Museum Archives, Chesterwood, Stockbridge, Massachusetts, a Property of the National Trust for Historic Preservation. 266, bottom—De Witt Ward, photograph of Lincoln Memorial lighting problem; 1922. Chesterwood Museum Archives, Chesterwood, Stockbridge, Massachusetts, a Property of the National Trust for Historic Preservation. 267—Ilya Repin, *Unexpected Return*. Tretyakov Gallery, Moscow. 269, top—Egon Schiele, *The Artist Drawing a Model Before the Mirror*. Graphische Sammlung Albertina, Vienna. Courtesy Galerie St. Etienne, New York. 269—Egon Schiele, *The Family*. Oesterreichische Galerie, Vienna. Courtesy Galerie St. Etienne, New York.

References

Darwin, Charles. *The Expression of Emotion in Man and Animals*. London: John Murray, 1872; reprint, Chicago: University of Chicago Press, 1965.

Ekman, Paul, and W. V. Friesan. *Facial Action Coding System (FACS): A Technique for the Measurement of Facial Action*. Palo Alto, Calif.: Consulting Psychologists Press, 1978.

Ekman, Paul, and W. V. Friesen. *Unmasking the Face: A Guide to Recognizing the Emotions from Facial Expressions*. Englewood Cliffs, N.J.: Prentice-Hall, 1984.

Ekman, Paul, ed. *Emotion in the Human Face*. Second edition. Cambridge: Cambridge University Press, 1982

Goldfinger, Eliot. *A Guide to Human Anatomy for Artists*. New York: Oxford University Press, forthcoming.

Gordon, Louise. *How to Draw the Human Head: Techniques and Anatomy*. New York: Viking Press, 1977.

Hjortsjo, Carl-Herman. *Man's Face and Mimic Language*. Sweden: Lund, 1970.

Hogarth, Burne. *Drawing the Human Head*. New York: Watson-Guptill Publications, 1965.

Lee, Stan, and John Buscema. *How to Draw Comics the Marvel Way*. New York: Simon and Schuster, 1978.

Peck, Stephen Rogers. *Atlas of Facial Expression: An Account of Facial Expression for Artists, Actors, and Writers*. New York: Oxford University Press, 1984.

Peck, Stephen Rogers. *Atlas of Human Anatomy for the Artist*. New York: Oxford University Press, 1951.

Vanderpoel, John H. *The Human Figure*. New York: Dover Publications, 1935.